ADVANCE PRAISE FOR

Global Dialectics in Intercultural Communication

"In *Global Dialectics in Intercultural Communication*, communication professors Jolanta A. Drzewiecka and Thomas K. Nakayama have compiled a wonderfully complex, rich, and diverse set of chapters that help to understand communication globally. Each chapter examines an interesting communication problematic, ranging from the construction of 'bad women' to the 'right' bodies of sex workers. In each, a deep awareness of cultural context, privileges, social struggle, historical and contemporary markers of difference, and geopolitical and globalizing features of culture-scapes broadly make this book a must-read in communication courses that want to explore things from a global perspective."

—*Kent Ono, University of Utah (USA)*

"We have here a diverse, distinctive collection of essays concerned with the human implications and on-the-ground entanglements of life under globalization, that seemingly intractable but unavoidable phenomenon."

—*Crispin Thurlow, University of Bern (Switzerland)*

Global Dialectics in
Intercultural Communication

Critical
Intercultural
Communication
Studies

Thomas K. Nakayama
General Editor

Vol. 23

The Critical Intercultural Communication Studies series
is part of the Peter Lang Media and Communication list.
Every volume is peer reviewed and meets
the highest quality standards for content and production.

PETER LANG
New York • Bern • Frankfurt • Berlin
Brussels • Vienna • Oxford • Warsaw

Global Dialectics in Intercultural Communication

Case Studies

Jolanta A. Drzewiecka
& Thomas K. Nakayama,
Editors

PETER LANG
New York • Bern • Frankfurt • Berlin
Brussels • Vienna • Oxford • Warsaw

Library of Congress Cataloging-in-Publication Data

Names: Drzewiecka, Jolanta A., editor. | Nakayama, Thomas K., editor.
Title: Global dialectics in intercultural communication: case studies /
edited by Jolanta A. Drzewiecka and Thomas K. Nakayama.
Description: New York: Peter Lang.
Series: Critical intercultural communication studies; vol. 23 | ISSN 1528-6118
Includes bibliographical references.
Identifiers: LCCN 2017017246 | ISBN 978-1-4331-4321-2 (hardback: alk. paper)
ISBN 978-1-4331-3224-7 (paperback: alk. paper) | ISBN 978-1-4539-1727-5 (ebook pdf)
ISBN 978-1-4331-4272-7 (epub) | ISBN 978-1-4331-4273-4 (mobi)
Subjects: LCSH: Intercultural communication.
Classification: LCC HM1211 .G558 | DDC DDC 303.48/2—dc23
LC record available at https://lccn.loc.gov/2017017246
DOI 10.3726/978-1-4539-1727-5

Bibliographic information published by **Die Deutsche Nationalbibliothek.**
Die Deutsche Nationalbibliothek lists this publication in the "Deutsche
Nationalbibliografie"; detailed bibliographic data are available
on the Internet at http://dnb.d-nb.de/.

The paper in this book meets the guidelines for permanence and durability
of the Committee on Production Guidelines for Book Longevity
of the Council of Library Resources.

© 2018 Peter Lang Publishing, Inc., New York
29 Broadway, 18th floor, New York, NY 10006
www.peterlang.com

Printed in the United States of America

Contents

Migration

Situated Cultural Practices

Strategic Communications in Crisis

Environmental and Social Justice

Figures

Tables

Contributors

Nilanjana Bardhan is a professor in the Department of Communication Studies at Southern Illinois University—Carbondale, USA. Her research interests span intercultural/transnational communication, postcolonial theory, and the communicative construction of identity in human and mediated environments. She also conducts research in the area of public relations, specifically in global contexts. She has published articles in the *Journal of International and Intercultural Communication, Mass Communication & Society, Communication Education, Communication Quarterly, Journal of Public Relations Research, Public Relations Review, International Journal of Strategic Communication, Journal of Communication Management,* and the *Journal of Health Communication.* She is the coeditor of the books *Public Relations in Global Cultural Contexts: Multi-paradigmatic Perspectives* and *Identity Research and Communication: Intercultural Reflections and Future Directions.* She is coauthor of *Cultivating Cosmopolitanism for Intercultural Communication: Communicating as Global Citizens.*

Heinz Bonfadelli is professor emeritus at the Institute of Mass Communication and Media Research, University of Zürich. He conducted research and published on uses and effects of mass media in fields such as children and media, health campaigns, environmental communication, media and migration.

Massimo Di Felice is a sociologist with a PhD in Communication. He is professor of Theory of Digital Communication in the School of Arts and Communication, University of São Paulo (ECA/USP). He is coordinator of ATOPOS (ECA/USP), a research center that develops interdisciplinary and international studies on social changes promoted by the advent of new digital communication technologies. He is also a Visiting Professor at Libera Universitàdi Lingue e comunicazione (IULM) in Milan and visiting professor at the University of Cordoba in Argentina, and Université Paul-Valéry Montpellier 3. He is the author of eight books, including: "Paisagens Pós-urbanas—o fim da experiência urbana e as formas comunicativas do Habitar" [Post-Urban Landscapes—the end of the urban experience and communicative forms of dwelling] (São Paulos, Annablume, 2009), translated into Spanish, Italian, and French. "Redes digitais e sustentabilidade" [Digital networks and sustainability] (São Paulos, Annablume, 2009), and "Pós-humanismo: as relações entre o homem e a técnica na época das redes" [Post-Humanism: the relationship between man and technology at the time of the networks] (São Paulo, Difusão, 2010). His new book published in Italian: "Net-attivismo: dell'azione sociale all'atto connettivo" [Net-activism: of social action to the connective action] (Rome, Edizioni estemporanee, 2017). He is also the author of articles published in Brazil and Europe.

Jolanta A. Drzewiecka is Assistant Professor at Università della Svizzera italiana in Switzerland. She recently moved to Switzerland after teaching in the US for many years. She teaches courses on intercultural communication and globalization. Her research concentrates on cultural identities, representations of immigrants, nationalism, and public memory in transnational contexts. She has published her work in journals such as *Communication Theory, Critical Studies in Media Communication, Journal of International and Intercultural Communication, Communication* and *Critical/Cultural Studies.*

Mohan J. Dutta is Provost's Chair Professor and Head of the Department of Communications and New Media at the National University of Singapore (NUS), Adjunct Professor at the Interactive Digital Media Institute (IDMI) at NUS, and Courtesy Professor of Communication at Purdue University. At NUS, he is the Founding Director of the Center for Culture-Centered Approach to Research and Evaluation (CARE), where he leads 19 culture-centered projects spread across 7 countries exploring marginalization in contemporary health care, health care inequalities, the intersections of poverty and health experiences at the margins, political economy of global health policies, and other topics. He has published in *Communication Theory, Health Communication,* and the *Journal of International and Intercultural Communication,* among others.

Shiv Ganesh is Professor of Communication at Massey University's School of Communication, Journalism and Marketing. His work examines communicative dynamics involved in collective action in the context of globalization and digital technology. His work appears in such journals as *Communication Monographs, Communication Research and Practice, Communication Theory, Human Relations, International Journal of Communication, Journal of Applied Research Communication, Journal of International and Intercultural Communication, Management Communication Quarterly, Media, Culture & Society, Organization Studies,* and *Women's Studies in Communication.*

Marouf Hasian, Jr. is a full professor in the Department of Communication at the University of Utah. His areas of interest include critical cultural studies, law and rhetoric, postcolonial studies, and critical memory studies. Professor Hasian is the author of 14 books on varied critical topics, ranging from Holocaust and genocide studies to medical humanitarianism. His work appears also in journals such as *Rhetoric and Public Affairs, The Quarterly Journal of Speech, Critical Studies in Media Communication,* and *Communication Inquiry.*

Mustafa Ideli is PhD candidate in sociology and communication science at the University of Zürich. His dissertation project focuses on migrants and media from Turkey in Switzerland.

Etsuko Kinefuchi (Ph.D., Arizona State University, 2001) is an associate professor of Communication Studies at The University of North Carolina at Greensboro. Her current research examines culture and communication from a critical, cultural-ecological perspective. Her work appeared in various communication and culture journals and edited books, including *Journal of International and Intercultural Communication, Critical Studies in Media Communication, Communication, Culture, and Critique, Howard Journal of Communications,* and *The Blackwell Handbook of Critical Intercultural Communication.*

Hans J. Ladegaard studied at Odense University, Denmark and Cambridge University, England. He is Professor and Head of the Department of English at the Hong Kong Polytechnic University. His research interests include intercultural communication, language attitudes and stereotypes, language and gender, narratives of migration, and pragmatics and discourse analysis. He has been involved in research on domestic migrant workers in Hong Kong and overseas for the past eight years. His book on the life stories of domestic migrant workers in Hong Kong will be published by Routledge in 2016. He is coeditor and review editor of *Pragmatics & Society* (John Benjamins).

Moon J. Lee (Ph.D., 2001, University of Florida) is an associate professor in the Department of Public Relations at the University of Florida. Lee's research focuses primarily on media effects, development and evaluation of media technologies, health communication and promotion, and public relations research. Lee has published in top-tier refereed journals in various disciplines, such as *Journal of Health Communication, Health Communication, Journal of Educational Computing Research, Journal of Computer-Mediated Communication, Journalism & Mass Communication Quarterly, Mass Communication & Society, Journal of Communication Management, Journal of Psychology: Interdisciplinary and Applied*, and *Journal of Social Psychology*.

Rahul Mitra (PhD, Purdue University) is an Assistant Professor in the Department of Communication at Wayne State University (USA). His research focuses on the communicative implications of organizing sustainably, and topics of study include: sustainable business, corporate social responsibility, leadership, career/work discourses, and organizing for social change. He has been published in peer-reviewed academic journals, such as *Human Relations, Environmental Communication, Journal of Business Ethics, Journal of International and Intercultural Communication*, and *Management Communication Quarterly*, and his work has also appeared in several edited scholarly books.

Thomas K. Nakayama (Ph.D., University of Iowa) is professor of Communication Studies at Northeastern University. He is a fellow of the International Association of Intercultural Research, a former Libra Professor at the University of Maine, and a former Fulbrighter at the Université de Mons in Belgium. He is coauthor of *Intercultural Communication in Contexts, Experiencing Intercultural Communication, Human Communication in Society* and *Communication in Society*. He is coeditor of *Whiteness: The Communication of Social Identity* and *The Handbook of Critical Intercultural Communication*. He is the founding editor of the *Journal of International and Intercultural Communication*.

Joseph Oduro-Frimpong is an Assistant Professor at Ashesi University. His research examines contemporary Ghanaian public culture and its relationship to understanding contemporary Ghanaian social life and political concerns. His works appear in *International Journal of Communication, African Studies Review* and the edited volumes: *Popular Culture in Africa: The Episteme of the Everyday* and *Encyclopedia of Social Movements Media*.

Nicholas Paliewicz is an Assistant Professor at the University of Louisville, Department of Communication. His research interests include rhetoric and argumentation, critical memory studies, and environmental communication. He is

published in journals such as *Argumentation and Advocacy, Western Journal of Communication*, and *Popular Communication.*

Eliete da Silva Pereira is a historian and has an MA in the Social Sciences from Research Center and Graduate of the Americas (CEPPAC) University of Brasília (Brazil), PhD in Communications from the School of Arts and Communication, University of São Paulo (ECA/USP), where she is researcher at the International Research Center ATOPOS ECA-USP, and coordinator of line of research "Tekó: digitization of local knowledge". She is author of the book Ciborgues indígen@s. br: a presença nativa no ciberespaço [Indigenous cyborgs.br: native presence in cyberspace] (Annablume, 2012) and she published the article "Indians on the Network: Notes about Brazilian Indigenous Cyberactivism" in the *International Journal of Communication* (2013).

Andrea Piga, PhD, wrote her dissertation on the topic of media and integration of migrants from Italy in Switzerland. She is working at the department of program strategy and audience research of the Public Broadcasting SRF in Zürich.

Dyah Pitaloka is Lecturer at the Department of Indonesian Studies, the University of Sydney. Prior to joining the University of Sydney, she was a postdoctoral fellow at the Center for Culture-Centered Approach to Research and Evaluation (CARE), Department of Communication and New Media, National University of Singapore (NUS). Her research centers on health communication and culture, marginalization in contemporary health care, the meanings of health in the realms of marginalized experiences in highly underserved communities in Southeast Asia particularly Indonesia and Singapore, and the ways in which participatory culture-centered processes and strategies are organized in marginalized contexts to coinitiate structural and social changes. Currently she is working on her book exploring the influence of culture and traditions in diabetes management among poor village women in Central Java, Indonesia.

Melissa Steyn holds the South African National Research Chair in Critical Diversity Studies, and is the founding director of the Wits Centre for Diversity Studies. Her work engages with intersecting hegemonic social formations, and includes the publication of five (co)edited books on race, culture, gender, and sexuality. She is best known for her publications on whiteness and white identity in post-apartheid South Africa. Her book, *Whiteness Just Isn't What It Used to Be: White Identity in a Changing South Africa* (2001, SUNY Press) won the 2002 Outstanding Scholarship Award in International and Intercultural Communication from the National Communication Association (USA). Melissa was featured as one of Routledge's Sociology Super Authors for 2013.

Maria Szmeja, Dr hab., is a professor of sociology at AGH, University of Science and Technology in Kraków and is a sociologist. She completed her PhD at Jagiellonian University, Kraków. She is interested in ethnic problems: ethnic identity, ethnic minorities, national development, borderland groups, communication between minorities and dominant group in society. She has published books, *Starzy i nowi mieszkańcy Opolszczyzny* (1997) and *Niemcy? Polacy? Ślązacy!* (2000) and research articles in English in journals such as *Polish Sociological Review* and *Journal of Borderland Studies*.

Dazzelyn Zapata is a lecturer at the Communication and New Media Department of the National University of Singapore where she also completed her PhD in 2015. She is affiliated with the Center for Culture-Centered Approach to Research and Evaluation working on projects with Foreign Domestic Workers and Transgender Sex Workers in Singapore. Her other research interests include mobile phones, technology use in marginalized settings, indigenous peoples, and development. Prior to moving to Singapore, she was an Assistant Professor at the University of the Philippines (UP) Baguio. She completed her BS Development Communication degree at UP Los Banos and MA Media Studies at UP Diliman. She is a volunteer in various indigenous communities in the Philippines for the past 14 years, mostly in the Cordillera Administrative Region where they have one of the highest concentration of indigenous peoples in the Philippines.

Introduction

Thinking Dialectically about Intercultural Communication on a Global Scale

JOLANTA A. DRZEWIECKA, UNIVERSITÀ DELLA SVIZZERA
ITALIANA, LUGANO, SWITZERLAND, AND THOMAS K.
NAKAYAMA, NORTHEASTERN UNIVERSITY, BOSTON, MA, USA

The 21st century is emerging as a dynamic era of rapid changes. These changes are not simply technological—although technological changes have shaped and influenced the dynamic feel—but extend across the social scene at home and abroad. The century began with the horrific and deadly attacks on the World Trade Center towers in New York City and the incredible dynamic character of the century has unfurled since then. The majority of British voters voted to leave the European Union (Brexit), many other European countries are seeing a resurgence of xenophobic nationalism, Europe is fiercely fortifying itself against the flows of refugees and migrants who are bringing to its shores the consequences of Europe's long-standing international policies and practices, the Arab Spring forged a democratic vision for the Middle East region, ISIS is threatening these gains, many Syrians have been displaced by war into many countries in the region and far beyond, and US President Donald Trump rose to loud applause by promises of building a wall between the US and Mexico during his campaign. It has not been so long since the destruction of the Berlin wall was seen as a major human accomplishment promising a better future. Since then, Israel has separated itself from Palestinian territories with an imposing wall. Walls and border fences proliferated and are once again seen as appropriate migration management strategies. While there is no doubt that we are living in a world that is more interconnected, this has not brought on more equality or intercultural understanding and walling off or fencing off is practiced both physically along

the borders and metaphorically in intercultural relations. Old and new divisions and separations cut across intense connections.

One part of these rapidly changing developments is happening in communication technologies itself. The rapid rise of social media has enabled new ways of communicating and connecting around the world, although there is disagreement about their precise impact which is still being examined. What we do know is that new media technologies have enabled more and more people to become cultural producers. Social media has become increasingly important to the everyday lives of millions, while at the same time, the digital divide means that millions more do not have access to these same communication technologies.

Currently, Facebook is banned in China. The need for some countries to block some social media platforms points to the potential of social media to invoke social change on a global level. While there has been debate over the role of social media in the Arab Spring, social media has been shown to mobilize people that can lead to significant political and social change. Studies show that diaspora activists were very active in the Arab Spring and the Syrian conflict by, among other things, providing insider reports to the Western media (Andén-Papadopoulos & Pantii, 2013) and posting YouTube clips and comments (Al-Rawi, 2014). Such activism is not new; as Anna Everett (2009) demonstrated, the digital black public sphere was formed early on by African and African-American activists. Nigerian diaspora in the US constructed Ninjanet, an online site where they forged connections among ethnic groups divided by the legacy of the colonial rule, voiced dissent against the current regime, challenged sexism within their community, and imagined a new African identity. Black online activism was crucial into mobilizing participation in the Million Woman March in Philadelphia in 1997. Social media breathed new life to diaspora groups so that we cannot think theoretically about these groups connected across borders without attention to social media platforms as not just sites but active tools of diaspora formations.

Social media is an important site for the ways that cultural attitudes influence intercultural communication. For those interested in intercultural communication, it is important to "attend to the cultural dimensions of new media and the ways in which they impact norms of intercultural communication" (Cisneros & Nakayama, 2015, p. 122). Social media platforms allow groups to share experiences, build communities, and enact solidarity in real time across borders and time zones. Such groups negotiate who belongs and who does not, and forge identifications and/or express antagonisms. Online spaces are used as safe spaces for self-expression and empowerment, e.g., when queer East Indian people connect with others and resist racism (Mitra & Gajjala, 2008). However, social media also offer spaces for enactment of fixed and essential identities. A study of a Chinese diaspora online showed that while participants in a social media site challenged singular notion of Chinese ethnicity, they asserted a nationally singular and pure identity when discussing topics

related to Chinese government's interaction with governments of other countries (Chan, 2005). When groups participate in online fora, they may communicate with each other in ways that impede dialogue (Witteborn, 2011). We can see creation of "ideological niches" where users with similar beliefs and biases exchange information and comments (Chao, 2015). Thus, social media are spaces for creating cross-border alliances as well as for debate and contestation (Everett, 2009).

Many hoped that social media would facilitate intercultural contact and understanding. While it certainly does so, it also provides a platform for racist, sexist, and xenophobic expressions. The absence of direct consequences, anonymity on some sites, the blurring of the public and private, removal of time and space barriers, and the "quick comment" feature facilitate hate speech (Chao, 2015). This is compounded by "context collapse" whereby the audiences are invisible and acontextual (Cisneros & Nakayama, 2015). While some sites, such as newspaper comment sections, have turned to moderation, this is also problematic as it provides "a false sense of a 'post-racial' or 'colourblind nation'" (Hughey & Daniels, 2013). Social media are also impacted by intercultural communication and contact. This dialogic relationship needs further exploration as communication technologies continue to develop. Pereira and di Felice's chapter provides insight into how new communication technologies enhance not only the cultural survival of indigenous groups but yielding of power and enactment of activism.

As many more people around the world are better connected and able to respond quickly through social media, the impact of current and future communication technologies has yet to be realized. These changes can have a tremendous impact on communication and globalization. As we think about future developments in globalization and intercultural communication, we must pay attention to communication technologies.

Globalization, as a concept, describes the intensification of interconnections across borders that bring on profound changes. The many changes facing all of us may feel unwieldy, but they are not random or willy-nilly. Their complexity is captured by the notion of *scaling*. A *scale* is "a space where diverse economic, political, social and cultural relations and processes are articulated together as 'some' kind of structured coherence" (Fairclough, 2006, p. 65). Rescaling reorients action within a different scale, e.g., from local to regional, and might destabilize our understanding of how our local scale is related to the regional and global scales where many economic as well as cultural processes take place. Scales are not a simple nested hierarchy; instead, they interact in complex ways (Sassen, 2007). A global scale might open up *within* a national scale or even a local scale such as when local practices, e.g., farming of particular crops, are changed by global climate change or when abundant cheaper crops produced elsewhere flood the international markets. Likewise, the displacement of refugees from Syria is global in scale and this global scale is opened up in particular locations

where groups of refugees settle and change the environment around them. We can see in these processes *time–space compression*, whereby effects of global or distant actions are felt locally and thus the relationship between time and space is altered (Harvey, 1990).

We can better understand the nature of global processes when we think of them as shifts in already existing dialectical tensions that have long undergirded the social scene. The notion of *dialectics* highlights the contradictory and simultaneously interconnected nature of the social phenomena. Dialectics enable us to tease out how seemingly contradictory pulls and pressures dynamically work together, not as dichotomies but as relational dynamics that enable further development of global social systems and processes (Martin & Nakayama, 1999). This process is not smooth, balanced, or coordinated but rife with contradictions and disjunctures.

The concept of *disjuncture* comes famously from Arjun Appadurai (1990) who proposed that global processes should be understood as occurring on five scapes: *ethnoscapes*, *mediascapes*, *technoscapes*, *financescapes*, and *ideoscapes*. The scapes are not necessarily aligned, harmonized, or distributed evenly across the globe. For example, many of us in the Western hemisphere might understand globalization as Westernization or even Americanization and thus our ideoscape, that sees the US as the world leader and the West as more advanced than the Rest, obscures for us non-Western cultural influences. Hence, while we commonly think of McDonald's as the epitome of globalization, many US Americans might not see Chinese restaurants, which are more numerous than McDonald's in the US, or migrant workers laboring in the fields as globalization of our environment. Thus, a dominant US ideoscape portrays globalization as "them" becoming more like "us" but not the other way around. From the Western American ideoscape, call centers in India are seen as "flattening" the world by bringing in economic and cultural opportunities to India and enhancing globalization understood as Americanization. This ideological lens blurs from view the extreme burnout and cultural resistance by Indian call center workers (Pal & Buzzanell, 2013). It also obscures from view the US economic dependence on countries providing "cheap" labor that fuels its dominant position. Once we see through the dominant ideoscape, the meaning of terms such as globalization, flattening of the world, or assistance changes. These examples also show that while global processes might proceed at different speeds, direction, or extent and toward different effects at the different scapes, many practices are not limited to just one scape but occur at intersections. Thus, migration is not simply a flow of people through an ethnoscape but is shaped by and produces effects in mediascapes (e.g., representations of migrants as well as flows of media products to the migrant community), financescapes (e.g., many industries heavily rely on migrant labor), and ideoscapes (e.g., while neoliberal capitalism dislocates people from their local jobs and communities and propels them to search for work

across borders, nationalism in the destination countries perpetuates precarious conditions of those who can get low-paid jobs but not documents). We thus view dialectics as tensions within and across scapes.

Our chapters highlight the communicative complexities at the intersections of two or more scapes. Ethnoscape intersects with financescape, mediascape, and ideoscape in chapters on *Migration*. Ladegaard shows us the interaction of the financescape and ethnoscape as women in the Philippines and Indonesia are forced by poverty to move and leave their families behind. They change the ethnic makeup of Hong Kong, sustain their families back home with remittances, and provide benefits to the already privileged employers in the form of cheap labor. Economics and the ethnoscape in the form of racial stratification also interact in Steyn's chapter on white emigration from post-apartheid South Africa. White South Africans began to emigrate since the collapse of apartheid neared in search of racially advantageous contexts. This migration also undermines ongoing decoloniality, and attempts to dislodge the colonial matrics of power persisting after the end of formal colonialization, i.e., the ideoscape. Bonfadelli et al.'s chapter on Switzerland shows us the interaction between ethnoscapes, mediascapes, and ideoscapes highlighting the importance of media practices for how we imagine who belongs and who is a citizen. This then also has implications for ethical journalistic practices.

Mediascapes, ideoscapes, and technoscapes intersect in chapters on *Situated Practices*. We see that groups find new ways of asserting their rights and recreating their identities by learning strategies from and modeling a sense of self-awareness on other groups under conditions of democracy (Szmeja). Consequently, a global scale of increased minority group's claim to rights opens up within the national scale via the local (the specific location and identity of a national minority group). Indigenous groups devise ways to survive culturally, economically, and territorially in their natural environment through the use of enhanced global technologies to sustain their local traditional cultural practices and values (Pereira and di Felice), whereas Hasian and Paliewicz show how media images of the Holocaust circulate globally, and thus create a global memoryscape (a sixth scape proposed by Phillips & Reyes, 2011), intersect with national ideologies, and frame the memorialization of the 9/11 attacks. Many crises are global in scale reverberating through the mediascape, financescape, and ideoscapes. No nation is isolated and PR practices have to now address these growing interconnections.

DIALECTICS

We now discuss in greater depth the dialectics that we see as key dynamics shaping global processes and playing out in the chapters.

The Nationalism-Globalism Dialectic

The tensions between nationalism and globalization are among the principal tensions being played out in different ways in the 21st century. Many scholars predicted years ago that the nation-state would wither away under the pressure of global processes overriding national borders and render nationalism mute. Economic globalization is driven by a logic of neoliberal free movement of capital and goods across borders that undermines the state's power to control economic processes within its territory. Additionally, as migrants move and settle but continue to maintain not just connections to but involvement with the cultural, economic, and political processes in their old homes, it is no longer sufficient to think in terms of the nation-state. Instead, scholars argue that we need to think in terms of *transnationalism* to understand that the boundaries of nations (if not state borders) are not just permeable but are pried open by practices along the scapes. In communication studies, the concept of globalization was first applied to media as transnational conglomerates bringing on homogenization and monopolization of the media market. Media are also prime carriers of cultural ideas and images across borders and make communication across time zones possible, which is critical to the functioning of the financescape. They also shape the ideoscapes across the globe by emphasizing consumerism of products sold globally as strategies of self-presentation, self-realization, happiness, and even social awareness (i.e., when companies advertise that they will donate to social causes in distant places from the sale of their products). Many different processes now cross national borders and thus organizations such as Doctors Without Borders (Bardhan) or even national governments (Lee) have to manage their public relations with an awareness of audiences and repercussions across borders. The chapters on migration also show the different ways in which migrants' lives are materially, symbolically, and emotionally involved in multiple relations across borders (Ladegaard and Steyn).

While transnationalization is a real process, we also see that the nation-state is shored up by a resurgence of vocal nationalism, often in the most virulent, xenophobic forms. This is not a simple contradiction when we understand that in practice, global economy relies on state governments to create conditions that are favorable to investors, transnational corporations, and "open" markets. This involves a combination of citizens' support for neoliberal policies and the state, which means that governments use nationalist rhetoric to garner such support. State governments flex their power to exact consent as well as submission. The chapter by Shiv Ganesh shows us that state governments appropriate the discourse of the "global war on terror" to subdue activist organizations fighting for rights for their communities. While the nation is an imagined community (Anderson, 1991), nationalism is a powerful force that maintains states in power.

National(istic) discourse unites citizens who are divided and alienated from the state by class divisions produced by economic inequalities.

But there are global dimensions at work in nation(alism) too. Even the nation as a form of alliance and governmentality is a globalized format continually spreading. Depending on international recognition and definition, there were 101 nation-states in 1950 and there are 193 states recognized by the UN in 2016. The emergence of nationalistic rhetoric against refugees and migrants in European member states of the European Union shows striking similarities. The creation and enlargement of the European Union was represented in its documents and plans as equalization and unification, and inspired hope for decrease in nationalism and more rights for workers who could move across borders in search of better jobs. The EU free movement of people is indeed an advancement running counter to the neoliberal logic which promoted free movement of capital and goods, *but* not people. Nevertheless, the EU enlargement very much relied on strategic promotions by state governments that themselves needed to continually inspire their citizens' national(istic) feelings for support of their rule. Simultaneously, the EU constructs itself as Fortress Europe in its unifying immigration policies targeting migrants from outside of the EU. Media across the globe continue to sustain the imagery of nation-states even when reporting news with clear international and global implications (e.g., Fursich, 2002; Ojala, 2011). Bonfadelli, Ideli and Piga's chapter shows us that while migration is a global phenomenon connecting many places, media rarely present it within a global scale, focusing instead on its national significance. This means that while our financescapes are deeply global, our ideoscape remains national(istic) in great measure.

We can thus see that the seemingly contradictory pulls of economic globalization and nationalism are actually a key mechanism of propelling the dominant economic and inter-national system. For example, we saw that the newspapers in the United Kingdom represented Polish intra-EU migrants as an economic threat to the nation. Simultaneously, however, they promoted the idea of free movement as a source of cheaper labor benefiting employers, homeowners, and the UK economy in the form of "disposable Polish pawns" who will leave when the low-paid jobs dry up (Hoops, Thomas, & Drzewiecka, 2016). Importantly, the coverage reminded the British workers that they were indeed replaceable by a cheaper and more agreeable workforce and, simultaneously, promoted their nationalistic jingoism against this migrant workforce. While more recently, the British voters voted by a small margin for leaving the EU in an apparent win for nationalism, the British leaders brought to power on the wave of this sentiment are already negotiating with the EU for a favorable access to its markets.

Although we might be seduced to focus solely on the tension between the nation and the European Union or various nations vs. free trade agreements, defense treaties, and other international connections, we shouldn't frame dialectical thinking

in such binary terms. Prior to the Brexit vote in 2016, Scotland voted to remain part of the United Kingdom in 2014. Rather than create its own nation-state, Scottish citizens voted narrowly to remain part of the UK. But this does not mean the end of this tension between Scotland and the UK. It may be an ongoing tension that emerges from time-to-time, much like the independence discussions from a number of regions, e.g., Catalonia vs. Spain, Flanders vs. Belgium, Quebec vs. Canada.

However, the notion of the nation-state as it emerged in the 19th century may not offer the stable framework we once thought it did. The emergence of ISIS, the Islamic State of Iraq and Syria, challenges the traditional notion of the nation-state. Here, a new tension emerges over the very concept of the nation. The Islamic State does not have internationally recognized borders, government, passports, citizens, and so on. It welcomes people to join it, rather than creating barriers to immigration. It uses terrorism rather than more traditional wars to advance its position. It raises the issue of how we might think about the nation-state more generally and its implications for national identity, borders, passports, immigration, refugees, and more.

The Symbolic-Material Dialectic

We can then see that the material economic processes are a central engine of the global changes around us. But how we name these processes makes a difference in terms of how we perceive their relevance and how we may decide to act on them. Hence, the material, i.e., the economic processes, state borders, or labor, is in a dialectical tension with the symbolic dimension (i.e., meanings we make of it). The tension between the two is key to understanding not only that communication occurs in specific material conditions but that such conditions make certain meanings viable while others are rendered mute. Further, which labels and meanings are assigned to material processes is always subject to political choices, exercise of power, and contestation. In turn, such labels and meanings have material consequences.

In its most hegemonic version in popular discourse, globalization names economic processes by multinational corporations which are said to "flatten the world" by improving everyone's access to the market, diminishing economic differences, and homogenizing a wide range of cultural practices (Friedman, 2005). Those who oppose globalization are labeled as antiglobalization protesters and charged with trying to stop progress but their actions are deemed futile. That these protesters develop global alliances and connections with many others in their attempt to stop corporate capitalist exploitation is seen as a contradiction rather than evidence that globalization is about multitude of processes in various spheres of life that are not necessarily aligned but, in fact, often contradictory. Very little, if any, attention is given to why the protesters oppose "globalization." Thus, in popular discourse, "globalization" has functioned as a symbolic God-term (McGee, 1980),

an unquestioned term with an assumed meaning that obscures relations of power and domination in global processes for many of us.

But trouble has been afoot. The dominant understanding of globalization has already been challenged, and not just by grassroots movements from below. Already in 1997, the billionaire George Soros argued:

> Although I have made a fortune in the financial markets, I now fear that untrammelled intensification of laissez-faire capitalism and the spread of market values to all areas of life is endangering our open and democratic society. The main enemy of the open society, I believe, is no longer the communist but the capitalist threat.... Too much competition and too little cooperation can cause intolerable inequities and instability. (quoted in Friedman, 2004, p. 77)

Such sentiments seem to swell more recently, especially in the wake of Thomas Piketty's book, *Capitalism in the 21st Century* (2014).

The chapters show the tensions between material conditions and meanings in different contexts. Dutta, Pitaloka, and Zapata show us that the material constraints on transgender individuals in Singapore include personal economic resources, sex work, the law, physical health risks, affordability of the sex change operation, and the physical vs. desired body. The material elements and conditions shape and constrain individual actions and desires. How they are negotiated has everything to do with discourses of sexuality and meanings that are or are not available for interpretation of self, expressing desires and acting on them. While nuclear power plants, nuclear energy and its effects on the environment are all material, Kinefuchi shows us they are brought into existence by the persuasive power of discourses underwritten by powerful interests. What we consider important (more development and consumptions, well-being, protection of the environment) is shaped by how dominant and counterdiscourses are able to compete with each other. Material conditions not only push people to migrate but also might constrain or enable identity choices (Ladegaard, Steyn). These are just a few examples of such tensions which manifest themselves in all the chapters.

The Local-Global Dialectic

Robertson's (1996) concept of glocalization has been profoundly influential in communication studies. Robertson argued against mythologizing globalization as homogenization and argued that it involves not simply large-scale phenomena but rather works through and is manifested locally. The local is constructed on a trans- or supralocal basis. The local and global are not in a relation of contradiction or opposition but rather one is expressed through the other. Locality and globality are relative spatially and temporally and are the "conditions of production of cultural pluralism" (Robertson, 1996, p. 32).

The chapters in this volume highlight the role of this dialectic in many different contexts. Oduro-Frimpong shows that while the format of political cartoons is a globalized form, cartoons by a Ghanaian artist utilize specific local cultural features to address political opinions about local issues to the local public. We see the linking of localities in the chapter by Lee which shows that government responses to local disasters offer important comparative lessons about how to improve strategic communication which leads to development of global standards for practice and evaluation. A Polish national minority group with deep historical roots recently began to assert its local distinctiveness and demand rights, in part, through adopting globally circulated discourses of minority group's self-assertion and rights (Szmeja). And environmental nonprofit organizations work with local grassroots efforts as they seek to establish broader resource management practices and accomplish goals on a global scale (Mitra).

Global-in-local dynamics raise many questions. Hasian and Paliewicz argue that the National September 11 Memorial and Museum has become a Judeo-Christian site of secular and sacred memory through the globalized Holocaust memoryscape that has become a universal measure of evil. The memory of the Holocaust has become a global memoryscape by losing some of its specificity and washing out the complexities of the involvement of many people through every day practices in the annihilation of Jews. Scholars working at the US Holocaust Memorial Museum tell us that it would have been impossible for so many people to die if not for the mundane involvement and complicity of many in the multiple sites of murder. But the Holocaust memoryscape represents it as the greatest evil committed by the Nazis in concentration camps, thus foreclosing questions of complicity and banality of evil to borrow Hannah Arendt's famous phrase. This presentation allows appropriation of this memory to local and national grieving without encouraging broader questions.

The Past-Future Dialectic

Globalization is not a new process as colonization of large numbers of people and swaths of land already gave rise to a "planetary consciousness" which, as Mary Louise Pratt (1992) argued, projected Europe as the pinnacle of human civilization. While developments in communication and transportation technologies since World War II intensified interconnections, the developing patterns followed Western exploitations and dependencies on formerly colonized places through neocolonial practices. Colonization created ideologies, conditions, and relations of inequality that continue to have profound structuring effects on all the global scapes. All of these long-term implications are lost or obscured if we think of globalization as a new process.

We see the presence of the past in the chapter by Pereira and di Felice which focuses on indigenous tribes decimated and dislocated by European invasion that

are now acquiring new forms of power to protect their land and ways of life through adoption of communication technologies. Melissa Steyn's chapter shows the lasting legacy of colonization as white South Africans can move to locales that afford them the best racial-economic advantages and thus undermine decolonial processes. White South Africans already have material resources that have accrued to them individually and collectively in material and symbolic forms since colonization. They move to enhance them as well as the symbolic value of their identity and the freedom to choose how to define and assert themselves without pressures of the changing racial power grid of the multicultural South African society. Contrarily, the Filipino and Indonesian migrant women are forced to move by the colonial legacies and neocolonial dependencies. The result of their move is not freedom but constraint on their identities as Ladegaard's chapter shows. While Ladegaard demonstrates that identity is a site of constraint and an individual impossibility in the case of female migrant workers, Steyn illustrates white identity as a site of transnational advantage. Colonial logics are hard to eradicate and, as Etsuko Kinefuchi's chapter shows, inform new ventures in different contexts in new forms such as the rationalist dualism which sees populations living near nuclear power plants and the environment as expandable. Hence, we can see that the ethnoscape is shaped by the historical forces which continue to chart pathways toward the future.

But are we doomed to follow the paths? The chapters apply a critical lens and encourage us to envision a different future and work toward decreasing precarity and exclusion of marginalized groups. In her critical analysis of the media representations of the Ebola epidemic and the Doctors Without Borders PR releases, Bardhan show us that the predominant images of Africa flowing through the mediascape are colonially based images of Africa as the dark diseased continent. Keeping the past colonial legacy in mind, she thinks about the future and drafts ethical guidelines for International Public Relations practitioners. Kinefuchi takes insight from indigenous communities and activists to urge us to rethink the relation between ourselves, others, and the environment and create a self-sustaining culture of mutuality, balance, and respect.

CHAPTERS

A recent *New York Times* article once again tells us that US Americans pay little attention to even the small amount of international news (Taub, 2016). This suggests that they seemingly know very little about the places where globalization produces local effects. This book offers in-depth case studies from specific locations that demonstrate the complexity of dialectics of globalization and also provide contextual knowledge. They are written by an international group of authors. They also present a broad array of communication practices in intergroup, intercultural,

traditional media and new media, professional communication, and media representation. Topics covered include international public relations, social movements, social justice, representations of immigrants, cross-border flows, global organizations, and global health. They address issues in Brazil, Ghana, Japan, Liberia, New Zealand, Poland, Singapore, South Africa, South Korea, and the US. We present the summaries of the chapters in the next section.

Migration

The section on migration includes chapters that address key issues of current global migration flows such as the ability or lack thereof to negotiate advantageous economic and cultural conditions and the role of media representations of migrants. In *The Destructiveness of Distance: Unfaithful Husbands and Absent Mothers in Domestic Migrant Worker Narratives*, Hans Ladegaard demonstrates the impact of separation from children and spouses on foreign domestic helpers from Indonesia and the Philippines in Hong Kong. While domestic work is among the lowest paid labor, it does provide an important benefit to upper and middle class families in affluent societies, increasing their status. Domestic helpers are among those who are chewed up by the engine of globalization that fuels the growth of the affluent. The chapter gives us insight into the lives of women who are forced to migrate and leave their families in search of work. The author discusses how cultural construction of servitude, sidestepping of labor laws, abuses, and separation from family combine to constrain the women. Defined as "just workers" by Hong Kong and by their own states as "bad women," feeling distant from children who do not know them and husbands who find mistresses, they do not have the luxury of identity negotiation as an individualist endeavor. Their identities are fractured by discontinuities of space and close relations as well as a lack of resources and choice. They are also constantly battling feelings of insecurity about whether their sacrifices will pay off long term. Their mobility is actually a site of constraint for them. All these issues come to us through a narrative analysis of storytelling by an engaged researcher who empathizes with their situation. The storytelling functions as therapy as it also reveals the important role of solidarity and mutual support among the women.

Eden Recouped: White South Africans in Tanzania and Zambia by Melissa Steyn discusses white emigration from South Africa. After the collapse of apartheid, white South Africans were forced to renegotiate their racial identity and their economic position. Some have opted out of this process and chose to leave South Africa for places that afford them greater racial–economic privilege. The chapter addresses how whiteness maintains and replicates its privilege through global mobility and translation/incorporation into new national contexts. The authors advance a theoretical framework linking scholarship on ignorance, racial contract, diaspora, and racial incorporation. They show how the white South African

imaginary reinscribes white hegemony and undermines processes of decoloniza-tion. The authors demonstrate how the symbolic dimension of identity—its mean-ings and rhetorical strategies—is mobilized by, is grounded in, and has secured its material resources and larger economic structures.

Switzerland is a small country with four official languages and three language regions, each with its own media. It has a high percentage of "foreigners," indicat-ing both relatively high immigrant admission rates and also citizenship restriction laws that require long waiting periods before eligibility. Although it is not a member of the EU, it is a member of the European Schengen zone which means that its borders are open to free movement for EU citizens. Thus Switzerland is inescap-ably affected by global migration flows both within Europe and from beyond. In *Swiss Media and Migration*, Heinz Bonfadelli, Mustafa Ideli, and Andrea Piga map out the representation of immigrants in the Swiss German-speaking and French-speaking media. They found that the issue of immigration is particularly salient in print national news. The Swiss direct democracy makes it possible for even fringe parties to put issues on the national agenda and such parties often propose limiting immigration to rouse up and garner new supporters. The chap-ter focuses on coverage of immigration following such an initiative. The authors find regional differences between how immigrants were represented and develop a number of useful strategies for more inclusive representations. Representations of immigrants are an important topic because media are forces of integration of migrants as well as of their exclusion depending on how they are represented.

Situated Cultural Practices

This section presents cases of different cultural practices that are shaped by global flows expressed in specific local contexts. *Meanings of Health among Transgender Sex Workers in Singapore: A Culture-Centered Approach* by Mohan Dutta, Dyah Pitaloka, and Dazzelyn Zapata shows us that experiences of gender identity by transgender individuals have been shaped by a nexus of global flows, historical processes, and cultural patterns. The authors examine transgendered individuals' health experiences and needs from a culture-centered approach, which highlights inseparable interrelationships between structural factors (i.e., the state, economic conditions), culture (i.e., familial relations and expectation, gender norms, cul-tural meanings), and agency (as expressed through desires for the "right" body and taking up sex work to accomplish this goal). Stigmatization as deviant, feel-ings of being in the "wrong" body, hormone therapy, sex reassignment surgery, and performing sex work to achieve a body matching gender identity all present health risks shaped by contradictory pulls and pressures. The analysis of the narra-tives of study participants brings the health issues and contradictions to light. The authors also highlight for us different cultural meanings and state policies across

Asia regarding transgender and LGBT rights that position Singapore as a unique place. Singapore criminalizes homosexuality—the laws originate in British colonialism—but has softened its approach to public expressions by same-sex couples and leads the region in sex reassignment surgery, although its cost is prohibitive to some. Legally, transgender individuals have the ability to establish a new identity and marry but experience cultural stigma during the process and some seek surgery in other countries where it is less expensive.

In *Thanatopolitical Spaces and Symbolic Counterterrorism at the National September 11 Memorial and Museum*, Marouf Hasian and Nicholas Paliewicz show the local and global dimensions of how the National September 11 Memorial and Museum in New York is interpreted. The authors add to our understanding of glocalization by demonstrating that when local vernacular practices appropriate symbolic resources from the global memoryscape of the Holocaust as the greatest evil committed by people against people, this creates national and international contestations. Different stakeholders argue about whether and which parallels should be drawn between the two events as well as whether it is appropriate and useful to think about suffering, grieving, and evil in global rather than local and specific terms. Such questions are further complicated by discourses about securitization and terrorism. Another layer is added by the global phenomenon of dark tourism whereby sites of death and disaster become destinations for tourists searching for a different quality of affective experience. Having examined discourses emerging on different platforms over the last decade, the authors argue that the Memorial itself should be considered a global memoryscape.

Glocalization and Popular Media: The Case of Akosua Political Cartoons by Joseph Oduro-Frimpong examines the mundane ordinary characteristics of political cartoons as a case study of glocalization. The author shows that Akosua's political cartoons blend global cartoon conventions and local cultural expressions (i.e., indirectness, "women's" talk patterns) to address local concerns and express global democratic practice of free speech. While large sections of Ghana's population are illiterate, the cartoon's aesthetics as well as the practice of reading the cartoons on the radio make them accessible to a large cross section of national audiences.

In *Communicative Forms of Indigenous Dwelling: The Digitalization of the Forest and Native Net-Activism in Brazil*, Eliete da Silva Pereira and Massimo Di Felice discuss the digitalization of indigenous activism in Brazil whereby indigenous people acquire new forms of power as speaking subjects and content producers. Their net activism involves protecting the forest from the position of coexistence within it and in the spiritual world that now involves the new communication technology. The authors advance the concept of dwelling as digitalization whereby technological knowledge meets and is translated through cultural knowledge of the forest, creating what they refer to as a reticular ecology. Digitalization expands the territory and the

ecosystem increasing visibility of local knowledge and culture and fortifying local heritage.

In *The Silesians in a Global Perspective: Communication with the Dominant Group in the Local and National Context*, Maria Szmeja presents a case study of a minority group which has recently begun to assert its rights to a separate identity and call for self-autonomy. The Silesian's history involves absorption of different imperial formations and then later emerging states that stigmatized them and attempted to wash them off their specific culture and identity. The group maintained its culture even under the state socialism which denied and suppressed cultural differences throughout Poland. As the state socialist regime collapsed, they began to assert their specificity, claim history of violence against them, and struggle against the dominant group who responded with hostility and/or indifference. While Silesians are a small group, as the author notes, they have joined other groups claiming distinct identities. This is a relatively new situation for Poland where these new dynamics have not yet effected changes in cultural awareness or labeling and thus even in academic language. The categorization into "Poles" and "Silesians" excludes the latter from the category Polish. Nevertheless, Silesians' history calls attention to the arbitrariness of borders providing an important historical context for understanding the current processes of transnationalization.

Strategic Communication in Crisis

This section addresses the evolving role in international and national public relations practices under the conditions of transnationalization. In *Telling the Story of Ebola: Cosmopolitan Communication as a Framework for Public Relations in Local–Global Contexts*, Nilanjana Bardhan examines news reports and evaluates news releases issued by Doctors Without Borders during the time of Ebola epidemic from the perspective of cosmopolitan communication. The media discourse presented sensationalized depictions of the Ebola epidemic articulated through colonial racist stereotypes of Africa that perpetuated fear of the Other both "over there" (in Africa) and "over here" (in the West, in "our" country, and "our" neighborhoods"). While we cannot be certain what effects such discourses produce, the press releases of Doctors Without Borders show increasing frustration with lack of help from the West. Doctors Without Borders is a global organization working in a local context and producing global–regional–local communication flows. It acts, in the terminology advanced by the author, as a cultural intermediary that faces enhanced ethical responsibilities to advance the cause of global justice. The author argues that this can be accomplished more effectively if we challenge the essentialist understanding of culture that dominates the field of public relations. The author develops a framework for evaluating the ethics of the PR discourse. She demonstrates that while the organization was critical of the world's response

to the Ebola crisis, highlighted interconnectedness, and called for engagement with the other, the increasingly desperate tone of its press releases emphasized its own identity as heroic and excluded local community voices representing West African communities as powerless voiceless victims. The author provides a number of useful recommendation for international public relations practitioners.

The Sinking of a Ferry, Sinking of Public Confidence: A Comparative Analysis of Government Crisis Management Cases by Moon Lee explores how different governments manage crises such as ferry sinking, earthquakes, outbreak of diseases, hurricane, terrorist attack, etc. The analysis evaluates government crisis management practices in different countries and contexts while assessing similarities, differences, and global convergence. The chapter explores the case of the Sewol Ho ferry sinking incident in Korea in depth. It shows us that under time–space compression, no crisis remains isolated and limited to the national sphere. Instead, the handling of different crises can be and is compared leading to comparative evaluations and creating a transnational basis of evaluation and standards for public relations practices.

Environmental and Social Justice Movements

The chapters in this section focus on social and environmental rights. The limitation of earth's resources creates challenges and risks that are not constrained by local or national borders and require actions and ethics that work with global and local concerns. In *Environmental Nonprofit Organisations and Networked Publics: Case Studies of Water Sustainability* Rahul Mitra shows us that global nonprofit organizations face special challenges created by working on a global scale with globally networked stakeholders as well as on a local scale in particular places and entities. Such organizations have global goals, in this case it is water conservation, that they have to accomplish through local projects. They thus have to negotiate with a variety of interests that are sometimes at odds with each other such as corporate and environmental activism. The chapter shows us how these dialectical pressures play out somewhat differently in the case of two nonprofit organizations focusing on water conservation. As the author observes, each organization creates a highly diversified discourse to address different stakeholders while balancing the dialectical pressures in different ways. The chapter advances a theoretical framework for understanding globally and locally positioned organizations.

In *Production of the Internal Other in World Risk Society: Nuclear Power, Fukushima, and the Logic of Colonization*, Etsuko Kinefuchi shows how the colonial logic in the form of rationalist dualism legitimates exploitation and disregard for the environment and local communities in the drive for development. Kinefuchi focuses on nuclear power and the fallout from the reactor meltdown at the Fukushima Daiichi Nuclear Power Station in Japan. While nuclear power is presented as green and

affordable, it emerges from rationalist culture that accepts separation between human communities and between humans and the environment. This leads to greater risks in a highly compressed world but such risks are obscured by physical, communicative, and epistemic distance between the consuming metropolis and the local community around the power plant. The chapter reminds us of the enormous costs of the Chernobyl nuclear accident that have been dissociated and seemingly forgotten. The author turns to cultural philosophies of indigenous communities and activists as guidelines for how to develop a sustainable culture and relations between humans and the environment.

Resistance is also a topic of *What's New about Global Social Justice Movements?* by Shiv Ganesh who challenges some of the main assumptions about social movements, foremost being their "newness." He argues that the scholarly drive for discovering "newness" has shaped knowledge about a wide range of phenomena including global social movements. The author draws from a qualitative study of 63 organizations over three years in New Zealand to advance a theoretical framework for understanding activist organizing on a global scale.

We hope that this collection of essays contributes to a broader and deeper understanding of the tensions at work in contemporary intercultural communication around the world. While locally specific case studies offer deeper explorations of their situations, they must also be understood in larger global contexts. Given the dynamic world that we live in, there is never a last word on culture, communication, the local, and the global, but, taken together, these essays lay important groundwork for understanding the complex world we live in.[1]

NOTE

1. The authors would like to thank Gian-Louis Hernandez, Research Assistant at Università della Svizzera italiana, for his assistance with editing tasks.

REFERENCES

Anderson, B. (1991). Imagined communities: Reflections on the origin and spread of nationalism. New York, NY: Verso.

Al-Rawi, K. A. (2014). The Arab Spring and online protests in Iraq. *International Journal of Communication, 8*, 916–942.

Andén-Papadopoulos, K., & Pantii, M. (2013). The media work of Syrian diaspora: Brokering between the protest and mainstream media. *International Journal of Communication, 7*, 2185–2206. doi:1932-8036/20130005.

Appadurai, A. (1990). Disjuncture and difference in the global cultural economy. *Theory, Culture and Society, 7*, 295–310.

Chao, E. (2015). The-truth-about-Islam.com: ordinary theories of racism and cyber islamophobia. *Critical Sociology, 41*, 57–75.

Chan, B. (2005). Imagining the homeland: the internet and diasporic discourse of nationalism. *Journal of Communication Inquiry, 29*, 336–368. doi:10.1177/0196859905278499.

Cisneros, J. D., & Nakayama, T. K. (2015). New media, old racisms: Twitter, Miss America and the cultural logics of race. *Journal of International and Intercultural Communication, 8*(2), 108–127.

Everett, A. (2009). *Digital diaspora: a race for cyberspace.* Albany, NY: SUNY.

Fairclough, N. (2006). *Language and globalization.* London: Routledge.

Friedman, J. (2004). Globalization, transnationalization, and migration: Ideologies and realities of global transformations. In J. Friedman & S. Randeria (Eds.), *Worlds on the move: Globalisation, migration and cultural security* (pp. 63–88). New York, NY: I.B. Touris.

Friedman, T. (2005). *The world is flat.* New York, NY: Farrar, Straus and Giroux.

Fursich, E. (2002). Nation, capitalism, myth: Covering news of economic globalization. *Journalism and Mass Communication Quarterly, 79*(2), 353–373.

Harvey, D. (1990). *The condition of postmodernity: An enquiry into the origins of cultural change.* Cambridge, MA: Blackwell.

Hoops, J. F., Thomas, R. J., & Drzewiecka, J. A. (2016). Polish 'Pawns' between nationalism and neoliberalism in British newspaper coverage of post-European Union enlargement polish immigration. *Journalism, 17*(6), 727–743.

Hughey, M. W. & Daniels, J. (2013). Racist comments at online news sites: a methodological dilemma for discourse analysis. *Media, Culture, & Society, 35*, 332–347.

Martin, J. N., & Nakayama, T. K. (1999). Thinking dialectically about culture and communication. *Communication Theory, 9*, 1–25.

McGee, M. C. (1980). The 'ideograph': A link between rhetoric and ideology. *Quarterly Journal of Speech, 66*, 1–16.

Mitra, R., & Gajjala, R. (2008). Queer blogging in Indian digital diasporas. *Journal of Communication Inquiry, 32*, 400–423. doi:10.1177/0196859908321003.

Ojala, M. (2011). Mediating global imaginary: Obama's "Address to the Muslim world" in Western European Press. *Journalism Studies, 12*, 673–688.

Pal, M., & Buzzanell, P. M. (2013). Breaking the myth of Indian call centers: A postcolonial analysis of resistance. *Communication Monographs, 80*, 119–219.

Phillips, K. R., & Reyes, G. M. (2011). Surveying global memoryscapes: The shifting terrain of public memory studies. In *Global landscapes: Contesting remembrance in a transnational age.* Tuscaloosa, AL: University of Alabama Press.

Piketty, T. (2014). *Capitalism in the 21st century.* (A. Goldhammer, Trans.). Cambridge, MA: Harvard University Press.

Pratt, M. L. (1992). *Imperial eyes: Travel writing and transculturation.* New York, NY: Routledge.

Robertson, R. (1996). Glocalization: Time-space and homogeneity-heterogeneity. In M. Featherstone, S. Lash, & R. Robertson (Eds.), *Global modernities* (pp. 25–43). London: Sage.

Sassen, S. (2007). Deciphering the global. In S. Sassen (Ed.), *Deciphering the global: Its scales, spaces, and subjects* (pp. 1–20). New York, NY: Routledge.

Taub, A. (2016, October 1). Why some wars (like Syria's) get more attention than others (like Yemen's). *New York Times*, Retrieved October 1, 2016 from http://www.nytimes.com/2016/10/02/world/why-some-wars-like-syrias-get-more-attention-than-others-like-yemens.html?_r=0

Witteborn, S. (2011). Discursive groupings in a virtual forum: dialogue, difference and the 'intercultural.' *Journal of International and Intercultural Communication, 4*, 109–126.

Migration

The Destructiveness of Distance: Unfaithful Husbands and Absent Mothers in Domestic Migrant Worker Narratives

HANS J. LADEGAARD, THE HONG KONG POLYTECHNIC UNIVERSITY, HONG KONG, CHINA

Immigration is an essential premise of life in a global world. Globalization has offered increased opportunities to professionals and skilled workers who can choose to deploy their mobile resources across different contexts for shorter or longer periods of time. However, for people at the bottom of the globalization market, as Blommaert (2010, p. 179) puts it, globalization has seriously constrained their lives and opportunities because they do not possess the resources and qualifications that are sought after in the global economy. For refugees, asylum seekers, and unskilled migrant workers, immigration is not a free choice but a necessity. People from developing countries are often faced with grim choices: either they stay at home, which means the family is kept in poverty with no prospects of a better future, or they become migrant workers, which means suffering the pains of more or less permanent separation from their families. This chapter is about a group of people who have become victims of globalization, whose position remains vulnerable, and whose future is precarious. It is about domestic migrant workers in Hong Kong.

The majority of migrant workers are women. Most of them work as domestic helpers primarily in the Middle East, or in other Asian countries like Hong Kong, Malaysia, Singapore, and Taiwan, but in recent years, increasing numbers

of foreign domestic helpers[1] (FDHs) have also found work in Europe and North America (Gutierrez-Rodriguez, 2010; Pratt, 2012). There are about 330,000 FDHs in Hong Kong, the vast majority being from the Philippines and Indonesia. They work as live-in maids on two-year contracts providing much-needed remittances to their families back home. For many years, nonlocal domestic workers in Hong Kong were almost exclusively from the Philippines, but in recent years, increasing numbers of Indonesian women have been recruited to meet labor shortage. Smaller numbers are also being recruited from Bangladesh, Thailand, and Myanmar. Historically, upper- and middle-class families in Hong Kong have a long tradition of employing Chinese *amahs*, live-in maid servants, and this has paved the way for a massive influx of foreign labor, particularly in the 1980s and 1990s when many Chinese domestic workers turned to paid work outside the home for better wages. However, as Constable (2007) argues, the Chinese *amahs* also paved the way for a system that expects domestic helpers to be subservient and humble and obey their master without question. Thus, the *amah*-system has become "a metaphor for control and domination and a tool with which to put present day workers 'in their proper place'" (p. 62).

Recent research in Hong Kong and (and elsewhere) has reported widespread abuse and exploitation of domestic migrant workers. Despite legislation designed to protect their rights, labor laws are often not enforced, and stories of verbal abuse and physical assault, underpayment, excessive working hours, starvation, and sexual assault have been reported by several studies (see, for example, Chiu, 2005; Constable, 2007; Ladegaard, 2012, 2013a, 2015). However, even if FDHs' diasporic lives in Hong Kong are not plagued by the anxiety and fear that come from working for an abusive employer, they still suffer the pains of being separated from their children and other close family members. Pratt (2012) has referred to this pain as "the destructiveness of distance." Research has shown that geographical separation is a strain on migrant worker families; it is a strain on the intimacy between parents and children and on the long-term sustainability of the relationship (Parreñas, 2005). The outcome, sadly, is countless broken migrant worker families, and, as Parreñas' (2005) research has shown, children who grow up with the emotional turmoil that often comes from permanent separation from one, or sometimes both, of their parents. Part of the problem is structural: that Hong Kong's migrant worker laws define them as "just workers," not women who have husbands and children and who therefore have a desire, and a right, to be with them. As Constable (2014, p. 59) argues

> The laws and policies in Hong Kong and their home countries make it essentially impossible to be both a good worker and a good wife/mother/daughter. Migrant workers challenge Hong Kong's attempt to define them as just workers, and they contest their own state's attempts to label them as bad women. [...] They aspire to be good mothers and workers, and sometimes wives, which is nearly impossible to do as legal workers in Hong Kong or as single mothers back home.

Thus, we see the agonizing dilemma domestic migrant women are faced with. If they stay at home with their children and husbands, they have to endure poverty and no prospects of a better life for their children. If they go overseas as migrant workers, they may be able to sustain their families and give their children an education, but the price they pay is separation, loneliness, and alienation from their children and their husbands. The narratives that will be analyzed in this chapter illustrate this painful dilemma.

THE RESEARCH

Theoretical and Methodological Frameworks

The research that I report on in this chapter draws on a variety of theoretical frameworks and analytical concepts from sociolinguistics, social psychology, pragmatics, and discourse analysis. The data was collected using the ethnography-of-communication approach (Saville-Troike, 2003), which argues that the researcher needs to closely observe the research site and include as much contextual information as possible in the interpretation of data. Another framework that has been important for understanding how discourse is conceptualized in the research is social constructionism (Burr, 2003), which emphasizes the situated nature and dynamic aspects of talk. It argues that when people talk, they present, negotiate, and construct their social identities. A social constructionist approach would question the idea that identity (and other forms of social categorization) should be perceived as evidence of underlying psychological states. Rather, it would see identity as a discursive construction involving not just the narrator but also the audience. It would see talk (and, in the current study, narratives) as constitutive of the context, and the people who talk/narrate as social actors (Augoustinos, Walker, & Donaghue, 2014). The narratives have been analyzed using a narrative-analysis approach, which combines Toolan's (2001) attention to linguistic detail with a therapeutic component of narrative research (Brown & Augusta-Scott, 2007; White & Epston, 1990). Narrative therapy argues that we live storied lives and we are therefore encouraged to tell our stories in order to make sense of our past experiences because "our stories do not simply represent us or mirror lived events—they constitute us, shaping our lives and our relationships" (Brown & Augusta-Scott, 2007, p. ix).

Medved and Brockmeier (2008) propose five key functions of storytelling. First, it creates coherence by synthesizing different personal experiences that may initially appear disconnected. Second, narratives serve a distancing function in that the storyteller distances herself from the immediacy of her experiences by converting them to stories. Third, storytelling serves a communicative function:

it connects the narrator to her audience and, thereby, makes the narrator's universe a shared experience. Fourth, narratives help storytellers evaluate past events; they provide perspective and the possibility to reevaluate and propose alternative interpretations. Finally, storytelling serves an explorative function; it encourages the storyteller to compare two sides of human experience: the real and the possible. This function is particularly important in FDH narratives because the shelter encourages the women to question the dominant degrading discourses they have been subjected to while working for abusive employers, and try to "re-author their lives from victimhood to survival and beyond" (Duvall & Béres, 2007, p. 233).

The Church Shelter

Bethune House church shelter is part of the Mission for Migrant Workers, an NGO run by the Anglican Church in Hong Kong. It provides temporary accommodation to FDHs who have either run away from abusive employers, or whose contract has been terminated prematurely. Any newcomer to the shelter is invited to share her story with other migrant women and a volunteer in a sharing session. The invitation is issued by one of the Filipina volunteers in order to ensure that the women may decline if they prefer. The purpose of the sharing sessions is twofold: first, to clarify the details of a particular incident in case a domestic worker needs to file a complaint to the Labour Department (for labor law violations) or to the police (for criminal cases), and second, to serve a therapeutic function by giving the women an opportunity to talk about their experiences in a safe environment.

I joined the shelter as a volunteer in 2008, but I soon realized that the work at the shelter might receive more public attention if stories were documented and shared with a wider audience. Therefore, the project was converted into a research project on migrant worker narratives, while I continued my work as a volunteer at the shelter. I am aware of the potential problems involved in trying to fulfill two roles at the same time: the role of the researcher who is trying to observe and analyze language without "contaminating" the social environment I am studying, and the role of the volunteer whose job it is to document the stories and encourage the women to talk about their (traumatic) experiences. I know that I cannot avoid taking sides; I am on the side of the women and I make no secret of that. I see myself as a researcher *and* a social activist, and I see these roles as complementary rather than contradictory (Phipps, 2012, 2014). Scholars have argued that a sharp distinction between research commitments and social commitments cannot be upheld in projects involving underprivileged marginalized groups (Shuman, 2005). Thus, I argue that research on FDH narratives should not only do research *on* migrant workers, but also *for* and *with* them (Cameron, Fraser, Harvey, Rampton, & Richardson, 1992). Each week, I would meet with newcomers who had

signed up for a sharing session (usually 4–6 women); so far, more than 300 FDHs have participated in Hong Kong, and more than 100 recent returnees have had their stories recorded in Indonesia and the Philippines. Recordings are still ongoing, and data is being transcribed and, for the Indonesian data, translated[2] continuously. Each sharing session usually lasts between 1 and 2 hours. Prior to each session, the women were informed about the research component of the project, and they were asked to give their consent. They were promised full anonymity; all names are pseudonyms.

DATA ANALYSIS

Unfaithful Husbands

The first examples to be analyzed deal with migrant women's painful awareness of their husbands' infidelity. It is from a sharing session with four Filipina women. One woman (Lucy) has told her story after which the women engage in what Toolan (2001) calls a "diffuse story." This pattern is typical in the sharing sessions where "a chunk of story is followed by a chunk of multi-party conversation glossing, clarifying and amplifying aspects of the story chunk just told" (p. 162). Just prior to Excerpt 1, Lucy tells the group that long-distance relationships are difficult because "the man will maybe find another woman." The interviewer asks if it is common for husbands in the Philippines to find a mistress, to which the women respond with a heavily stressed "**yes.**" Despite the seriousness of the topic, the women manage to joke about it and claim that the problem may be "that men cannot keep their dick in their pants" (see Ladegaard, 2013b for an analysis). Then follows another painful conversation about trust between the husband and his absent wife (see transcription conventions in the Appendix).

Excerpt 1

Lucy, 37 years, Filipina, 9 years in Hong Kong (HK); Joan, 36 years, Filipina, 9 months in HK, 2 years in Lebanon before HK; Grace, 33 years, 1 year in HK, 3 years in Lebanon. One more Filipina helper participated in the sharing session (original in English).

1. Lucy: but of course (0.5) trust, you cannot trust because you're far away (1.0)
2. sometimes, because it's not only men, even women
3. Joan: yes yes
4. Lucy: some women also
5. Joan: I agree
6. Lucy: sometimes they need that, but of course if you're not with your husband, maybe
7. you can think that you can find one also, sometimes (1.0) sometimes people (2.0)

8.		but the thing is we have phones and computer now to communicate
9.	Gra:	it's easy to communicate
10.	Lucy:	not like before
11.	Joan:	not like before
12.	Lucy:	so sometimes er: most of the, most (1.0) have a: family, and then, broken because
13.		of something
14.	Gra:	//oh yes//
15.	Lucy:	//they are//
16.	Int:	so many broken families?
17.	Lucy:	yes, many broken families, **but** I hope our family is not like that, I hope so
18.		[laughs] I don't know […] I hope it cannot break even though he still have
19.		(1.0) another woman, but I hope er: we're married, if I go back, I'm still the
20.		original wife
21.	Gra:	number one
22.	Int:	but does he have another woman? You **know** that, or you **don't** know, or you
23.		don't **want** to know?
24.	Lucy:	I don't know, or I don't **want** to know because of course if you know, it hurts,
25.		never mind to know […] never mind me because I can understand, but they need
26.		that one, even though women we need that too, but maybe women are just more
27.		er:
28.	Joan:	more strong, ah: control
29.	Lucy:	control yeah
30.	Joan:	self-control
31.	Lucy:	self-control maybe
32.	Int:	you work 18 hours a day so when **should** you do it? [general laughter]
33.	Lucy:	of course only Sunday, and then Sunday 6 o'clock we have to go back because
34.		you go to work (0.5) how can you find it between 11 o'clock and 6 o'clock?
35.		[general laughter]

The amazing thing about this and many similar sharing sessions is that the women were sharing difficult stories, including painful self-disclosures, and they cried about them, but there was also a lot of mutual support and frequent laughter. In Lucy's first turn, the lack of trust between husband and wife is brought up (lines 1–2): the nagging fear that, despite all the best intentions, the husband may have extramarital affairs. The same may be true for the women in Hong Kong, as Lucy's next turn demonstrates (lines 6–7). It seems like Lucy is about to reveal more details about FDHs' extramarital affairs, and then

changes her mind. She stops after two lengthy pauses (line 7), and changes the topic completely to modern communication technology and how it has made communication with the family back home easier (line 8). Note how her friends immediately support her in the change of topic and provide appropriate relevant feedback (lines 9–11).

However, Lucy returns to the topic of infidelity (lines 12–13) and the impact it has on the family. Again, her comment about broken families receives support from her peers (line 14), and the women talk openly about their fear that it may affect, and possibly destroy, their own family (lines 17–18). The fear of a broken family is real for FDHs, who, despite the sacrifices they make to save the family, often see their own family fall apart (Parreñas, 2005). Lucy's laughter (line 18) may function as a face-saving device, followed by a confession that she does not know whether or not her own family will survive the separation. She returns to the fear of her husband's possible infidelity (lines 18–20), and, in response to the interviewer's request for clarification (lines 22–23), she explains that she does not want to know if he has other women, because if she knows, "it hurts" (line 24). Therefore, she prefers to live with uncertainty and hope (lines 17–20).

However, Lucy also acknowledges that men have sexual needs, conveniently euphemized as "that one" (line 26) or "it" (line 34), whereas women's needs, they argue, need to be controlled. Note how the women support each other in building up discourse together (lines 28–31). One woman provides a cue, which the next person builds on to arrive at the intended meaning: that women know how to control themselves (line 30). The result is a strong sense of in-group cohesion and solidarity with gender as the salient variable. The women are reinforcing in-group cohesiveness by emphasizing their own strength (women's self-control) against the alleged weakness of the comparable out-group (men), who are believed to be at the mercy of their sexual desire. In-group cohesion and harmony are strengthened, and the out-group is conveniently positioned as morally inferior (Hogg & Abrams, 2003; Ladegaard, 2011). Therefore, the male interviewer's comment in line 32 could be seen both as an attack disguised as humor (Holmes, 2000) on the women's alleged self-control, and as an acknowledgement of the difficult circumstances they are living under in the city. They are recognized as workers, but not as women with needs and desires (Constable, 2014). The interviewer's remark is received with a roar of laughter from the women (line 35), and they continue the joint narrative (in subsequent lines not reported here) by jokingly suggesting that if they had a man, sex would need to be on Sunday squeezed in between mass at 10 am and their domestic duties, which they would usually need to resume Sunday night by 6 pm.

A different but equally damaging kind of unfaithfulness frequently experienced by domestic migrant women is that the money they send home is not being spent on food and the children's education. Because there is usually no

work to be had in the rural communities the women come from, it is tempting for the abandoned husband not only to take a mistress, but also to start drinking and perhaps develop an alcohol abuse problem. The next excerpt provides an example. Toward the end of a sharing session with three domestic helpers from the Philippines, the women are discussing what they think is the most difficult part about being a domestic helper.

Excerpt 2

*Sam, 26 years old, Filipina, 3 months in HK; **Marites**, 30 years old, 18 months in HK; Jessa, 23 years old, Filipina, 4 months in HK (original in English).*

1.	Int:	what's the most difficult thing about being a domestic helper?
2.	Sam:	[to be] treated like slaves
3.	Mar:	like animals (3.5)
4.	Int:	what about the separation from your family? (1.5) is that?
5.	Sam:	it's very difficult, that's why we say 'homesickness versus dollars'
6.	Int:	homesickness versus dollars, right, yeah
7.	Mar:	and I see my family, if I send them money (2.5) sometimes the money is drinking
8.		drinking, like that like that, it's not enough, it's not easy to find here, money in
9.		Hong Kong
10.	Int:	yeah
11.	Mar:	'I send the money, and **you** (2.0) **you** buy first the' (2.0) how do you call it (1.0)
12.		remembrance (2.5) when I go back I saw also 'ah: this is my money from Hong
13.		Kong, I work so hard', and I saw also the pictures
14.	Int:	okay, yeah, what did you say about drinking? I didn't understand that
15.	Mar:	sometimes when I send my money, my husband buy, buy the (1.5) what do you
16.		call that?
17.	Jes:	alcohol
18.	Mar:	alcohol
19.	Int:	okay, so he drinks?
20.	Mar:	yeah, I say also 'my money is not easy to find here (1.0) all are my (3.0) blood
21.		and sweat (1.0) so hard'
22.	Int:	blood, sweat and tears, yeah

The sacrifices made by migrant women are highlighted in this excerpt. Not only are they sometimes treated like slaves or animals (lines 2–3), they also have to endure the hardship of long-term separation from their children and other loved ones, and the homesickness that ensues, in order to send money home to their families (line 5). A further frustration is recounted in Marites' narrative: that the

money she sends home is spent on alcohol (lines 7–8) and, thus, indirectly creating an additional social problem for migrant families rather than solving one. Marites' account of the problem is reinforced by the repetition of the word "drinking" (lines 7–8). This practice is common among domestic helpers at the shelter. They would often refer to the aggravated nature of a problem by repeating the verb used to describe the activity; for example, "she's always shouting shouting" (referring to an abusive employer), or "they always go talking talking" (referring to other helpers gossiping about her). This practice, which is grammatically impossible in English, is possible in both Tagalog and Cantonese where verbs can be repeated for emphasis (e.g., "Sing yat kong kong kong" in Cantonese, literally: "All day, talk talk talk", or "Talking all day long").

It is noticeable how Marites engages in a fictitious dialogue with her nonpresent spouse: "**I** send the money and **you** (2.0) **you** buy first the" (line 11). Toolan (2001) refers to this practice as narrative performance, which is used to act out a particularly involved narrative activity, and the aim is "to furnish one's addressees with a more vivid and involving experience of that story" (p. 161). The word she is looking for in line 16 is probably "alcohol" (ironically the same word in English and Tagalog), and it is not clear what she means by "remembrance" (line 12). It is possible she meant to say "remittance," and thereby reminding her husband of the sacrifices she makes by sending money home. By stressing the pronouns "**I**" and "**you**" (line 11), Marites presents an intergender dichotomy (the faithful wife versus the unfaithful husband), and she implicitly accuses him of deception and wastefulness. The scenario continues in lines 12–13 when Marites remembers how she, during a visit to the Philippines, discovered how her hard-earned money was being spent. She reminds her husband how hard she worked for the money (line 13), and she refers to pictures, possibly of her husband drinking with his friends, as suggested later in the sharing session. More than once, she reminds her husband that money is not easy to find in Hong Kong (lines 8 and 20). This might be a reference to a popular myth in FDHs' home countries that Hong Kong is a place flowing with milk and honey (cf. Exodus 3:8). Migrant women are expected to bring *pasalubong*, home-coming gifts, which they are expected to give not just to their families but also to neighbors and other people in the village. Therefore, going home can be a costly affair, and Marites reminds her unfaithful husband that the money he is using for alcohol was earned with her blood, sweat, and tears (lines 20–21).

Absent Mothers

Another predominant and painful theme, which was brought up in most sharing sessions at the shelter, was the women's relationship with their absent children. This part of sharing session usually involved a lot of painful self-disclosures and crying was frequently part of the sharing, as the next example shows.[3]

Excerpt 3

*Michelle, 30 years old, 2 months in HK; **Ruby**, 42 years old, 15 months in HK, 2 years in Qatar, and 2 years in Singapore; **Janet**, 37 years old, 6 years in HK. One more Filipina helper was in this sharing session (original in English).*

1. Int: did you volunteer to come here?
2. Jan: yes, I volunteered, I decided (1.0) by myself (2.0) luckily the first two con-
 tracts
3. was a good experience (1.0) the third contract is, unlucky [whispering]
4. Int: yeah yeah (2.0) you're making **huge** sacrifices for your family, how do you feel
5. about that?
6. Jan: I'm proud, I help them [whispering]
7. Int: yeah okay
8. Jan: (4.5) but sad [general laughter]
9. Jan: because the situation, our own situation behind the er: help we gave to our
 family,
10. it's the **sacrifices** that the situation has [wobbly voice]
11. Int: yeah, yeah (3.5) what about you Ruby? How do you feel?
12. Rub: speechless already [laughs]
13. Int: speechless already, I don't blame you (3.0)
14. Rub: I don't know now because I'm the one who support (2.0) but now I don't
 know
15. how to start [wobbly voice]
16. Mic: because you're a single mom
17. Rub: I'm a single mom, I don't know how to start [sobbing]
18. Int: yeah, yeah, don't you get any support from your husband?
19. Rub: no, er: we separated when our youngest child is only six months, now he's
 nine
20. years old [wobbly voice] (2.0) haven't seen the kids, 'you are still alive there, no'
21. Int: so who takes care of your children?
22. Rub: my sister, my children [are] really very happy because they can see me
 already
23. 'Oh my mom', but they don't know me, they don't know what's the
24. consequences [wobbly voice], they don't know that if I'm coming back, we
 have
25. nothing to **eat** [sobbing] and my sister keeps only explaining to them (2.0)
 'you
26. don't know what's your mom's situation there now' (2.0) she's trying hard (3.5)
27. only God can help us [wobbly voice]

Skeggs (2008) argues that in much contemporary identity research, it is assumed that everybody "has" or "owns" an identity. This thinking is part of a Western tradition, which fails to recognize that "identity is not equally available to all and so operates as an unequal resource that only some can use" (p. 11). Contemporary identity research is tied up with visibility, value, and recognition and, therefore,

does not capture the experiences of migrant women who are granted little recognition and value, and virtually no visibility. For them, identities are enforced positions, a "fixed pathology" for which there is no alternative (Skeggs, 2008). Domestic migrant workers cannot choose freely how they want to live and where, and thus, they cannot claim an individual identity through ownership of their own experiences. It is not uncommon, for example, for Indonesian women that their fathers or husbands signed them up to become migrant workers. The head of the household would make an agreement with a local recruiter, receive the money one gets for signing somebody up for migrant labor, and, thus, essentially "sell" their daughters and wives, sometimes without even asking for their consent.[4] However, like most Filipina migrant workers, the women in Excerpt 3 volunteered to go to Hong Kong. They are proud about helping their families (line 6), but they are also painfully aware that they are sacrificing their own lives and happiness (lines 9–10). The schism these women experience is that they need to remember their families back home because this gives them the strength to endure their hardships, but they also need to forget them because remembering is too painful when they cannot be with them. This calls for what Lai (2011, p. 580) has labeled "compartmentalized forgetting and remembering simultaneously," or "a fractured identity separate from yet tied to the family back home."

In the first testimony (lines 2–3 and 6–10), Janet initially whispers. She is close to crying and in the attempt to conceal a wobbly voice, she whispers. The laughter from the other groups members (line 8), as well as Ruby's laughter in line 12, are not examples of humorous laughter, but, more likely, the women laughing at adversity: "events that are so hopeless, and therefore tragic, that they could only be endured by also conceiving them as absurd, and therefore comic" (Ladegaard, 2013b, p. 406). Thus, crying and laughter serve similar functions in FDH narratives; it is a means to deal with adversity without being destroyed by it. Ruby's situation is particularly precarious because she is a single parent. Note how Michelle supports Ruby in constructing a painful self-disclosure (line 16). She provides the cue Ruby needs to explain why she is devastated: she is the sole breadwinner and, therefore, has no idea what to do after her contract was terminated. Also note the impact Michelle's support has on Ruby; after Michelle has helped her identify the cause of her sadness and anxiety, she moves from silent crying (lines 14–15) to loud sobbing (line 17).

Through the use of direct speech addressed to her absent husband, Ruby voices a subtle protest about the lack of support from him and lamenting the fact that he has not even been home to see the kids (line 20). There is a climax in Ruby's crying sequence (lines 23–25). First, she makes the point that the children are not suffering. "They can see me already" (line 22), presumably referring to a photo of the mother, but the crux of the matter for the absent mother is that "they don't know me" (line 23), and they do not understand that if she came back, the

family would have nothing to eat (lines 24–25). She sobs as she verbalizes this painful dilemma: that in order to provide for their children, migrant women have to give them up. Ruby concludes, as many migrant women do when faced with insurmountable difficulties: "only God can help us" (line 27) (Ladegaard, 2017a).

The painful dilemma of the absent mother is further explored in the next two examples.

Excerpt 4

Vanessa, 41 years old, 18 months in HK, 14 years in Singapore; Joyce, 33 years old, 14 months in HK, 2 years in Dubai. Three more Filipina helpers were in this session (original in English).

1.	Van:	we miss Christmas, we're separated from our children, New Year, our family
2.		especially the very young children, when it's their first birthday, you (1.0)
3.		**must** be there on their first birthday, you wish but you can't, so we just talk
4.		to them
5.	Int.:	yeah
6.	Van:	tell them we work hard for them (1.0) we can give care like calling them, we
7.		can send them dolls and toys, but love and care we can't give
8.	Joyce:	we give only financial help, but our love we cannot (1.0)
9.	Van:	financial help
10.	Joyce:	financial[ly] we support them but our (1.5) true love to them we cannot [give]
11.	Int.:	no, but that's also love what you're doing, that's a different kind of love,
12.		right? but that's certainly also love, that's er: tremendous love because you're
13.		sacrificing
14.	Joyce:	yeah, sacrificing for their future also

Excerpt 5

Grace, 33 years old, 1 year in HK, 3 years in Lebanon; Lucy, 37 years old, Filipina, 9 years in HK. Two more Filipina helpers participated in the sharing session (original in English).

1.	Grace:	I came home from er: Lebanon and they met me in the airport my er: husband
2.		said 'this is your mother, this is the one who hold you' (1.0) even though in a
3.		week, three or four times we talk to each other and chatting, it's still (1.0) it's
4.		**very** far for //
5.	Lucy:	//for the feelings//
6.	Grace:	//for the feelings, yeah
7.	Grace:	and sometimes (0.5) er: me and my husband are sitting beside each other, my
8.		son don't want to, 'no, no don't sit beside mama, don't sit beside her'
9.		[laughs] he don't want to sit beside me, and yeah, going to sleep at night, he's
10.		the one who sleep <u>beside my husband, not me</u> [sobbing]

11.	Int.:	not you
12.	Grace:	yeah [sobbing]
13.	Lucy:	mine is 9 months when I leave, the youngest one is 9 months, and when I go
14.		back er: almost 2 years old, and then he don't want me, but of course I just
15.		stay with him, and then (0.5) three days before I go back, he likes me already,
16.		but of course, I'll go back [laughs]
17.	Grace:	it's very difficult
18.	Lucy:	because I'll go back but er: (0.5) fear is er: in my mind, yeah

These two excerpts provide further evidence of migrant women's sacrifices at the personal level. This is evident not only in the women's testimonies but also in the tragi-comic laughter (Excerpt 5, lines 9 and 16), and in the continuous crying (lines 10–12). Vanessa in Excerpt 4 recounts how they miss Christmas and New Year celebrations, as well as the children's birthdays (lines 1–4), but they are still trying to be mothers. Parreñas (2005) discusses how women's migration has forced families in the Philippines to redefine traditional gender roles. Traditionally, men were expected to sustain the family financially, while women were seen as "the light of the home": they should "radiate" in the home and hold the family together, and do everything possible to care for the children's emotional and practical needs. However, with men unable to sustain the families financially, and this leading to women's departure from the home, migrant women have become the breadwinners, but, as Parreñas (2005, p. 103) argues, they are still trying to do long-distance mothering:

> They not only reconstitute mothering by providing acts of care from afar, but also often do so by overcompensating for their physical absence and performing a transnational version of what Sharon Hays [1996] identified as 'intensive mothering'. They attempt to maintain intimacy from a distance. Thus, while men reject the work of nurturing the family from up close, migrant women struggle to nurture their children from a distance.

The women in the two excerpts above are trying their best to do "intensive mothering" by calling their children, sending toys and other gifts, as well as providing for their financial needs (Excerpt 4, lines 6–8). But they are also painfully aware that "love and care we can't give" (line 7). In her research among children of migrant families in the Philippines, Parreñas (2005) found that it was easier for the children to accept their mother's absence, as well as their attempts to provide nurturing and be mothers from afar, if they knew that the mothers suffered because of the separation. Thus, Parreñas has coined the term "Martyr Moms" and argued: "the construction of domestic workers as heroes is subject to their suffering and likewise suffering is required for migrant women to be good mothers" (p. 109).

There is no doubt about these women's suffering: Joyce and Vanessa in Excerpt 4 may have found some comfort in acknowledging that rather than depriving their

children of love, they have to redefine the concept and accept that the sacrifices they make for the family are also acts of love (lines 11–14). But Grace and Lucy in Excerpt 5 are in agony as they recount how their children reject them when they come on their biannual visits (lines 8 and 14). Grace is introduced as "the one who hold[s] you" (line 2), presumably referring to a photo the children have in the home of their mother holding them, but her son rejects her despite the frequent phone calls, which makes her realize that for a little boy, there is no emotional attachment (here signified as being "too far for the feelings" to evolve, lines 3–6). Grace is in pain when she remembers that the boy does not want his parents to sit together (line 8), and she sobs as she recounts that it is the boy who sleeps next to the husband, not her (line 10).

Lucy shares with the group another typical experience for migrant worker returnees: that it takes 2–3 weeks for the children to accept the presence of the absent mother, and by that time, it is time for her to go back to Hong Kong (lines 14–16). And what stays with the women after they have left is the fear in their mind (line 18). What Lucy is referring to here is probably the fear of being completely alienated from their children; the fear that whatever relationship they may have been able to build up during a 2–3 week stay at home will be ultimately lost by the time they meet up again, despite frequent phone calls and toys. Another type of fear, as recounted by Lintang, a 37-year-old helper from Indonesia, in another sharing session, is that their sacrifices have been in vain. Lintang's contract has been terminated prematurely and she sobs while she shares her predicament with the group:

> I'm very very sad [sobs] my child still needs the money (0.5) for his education (1.0) if I end up losing my job, what's going to happen with him? I'm really afraid that he can't continue his education (2.0) I'm afraid his future will be like mine (0.5) I hope that they won't have the same fate as me [sobs]. (original in Bahasa)

The ultimate fear for migrant women is that the sacrifices they have made for the family have been for nothing; that the children will end up as migrant workers caught in a vicious circle of poverty, migration, and absence from their loved ones. And yet, despite their efforts and sacrifices, they may end up like their parents: in poverty, migration, and dependence (Constable, 2014).

GENERAL DISCUSSION AND CONCLUSION

It would be wrong to argue that domestic migrant workers cannot engage in discursively constructing and positioning themselves. Some FDHs do engage in discourses of resistance; they object to their employers' demeaning discourses and attempt to claim a more positive identity for themselves (Ladegaard, 2017b).

However, for a majority of the women at the shelter, they are constructed and positioned by others. As Lin (2008, p. 1) cogently put it

> It is usually the powerful who are entitled to and have both more and the right kinds of capital and resources for constructing for themselves advantageous identities. Although people who find themselves in subordinate positions can attempt to construct positive identities for themselves in their struggles to gain recognition, it is often the dominant regimes of the powerful that dictate the identity game to them on the basis of a rigged and stacked text.

What we have seen in the narrative excerpts that have been analyzed in this chapter is that migrant women's identity game is largely dictated to them by others. These others may be their families, not least their children, for whom they are prepared to make the ultimate sacrifice: to leave them in order to sustain them. The domestic migrant workers at the shelter discursively construct themselves as sacrificial mothers, wives, and daughters with an ambivalent connection to their home countries. They demonstrate "a keen awareness of a fractured identity separate from and yet tied to the family back home, and a troubling gap and tension between taking care of the family and caring for oneself" (Lai, 2011, p. 580). The narratives also show evidence of

> women's role as "ethnomarkers" (i.e., cultural carriers ensuring the symbolic and material maintenance and practice of their respective cultural and ethnic values through their role as mothers [Moghadem, 1994]) and their gendered identities (defined relationally to the family—as sacrificial and dutiful sisters, daughters, mothers, wives, and guardians of family honour) are reinforced in/through diaspora. (Huang, Teo, & Yeoh, 2000, p. 395)

A common theme in the narratives is migrant women's identity as distant mothers who are engaged in long-distance mothering through social media and, at the same time, get fulfillment in their job and strength to endure suffering and separation through the sacrifices they make for their families.

Identity research has been heavily influenced by what Skeggs (2008) has called "possessive individualism," a Western concept that depicts how individuals generate the resourceful self. Simply by naming somebody (or oneself) "an individual," discourse is believed to bring into effect what it names, i.e., it is performative (Butler, 1990). Thus, we are inclined to think that everybody "owns" various social identities, which can be "performed," "negotiated," "modified," or "changed" according to contextual needs, but identity formation is not a universal aspect of human experience, as Rouse (1991) has pointed out. It is a culturally specific conception of personhood, which was developed in the affluent West in recent times. As social actors we can use race, class, femininity, profession (or any other social category) as a resource, but *only* if we are not positioned (restricted) by these resources. In other words, only if these labels do not stick to us, if we can appropriate them, attach, and detach them as mobile resources and make them fit our

needs, do they become resourceful identity positions that will enhance our status and recognition (Skeggs, 2008, p. 25). Domestic migrant workers are positioned and severely restricted by their class, ethnicity, gender, and profession. They are widely perceived as poor, vulnerable, and dependent, so they are forced to perform an inscribed identity. FDHs epitomize how inequality has become one of the driving forces of globalization providing some (such as privileged academics and professionals) with increased opportunities, but at the same time seriously constraining the lives and opportunities of others (Blommaert, 2010).

In identity research informed by Western paradigms, identity is tied up with the notion of choice. We "perform," "negotiate," or "change" identities only if we have choice. For people at the bottom of the globalization market there is little choice when it comes to identity construction. Privileged people, who possess some of the qualities that are sought after in the global economy, become mobile; others, like domestic migrant workers, become fixed in place. Or they are provided with a "choiceless choice" (Langer, 1991): they stay at home with no prospects of giving their children a better future, or they become migrant workers and suffer the pains of being (more or less) permanently separated from their children and other loved ones.

In her recent book, *Mama: Love, Motherhood and Revolution*, Australian author Antonella Gambotto-Burke argues that the expectation for women in most Western countries to go back to work shortly after they have given birth constitutes the ultimate sacrifice, which will have detrimental consequences, not just for children in the West who are brought up with absent mothers but for society as a whole. Many parents would probably sympathize with Gambotto-Burke's concern, but Western parents still have choice: they can choose to leave, or not to leave, their children in nurseries or kindergartens. And even if they choose to put them in full-time day care, they get to pick them up again, have dinner with them, and put them to bed. Migrant workers do not have that privilege. They miss the day-to-day interactions with their children, and they miss Christmas, New Year, and their first birthday, as Vanessa retorts in Excerpt 4: "we can send them dolls and toys, but love and care we can't give" (line 7). *This* is ultimate sacrifice for any parent—to take on the enforced identity of absent mother and rely on occasional text messages and e-mails to do long-distance mothering. Thus, Gambotto-Burke's vision (however legitimate it is) fails to recognize the detrimental consequences lifelong separation between parents and migrant mothers and fathers has for children in developing countries (Gamburd, 2000; Parreñas, 2005).

Domestic migrant worker communities are as different as other communities, so it is not surprising that different ethnographic studies have come to very different conclusions about FDHs' lives and experiences. Thus, it is not meaningful to discuss domestic migrant women as a uniform group. However, many studies seem to do just that and warnings against treating domestic migrants as victims abound

in the literature. It is posited, for example, that Filipina migrants are not neces-sarily victims and should not be analyzed as such (Liebelt, 2011 p. 191); and that Filipina domestic helpers both contest and embrace existing power structures and, therefore, both resist and willingly participate in their own oppression (Constable, 2007, pp. 14–15). It has even been argued that

> It does not follow that people who have decided to leave home, travel abroad and look for work, even in the most arduous conditions, *never* have leisure time, engage in tourist activ-ities or look for pleasure. Combining business with pleasure is a concept available to the poor as well as the rich, to those with a false passport as well as those with a real one, and to those working in stigmatised occupations such as sex work as well as those doing what societies call "dignified work." (Agustin, 2003, p. 32)

I shall argue as strongly as I can against Agustin's interpretation of migrant work-er's lives and experiences. The discourse is permeated with Western concepts of privilege and choice, concepts that do not apply to the domestic migrant women in this study. I am not arguing against Constable and Liebelt's position per se, but I would like to problematize Constable's statement with a counterargument: to oppose oppressive discourses requires resources and choice. It also requires a voice and an awareness of alternative discourses based on equality. Many of the women in my study do not have access to these resources, so to apply concepts like "choice" and "resistance" to their life stories makes little sense. Many of the Indonesian women at the shelter have had little formal education, they do not speak (much) English or Chinese, they usually have no awareness of domestic helper rights, and many did not sign up themselves.[5] When these women come to Hong Kong and work, they do not—all of a sudden—develop a voice, or choose to participate in their own oppression. They obey and comply as the obedient daughters and wives they are. These women are victims on several levels: they are some of the victims of globalization whose poverty and social deprivation have forced them to migrate, and they are victims of exploitative unscrupulous agents and a repressive patriar-chal regime that has denied women a voice.

I am not suggesting that victimization should be the modus operandi for people speaking on behalf of migrants (cf. Agustin's [2003] critique). Domestic migrant women are not victims per se, but the experiences of the women whose stories were recorded at Bethune House, and the women whose stories were recorded in Indonesia and the Philippines for the follow-up project on returnee narratives, are a far cry from Liebelt's (2011) empowered Filipina migrants in Israel who "actively negotiate power, belonging and even citizenship on a global scale" (p. 188). In order to actively negotiate personal power, group membership, and belonging, one needs choice, and the overriding problem for many migrant workers is they only have a "choiceless choice." They can go home and be with their children, but only as a hypothetical option. As Brenda, a 37-year-old helper and mother of four from

the Philippines, aptly put it: "If your children cry at night because they're hungry and you cannot feed them, you don't ask, you go." I argue that migrant women's choice, and their precarious lives, should be viewed in the light of this statement. I shall leave the last word on enforced identities and choice to Laarni, a 32-year-old domestic migrant worker from the Philippines:

> Maybe the reason why we still survive despite the difficulties is because we have hope (0.5) faith in God (0.5) our family is our first inspiration and the reason we're here and lastly and the most important one, is the money we owe in the Philippines (1.0) that's what give us, what make us holding on and striving for us to survive here in Hong Kong (0.5) we have no choice, because in the Philippines (1.0) the salary is not enough, cannot support the family so we have no choice even though it's difficult to work here, we have to grab it for us to survive, uhm: self-sacrifice for the common good.

ACKNOWLEDGEMENTS

The research in this chapter was supported by two research grants from the University Grants Committee of Hong Kong [grant numbers: HKBU-244211 and PolyU- 2444/13H]. I am grateful for their support, and for the support of staff and volunteers at Pathfinders and Mission for Migrant Workers, two migrant worker NGOs who work tirelessly to support domestic migrant workers in Hong Kong. Last but not least, my immense gratitude goes to the migrant women who shared their stories with me. Part of this chapter was previously analyzed in Ladegaard 2017b.

APPENDIX

Transcription Conventions
Bold = pronounced with stress/emphasis
[it's a] = word(s) inserted by the transcriber to ease comprehension
, = short pause, less than 0.5 second
(2.0) = pause in seconds
'give me that' = reporting direct speech
: (as in ah:) = the vowel sound is prolonged
// = interruption; //as I said// = overlapping speech
? = question/rising intonation
[…] turn(s) left out
underlining = the feature of crying in [] applies to the previous underlined part of the discourse, as in: I have no money [sobbing]

NOTES

1. "Domestic worker" is the preferred term in the research literature because the term "helper" is seen by some as having negative connotations (Constable, 2014). I (also) use the term "foreign domestic helper" because the women in my data consistently refer to themselves as "domestic helpers." How groups of people decide to name themselves is important as it suggests (positive) self-identification, and thus, arguably, indicates how they see themselves, and how they want others to see them (see Milani, 2010; see also Ladegaard, 2017a).

2. The two dominant groups of migrant workers at the church shelter, Filipinas and Indonesians, are quite different in terms of their social characteristics. The Filipina women tend to be older, well educated, and married with children, and they have often lived abroad for many years. They are usually fluent in English and, therefore, sharing sessions with the Filipinas were conducted in English. The Indonesian women, on the other hand, tend to be younger, single, and with little or no formal education, and they have usually been overseas for shorter periods of time. Most Indonesian FDHs do not speak (much) English, and sharing sessions with them were therefore conducted with the help of an interpreter (usually a volunteer or another FDH) using a mix of English, Bahasa, and Javanese. The recordings with the Indonesian domestic workers were transcribed and translated by three Indonesian students who were fluent in all three languages.

3. This except was also analyzed in Ladegaard (2014) but the issues and foci are different.

4. This practice was revealed to me during a recent fieldtrip to Java, Indonesia. I met with migrant worker returnees and recorded their experiences of coming home, and during my sharing sessions with these women, some of them would relay how the male head of the household (their father or husband) had signed them up for domestic work overseas without even asking for their consent. Some had left home when they were only 16 or 17 years old, and had therefore been given falsified identity documents in order to pass Hong Kong immigration regulations.

5. During a recent field trip to East and Central Java, a migrant woman shared her story with me. Shortly after she got married, her husband told her that he had signed her up for a 2-year contract as a domestic helper in Hong Kong. She left shortly after and sent remittances home for four years while strongly suspecting that her husband had another woman. After four years he wanted to marry his mistress and demanded a divorce. He cited her absence from home as the reason he wanted to divorce her.

REFERENCES

Agustin, L. M. (2003). Forget victimization: Granting agency to migrants. *Development, 46*, 30–36.

Augoustinos, M., Walker, I., & Donaghue, N. (2014). *Social cognition. An Integrated Introduction* (3rd ed.). London and Thousand Oaks, CA: Sage.

Blommaert, J. (2010). *The sociolinguistics of globalization*. Cambridge: Cambridge University Press.

Brown, C., & Augusta-Scott, T. (Eds.). (2007). *Narrative therapy: Making meaning, making lives.* Thousand Oaks, CA: Sage.

Burr, V. (2003). *An introduction to social constructionism* (2nd ed.). London: Routledge.

Butler, J. (1990). *Gender trouble: Feminism and the subversion of identity*. London: Routledge.

Cameron, D., Fraser, E., Harvey, P., Rampton, M. B. H., & Richardson, K. (1992). *Researching language: Issues of power and method*. London: Routledge.

Chiu, S. (2005). *A stranger in the house: Foreign domestic helpers in Hong Kong*. Hong Kong: Hong Kong Institute of Asia-Pacific Studies and The Chinese University of Hong Kong.

Constable, N. (2007). *Maid to order in Hong Kong: Stories of migrant workers* (2nd ed.). Ithaca, NY: Cornell University Press.

Constable, N. (2014). *Born out of place: Migrant mothers and the politics of international labor*. Hong Kong: Hong Kong University Press.

Duvall, J., & Béres, L. (2007). Movement of identities: A map for therapeutic conversations about trauma. In C. Brown & T. Augusta-Scott (Eds.), *Narrative therapy: Making meaning, making lives* (pp. 229–250). Thousand Oaks, CA: Sage.

Gambotto-Burke, A. (2015). *Mama: Love, motherhood and revolution*. London: Pinter & Martin.

Gamburd, M. R. (2000). *The kitchen spoon's handle: Transnationalism and Sri Lanka's migrant housemaids*. Ithaca, NY: Cornell University Press.

Gutierrez-Rodriguez, E. (2010). *Migration, domestic work and affect: A decolonial approach on value and the feminization of labor*. New York, NY: Routledge.

Hays, S. (1996). *The cultural contradictions of motherhood*. New Haven, CT: Yale University Press.

Hogg, M., & Abrams, D. (2003). Intergroup behaviour and social identity. In M. Hogg & J. M. Cooper (Eds.), *The Sage handbook of social psychology* (pp. 407–431). Thousand Oaks, CA: Sage.

Holmes, J. (2000). Politeness, power and provocation: How humour functions in the workplace. *Discourse Studies, 2*, 159–185.

Huang, S., Teo, P., & Yeoh, B. S. A. (2000). Diasporic subjects and identity negotiations: Women in and from Asia. *Women's Studies International Forum, 23*, 391–398.

Ladegaard, H. J. (2011). Stereotypes and the discursive accomplishment of intergroup differentiation: Talking about 'the other' in a global business organization. *Pragmatics, 21*, 85–109.

Ladegaard, H. J. (2012). The discourse of powerlessness and repression: Identity construction in domestic helper narratives. *Journal of Sociolinguistics, 16*, 450–482.

Ladegaard, H. J. (2013a). Beyond ethics and equity? Depersonalisation and dehumanisation in foreign domestic helper narratives. *Language and Intercultural Communication, 13*, 44–59.

Ladegaard, H. J. (2013b). Laughing at adversity: Laughter as communication in domestic helper narratives. *Journal of Language and Social Psychology, 32*, 390–411.

Ladegaard, H. J. (2014). Crying as communication in domestic helper narratives: Towards a social psychology of crying in discourse. *Journal of Language and Social Psychology, 33*, 579–605.

Ladegaard, H. J. (2015). Coping with trauma and domestic migrant worker narratives: Linguistic, emotional and psychological perspectives. *Journal of Sociolinguistics, 19*, 189–221.

Ladegaard, H. J. (2017a). 'We're only here to help': Identity struggles in foreign domestic helper narratives. In D. Mieroop & S. Schnurr (Eds.), *Identity struggles: Evidence from workplaces around the world* (pp. 427–443). Amsterdam: John Benjamins.

Ladegaard, H. J. (2017b). *The discourse of powerlessness and repression: Life stories of domestic migrant workers in Hong Kong*. London: Routledge.

Lai, M. Y. (2011). The present of forgetting: Diasporic identity and migrant domestic workers in Hong Kong. *Social Identities, 17*, 565–585.

Langer, L. L. (1991). *Holocaust testimonies: The ruins of memory*. New Haven, CT: Yale University Press.

Liebelt, C. (2011). *Caring for the Holy Land: Filipina domestic workers in Israel*. New York, NY: Berghahn.

Lin, A. (2008). The identity game and discursive struggles of everyday life: An introduction. In A. M. Y. Lin (Ed.), *Problematizing identity: Everyday struggles in language, culture, and education* (pp. 1–10). London: Lawrence Erlbaum.

Medved, M. I., & Brockmeier, J. (2008). Talking about the unthinkable: Neurotrauma and the 'catastrophic reaction.' In L. Hydén & J. Brockmeier (Eds.), *Health, illness and culture: Broken narratives* (pp. 54–72). New York, NY: Routledge.

Milani, T. M. (2010). What's in a name? Language ideology and social differentiation in a Swedish print-mediated debate. *Journal of Sociolinguistics, 14*, 116–142.

Moghadem, V. (1994). Introduction: Women and identity politics in theoretical and comparative perspective. In V. Moghadem (Ed.), *Identity politics and women: Cultural reassertions and feminism in international perspective* (pp. 3–26). Boulder, CO: Westview Press.

Parreñas, R. S. (2005). *Children of global migration: Transnational families and gendered woes.* Stanford, CT: Stanford University Press.

Phipps, A. (2012). Voicing solidarity: Linguistic hospitality and poststructuralism in the real world. *Applied Linguistics, 33*, 582–602.

Phipps, A. (2014). 'They are bombing now': 'Intercultural dialogue' in times of conflict. *Language and Intercultural Communication, 14*, 108–124.

Pratt, G. (2012). *Migrant mothers and the conflicts of labor and love.* Minneapolis, MN: University of Minnesota Press.

Rouse, R. (1991). Mexican migration and the social space of postmodernism. *Diaspora, 1*, 13–27.

Saville-Troike, M. (2003). *The ethnography of communication* (3rd ed.). Oxford: Blackwell.

Shuman, A. (2005). *Other people's stories: Entitlement claims and the critique of empathy.* Urbana & Chicago, IL: University of Illinois Press.

Skeggs, B. (2008). The problem with identity. In A. M. Y. Lin (Ed.), *Problematizing identity: Everyday struggles in language, culture, and education* (pp. 11–34). London: Lawrence Erlbaum.

Toolan, M. (2001). *Narrative: A critical linguistic introduction* (2nd ed.). London: Routledge.

White, M., & Epston, D. (1990). *Narrative means to therapeutic ends.* New York, NY: Norton.

Eden Recouped: White South Africans in Tanzania and Zambia

MELISSA STEYN, WITS CENTRE FOR DIVERSITY STUDIES,
UNIVERSITY OF THE WITWATERSRAND, JOHANNESBURG,
SOUTH AFRICA

Like most things South African, migration into and from the country has been, and remains, highly racialized. The emigration of white people from South Africa is nothing new. After the British defeat of the Boers in the South African War at the turn of the previous century, there was a wave of emigration of Afrikaners to, among other destinations, Argentina and Kenya. During the antiapartheid struggle, some white people who refused to participate in the racially oppressive system or foresaw civil war left to live abroad. However, in the postapartheid era, the movement of white people out of South Africa takes place in distinctly different political, social, and economic circumstances, and has increased dramatically. Statistics indicate that between 1986 and 2015 approximately 655,000 white South African left the country (Wakefield, 2015). Three years later, the South African Institute for Race Relations reported that 'the white population continues to experience the effects of large scale emigration of adults between the ages of 20 and 35' (SAIRR, 2008, p. 1). These statistics are powerful indicators of the ways in which South African whiteness has, in effect, 'gone global.' The countries of choice for white emigrants are the United Kingdom, Australia, New Zealand, Canada, and the United States. This movement also, however, includes a small outflow to states further north on the African continent. This chapter investigates the ways in which white people who have left South Africa reposition themselves in new contexts in the region.

Studies into migration patterns in South Africa post-1994 focus mostly on in-migration of African citizens from other African countries, often couched in discussions of South African xenophobic sentiment (Crush, 2005; Landau, 2004, 2012; McDonald & Crush, 2000). The outmigration of hundreds of thousands of white South Africans to 'regroup' into whiteness in developed, white majority ruled, Western centers is almost always cast as 'brain drain' (Brown, Kaplan, & Meyer, 2000; Crush, 2002; Crush, McDonald, & Williams, 2000; McDonald & Crush, 2002; Oberoi & Lin, 2006; Padarath et al., 2003). The geopolitics of white global mobility has generally been understood through patterns of conquest, colonialism, and imperialism. A small, but growing, line of research examines how geographically disparate whitenesses are stitched across the globe, through processes of migration and identity translation (Andrucki, 2010; Drzewiecka & Steyn, 2009; Leonard, 2010; Pande & Drzewiecka, 2017). The positioning of emigrating South Africans has implications for how we conceptualize the way in which whiteness travels, translates, and consolidates itself globally, and especially salient when one considers the violence and hostility met by geopolitically and economically oppressed groups who flee their homelands in search of better life circumstances.

This chapter forms part of a larger study on the ways in which whiteness, as a dominant social positionality, works to remain structurally and ideologically intact, and how continuities of whitenesses are facilitated and disrupted. It shows how white identities move within global networks of white imaginaries, including across Southern Africa, as the globally privileged position of whiteness remains largely normalized. The chapter explores key epistemic dimensions of whiteness such as how ignorance is implicated in this white mobility.

WHITENESS IN SOUTHERN AFRICA

Since the time of colonial conquest, European settlers and their descendants have formed linked networks across the Southern African region. For example, the dream of the arch colonialist, Cecil John Rhodes, to create a unified British territory from 'The Cape to Cairo' connected territories such as Northern and Southern Rhodesia (now Zambia and Zimbabwe) to South Africa in crisscrossing patterns of landownership, resource extractive industries, familial connections, travel and leisure, and conservation. This network was predominantly, though not exclusively, among English speakers. After the Second World War the German territory of South West Africa (now Namibia) was governed by Pretoria, in effect as a province of South Africa, strengthening similar affiliations among Afrikaners. The entire region became something of a playground for white masculinities (Pieterse, 1995). With the introduction of antiapartheid sanctions, South Africa

was isolated from the rest of the continent. The exceptions were the flow of insurgent and military forces on both sides of the struggle for liberation, and migrant labor from neighboring countries such as Mozambique, brought into South Africa to work on the mines and farms. The changes of 1994 opened the borders and South Africa started to redefine itself as an African country, creating possibilities for cross-border movement for both black and white South Africans.

As the most 'settled' territory, South Africa has tended to be viewed through a lens of exceptionalism (Mamdani, 1997; Matsinhe, 2011, 2016), regarded as more industrialized, 'modern,' and advanced.[1] The psychological map can be visualized as a continuum, extending from the Cape toward Central Africa: from a hybridized European, cultivated, ethos that is comfortable for white people, toward the untamed, undeveloped, challenging, and dangerous Central Africa of the colonial imagination, inhospitable to whites.

As a small, but visible, minority in the nation, white South Africa experienced the loss of state power more than twenty years ago as ushering in a condition of vulnerability, particularly given their historical debt to the black majority—a debt which they feared might be exacted. White South Africa undoubtedly was protected by the reconciliation process and has benefited economically from the policies of the governing African National Congress. Nevertheless, the hegemony of whiteness has been challenged and partially dismantled in South African society, particularly as a decolonizing sentiment is gaining ground among the black population. The sense of white control over the environment in which they live is slipping away. Nevertheless, South Africa probably still has the largest white population living in a context where they do not control the state, and certainly is home to the largest white population in Africa at 8.7% of the total population (AfricaRanking, 2016).

In other colonial contexts, Europeans generally 'decanted' back to their home countries once independence was attained (Hall, 2000; Van Hear, 1998); the outflux of white people after the demise of apartheid was a foregone conclusion. Most white South Africans who leave the country cite factors that indicate racialized insecurities (Schönfeldt-Aultman, 2009) such as crime, affirmative action, the expectation of deteriorating prospects relative to black South Africans, and the inability to deal with the changing social dynamics in the country (Van Rooyen, 2000; Vorster, 2016). It seems most counterintuitive, therefore, that white South Africans would leave the country to live in other African countries that have been independent for longer than South Africa, where the white population is very much smaller, and which can be regarded as more 'African.'

There are small communities of white people in many sub-Saharan countries, mostly remnants of earlier settler colonial times, but these have seldom been researched (Ranger, 1998). A common refrain in the existing research is anxiety among white people about the terms of belonging to African societies. In

Kenya, for example, scholarship by Janet McIntosh has revealed various strategies employed by whites to craft a sense of connection (McIntosh, 2006, 2014a, 2015). She identifies 'structural oblivion' as characterizing the epistemological relationship of the white Kenyans to the local communities (McIntosh, 2014b). In Zimbabwe, David Hughes has examined 'ecological belonging.' It characterizes white Zimbabweans' claim to belong to the land and its conservation rather than belonging to the African societies (Hughes, 2010), and Rory Pilossof has traced the continuities in the ways white Zimbabweans talk about the land reform program and the colonial discourses about Africa and Africans (Pilossof, 2009). Similarly, Heidi Armbruster found that white Germans in Namibia disassociate from 'Africa' and recycle colonial imaginations (2008, 2010).

THE RACIAL CONTRACT AND WHITE IGNORANCE

The theory of the Racial Contract, put forth by Charles Mills (1997), frames this chapter. The Racial Contract corrects the better known Social Contract of western political theory in showing that there is a deeper contract that configures the arrangement of modern society: 'the differential privileging of the whites as a group with respect to the nonwhites as a group, the exploitation of their bodies, land, and resources, and the denial of equal socioeconomic opportunities to them' (Mills, 1997). Mills argues that while all whites are not necessarily 'signatories' to the Racial Contract, all whites are beneficiaries of it. Emphasizing the global reach of the Racial Contract, Mills points to the legacy of colonization as the means through which the Racial Contract became a global phenomenon in that 'we live in a world which has been foundationally shaped for the past five hundred years by the realities of European domination and the gradual consolidation of global white supremacy' (Mills, 1997, p. 20). In pointing to areas of the world that were formally brought under the rule of European and North American powers through processes of colonization, Mills argues that the Racial Contract has created 'a transnational white polity, a virtual community of people linked by their citizenship in Europe at home and abroad. ... As European, as white, one knew oneself to be a member of the superior race, one's skin being one's passport' (Mills, 1997, p. 30).

The relevance of ignorance to the Racial Contract is explicit:

> The Racial Contract prescribes for its signatories an inverted epistemology, an epistemology of ignorance, a particular pattern of localized and global cognitive dysfunctions (which are psychologically and socially functional), producing the ironic outcome that whites will in general be unable to understand the world they themselves have made...one could say then, as a general rule, that white misunderstanding, misrepresentation, evasion, and

self-deception on matters related to race are among the most pervasive mental phenomena of the past few hundred years. …the Racial Contract…requires a certain schedule of structured blindness and opacities in order to establish and maintain the white polity. (Mills, p. 18)

Robert Proctor argues that it is imperative to problematize the naturalness of ignorance and direct our attention to the 'conscious, unconscious, and structural production of ignorance, its diverse causes and conformations, whether brought about by neglect, forgetfulness, myopia, extinction, secrecy, or suppression' (Proctor & Schiebinger, 2008, p. 3).

I argue that in postapartheid South Africa, the Racial Contract has 'gone wrong' in significant ways, but that it is the unexamined 'passport' (Andrucki, 2010) to cross-border flows of South African whiteness to other African states. An agreement to maintain the ignorances of whiteness—the 'Ignorance Contract' (Steyn, 2012)—translates across Southern Africa, carried discursively in *White Talk* (Steyn, 2005; Steyn & Foster, 2008). This discursive repertoire is replete with self-serving ignorance of racial dynamics, allowing the advantages of whiteness to be rationalized and perpetuated, while at the same time avowing prosocial views that legitimize the white presence in Africa. Deconstructing assumptions that inform the Ignorance Contract is aligned with Decolonial Studies, which urge disobedience to the epistemological authority of the coloniality of power (Mignolo, 2007, 2010).

I visited Tanzania for a month in 2006 and Zambia for a similar period in 2008. Interviews and focus groups were conducted with twenty-one white South Africans who have relocated to these countries. The interviews were mostly conducted in English, but where it was more comfortable for the participants, we spoke Afrikaans and I translated the excerpts presented in this text.

SCATTERINGS OF WHITENESS

The concept of 'diaspora' has conventionally been used to refer to the 'scatterings' of oppressed groups, such as those dispersed through the transatlantic slave trade, or in the case of the Jewish people, through forced exile. The use of 'diaspora' to refer to a privileged white group is contentious, but can be justified in terms of the concept of subjectivity shaped in displacement:

Diasporas…Can be understood as 'communities imagined in a certain way' (Butler, 2001, 192); people who share a subjectivity that is dislocated from their primary centres of identification, shaped within contexts of limited power in relation to the centres which impact immediately upon their lives, and which does not assimilate into the dominant identifications of the host society. (Steyn, 2003, p. 30)

Moreover, these dispersed populations are often visible minorities, bonded by shared 'structures of feelings,' identity logics, and epistemological assumptions that link them to the places of their primary identification (Steyn, 2003).

The argument of this chapter is that while it may be more accurate to talk about 'regrouping' for the movement of white South Africans into Western contexts, diasporic qualities are evident in how 'white talk' translates and mutates as white South Africans remake themselves within other Southern African countries.

THE RACIAL CONTRACT TURNS BELLY-UP

With the exception of only a few farmers in Zambia, all of the South Africans in this study declared themselves to have been in general support of the political changes at the time, or at least not to have been opposed to democracy. The political changes opened up new possibilities for economic advancement, which they embraced. Yet it was clear that something had become uncomfortable, and set them seeking other opportunities:

> I am totally opposed to apartheid. But we are paying for something I had nothing to do with. I had no race issues, it's all human race. (K2, T)

> I agreed with the changes, but not how it was implemented. All the conservative farming folk accepted the changes, had good relations with their farm workers, but things have deteriorated, especially economically, and the old order gets the blame. (K, Z)

Land restitution, the introduction of affirmative policies, and the inevitable demise of a life of white preference meant that opportunities were to be shared in ways that white South Africans were not prepared for. The fact that these changes are driven by the state, and are accompanied by an increasing societal challenge to the underpinnings of white supremacist ideologies, presaged the dismantling of the colonially inspired understandings of whites as the bearers of civilization/modernity, implemented for the benefit of those they control economically. White men interviewed felt particularly targeted by the new order. Discomfort was evident as they told of their role in South Africa being brought into question.

> We…decided that it is probably better here because your loans are underwritten by the World Bank. So, your land value, your property values are secured in a way, where you don't have it in Zimbabwe, you don't have it in South Africa. And the transition is coming in South Africa, whether we want to believe it or not, it's coming isn't it? (M, T)

The myth of white benevolence can only be maintained by holding onto a resolute ignorance of the injustices of the colonial and apartheid past. Faith in one's innocence in such circumstances requires that all involved must sign onto the

Ignorance Contract; even the historically injured must forgive and forget. Such conditions no longer pertain in South Africa.

> No, amazingly Tanzanian people aren't bitter about the past and it's one thing I really like about them. They are just not bitter. Whereas in South Africa you have massive numbers who are a) bitter, b) have chips on their shoulder. Tanzanians tend not to be like that. They are happy with their lot and they are quite happy to get on with life rather than worrying about the past. (FG, T)

The belief that opportunities were being closed down in South Africa, especially for white men, necessitated an open mind, a willingness to create new opportunities:

> I believe it's people that you know, husbands at their wits' end. They can't find jobs in South Africa or there's nowhere else for them to go. They either get laid off or money pressure or financial pressure is getting too much, they need to find something else. (Y, T)

WHITE TALK TREKS NORTH

Moving north of the Limpopo River underscored the fallacy of the Otherness of the rest of Africa, a cornerstone of white South African identity:

> Most South Africans are not African and they don't know what's going on north of their borders. (FG, T)

> Most white South Africans would not classify South Africa as Africa. It's almost like a little continent on its own and they say it's very interesting being here in Africa. (FG, T)

> That's part of the whole shift that needs to happen in South Africa: people need to be properly grounded in the realities of where they are because they have been sheltered for so many years, deluded for so many years actually, like a little part of Europe (M, T)

> People thought if we didn't have a 4X4 we wouldn't be able to move. Like they would ask, 'Don't your neighbors eat your children?' (FG, Z)

The physical crossing, however, did not guarantee a psychological shift concomitant with the physical relocation:

> But I think Africa is divided into two. If you say Africa, you don't immediately think South Africa. South Africa is like, separate. When you think of Africa you think of Nigeria and Kenya and Uganda. South Africa is like your separate, developed part of Africa. (FG, T)

> Ja there is definitely that sense that South Africa is not part of Africa. And I think it's just because South Africa is just so far ahead of all the other African countries. Yes Botswana

is close, Namibia is close. But it's not there yet. I think that's the only thing. I think South Africa is too much first world for Africa. (Y, T)

Continuities of Whiteness

It was notable that all the people interviewed regarded themselves as happy. They boasted a good standard of living, comfortable homes, 4 × 4 vehicles, a variety of staff in different combinations: domestic workers, gardeners, guards, drivers. In some cases, the children had dedicated drivers and 4 × 4 vehicles to take them to (an international, private) school. People enjoyed the outdoor life, access to game parks, some spoke of country clubs, and (in Dar-es-Salaam) of yachting. Circumventing inconveniences was part of the lifestyle: not always having everything at hand, paying high prices, learning to improvise, and be highly self-reliant.

The people interviewed in Tanzania had come to the country as part of a professional class, working on projects of international corporates. By their accounts, financial incentives played a role in the decision to relocate; companies may pay in dollars or pounds, sometimes continuing to pay a salary in South Africa as well. In Zambia, the interviewees were farmers, all of whom reported to be doing very well financially.

Having undertaken the brave move united the respondents in a sense of being part of a vanguard: pioneering, adventuring, initiating. While there were obviously a range of interpretations of their role in the countries where they now lived, all the South Africans interviewed imagined their white presence within narratives that draw on settler colonial historiography. This implicit tale was told purely in terms of economic and technological advancement; no mention was made of the historical costs in human terms borne by African people as the machinery of capital ground forward. The broad contours were invariably paternalistic: whites had brought development, skills, productivity; their efforts came with a 'stamp of quality' (M, Z). With South Africa clearly recognized as the most advanced country in the region, having 'benefited' from the presence of the sizable white population, it was appropriate to spread the skills base north. Living in an indisputably African country, nobody could accuse one of being opposed to democracy and black government.

> White South Africans are accepted as one of them, they allow it. We have experience, new ideas, capital—but they have their own initiative and originality. We are able to provide leadership. (K, Z)

> Skilling people and also showing them what the outside world is like because they learn that through our behaviors. They can see through us that that's how other people live, how other people do. …And umm, it can go two ways. It's either very good or very bad. (Y, T)

In the new contexts, however, the contributions of whites are clearly supportive of the economy of a society in which they have no controlling interests, unlike the situation they had left in South Africa. This gives greater credence to the belief of whiteness in service of the continent:

> Tanzanians are…very friendly, very willing, but very unskilled. You have to, we are here to impart that knowledge. (K2, T)

> We contribute—we buy fuel, pay our tolls, grow food and create work. By June I will be employing 120 people. (K, Z)

> I think because the country is independent so long and they saw that if a foreigner or European is coming here, they are coming here for help. And assistance and working together and create jobs. I think in South Africa with this Affirmative Action story is that there is more of a jealousy about jobs. If you hear what I say, If I come here, I create jobs. I feed like ten families. I am keeping them alive. You hear what I am saying? (P, Z)

The underlying faith in the superiority of white capacities—moral, intellectual and productive—is not subverted by living in a context where whites are a small, highly skilled, affluent diaspora.

> He said, 'Ja, but these guys are stupid. They are useless'. I said 'Listen, if they were so clever, would you be here? Their inabilities and their weaknesses create an opportunity for a [his own name] of the world to be here and you.' (K2, T)

Notions of whiteness as both norm and ideal are reflected back to the diaspora in multiple ways:

> I must say I love it [being white in Tanzania]. I don't know. I don't think it makes a difference but I think, I don't know why, the locals think that whites are quite beautiful. I have often been told, 'Ah, mazuri mazuri' which means beautiful. I am overweight. Well, in South Africa, well I have never turned heads. Maybe when I was younger but not now as a 46 year old, 47 year old lady do I turn heads in South Africa. But when I come here I do. So, it's wonderful. I don't know if you have noticed that too? (S, T)

The net effect is that the white subjectivity, formed through successive iterations of colonial and white domination in South Africa, remains essentially unchallenged in significant ways.

> My house-boy speaks English and my house-girl speaks English and all my staff speak English at the office and shop and everything. So you know, there is no need to learn. (Y, T)
> Tanzanians are very ready to serve and when the white man comes across typically to lead, that's expected to serve the white man. (FG, T)

Staying within Africa nevertheless provides the comfort of familiarity, a sense of rightness for body and psyche, a sense of belonging and competence:

You definitely pick up a rapport with African people. You can't always instantly pick up a rapport with people from other…Maybe if you had to sit me down with a Russian here I probably wouldn't be able to pick up sort of a rapport with him just because he is white. I wouldn't know where he is coming from. But if you sat me here with someone from anywhere here in Africa, I would probably instantly pick up a rapport. (K, T)

Well we had traded before in the, we were trading in the townships, the township shops. So we were quite sort of used to working with Africans all the time, how they think, how, you know. (M, Z)

Familiarity with Africa and Africans is seen as a competitive advantage—many spoke of 'understanding Africa' as increasing their value to the countries where they were contributing their expertise, and also the reason for choosing not to emigrate elsewhere.

You know, I understand Africa. I don't understand those places. (K, T)

South Africans are better able to work with Africans, we grew up together. (K2, Z)

Implicit within this claim to familiar knowledge is the implication that Africa is inscrutable to those not as deeply immersed, or initiated into the ways of the continent. South Africans come with depth of insight, an aptitude and temperament that other people from the global north, despite technical skills and theoretical knowledge, lack when confronted with local challenges.

I think that if people realize that they are the visitors here, they would be much happier. I was listening to [name]. They were complaining about…not having stuff done when they want it. They have got to realize that this is not the first world. This is definitely third world. And also on African time. Maybe coming from South Africa, I know about African time. If you come from Europe, you don't really know about it, you don't realize that it actually happens. I suppose in Germany everything happens on the hour on the dot to the last second. In Africa, it doesn't. (J, T)

This knowledge is also an internalization of the narratives of the colonial imagination: Africa is inscrutable, unpredictable, unstable, untrustworthy. The specter of Zimbabwe came up repeatedly, always the marker of an inevitable, or at least a perpetually possible, white nightmare. Those who know Africa are not naïve about the supposed innate propensities of the continent:

If Africa carries on the way it's going in certain areas, it's not going to look positive. I think it will change but not in our lifetime: we won't see it, it's still a long way off. The idea of an African Renaissance was a pipe dream as tribalism is too strong in Africa. The continent is hopeless because of corruption. (FG, T)

What I don't see happening is initiatives and I think it's throughout this continent. Initiatives which happened in our own cultures in Europe, it comes through what happened

with the reformation: that sort of stirring which led to the Enlightenment and so on. That needs to happen. (I, T)

Premier among those guilty of acting from naïveté and therefore guilty of unintended harm are the NGOs, which subvert the market's labor dynamics. The topic was raised, unsolicited, by many of those interviewed, although some of the women who are prohibited from undertaking paid work by visa restrictions, were themselves active in this sector.

> A lot of people that come here and work for an Aid Agency or some NGO and they will give you a very distorted perspective of Tanzania. ...They don't deal with reality here. ... Yeah, you don't have to, nothing has to be successful. It doesn't have to happen. They have got minimal goals and they have got lots of money to spend. They don't have to make any money. They have just got to try and make a few things happen within certain parameters. So you will get an extremely distorted perspective from people who work for NGOs. (K, T)

> I don't think NGOs come into this country and do much good. They take away the will to work which is what's happening in South Africa with these grants. They get the children and then having a child you have this grant. Its taking away that will to really study and do something for yourself. They're turning it into a nation of beggars, hey? We have had workers here that say don't worry to pay me this month, the NGOs is paying me maize down the road. You can keep our money this month. Next month give me both, lots, and I am going to buy a bicycle. ...And then next the NGO is gone because they have run out of money or the dollar exchange rate has now caused or is not viable for them to give this maize. Our fellow has lost his job, or he has lost everything. That is now a continuation of a plan for them. No I don't think NGOs do people a favour. They say, I know my husband was in Uganda, and they say it's deliberate, to keep people in Africa instead of letting them all wanting to emigrate overseas. It's cheaper for the first world countries to dish out bits this way in Africa in general. (M, Z)

A Beautiful Life

While interviewees spoke of the many challenges of living away from the comforts of South Africa, such as the poor roads, lack of potable water, unreliable electricity, malaria, and more, many aspects of the good life from South Africa were even better away from the trappings of modernity. The people who reportedly were most affected by the hardships were wives who were proscribed from working because of visa restrictions and had to deal with daily inconveniences such as the informal markets. One man reported that his ex-wife had not been able to make the adjustment and had gone back to South Africa (K2, T) which was not unusual, according to the reports. Another man reported that his wife was a virtual prisoner in their home as she was too afraid to leave the house (B, T). For the most part, the men worked in industries closely linked to what they saw as quintessentially African—agriculture, nature conservation, mining, hospitality—industries occasioned

by natural resources and new ventures—putting new things in place rather than simply maintaining an already existing system. It required a pioneering spirit congruent with sense of whiteness in Southern Africa. As a farmer in Zambia said, 'We started from the ground up. We chopped down the trees and have built the most modern pig farm in Zambia' (FG, Z). The personal satisfaction of having a tangible impact, greater than would be possible in the more established, competitive work environment of South Africa, was evident. And the African playground provided endless adventure:

> Although running a business here in Tanzania is perceived as corporate, it's not. It is a small operation. [Company name] South Africa is mammoth. But this is Tanzania and I can run it the way I want to run it. …But going back into that corporate environment I don't think that would work because you would have to report to someone when you have been the top dog for five years, I don't think it's that easy. (P, T).

> It's exciting. It's adventure. To me this is a huge adventure. When I first got here, going to buy bread was a big adventure. (J, T)

> I mean you can't beat this lifestyle anywhere in the world. (Y, T)

Whiteness slipped from one context to the next in how people were inserted into managerial positions, labor relations, ownership, leisure, and the unproblematized sense of appropriateness of these advantages. Generally, comments focused on the quality of life for whites in Africa:

> Why I am feeling privileged to stay here? It's just the way I feel. This place is like ummm, best kept secret. It's luxury. Maybe because I know my husband is working very hard and he has lots of difficult issues. …I think men here in general have a harder time obviously than the expat wives who sit and play bridge and stitch and whatever. (J, T)

> Because help is so cheap here. And as I said I am employing four people, two outside and one inside or two inside my house now and I just can't live without them. The two outside [are] like askaris, like garden boys, they open the gate, they wash cars, they fill generators with diesel and all that. When I go shopping, I stop my car at the house and my house boy comes and fetches the shopping at the car. When we stop at the gate, the gate is basically open. There's no buttons to push or anything. They wash our cars every day. It depends on how far you want to push it. …It is a big trend here to have full time nannies because help is so cheap. Yeah, it's just the thing with these people. They love kids. They are very good with kids. …(Y, T)

With few exceptions, socializing was limited to other South Africans and expats from first world countries.

> We have got some South African friends, we have got Greek friends, we have got Italian friends, we have got Scottish people that we know. So, it's a wide variety of nationalities basically. (Y, T)

Most of the talk about the lives of local people communicated a sense of being at a remove from their pressing problems. Disconnection from the local people felt all the more legitimate because it was not their country. 'One can just relax and not worry about it,' one interviewee explained. 'Expats live in another dimension than local people. One has financial standing and links to home, and can get out if it all gets too much. ...I can't imagine where my staff live, and I'm afraid to find out' (A, T).

> I just put on a light, have a hot shower...have my driver come and pick me up in the morning which he does. He comes to my house. How spoilt am I? How fortunate am I? This poor guy had to get up at 4 o'clock. Doesn't have hot water. Catches three buses to come to work. (K2, T)

Positioned structurally as leaders and experts, no one problematized or expressed a desire to challenge the immense disparity between the wealth of the white residents and the locals, which kept the familiar racial relationship intact. At an individual level, dynamics could be fraught, but the order itself rewards whites in line with their desserts.

> I think they [black Africans] look at us and see money definitely so whether you buy a potato or whatever, you are going to pay double. I mean my garden boy, the shamba boy, when there was a power cut, the power has hardly gone off and he switched on the generator and I said: 'Why? The fridges are not going to defrost in ten minutes. Diesel is expensive'. He said 'What? You muzungu: wazungu peza mengi.' Muzungu is white, wazungu is the plural. Pesa that's money. Mengi lots. (FG, T)

> I feel bad when I come to the shop and I go to the village and I think 'Oh gosh and I try not to put my cash slips in the dustbins because they will see what this woman is spending on nothing. I was taking the labels off the cat food in Malawi because you feel embarrassed for the people who work in the house. We were paying them a fantastic salary but I just felt bad'. [FG, T]

Without exception, interviewees denied any sense of connection to Europe except as a rather vague ancestral homeland. The link to the broader white world was embedded within white South Africanism, 'the place that has everything' (M, T) and performed the role of a regional proxy. Despite often identifying as African, the interviewees' whiteness provided the buffer that enabled a safe sense of not being locked into the lot of Africa. Whiteness linked people to the world beyond the continent that underwrites their subjectivities, their beliefs, their ways of being, and especially their economic ideology.

> My daughter, I have looked at Australian Universities. She wants to go to America. ...She would like to get into America to get into her military field. I would like to see them get citizenship in another first world country, hopefully giving them better opportunities than we have because they are not interested in agriculture. ...My husband says South Africa but I am not so keen because of crime. (M, Z)

As with any diasporic community, identification with and ties to South Africa varied, but it often featured as a kind of background insurance policy. For those who were not taking out citizenship, there was the expectation of retirement in South Africa, and it could provide specialized medical care if needed.

> We were there for Christmas and I am going now at the end of this month because I am pregnant at the moment so I am doing more trips down. And then end of the year, I will still have my baby there because medical aid there or the medical is just so much better than here. I don't want to take a chance here. (Y, T)

The distance from the struggles of the local people is also evident in how some of the issues and activities people cared about most were framed.

> I am not at all an activist. I am more into animals than women and children. I do believe sometimes too much is done for women and children and not enough for animals. …Yes, poverty is a problem. It's a big problem here. And it's going to be very strange to say but it's not affecting me straight on. I suppose it's very selfish. But the way that it gets me more, as I said, animals. People having animals, they can't feed them. And you know they want to, they have the love for the animals but they just can't look after them. That gets me. (Y, T)

A Second Chance

There was a general sense that white South Africans would all benefit from discovering how different it is to live outside of South Africa. People reported becoming less materialistic—at first from necessity as goods and services were not freely available—but increasingly as they learnt to value the freedom from things, they felt more spiritual, more self-sufficient and inventive:

> I mean since we have been here has been a couple of times when Dar has had no water for ten days because the pipeline has burst or whatever happened to the water system. And life goes on: restaurants are open for business, everyone. Now try and imagine New York, London, and even Joburg not having water for ten days and life doesn't skip a beat? And that's why we used to say, survival of the fittest and who is to say who the fittest is? Is the first world's reliance on modern technology going to be their undoing? (S, T)

Self-reliance, taking initiative, living in a more family-oriented manner: the benefits were many.

> You have to become quite self-reliant on yourself, very self-reliant. Everything you need to have done, you must orchestrate from step one. There is no infrastructure. (M, Z)

> I wouldn't have learnt in South Africa. The opportunity I have had here and what I have got myself involved in in the last couple of years is an experience you would never pick up in South Africa. [I, T]

Moving from a context where one is confronted with the injury committed in your name, and the guilt and shame that this recognition induces, white relocators experienced in other African countries a restoration of faith in their own goodness. The racial dynamics in the countries researched provided a revelation of themselves as well intentioned—'good whites' after all—often without the burden of introspection. In fact, in some cases one could simply carry on with business as usual:

> Many AWB[2] people have come here, they were against reform, anti-black. Today they are farming here. It is different here. (K, Z)

When racial relations were raised, mention would be made of other South Africans who treat local people badly, either historically or currently, and who give all South Africans bad name—but of course these always explicitly excluded the interviewees. Racism was not limited to white South Africans, though, and mention was made that expats from European countries were often more bigoted (S, T).

> There is some anti-white feeling in some businesses. When we first came there were anti-South Africa marches in Lusaka. Many of those white South Africans who did not make it gave us a bad name. They left bad debt, treated people badly, were dishonest. But things have stabilised. (FG, Z)

> And in Tanzania they have got a phrase which comes from Nyerere's time which is Kaboer. When a Tanzanian calls you a Kaboer, it's actually an insult. So, they will generalise when they talk about South Africans: 'He is a Kaboer'. But when they're talking about somebody and say that guy is a Kaboer, that's an insult. He is from that apartheid era where he treats the blacks badly and things like that. So it's a very bad phrase for a South African. And a lot of these guys, they see them that way. And once you have been labelled a Kaboer in Tanzania, they lose all respect for you. They won't listen to you. (P, T)

Provided one remained fairly under the radar, one did not have to change, be scrutinized, or account for oneself other than delivering results. This was partly because white South Africans were engaged constructively in the society, but also because the local people were so free of animosity. Reports of their friendliness, gentleness, and tolerance were virtually unanimous, despite difficult political contexts.

> So I think people's expectations were raised whereas in Tanzania that didn't happen. And for years people actually had nothing. Even today, Tanzania is still a poor country. (K, T)
> Friendly and helpful. And scared. Fairly corrupt. Not all of them. Corruption is fairly high. (M, Z)

> If I am polite to you and you are polite back to me, I have got no problem with you and I think that's the thing here as well. Because these are not a violent people or an aggressive people. (Y, Z)

In such a context, the 'correct' racial order prevails. While many spoke of the corruption, bribery, petty crime, and ruthless township justice, the local people—other than some of 'the new educated types' (A, T)—were represented as good, uncomplicated souls, who make you feel welcome and accepted, even loved.

> I enjoy the people here and there's little violence. Everything is negotiable in one way or the other. And there is this thing called the Swahili compromise where people will tend to try and work out a situation so that it's beneficial to everybody. And when you start with that mentality, you have actually got a good chance of succeeding. It's actually a pretty good way of thinking I suppose. Why fight with somebody when you can come to a compromise that everybody scores on the deal. (K2, T)

> Even the traditional institutions are very democratic. If want to invest as a white person, you just enquire at the chief, go and find the land you want, they will give you a guide, and the headmen come together, indicate the beacons, are marked, then there is a meeting of the local people, it is discussed, they are asked three times if there are any objections to the allocation of the land, and then it is yours. It will never be taken from you. I'm busy building tourist camps, crocodile farms, fish farms, game farms. (K, Z)

Emancipation from being part of a dominating class enabled white South Africans to discover liberal tolerance, both as receivers and bestowers, which greatly enhanced their sense of self-esteem.

> I am certainly more racially tolerant. Beyond any question of a doubt. A tremendous amount. Basically tolerance. People are so intolerant in South Africa, incredibly intolerant. (P, T)

Good race relations, it transpired, enabled them to discover their own nonracialism, of being capable of human connection across race. This radical unburdening, facilitated by shedding old blinkers, allowed for seeing the potential in people and countries that could not have been envisioned in South Africa:

> When I first got here, it was actually an Argentinean lady that told me. Her husband apparently had knocked over a little boy, a Tanzanian kid, many years ago. They have been here for 14 years. And I think maybe she was a bit paranoid. I was petrified. And about 8 months ago I got stuck in the mud, probably last year this time. It was the rainy season. And cars travel here in all directions from all over the show. And I swerved to move out. Somebody was coming towards me in the left-hand lane, I moved over to the left and the whole left side of my car, the wheels just disappeared into the mud. They had obviously dug a trench there, covered it up with loose soil and when I drove over it, I couldn't get out. I have got four-wheel drive, I've got all sorts of power steering and nothing helped me out of there. At first I was scared, 'cause there were lots of locals around and they were prepared to climb in there and pull me out physically. They were so sweet'. (J, T)

> The longer you stay here, the longer you become humbled and realise that some of them have passed through better education systems, very well spoken, very well skilled. We have a black accountant and black lawyers. They really are so capable. We have just bought a

farm and it's all been done so well. Who are we now all of sudden to think to sort of think that we are perfect? It's a good humbling ground. Good wake up call for many of us. (M, T)

We were blinded by propaganda. We were denied so much by the old Nationalist government—human relations, economic opportunities. (K, T)

Particularly for the men who had served in the South African Defense Force migration seemed to offer a second chance away from an implicit judgment, of the burden of reminders of culpability—'Well, I don't want to go into that. ... Anyway, that's history' (P, Z). One Zambian farmer who had been a professional soldier, even joining the old Rhodesian army, explained that he felt ill at ease and unwelcome among fellow South Africans, but at home among Zambians. He maintained that his friends felt the same way. He believed that if you obeyed the laws, you were treated as a fellow citizen. This was a context in which even those who were politically conservative could discover that they were actually benign, even generous, and deserving of recognition for that.

South African whites have so much to learn from Zambians. The white people must relax, accept that things are going to be more difficult and mustn't get the jitters. But they must not keep their old attitudes. There is much better communication between people here, we joke together. When I look back, I think we should have left people to develop together. (K, Z)

You must give them recognition, nothing will happen to you if you accept what they tell you. I would never have had that relationships in South Africa. (FG, Z)

Some see the white person as a threat. Others say, 'Thank god the Mlungu is back. They live better, there are jobs. I have never felt threatened. Respect is important, but you have to earn it'. (FG, Z)

While one can recognize shocking paternalism in many of these accounts, introspection has been important for others in their personal journeys:

I was your classic little, white suburban South African girl. I knew nothing, nothing, knew absolutely nothing, didn't think to question because I am not a questioning kind. You tell me this is that and I am happy. (M, T)

I used to belong to the Conservative party. I learnt so much here, I had to be honest with myself, that is why I learnt. If you don't do that, you would not be able to adjust. (K, Z)

The relief, especially among Afrikaners, of enjoying amiable race relations was palpable.

Zambia was an eye opener for me. You go to a place like South Africa or New Zealand where there is hatred, racial hatred. You come to a place here where there is not, well its non-existent as far, well there is very few here and there. It's very, very scarce. You come to a country where there is friendly people and you are thinking to yourself...here [in Zambia] there is no racism, we are all the same and we are colour blind here. (P, Z)

The crucial point in all of this, however, is that differences between the people of the countries, as well as the personal changes people reported, were attributed to the personal qualities of the people concerned. The structural privileges of whiteness, domination, and oppression remained stubbornly out of sight and out of mind.

> But on the whole, Zambian people are excellent. I will tell you that. (P, Z)

The Posttransformation State

The most salient reason presented for the greater comfort and greater personal functionality in the new environment, however, was unequivocally the fact that these countries were what might be understood as 'post-transformation.' Those who were staunch adherents to the Racial Contract stridently expressed antagonism to the changes being made by the state in South Africa. These were construed as an insult and injury to white people and heralded inevitable national decline.

> I will rather live in a black country than in a country where things are taken from me and I have no say. ...They just sit on the patio, get money in the bank. I would rather trek into a black country. (FG, Z)

> There probably were some people who treated blacks badly, but not only black people. Here I am sort of the foreigner. When I listen to the stories of SA, people have not maintained things, kicked white people out, the deterioration was not necessary. Since being here we've seen how the names [of towns, streets] have been changed—it's one of the ways in which that which was yours has been taken away. It makes you feel unwelcome. (FG, Z)

> We foresee darkness in South Africa, I'm worried about the safety of my son, here we are peaceful, laid back, there you have to hold on to your handbag. SA will fall faster than other countries. Africa is too dependent on SA. (FG, Z)

Given the pervasive tendency to construct themselves as always having been apolitical, and therefore not implicated in the past wrongs, contradictions abounded in interviewees' testimonies. All the men interviewed mentioned 'rife' Affirmative Action and Employment Equity measures, cast as hate or retribution.

> I would like to be somewhere that's getting better not getting worse. So, it was my perception that the currency would devalue substantially—hasn't devalued quite as much as I thought it would—and that there would be a large amount of prejudice against me from a work point of view because of the colour of my skin whereas in the rest of Africa I don't have that problem. (P, Z)

> Well, I suppose people are trying to correct the imbalances from the past but not very well. But what about the present? And don't make the problems that other people created my problems—quite simple. (K2, T)

You get the anger from the white guys because of the jobs, promotions and everything. There is that white feeling that you are a 45-year-old male and haven't got a hope. [FG, T]

A widely held sentiment was disapproval, even hatred, of the ruling African National Congress in South Africa, which displayed 'irresponsible leadership.' Nelson Mandela was always presented as an exception. In contrast to the perception of the South African government, both the Tanzanian and Zambian states were seen to be welcoming of what white South Africans had to offer and the economic benefits they brought. Transformation was therefore usually construed as an obsession with past.

I just think the South African people live too much in the past. Yes, a lot of wrong was done to them. I agree fully. But I just think that people must get over themselves. They must realise you know what has happened has happened—ten, fifteen, twenty years ago. And they must decide now what they want. Do they want all of us now out of the country? Or do they want to live together? Because we are also Africans, we are also South Africans. We also have the right to be there. And I am not against people getting jobs that they qualified for. By all means, if anyone is better than, say we apply for the same job, if anyone is better than me then that's right. Get it. But it's just…it is at the moment people are getting jobs they doesn't, they don't belong in those jobs. They don't have the qualifications for it.

It feels different because the people are different. I believe the South African blacks have got a chip on their shoulder and I wouldn't say it's wrong of them but the other thing is people must get over themselves now and start living together. But here, you are a guest in a country, you act that way. South Africa we always felt like it's ours. Here, we always remember that we are just guests in their country and the people are friendly and they are always. They see you as a big dollar sign walking around because you are money for the country. And as I say to you also it is safe. No one is going to come into my house and kill me for a cell phone or something like that. I know it is strange. Everyone says to me, 'But there you live between them'. It's like I mean this town is like Soweto. But they are no threat. They are not threatening people. They are not violent people. (Y, T)

For ardent Racial Contractors, black South Africans were holding on to grievances unreasonably to gain illegitimate advantage:

Well, in South Africa today you have the blacks that feel they are so, they are underprivileged and all the rest. They're not man. They're doing well now in the new South Africa. Like here in Zambia it's not black and white, white and black. It's ridiculous. It hits you like a wall when you first come here. This one's got a coloured wife. That one's got an Indian wife. I mean we got an Afrikaner, real African, with an Indian wife, South African Indian wife. They look most incompatible but they're not. And nobody cares here. Although, I must say, I would prefer not to go down that road. (M, Z)

Having reneged on the contract, South Africa has become a constraining environment, in which especially white men cannot express their full potential. As one male participant in Tanzania put it, 'Unlike South Africa, these other countries do

not have a problem with the white man's authority' (P, T). This view was widely expressed, to the point of consensus.

> There is a very strong perception that the white guy is an expert. Tanzanians are generally a very lazy race and they will be the first to admit it and then they see the white guys coming in. …What they find is that the white South Africans are extremely hardworking: English and Afrikaans, across the board, together with the perception that the white guy is the expert and he knows everything. It's not resented at all and they enjoy being in the presence of somebody that they perceive to have better knowledge. [I, T]

> Some see the white person as a threat, others say, thank God the Mlungu is back. They live better, there are jobs. I have never felt threatened. Respect is important, but you have to earn it. (FG, Z)

A common theme in the construction of 'posttransformation' was that a post-colonial African country goes through an inevitable cycle which initially involves expelling, or punishing the white settlers, during which period countries suffer mismanagement and economic decline. But as time goes by, they regain a kind of equilibrium, recognize the error of not valuing what the white man can offer, and welcome them back. South Africa is still in the early stages of repeating this history:

> You know Africa is a sort of cycle. (M, Z)

> Zambia had a very small white population, but it has gone through all its phases to where it is now, and has one of the healthiest economies in the Southern Africa. (K, T)

> I find it quite refreshing in some ways because you come here [Tanzania] and you are not the enemy and there's not that underlying antagonism so you haven't got to work through all of that first. Historically, the colonial or the white rule here was years ago, whereas in South Africa it became such a big thing and for so long, it's huge. You haven't got that history of anger in some ways. (S, T)

> South Africa still has to face a lot of difficulties, a lot of hardships. Both sides must learn. …SA will deteriorate economically, and then improve. (K, T)

> 'Guys, this is Tanzania. It is owned by the Tanzanians, forty-five years now. Run by them. What do you want to tell them about transformation? It's their country. Get over it. You want to talk about transformation, go back to South Africa and talk about transformation'. It means nothing in Tanzania, absolutely nothing. So, if you come to Tanzania and say 'This is my Transformation Strategy for [Company name] Tanzania' it is an insult. 'It's my country. Is it transformation to bring in more white people? What do you want to trans-form? It has been my country for forty-five years.' (P, T)

By relocating to a country that is further along in this trajectory, white people get to avoid living through the period that is seen to be unfair to them. There is always the option to go back after the transformation years—when South Africa is further down the trajectory.

Hopefully by the time it changes, South Africa will be over its transformation years. I must say I still enjoy the luxuries in South Africa, the shopping. Walking into a shopping center and everything is there. And it's like Christmas every time you go down. Because there are a few things that you can't get here or it's just a bit more difficult to get. But like you say there's pros and cons in everything and if you weigh it up the pros are much more in this country. (Y, T)

But for the most pessimistic, there is of course always the possibility that the state could regress:

Good relationships, no hatred, no aggression. They will become sulky but won't argue, unless they can get money out of you. Then they threaten to deport you. (FG, Z)

Eden Recouped

A 'posttransformation' environment, where life is laid back, not cut-throat, and competitive, where it is wonderful to raise children (I, T), and where you are welcome as a white person—the attractions of living in such an environment are obvious. The 'land of milk and honey' (P, T) narrative was inextricably linked to opportunity, especially economic opportunity, encouraged by less regulation from the state.

Minerals, just unbelievable minerals. Farming. The ability to come and farm. You could plant a twig in the ground and it will grow. The ground is so fertile, untouched. There is so much land available. So much farming to be done. So many minerals to be discovered. They have got oil between here and Zanzibar in the Zanzibar channel. (P, T)

There is human potential, land, water, minerals, oil. It can become an economic power-house. (K, T)

Awakening to the immense value and potential of Africa was in tension with the deep narrative of inevitable African decline and decay. White people, it seems, play an essential role as the buffer to this fate. With notable exceptions, such as a missionary couple in Tanzania who were most aware of the social dynamics that had led to poor relations in South Africa, people did not make the connection between the degradation of African societies and economies and white domination and black oppression.

A repeated refrain was the land's pristine beauty, about 'lots of land here just as it was created. Places that have never seen a white person' (FG, Z). The romantic element betrayed the luxury of means to buy relative comfort; the region, one woman bemoaned, will lose its charm as it becomes more developed (Y, T).

Zambia is a passion—like in "Out of Africa" to an extent it still is, like a picture. The north is bush. (FG, Z)

It's like a fairytale but it's the truth. We got some of the best national parks in the world. We got the Big Five here. (P, T)

It is a short step from here to the emergence of the other archetype of the colonial imagination—Africa as paradise:

> It's absolute paradise. (S, T)

> There are glaring differences between Europe and Africa and if we trace it back perhaps this is where the Garden of Eden was. (FG, T)

CONCLUSION

White privilege is not deconstructed in these 'more African' locations, it is privatized, socially and economically. As a diasporic whiteness without political prospects and no expectations of controlling the state, it finds a new niche for itself. It is more supportive than dominating, and fits within the ecology of the African countries. This may even be experienced as a relief. The important thing is discovering a more benevolent, if modest, way to be white—untrammeled by accountability for historical injustice, guilt, or shame. Rather, these contexts restore the sense of the white man's worth, his faith in his benevolence, and the value of his contribution even as he becomes wealthy through participation in the neoliberal, capitalist system. No longer overt oppressors, white South Africans discover their capacity for liberalism, their benign nature, and feel appreciated. White ignorance need not be disturbed. The position of structural advantage that comes with whiteness, even if more visible, still feels appropriate, even augmented by the relative underdevelopment of these countries in relation to South Africa. Racialization is unproblematic, as poor life opportunities are attributable to local dispositions and mismanagement.

Moving into, and experiencing first-hand, countries north of South Africa, unlocked possibilities for rethinking the usual exceptionalism afforded to South Africa, even to reimagine the regional political arrangements: 'The Southern African borders are going to fade, it is a fact it will become one bloc' (K, Z). However, it also enables a different narrative of exceptionalism to emerge, a key reconfiguration of the migrating White Talk.

The new exceptionalism depends on the tried and tested ideological move of 'good blacks, bad blacks.' Good blacks mirror an image to whiteness in line with its self-congratulatory self-image, leaving it comfortable, and ignorant of itself. Bad blacks challenge whiteness, making it face its own unconsciousness. In this new exceptionalism, the dynamics are extended to 'good state, bad state.' Black people in these countries are experienced as 'happy natives'—gentle, friendly, welcoming, malleable, compliant, not suspicious, even though not above some racial envy of white wealth, often lazy, and tending to petty crime. They are free from the racial

animosity that is seen to characterize black South Africans, 'bad blacks' who are race obsessed, resentful, threatening, and more prone to violent criminality.

By extension, the state in South Africa, now seen to be in the hands of black people who cannot be trusted with power, is seen to be antagonistic to the interests of white people, and certainly taking the country down a path of decline. However, it is still powerful enough to implement policies that dismantle the edifices of white colonial and apartheid power, including its epistemological dimensions. In such a context, the Racial Contract is violated, and the country is no place for a white man. The governments of more seasoned postcolonial African countries, on the contrary, are praised for welcoming your whiteness, provided you keep to the bargain of not developing political ambition. This is regarded as smart; an investment in the right people. Especially financially and economically, the state is not an enemy. It has other priorities, and probably not the capacity or infrastructure to micromanage. In sum, whiteness can migrate because it is scaled down in its ambitions to dominate. In many key respects the Racial Contract remains intact; migrating along the modulating intonations of *White Talk,* and secured from self-reflexivity by the Ignorance Contract. There is no pressure to have to face the demons of white culpability.

If, as some interviewees maintain, Africa north of the South African borders is Paradise, then this is truly *Whiteness That Has Not Tasted the Fruit of the Tree of Good or Evil.* Living in the Garden of Eden, untrammeled by Decolonial pressures, rewelcomed into the bosom of the Africa they love, but now in a context where all is forgiven, being white in Africa without the pain of consciousness is Paradise.

ACKNOWLEDGMENTS

This work is based on research supported by the South African Research Chairs Initiative of the Department of Science and Technology and National Research Foundation of South Africa. Any opinion, finding, and conclusion or recommendation expressed in this material is that of the author and the NRF does not accept any liability in this regard. The author would like to express appreciation to Finn Reygan and Jaco Oelofse for research assistance.

NOTES

1. The racialized sense of superiority is not confined to white South Africa, but has also been internalized by many black South Africans, expressed as negrophobia (Gqola, 2008).
2. The *Afrikaner Weerstandbeweging* was a far-right white supremacist paramilitary organization that attempted to derail the road to democracy in South Africa.

REFERENCES

AfricaRanking. (2016). African countries with highest white population. Retrieved September 15, 2016 from http://www.africaranking.com/african-countries-with-highest-white-population

Andrucki, M. J. (2010). The visa whiteness machine: Transnational motility in post-apartheid South Africa. *Ethnicities, 10*(3), 358–370.

Armbruster, H. (2008). "With hard work and determination you can make it here": Narratives of identity among German immigrants in post-colonial Namibia. *Journal of Southern African Studies, 34*(3), 611–628. Retrieved from http://doi.org/10.1080/03057070802259852

Armbruster, H. (2010). "Realising the self and developing the African": German immigrants in Namibia. *Journal of Ethnic and Migration Studies, 36*(8), 1229–1246. Retrieved from http://doi.org/10.1080/13691831003687683

Brown, M., Kaplan, D. E., & Meyer, J.-B. (2000). The brain drain: An outline of skilled emigration from South Africa. *Africa Insight, 30*(2), 41–47.

Butler, K. D. (2001). Defining diaspora, refining a discourse. *Diaspora: A Journal of Transnational Studies, 10*(2), 189–219. Retrieved from http://doi.org/10.1353/dsp.2011.0014

Crush, J. (2002). The global raiders: Nationalism, globalization and the South African brain drain. *Journal of International Affairs.* Retrieved from http://doi.org/10.2307/24357887

Crush, J. (2005). Johannesburg, South Africa: Breaking with isolation. In M. Balbo (Ed.), *International migrants and the city* (pp. 113-150). Venice: UN-HABITAT.

Crush, J. S., McDonald, D. A., & Williams, V. (2000). *Losing our minds: Skills migration and the South African brain drain.* Cape Town: IDASA.

Drzewiecka, J. A., & Steyn, M. (2009). Discourses of exoneration in intercultural translation: Polish immigrants in South Africa. *Communication Theory, 19,* 188–218.

Gqola, P. D. (2008). Brutal inheritances: Echoes, negrophobia and masculinist violence. In S. A. Hassim, T. Kupe, & E. Worby (Eds.), *Go home or die here: Violence, xenophobia and the reinvention of difference in South Africa.* Johannesburg: Wits University Press.

Hall, S. (2000). Conclusion: The multi-cultural question. In B. Hesse (Ed.), *Unsettled multiculturalisms: Diasporas, entanglements, transruptions* (pp. 209–241). London: Zed Books.

Hughes, D. M. (2010). Belonging awkwardly. In *Whiteness in Zimbabwe* (pp. 129–143). New York, NY: Palgrave Macmillan.

Landau, L. B. (2004). *The laws of (in) hospitality: Black Africans in South Africa.* Forced Migration Studies Programme, University of the Witwatersrand, South Africa.

Landau, L. B. (2012). *Exorcising the demons within: Xenophobia, violence and statecraft in contemporary South Africa.* Johannesburg: Wits University Press.

Leonard, P. (2010). Organizing Whiteness: Gender, nationality and subjectivity in postcolonial Hong Kong. *Gender, Work and Organization, 17*(3), 340–358.

Mamdani, M. (1997). *Citizen and subject: Decentralized despotism and the legacy of late colonialism.* Princeton, NJ: Princeton University Press.

Matsinhe, D. M. (2011). Africa's fear of itself: The ideology of makwerekwere in South Africa. *Third World Quarterly, 32*(2), 295–313. Retrieved from http://doi.org/10.1080/01436597.2011.560470

Matsinhe, D. M. (2016). *Apartheid vertigo.* London: Routledge.

McDonald, D. A., & Crush, J. S. (2000). Understanding skilled migration in Southern Africa. *Africa Insight, 30*(2), 3–9.

McDonald, D. A., & Crush, J. S. (2002). *Destinations unknown: Perspectives on the brain drain in Southern Africa.* Pretoria: Africa Institute of South Africa.

McIntosh, J. (2006). "Going Bush": Black Magic, White ambivalence and boundaries of belief in postcolonial Kenya. *Journal of Religion in Africa, 36*(3), 254–295. Retrieved from http://doi.org/10.1163/157006606778941922

McIntosh, J. (2014a). Linguistic atonement: Penitence and privilege in White Kenyan language ideologies. *Anthropological Quarterly, 87*(4), 1165–1199. Retrieved from http://doi.org/10.1353/anq.2014.0066

McIntosh, J. (2014b). *Structural oblivion and perspectivism: Land and belonging among contemporary white Kenyans.* African Dynamics in a Multipolar World, Centro de Estudos Internacionais do Instituto Universitário de Lisboa (ISCTE-IUL).

McIntosh, J. (2015). Autochthony and "family": The politics of kinship in White Kenyan bids to belong. *Anthropological Quarterly, 88*(2), 251–280. Retrieved from http://doi.org/10.1353/anq.2015.0020

Mignolo, W. (2007). Introduction. *Cultural Studies, 21*(2), 155–167. Retrieved from http://doi.org/10.1080/09502380601162498

Mignolo, W. D. (2010). Epistemic disobedience, independent thought and decolonial freedom. *Theory, Culture & Society, 26*(7–8), 159–181. Retrieved from http://doi.org/10.1177/0263276409349275

Mills, C. W. (1997). The racial contract. Ithaca, NY: Cornell University Press.

Oberoi, S. S., & Lin, V. (2006). Brain drain of doctors from southern Africa: Brain gain for Australia. *Australian Health Review, 30*(1), 25–33. Retrieved from http://doi.org/10.1071/AH060025

Padarath, A., Chamberlain, C., McCoy, D., Ntuli, A., Rowson, M., & Loewenson, R. (2003). *Health personnel in Southern Africa: Confronting maldistribution and brain drain.* Durban: Health Systems Trust.

Pande, S., & Drzewiecka, J. A. (2017). Racial incorporation through alignment with whiteness. *Journal of International and Intercultural Communication, 10*(2), 115–134. Retrieved from http://doi.org/10.1080/17513057.2016.1187761

Pieterse, J. N. (1995). *White on Black.* New Haven, CT: Yale University Press.

Pilossof, R. (2009). The unbearable whiteness of being: Land, race and belonging in the memoirs of White Zimbabweans. *South African Historical Journal, 61*(3), 621–638. Retrieved from http://doi.org/10.1080/02582470903189899

Proctor, R. N., & Schiebinger, L. (2008). *Agnotology: The making and unmaking of ignorance.* Stanford, CA: Stanford University Press.

Ranger, T. O. (1998). Europeans in Black Africa. *Journal of World History, 9*(2), 255–268. Retrieved from http://doi.org/10.1353/jwh.2005.0109

Schönfeldt-Aultman, S. M. (2009). A new trek, but the same old rhetoric: A review essay of Johann van Rooyen's the new great trek: The story of South Africa's White exodus. *African Identities, 7*(1), 113–125. Retrieved from http://doi.org/10.1080/14725840802583389

South African Institute of Race Relations. (2008). *South Africa survey 2008/2009: Employment and incomes.* Retrieved from http://www.sairr.org.za/research-and-publications/south-africa-survey-2008-2009

Steyn, M. (2003). *White talk: White South Africa and the strategic management of diasporic whiteness* (Unpublished PhD thesis). University of Cape Town, South Africa.

Steyn, M. (2005). White talk: White South Africans and the management of diasporic whiteness. In A. Lopez (Ed.), *Postcolonial whiteness: A critical reader on race and empire.* Albany, NY: SUNY Press.

Steyn, M. (2012). The ignorance contract: Recollections of apartheid childhoods and the construction of epistemologies of ignorance. *Identities, 19*(1), 8–25.

Steyn, M., & Foster, D. (2008). Repertoires for talking white: Resistant whiteness in post-apartheid South Africa. *Ethnic and Racial Studies, 31*(1), 25–51. Retrieved from http://doi.org/10.1080/01419870701538851

Van Hear, N. (1998). *New diasporas: The mass exodus, dispersal and regrouping of migrant communities.* London: UCL Press.

Van Rooyen, J. (2000). *The new great trek: The story of South Africa's white exodus.* Pretoria: Unisa Press.

Vorster, G. (2016, March 30). *This one graph shows that South Africans are leaving the country.* Retrieved October 13, 2016 from http://businesstech.co.za/news/general/118390/this-one-graph-shows-that-south-africans-are-leaving-the-country/

Wakefield, A. (2015, July 23). Over 95 000 whites have left SA since 2011. *News24.com*, Naspers.

Swiss Media and Migration

HEINZ BONFADELLI AND MUSTAFA IDELI, UNIVERSITY OF
ZÜRICH, ZÜRICH, SWITZERLAND AND ANDREA PIGA, PUBLIC
BROADCASTING SRF, ZÜRICH, SWITZERLAND

Switzerland is a small country with a population of 8.24 million (2014) in the center of Europe, but resisted becoming a member of the European Union. Its federalistic *political system* is special insofar as Swiss citizens have far-reaching direct democratic rights to initiate and vote for or against so-called *Popular Initiatives* focusing on single issues, if each has been signed by at least 100,000 citizens. Citizens also have the right to vote for or against *Compulsory or Optional Referendums*, concerning constitutional amendments or regular legislation. And these unique direct-democratic citizen rights are quite frequently used in Switzerland, not at least for tighter laws against "too much" immigration.

Similar to the other countries of Europe, migration flows and immigration into Switzerland intensified especially after World War II and parallel to the rapid economic growth of the country. After a first wave of Italian working immigrants— first called "guest workers"—in the early 1950s, later immigrants came from Spain and in the mid-1980s especially from Portugal and the ex-Yugoslavian countries. Most of these immigrants have been working as labor force in industry and in the building sector. In addition, after early political refugee waves from Hungary 1956, Tibet 1963, the Spring of Prague 1968, and 1973 from Chile, induced by the military coup against President Allende, many new refugees pleaded for political asylum in the 1980s and 1990s, especially from Turkey (Kurds), Lebanon, the ex-Yugoslavian countries (Kosovo), and Sri Lanka. The increasing number of asylum-seekers led to the first asylum law in 1981, and later more refugees from

African countries like Eritrea and recently from Syria triggered even more restrictive practices and explicit opposition by the conservative political parties, namely the Swiss Peoples Party (SVP). Today, 24.3% of the Swiss population are foreigners (2014), including about 300,000 asylum-seekers, and more than a third of the population belongs to an ethnic minority or has a direct immigrant background (Bonfadelli, 2009; Piguet, 2006).

After a first liberal practice of granting working permissions, the fear of alienation or "overforeignization" (in German: *Überfremdung*) and even xenophobia increased in the mid-1960s, and a first so-called *Überfremdungsinitiative* was initiated by a small nationalist party in the Kanton Zurich and withdrawn in Spring 1968, because the Swiss Federal Counsel promised more restrictive regulations. Only a year later, the conservative politician James Schwarzenbach submitted another popular initiative, demanding an upper limit of not more than 10% foreigners. But the proposed countermeasures by the government effectuated a narrow rejection by 54% of the voters. Then in 1973, the first petroleum shock hit the industry in Switzerland as well and many foreign workers were forced to leave Switzerland. Then a second immigration wave, beginning in the mid-1980s, together with the increasing asylum problem, triggered later another half dozen not realized or rejected popular initiatives against immigration (1974, 1977, 1984, 1987, 1988, 1996, and 2000), until in 2014 the so-called *popular initiative against mass immigration* by the conservative-rightist SVP was accepted narrowly by 50.3% of the Swiss voters. And until then, politicians and stakeholders from the industry and NGOs were controversially disputing about how to implement the initiative without endangering the economy and the relationships with the European Union. To conclude, the radical-right parties in Switzerland, primarily the SVP, have used the controversial issue of immigration, associated by deep-rooted anxieties, to appeal to Swiss voters and thus made it a dominant topic in the center of Swiss politics (Skenderovic, 2007).

Not the least because of its direct-democratic instruments like the popular initiative, *Swiss media* are especially important, as so-called "free" public channels, in the process of drawing attention to issues, agenda-setting, and framing controversial political issues like immigration or refugees. And consonant to the political system, the Swiss media system is special as well because of the small size of the country and its pronounced regionalization (Bonfadelli, 2008; Meier, 2004, 2016). It is characterized by the following main features: There are many mostly regionalized medium to small newspapers in the three different language parts. And still many newspapers are tied to political parties or have at least a more or less explicit political bias. In the German part of Switzerland, there are three dominant newspapers, each with unique features and reader groups: the elite newspaper *"Neue Zürcher Zeitung"* (NZZ) with a liberal-conservative and industry-friendly bias, the *"Tages-Anzeiger"* as leading broad sheet paper with an implicit political tendency

slightly to the left, and *"Blick,"* the only tabloid paper. The press is supplemented by a strong public broadcast in German, French, and Italian Switzerland, financed by license fees and advertising, but only on public television programs. In addition, there are medium to small regional and local private radio and television stations, mostly owned by the big publishing companies.

MIGRATION, MEDIA, AND INTEGRATION

The above outlined development of the migration situation in Switzerland and together with the corresponding political discussions in the media and public sphere stimulated *communication science* first in Germany in the mid-1980s and later in Switzerland as well to deal with the *issue of migration, media, and integration* (Geissler & Pöttker, 2009). As a starting point, an *early press analysis* studied how Swiss newspapers covered the asylum issue, initiated by the National Swiss UNESCO-Commission (Kradolfer, 1994). The results demonstrated that the Swiss press coverage could not be labeled as "xenophobic"; the content was diversified, although asylum-seekers were present as active actors mostly in sex-and-crime contributions. And the tabloid paper Blick mentioned violence in almost every second asylum article. Contrary to that, the asylum coverage in the elite paper *NZZ* was mostly written in a factual and distant style. This early content analysis was followed by a survey, realized by the Swiss Broadcasting Corporation (Anker, Ermutlu, & Steinmann, 1995), analyzing *ethnic minorities' media use in Switzerland* for the first time. And an own later study (Bonfadelli, 2009; Bonfadelli, Bucher, & Piga, 2007) was focusing on *media use by ethnic minority youth* in Switzerland, based on a combination of a quantitative survey comparing Swiss indigenous youth with adolescents from immigrant families and an ethnographic study based on qualitative in-depth interviews with members of Turkish/Kurdish families and their children. These studies refuted the claimed thesis often made by politicians that migrants would remain in a so-called "media ghetto," still using only media from their home country. Moreover, a later own content analysis for the Federal Office of Communication (OFCOM) analyzed how the issue of migration and ethnic minorities has been covered in the programs of the public and private radio and television programs in Switzerland (Bonfadelli, 2012; Bonfadelli, Bucher, Piga, & Signer, 2010). The background was that the Swiss radio and television law requires that broadcasting programs should fulfill integrative functions as well. One main result was the below European average (ter Wal, 2004) presence of the migration topic, with only about 6.5% in domestic political reporting, together with a strong focus on migration politics on the one hand and crime news with underlying negative stereotypes of migrants on the other hand.

The underlying theoretical assumption of both research types—content analyses and media use studies—is that modern mass media play a far-reaching and complex role in today's multicultural societies: "They may be of relevance to the *social integration of ethnic minorities* in that they are, for example, an important source of information about politics, culture, and everyday life in society" (Bonfadelli, 2009, p. 45) and thus provide everyday orientation and convey social norms and values for the immigrants about the new host society. But they can also *contribute to exclusion and segregation*, not at the least by stressing stereotypes in the form of negative images of ethnic minorities and immigrants.

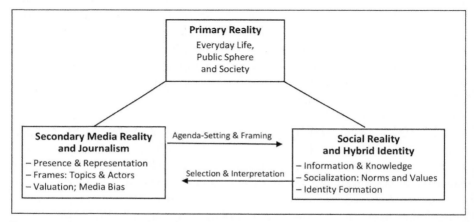

Figure 3.1: Media and Migration: Media Reality, Media Use, Media Effects. Adapted and Modified from Bonfadelli et al. (2010, p. 409).

Figure 3.1 visualizes the complex interrelationships between primary, secondary, and social reality. In their *primary reality*, immigrants and refugees interact in the everyday life of the new host society on the one hand with other immigrants but Swiss people as well and encounter direct experiences and interpersonal but media information about politics, economics, culture, and society as well on the other hand. The *secondary media reality* is produced by journalists and media in the guest country and guided by underlying rules like news values. Here, the main research questions deal with the amount and quality of the coverage of migration issues and migrants themselves: How much representation do they have? What are the central topics and actors? And how are they valuated by journalists and media? In a next step, there is the question of how this diverse media reality, produced and distributed by the indigenous Swiss media, but media from the countries of origin and ethnic media as well, is influencing Swiss media users, but immigrants and refugees as well by cycles of issue attention and processes of agenda-setting and framing? As a result, there are *media effects* on immigrants and refugees in the

form of information transmission, knowledge acquisition, socialization of norms and values, and last but not least also reinforcing prejudices and fostering discrimination by stories with a negative bias.

Whereas traditional *media-centric effects paradigms* like the agenda-setting approach analyze and explain the influence of media unidirectionally from the perspective of media messages only, other theoretical perspectives, e.g., based on the *cultural studies paradigm*, analyze the socialization and integration functions of media from the perspective of the migrant as active media user (Hall, 1980, 1993; Morley, 1993). Media use is seen as purposeful selection of content in different languages, both from media of the home and the new guest country. And the *reception process* is considered as active construction of meaning in the process of *formation hybrid identities*. Thus, cultural integration is not seen as passive *adaption* only to the norms and values of the host country, but is a complex process of active *integration* in today's pluralistic multicultural societies. There are processes of *bonding* with the home culture by using media from the home country, but as well processes of *bridging* between home and host country by using media from the guest country in the new acquired language (Peeters & d'Haenens, 2005). As a consequence, *social capital* in the form of mixed social networks of migrants and Swiss citizens, but as well *language skills*, e.g., of German language, play an important role in the complex process of integration into the new guest country. And the migration relevant content of the media from the host country, its main topics, actors, and dominant media frames can strengthen or hinder processes of cultural and social integration. The two following sections will illustrate and exemplifying this, based on two content analyses of the coverage of migration and migrants by Swiss newspapers and by radio and television programs of public and private broadcasting in Switzerland.

MIGRATION IN SWISS DAILY NEWSPAPERS

Following the introductory theoretical exposition, we will now discuss the general reporting on migration in Swiss print media. To this end, seven widely circulated Swiss daily newspapers from both the French and the German part of Switzerland will be analyzed, two of which are *supraregional* tabloid papers (Blick and Le Matin), three are large quality papers (Neue ZürcherZeitung NZZ, Tages Anzeiger TA, 24 Heures), one is a regional paper (Zürcher Oberländer ZHO), and one is a free newspaper (20 Minuten). The available database[1] includes 2216 contextually relevant national news articles in total. In the following, these articles will be subject to a quantitative content analysis. In the course of this analysis, a comparative perspective was applied with a focus on the two included language regions on the one hand and on the newspaper types on the other hand (see Table 3.1).

Table 3.1: Number of Articles with Migration Topics in Analyzed Newspapers.

Title of Newspaper	German (n = 1636; 73.8%)					French (n = 580; 26.2%)		Total
	Blick	20 Minuten	ZHO	NZZ	TA	24 Heures	Le Matin	
Relevant Contributions	294 13.3%	203 9.2%	320 14.4%	408 18.4%	411 18.5%	311 14.0%	269 12.1%	2216 100%
Average Article Length	298.3	128	318	430.1	411.2	484.1	423.8	372.1

As can be concluded from Table 3.1, the three quality papers 24 Heures, NZZ, and TA and in particular the two last-named German titles reported much more often on the topic of migration than the other four papers. The quality papers and particularly the two French titles are also dominating concerning the average length of article, regardless of the newspaper type (see Table 3.1). The average length of article across all papers is 372 words with a standard variance of 314 and a range from 15 to 5266 words. Additionally, in about every second article of national news the issue of migration occupies a central position, with the French papers as well as the quality papers clearly dominating in this aspect. In the Boulevard papers and the free paper, references to migration with a semicentral importance are predominant with approximately 50% and 40%, respectively. In the regional papers, again, the topic of migration appears mainly with a marginal importance of 44% of all migration-related articles.

The *event valence* in the relevant articles will be analyzed as a final formal aspect. We focus thereby on a valuation of the events underlying the migration-related articles. Do they have a negative connotation, e.g., like crime, argument, harm, etc., or are they associated with success, good performance, and benefits? According to the collected data, a majority of 52% of the relevant articles were based on events with neutral valence. The only exception is the free paper 20 Minuten where a negative-neutral valence is predominant in 36% of the migrant coverage. With 6.7% and 5.2%, respectively, the positive and negative valences both appear almost equally sparsely.

THEMATIC REFERENCE TO MIGRATION

An overview of all thematic references (main and secondary subject merged) can be found in Figure 3.2. In view of the first analyzed period (January to February 2014), it is no surprise that contributions about the popular political initiative

"Gegen Masseneinwanderung" articles dealing with the initiative focused on events with neutral valence, harm etc. or categories which seem strongly related to the mentioned initiative: immigration policy/law and free movement of persons (19%) and figures and statistics on migration/immigration (16%). The domination of these three categories can be attributed to cyclical factors, particularly to the debate around the initiative "Gegen Masseneinwanderung" in 2014 and its implications on the one hand and to the growing number of refugees on the other hand.

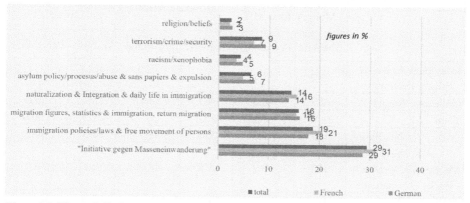

Figure 3.2: Thematic References in Articles by Language Region.

On the following fourth place, the topics *naturalization, integration, and daily life in immigration* can be found with 14%. Subjects with a negative connotation such as *terrorism/crime/criminality/security* and *racism/xenophobia* are situated at the bottom of the scale with 9 and 4 percentage points, respectively. However, it is remarkable that these last mentioned rarely occurring topic categories are slightly more common in the German newspapers than in the French ones. This slight disequilibrium can be traced back mainly to the free and tabloid papers, which is particularly true for the category *terrorism/crime/criminality/security*. Besides, it can be stated that there is a slight domination of the French papers concerning the topics *administration and daily life, immigration policy and free movement of persons*, and *naturalization and integration* compared to the German ones.

Appearance of Main and Secondary Actors

In total, 2329 actors[2] could be detected in the 2216 analyzed articles, two thirds of which were main actors (MAs) and one-third secondary actors (SAs). A further differentiation reveals that 53% of the MA are accounted for by individual

actors and 47% by collective actors (see Table 3.2). An inverse ratio can be stated for the SA with 45% and 55%, respectively. Additionally, data about either the presence or the absence of an immigration background could be recorded for 1721 actors, including 1089 MA and 632 SA. These data show that approximately every second of these actors has an immigration background. The proportion of actors clearly identified as Swiss is of about the same size.

Table 3.2: Appearance of Actors.

		Main Actors, MA		Secondary Actors, SA		Total	
		Absolute	Percentage	Absolute	Percentage	Absolute	Percentage
Individual Actors as Private Persons		789	53.4	384	45.1	1173	49.9
Collective Actors		689	46.6	467	54.9	1156	50.0
Total		1478		851		2329	100.0
Migration Back-ground	No, Swiss	537	49.3	323	51.1	860	49.9
	Yes, explicitly named	552	50.7	309	48.9	861	50.0
	Total	1089		632		1721	100.0
	Not Iden-tifiable	351		300			

Another further differentiation of the data shows that the majority actors with an immigration background are individual (70%) and only a minority collective actors (30%). Concerning the actors identified as Swiss, an almost inverted ratio can be seen with 38% and 62%, respectively. In this aspect, a comparison of language regions does not reveal any relevant differences. The prevalence of collective actors identified as Swiss can, however, be traced back mostly to the tabloid and quality papers, whereas the tabloid and free papers are mainly responsible for the domination of individual actors with an immigration background. The *assignment to a religion* was possible for 104 (12% of 861) actors with a migration background in total, with Islam as the most frequently mentioned religion. In contrast to their religious confession, the explicit ethnic or national origins had been mentioned for a majority (80% of 861) of the actors with an immigration background. Here, a comparison between language regions shows that German newspapers have a stronger tendency to name the actors' origin than the French ones (86% to 60%).

Besides, a further differentiation according to the communication status reveals that half of the Actors identified as Swiss appear as *statement subjects* (actively communicating, talking) in the analyzed articles and the other half as *statement objects* (almost no chance to speak/only talked about); see Table 3.3. The picture changes when looking at the actors with a migration background: Only a quarter of them are *statement subjects*, whereas a majority of three quarters figure as *statement objects*. A comparison between the language regions shows that in German newspapers, with a percentage of 48%, the communication status *statement subject* is linked twice as often to Swiss actors as to actors with a migration background (23%). This difference is less stark in the French papers with 50.4% for Swiss actors and 33.9% for actors with a migration background.

Table 3.3: Communication Status of Main and Secondary Actors by Language Region.

	Language Region											
	Total *(German and French)*				German				French			
Migration Back-ground	No, Swiss		Yes, explicitly named		No, Swiss		Yes, explicitly named		No, Swiss		Yes, explicitly named	
	n	%	n	%	n	%	n	%	n	%	n	%
Statement Subject	419	49.2	218	25.4	238	48.3	156	23.1	181	50.4	62	*33.9*
Statement Object	417	48.9	627	73.1	243	49.3	507	75.1	174	48.5	120	*65.6*
Statement Addressee	16	1.9	13	1.5	12	2.4	12	1.8	4	1.1	1	*0.5*
Total	852		858		493		675		359		183	

Overall Assessment of the Articles

In addition, an analysis mainly based on the subjective assessments of the coders had been conducted, which focused on three aspects or variables: Firstly, the *subjective assessment of the actors* in the analyzed articles; secondly, the identification of possible valuing perspectives (e.g., whether migrants are seen as a cultural gain or rather as a threat); and thirdly the overall evaluation of each article.

In regard to the question if and to what extent a valuation of the actors with a migration background takes place in the analyzed media, it can be stated that the four categories *not evident, mainly positive, mainly negative,* and *balanced* are almost equally likely to occur, with only a slight predomination of *mainly negative* (28%). Looked at separately, it strikes that the *mainly negative valuation*

dominates in the German (30%) compared to the French newspapers (19%). Then again, the *balanced valuation* occurs more often in the German (24%) than in the French ones (17%).

Furthermore, at least one *valuing perspective* could be identified in totally 686 articles (31% of 2216) with a migration reference. While the comparative value in the German newspapers is 32%, it is slightly higher in the French ones, with 28% of the articles containing at least one valuing perspective. Then again, the categories with a positive connotation are around 10% stronger in the French than in the German papers. No relevant differences concerning this aspect could however be detected between quality and tabloid papers: About every second article with a valuing perspective in both tabloid and quality papers is of a positive nature, whereas 8% are attributed a neutral and 42% a negative connotation. The picture changes when looking at the regional and the free papers, where two thirds of the *valuing perspectives* are rather negatively connoted.

Finally, almost half of the articles containing a migration reference and being subject to an overall assessment (n = 1908) were rated as *balanced*, 18% as *(rather) positive*, and the remaining 32% as *(rather) negative* (Figure 3.3). By comparison with the German papers, *(rather) positive assessments* are clearly more common in the French ones (25% to 18%), whereas there is no considerable difference concerning the category *balanced*. This is also true for the comparison between different newspaper types, with the exception of the free paper, where *rather positive valuations* surpass the *(rather) negative* ones.

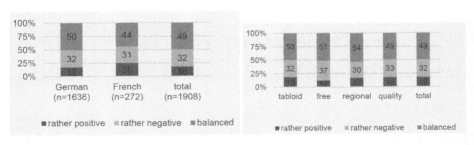

Figure 3.3: Overall Assessment of Articles by Newspaper Language and Newspaper Genre.

Summary

In the present study, the coverage of the subject of migration and/or integration has been analyzed in seven daily newspapers. It must be mentioned that the choice of the periods of data analyzed was heavily influenced by a key event, namely the popular initiative "*Gegen Masseneinwanderung.*"

Summarizing the main results of the study, it can firstly be stated that the three quality papers reported more frequently and also with longer articles on the topic of migration. This is particularly true for the time right before the vote on the said initiative. Concerning the average length, however, the articles in both French titles are dominating, regardless of the paper type. With regard to the valuation of the events underlying the news coverage, it can be stated that in both language regions *neutral events* surpass every other category by far. Then again, both French papers show a greater tendency to report on the basis of positive events than the German ones.

It seems that the choice of the said key event and thereby of the survey period resulted in a domination of the topic areas *policy/economy/law, migration/ integration* and *migration statistics* in the newspapers of both language regions. Negative connoted topics such as asylum procedures/asylum abuse, crime and xenophobia, in comparison, occur much more rarely. Looking at possible differences between the language regions, it seems that the German papers are slightly predominating concerning the former thematic group, whereas the same can be said about the German titles with regard to the latter, negatively connoted topics.

Concerning the form and chances of appearance of actors with migration background in the newspaper reporting, the data indicate at first glance a balanced presence of actors with and without migration background. At closer examination, however, certain differences arise across language regions: Actors with migration background, for instance, appear mostly as individual actors and just rarely as collective actors. Then again, an inverse ratio is present in actors identified as Swiss, not least because they often appear as representatives of authority or of an institution. In contrast, actors with a migration background are mostly present as ordinary habitants. Further differences can be found concerning the actors' articulation possibilities. Thus, around three quarters of the actors with migration background appear as *statement objects* and only the remaining quarter as *statement subjects*, with the difference once again being less striking in French papers. In actors without migration background, however, both categories are equally strong. Furthermore, the precise ethnical and/or national origins are assigned to a majority of the actors with migration background, whereas references of this sort are much more common in German than in French papers.

It can be summarized then that the above-mentioned results are also reflected in the overall assessment of the articles with migration reference. Thus, the reporting on migration is generally much more positive in French compared to German papers and in quality compared to tabloid papers.

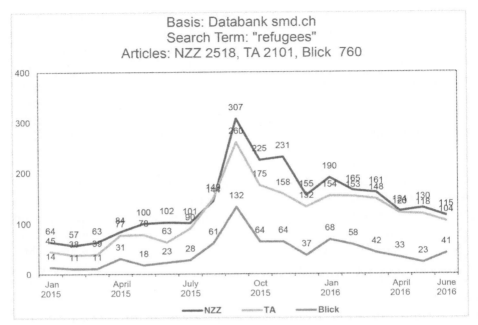

Figure 3.4: Media Resonance Toward the Issue of Refugees from Syrian War.
Note: Analysis Based on Swiss Media Databank (SMD) by Search Term "Refugees."

Interestingly, *media attention* not only in Switzerland shifted in the year 2015 from migration issues to the *topic of refugees,* trying to get away from the war in Syria and hoping to find asylum in Europe, especially in Germany. This represents a *shift in the issue attention cycle* (Figure 3.4). After more or less low media attention to the refugee topic in spring 2015, an increase in coverage started in July with a peak in coverage reached in September 2015. The widely diffused picture of the drowned three-year-old boy Aylan in the international media in early September symbolizes this. But the discussion of the so-called German "welcome culture" toward the Syrian refugees in the Swiss media as well shifted since the beginning of 2016 more and more to a discussion of the refugee problem for Europe and the construction of an immigration and refugee system in crisis, symbolized with media pictures of the building of fences at the southern border of European states like Hungary.

MIGRANTS IN SWISS BROADCASTING PROGRAMS

As mass media bear the potential to set agendas and influence users' opinions about certain predefined topics and people, the importance of the representation of migrants in the mass media cannot be underestimated. In 2007, the OFCOM

funded various studies on the integrative function of public and private broad-casters in Switzerland. As part of that, a content analysis of several national and local TV and Radio news programs was carried out by a research team at the Institute of Mass Communication and Media Research (IPMZ) at the University of Zurich (Bonfadelli, 2012; Bonfadelli et al., 2010; Piga & Bucher, 2008). In order to explore trends of migrants' representation in its news programs, the Swiss Public Broadcaster Schweizer Radio und Fernsehen (SRF) decided in 2015 to commission a replication of the 2007 OFCOM content analysis.

The underlying research questions of the potential of integration by media coverage were formulated and operationalized in relation to four different dimensions:

1) Presence: Is the topic of migration present in the news programs? Are migrants part of the news coverage?
2) Context: In what thematic context are migrants and migration covered in the news?
3) Bias: Is the topic of migration and are migrants as protagonists positively/negatively biased?
4) Roles: If migrants are protagonists, how are they described? What role do they play in the news coverage and do they get a chance to speak out?

The new SRF study primarily concentrates on differences between public service news coverage in 2007 and 2015 by analyzing the following national news programs (Table 3.4):

Table 3.4: Analyzed News Programs of Swiss Radio and Television SRF.

Radio		TV	
Kurznachrichten (5 pm)	Rendez-vous (12.30 am)	Tagesschau (7.30 pm)	10vor10 (9.50 pm)
HeuteMorgen (8 pm)	Echo der Zeit (6 pm)	Schweiz aktuell (7 pm)	

A standardized quantitative content analysis was carried out during a three months' period by a research team at IPMZ from March 15 until June 15, 2015. Only national news items were included.

Presence

As Table 3.5 shows, out of a total of nearly 3200 national news items that were analyzed in 2015, 286 items (i.e., 9% of the total) covered migration topics or included migrants as protagonists. This percentage was a bit higher in the SRF radio programs than in the TV programs.

The programs with the highest shares of migration coverage (11.8%) are HeuteMorgen and Tagesschau (9.7%). Compared to the findings of the OFCOM study, migration currently seems to play a little more prominent role in the news than it did in 2007 (overall share of 7% of total news coverage). The percentage of news items including a migration topic have increased by 30% within the TV programs and by 22% within the radio programs that have been analyzed.

Table 3.5: Coverage of Migration in National News of Swiss Radio and Television.

Programs	Total of National News Items	National News Items on Migration and/or Including Migrants	Coverage of Migration
Radio	1709	161	9.4%
TV	1479	125	8.5%
Total	3188	286	9.0%

Context

Looking into the thematic context of news items on migration, the 2015 findings (Figure 3.5) suggest that migration is covered mainly from a political perspective. Over 50% of the migration news items deal with politics or integration. Other main topics that apply to over 10% of the analyzed items are Sports (12%) and Law/Security (10%).

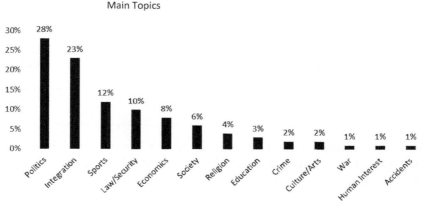

Figure 3.5: Context of Migration Coverage.

Because the list of topics in 2015 slightly differs from the one used in the 2007 study, the results concerning context of migration coverage cannot be fully compared. Still, the findings of the 2007 OFCOM content analysis suggested that migrants were framed as social problems and migration was covered mainly within

negative contexts. Topics like crime, war, security, etc., prevailed and accounted for a total of 33% of the topics covered. Within the last years, the occurrences of thematic negativity have significantly decreased: adding up all the frequencies of topics with negative implications (security, crime, war, accidents), a total share of only 14% was reached in 2015.

Bias

According to the 2015 SRF study, two out of three analyzed news items on migrants or migration are bias-free; in one third of the items a bias of any kind (negative, positive, or neutral) can be detected. Examples of negatively biased items include news framing migrants as troublemakers, as a financial burden, as cultural threat, or as rivals on the job market. Migrants contributing to cultural enrichment, being highly qualified workforces and contributing to a healthy economy, are examples of positively biased coverage. A neutral bias is explicitly balanced, in that it includes negative as well as positive points.

As shown in the Figure 3.6, 50% of the biased news items in 2015 include negative associations, 42% are positively biased. Compared with the results of the 2007 OFCOM study, negativity has decreased, while positive associations have increased by 8 percentage points each.

In 2015, bias was not only analyzed on the level of a whole news item, but also on the level of single characters or persons identified within the news items. When it comes to descriptions of the protagonists, three sets of criteria have been determined: sex, age, and types of personal attributes occurring (hobbies/interests, character traits, appearance, personal skills/expertise, and personal/family ties). Furthermore, any describing adjectives, phrases, or metaphors have been listed.

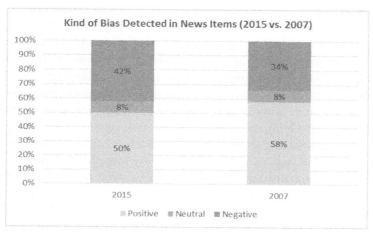

Figure 3.6: Bias in Migration Coverage.

According to the findings of the SRF study, male migrants are highly overrepresented in the news coverage, whereas the distribution between the sexes is balanced for protagonists of Swiss origin. While those Swiss protagonists are primarily between 41 and 65 years old, the majority of the protagonists with migration background are much younger, i.e., in their teenage years or below 40 years. Also the findings on the describing attributes reveal differences between Swiss and migrant protagonists: people of Swiss origin are more frequently described with regard to their personals skills and interests than people with a migrant background. On the other hand, information on their personal situation, family ties, and character traits is given more frequently when it comes to protagonists of migrant origin. The list of describing adjectives or phrases with negative/positive implications is rather short but includes a few more listings for migrants than Swiss characters. Overall, there are as many negative as positive phrases for migrants, including adjectives like ambitious, lazy, friendly, criminal, and competent.

Roles

Whenever news protagonists could clearly be identified as Swiss in the 2015 SRF study (35% of all characters), they primarily appear as collective players of higher influence with specific roles in society like politicians, representatives of public authorities or associations. Migrants (33% of all protagonists in 2015) mostly appear in their role as individual persons of rather low influence. They represent either the average citizen or a known sportsperson. In 2007, the situation was similar in that Swiss were representing officials or interest groups whereas migrants were representing individuals. The percentage was about 30% for both Swiss and migrant actors, whereas the origin of 40% of the characters could not be identified.

In 2015, the national origin of nearly 90% of the migrants covered is specified. Information on their religion is given for 8% of all protagonists, the vast majority of which are migrants. These numbers have remained stable compared with the findings of 2007. The nationalities of the news protagonists reflect migration movements and statistics in the respective years. While people from the Middle East, Syria, and Eritrea dominated the news in 2015, migrants from North Africa, Eastern Europe and Germany were among the most reported on in 2007.

In connection with the above-described roles that migrants play in the news, their influence is low, and so is their chance to say something or comment on an issue; 61% of the migrants have no possibility to express themselves in the news programs, i.e., they are not subject of a discussion but are being spoken about. On the other hand, 66% of the Swiss protagonists are given the possibility to comment. In 2007, this situation was even worse: 74% of the migrants in news coverage on migration had no chance to speak out.

Summary

The study of migration and/or migrants as a topic in Swiss newspapers was complemented by two further standardized content analyses of the same topic, but covered by the radio and television programs of the Swiss Broadcasting Corporation in the German part of Switzerland in 2007 and 2015. Although the focus on coverage of migration and/or migrants in the national news was similar in all three studies and the coding instruments partly the same, there are differences in the time points studied. In contrast to the press, the topic of migration obviously has a lower importance in radio and television news. This can be explained by structural differences, insofar radio and television news have significantly less contributions and thus are more focused on really important events, especially on the national and international level.

However, there are similarities as well. In both media, the newspapers and the broadcast news, migration as a topic is covered mostly in a political context and the migration topic is covered with a positive and with a negative bias. Surprisingly, there are much *more positively framed stories in the broadcasting news* with about 50% in 2015, whereas positive stories are rather seldom in the press with only 18%; therefore, a negative framing of the migration topic dominates almost every second press article.

In addition, *actors with Swiss background* mostly appear as collective players in the broadcast news, whereas *migrants mostly appear in the role of individual persons* with rather low influence. Whereas every second identified actor in the migration coverage of the press has a migrant background, only about a third of the actors mentioned in the broadcasting news have migrant background. In addition, 61% of the *migrants have no chances to express themselves* in the broadcasting news; on the other hand, two thirds of the Swiss actors have been shown in a communicative role. A similar gap between Swiss and migrant actors was found in the press: Only 25% of the migrant actors had been identified as subjects of cited statements in comparison to 49% of the Swiss actors.

These main results about media coverage or migration and refugees in the Swiss media are mostly consonant, e.g., with content analyses carried out in Germany (Geissler & Pöttker, 2009; Krüger & Simon, 2005). Interestingly, a new comparative press analysis of the coverage of the refugees and migrant crisis in Europe in 2014 and early 2015, carried out by the Cardiff School of Journalism, Media and Cultural Studies (Berry, Garcia-Blanco, & Moore, 2015), found similarities but as well marked differences between the five countries studied, namely, UK, Germany, Spain, Italy, and Sweden. Humanitarian themes, e.g., were mostly mentioned in the Italian press, focusing directly on the events in the Mediterranean, which can be explained by geographical proximity as a news factor. This is in accordance as well with the use of labels: In the UK the term "migrant" (54.2%) was more prevalent than in the Italian press (35.8%). And the prevalence of negative refugee frames was highest in

the British press, e.g., linking refugees and migrants to crime, and much lower in the press of Germany and Italy or Spain. Besides these variations in coverage between the countries studied, there are significant differences in the level of variation within the national press systems. As an example, the press coverage in the UK was far the most polarized, but in Germany as well, coverage of migration and refugees differed between "Die Welt" and "Süddeutsche Zeitung" according to its respective conservative or more liberal editorial orientation. Overall, there were few cases where reporting focused on the benefits that asylum-seekers and migrants could bring to the new host countries (Berry et al., 2015, p. 12).

CONCLUSIONS AND SUGGESTIONS FOR JOURNALISM

Let's conclude with some recommendations with the goal to get a better treatment of migrants and migration as a media topic on three levels, namely the media system, journalists, and media reality.

Media System

1. There should be more *specific program formats* especially in public broadcasting to intensify intercultural communication between majority Swiss population and minorities.
2. Media policy, e.g., by the OFCOM should encourage and subsidize *complementary or alternative community or ethno media* and more professional education for (amateur) journalists working there as it is done today.
3. Then, there should be stimulated more *active dialogue* between ethnic, religious, and cultural groups on the one hand and Swiss media and journalists on the other hand to enhance sensibility for migration issues, e.g., based on institutionalized "round tables" or "program committees."
4. And last but not least, more *media governance* as obligation to create self-determined explicit standards, quality cycles, and monitoring mechanisms in relation to minority issues should be enforced, and regular public reporting in the sense of stimulating best practices should be required.

Journalists

1. The diversity of professionals working in media should be enhanced. There should be more journalists with migration background or minority journalists in Swiss media to enhance today's low share of only 5% journalists with migration background. There is a need to discuss *explicit quotas*.

2. *The intercultural competence and sensibility* of Swiss journalists for migration issues needs enhancement as well, e.g., based on special modules in professional journalism education.

3. More *active investigations* by journalists at places in community and with involved migrants should be a goal as well.

4. Portrayals of minorities should be more accurate, fair, and nonstereotypical. To sum up: Interviewed (media) experts believe that sensibility toward migration as important social issue has increased in the last years in Switzerland, but still more has to be done, e.g., more migrants in live shows.

Media Reality or Coverage of Migrants and Migration

1. There should *be less marginalization and more presence* of both migration as a media topic and more migrants in media stories; e.g., ter Wal (2004) documented a coverage level of 11% in EU.

2. There should be *more diversity* in relation to contents and actors of migration coverage, especially more everyday world stories are needed.

3. It should be a goal as well to enforce stories that *focus on positive examples and successful problem solving* in opposition to the prevailing "crime & conflict" reporting and negativity stories.

4. In addition, *avoiding stereotypes and discrimination* is needed like an enhanced sensibility by journalists toward the use of discriminatory stereotypes and metaphors ("immigrant wave") and negative assessments.

5. *More perspectives from the inside* based on more direct minority voices, not only expert views from the outside, should be enhanced.

6. Migrants in Switzerland need *more service functions* delivered by the media with direct value to solve everyday problems.

7. And finally, more *migrant actors in entertainment formats* should be integrated as well.

To conclude, Swiss citizens have to become more knowledgeable and more sensitive toward the social, religious, and cultural diversity of the multicultural society they are living in. The dominant Swiss media do not only need more efforts, but new efforts in the form of civic education should be introduced in school as well. Then there is a general *need to communicate more actively* the valuable contributions realized by migrants for the Swiss society. But certainly, *immigrants* have obligations to integrate into the Swiss society as well, namely to respect norms, values, customs, and the existing legal obligations of their new (guest) society they are living in, and acquiring the majority language as a means of integration and participation. This could be stimulated by more mutual contact and communication between the different segments of society, not at least by the media, to prevent

the development of segregation in the form of closed cultures within our diverse society.

NOTES

1. The data from the above-mentioned daily newspapers were collected ex post over two publication periods from January 20 to 28, 2014 and from February 1 to 22, 2015 by students as a basis for their bachelor theses in the course of two research seminars conducted in parallel on the topic of "The Media and Societal Subgroups" at the Institute of Mass Communication and Media Research of the University of Zurich.
2. Actors appeared as either individuals (individual actors) or collectives (such as groups, institutions, authorities, and associations). Representatives of a collective (ethnic and/or religious groups, groups in the context of migration such as foreigners and refugees, governments, authorities, and associations) were coded as collective actors.

REFERENCES

Anker, H., Ermutlu, M., & Steinmann, M. (1995). *Die Mediennutzung der Ausländerinnen in der Schweiz: Ergebnisse einer schriftlichen Umfrage in der ganzen Schweiz vom März/April 1995*. Bern: SRG Forschungsdienst.

Berry, M., Garcia-Blanco, I., Moore, K. (2015). *Press coverage of the refugee and migrant crisis in the EU: A content analysis of five European countries*. Report prepared for the United Nations High Commission for Refugees. Cardiff: Cardiff School of Journalism, Media and Cultural Studies.

Bonfadelli, H. (2008). Switzerland: Media system. In W. Donsbach (Ed.), *The international Encyclopedia of communication* (pp. 4920–4921). Malden, MA: Blackwell.

Bonfadelli, H. (2009). Media use by ethnic minority youth in Switzerland. In R. Geissler & H. Pöttker (Eds.), *Media, migration and integration: European and North American perspectives* (pp. 45–69). Bielefeld: Transcript.

Bonfadelli, H. (2012). Die Darstellung von Migranten in den Radio- und Fernsehprogrammen der Schweiz. In B. Engler (Ed.), *Wir und die Anderen: Stereotypen in der Schweiz. Nous et les autres. Stéréotypes en Suisse* (pp. 97–115). Fribourg: Academic Press.

Bonfadelli, H., Bucher, P., & Piga, A. (2007). Use of old and new media by ethnic minority youth in Europe with a special emphasis on Switzerland. *Communications, 32*, 141–170.

Bonfadelli, H., Bucher, P., Piga, A., & Signer, S. (2010). Rundfunk, migration und integration: Schweizerische Befunde zur Integrationsleistung des öffentlichen und privaten Rundfunks. *Medien & Kommunikationswissenschaft, 58*(3), 406–423.

Geissler, R., & Pöttker, H. (Eds.). (2009). *Media, migration and integration: European and North American perspectives*. Bielefeld: Transcript.

Hall, S. (1980). Encoding and decoding in television discourse. In S. Hall, D. Hobson, A. Lowe, & P. Willi (Eds.), *Culture, media, language* (pp. 128–138). London: Hutchinson.

Hall, S. (1993). Culture, community, nation. *Cultural Studies, 7*(3), 349–363.

Kradolfer, A. R. (1994). "*… darunter zwei Asylbewerber.*" *Eine quantitative Inhaltsanalyse von Schweizer Tageszeitungen zur Asylthematik*. Bern: Nationale Schweizerische UNESCO-Kommission.

Krüger, U. M., & Simon, E. (2005). Das Bild der Migranten im WDR Fernsehen. Ergebnisse einer empirischen Programmanalyse. *Media Perspektiven, Heft 3*, 105–114.

Meier, W. A. (2004). Switzerland. In M. Kelly, G. Mazzoleni, & D. McQuail (Eds.), *The media in Europe: The Euromedia research group* (pp. 249–261). London: Sage.

Meier, W. A. (2016). *Switzerland*. Retrieved from http://ejc.net/media_landscapes/switzerland

Morley, D. (1993). Active audience theory: pendulums and Pitfalls. *Journal of Communication, 43*(4), 13–19.

Peeters, A. L., & d'Haenens, L. (2005). Bridging or bonding? Relationships between integration and media use among ethnic minorities in the Netherlands. *Communications, 30*(5), 201–231.

Piga, A., & Bucher, P. (2008). Der öffentlich-rechtliche und private Rundfunk: Programmanalysen und Perspektiven der Medienschaffenden. In H. Bonfadelli, P. Bucher, A. Piga, & S. Singer (Eds.), *Migration, medien und integration der integrationsbeitrag des öffentlich-rechtlichen, kommerziellen und komplementären Rundfunks in der Schweiz* (pp. 30–66). Zürich: IPMZ.

Piguet, E. (2006). *Einwanderungsland Schweiz: Fünf Jahrzehnte halbgeöffnete Grenzen*. Bern, Stuttgart, Wien: Haupt.

Skenderovic, D. (2007). Immigration and the radical right in Switzerland: Ideology, discourse and opportunities. *Patterns of Prejudice, 41*(2), 155–175.

ter Wal, J. (2004). *European day of media monitoring: Quantitative analysis of Daily Press and TV content in 15 EU member states*. Utrecht: European Research Centre on Migration and Ethnic Relations.

Situated Cultural Practices

Situated Cultural Practices

Meanings of Health among Transgender Sex Workers in Singapore: A Culture-Centered Approach

MOHAN J. DUTTA, DYAH PITALOKA, AND DAZZELYN ZAPATA,
NATIONAL UNIVERSITY OF SINGAPORE, SINGAPORE

If you cannot accept me then I will leave the house right now. I say if nobody will accept me, I am gonna leave the house. This is what I am. I'm going to be like this. And I'm going to be a woman one day. Whatever you gonna try it's not gonna work. This is what I am. This is the reality that I want to become woman, Okay? Stop beating me or I'll call the police.

> Catrine, 40
> Male-to-female at 26
> Sex worker since age 16

Catrine's narrative of negotiating familial structures as she searches and enacts her agency as a transgender individual depicts the interplay of power and control in defining the ambits of sexuality in the Asian context, and particularly so in the context of Singapore, which remains one of the few Asian countries yet to decriminalize homosexuality. Catrine describes these interpersonal negotiations as meanings of health and well-being. Especially salient in the negotiations of lived experiences among transgender sex workers is the interplay of the global and the local, and the continual reworking of the local constituted in the ambits of health. Salient in Catrine's narrative depicted above, the negotiations of

transgender identity are situated amid norms of filial piety and familial respect. Moreover, the experiences of transgender sex workers are situated amid the state's pragmatic neoliberal ideology that at once locates health in the realm of the individual and simultaneously caters to pragmatist vision of the state that seeks to speak to a large electoral base considered to be conservative (Yue, 2006). Experiences of health thus are often understood as the everyday experiences of negotiating stigma.

Catrine negotiates the stigma of being a transgender individual in the ambits of the familial structures and amid familial expectations, situated amid economic constraints and societal pressures of normatively fitting in. In a heteronormative society defined by colonially constituted gender norms, transgender individuals struggle with their identity of being born in the "wrong" body, and situate these struggles amid the broader societal structures, cultural tropes, and the limitations that are invisibly placed on discursive and material possibilities. The economic risks experienced by transgender community members translate into the health risks they experience and negotiate on a daily basis, with transgender individuals often having to perform sex work as a way for securing a living.

Moreover, the persistent desire to change to the correct body fuels the many changes their bodies go through, the health choices they make, and the risks that are structurally and culturally constituted in relationship to these choices: from hormone therapy which usually starts their transition, to the penultimate shift that is sex reassignment surgery (SRS), sex workers negotiate a wide array of procedures that also come with risks and necessities of care. These procedures are expensive and not easily accessible in Singapore, further exacerbating the economic burdens that constitute the context of lived experiences for transgender individuals. As transgender sex workers seek out health resources for SRS in cheaper places such as Thailand, they negotiate sex work as a way for supporting the surgery. For most of the participants we conversed with, sex work has been the means for them to shift to the desired body, as a vital economic resource for purchasing access to the surgery. How then are meanings of health and health seeking negotiated by transgender sex workers in Singapore? This essay draws on the conceptual framework of the culture-centered approach (CCA) to situate the meanings of sex work, health, and being transgender amid the interplays of structure and culture (Dutta, 2008). The CCA foregrounds the voices of communities at the margins as entry points for articulating a politics of change, situating the everyday meanings of health structurally. The narratives of the transgender sex workers who participate in our culture-centered project interrogate the interplay between culture and structure, depicting the agentic decisions that transgender sex workers make when negotiating health and well-being.

TRANSGENDER BODY AND SEXUALITY

The term "transgender" has been used as an umbrella term, capturing people who do not conform to a binary male–female gender category (Stotzer, 2009). In this study, we will use the term "transgender women" or "male-to-female transgender women" to describe individuals who were born biologically male but self-identify as women and desire to live as women (Israel & Tarver, 1997; Nemoto, Bodeker, & Iwamoto, 2011). The term "trans" represents a binary transgression between two opposite extremes from one to another, and altogether highlights the clash of conventional notions of sex and gender. As such, "transgendered people include anyone who identifies, whether temporarily or permanently, as other than the gender they were assigned at birth; and people who thought they identify as their assigned gender, are mistaken for members of the 'opposite' sex" (Findlay, 1999, p. 1).

In everyday life, the use of transgender terminology may indicate various groups of transsexual people (preoperative, postoperative, and nonoperative), transvestites of varying degrees of fetish, cross-dresser, gender-bender, gender queer, drag kings and queens, major and minor transgressions of gender as it is specifically and culturally recognized, emerging cross-gendered behaviors and subcultures, and more, depending on how tightly or loosely different groups of stakeholders, transgender or not, would want to police its definition (Chi Sam, 2010).

Compared to the Western concept of gender and sexuality, the Southeast Asian concept of gender and sexuality is less rigid and closely associated with gender and sexual pluralism (Davies, 2010; Earth, 2006; Peletz, 2009; Yue, 2012). In the East Indies society, for example, Benedict Anderson in his analysis of an ancient epic prose volume *Centhini* highlights the banality of homosexuality and its normalcy in Javanese sexual culture (Anderson, 1998). However, few countries, including Singapore, still see social pluralism as threatening and have yet to decriminalize homosexuality (Lenzi, 2015). To date, the debate regarding the identification of who might be considered "queer," like for example male-to-female and female-to-male, and people who occupy normative gender and sexual identity categories but whose erotic desires and sexual attachments and sentiments misalign within their putative location in normative heterosexuality (e.g., presumed heterosexual women whose partners are both "ordinary" men and masculine-identified *tombois*) (Blackwood, 2010; Blackwood & Johnson, 2012; Jackson & Sullivan, 1999; Lai, 2007; Sultana & Kalyani, 2012) still dominates the literature. Nevertheless, articulations of transgender bodies in non-Western cultures have consistently been subsumed under the Euro-American transgender theory; consequently Euro-American theory colonizes and degrades the category of transgender that thus emerges, treating transgender individuals as sites of intervention (Jackson, 2011; Roen, 2006; Winter, 2002).

Bodies for the transgender are rendered deviant, abject, abnormal, or wrong, but at the same time, for the transgender community, their bodies act as the bearers of transformative ways of knowing and being. Scholarly works argue that body itself is a site of knowledge, pleasure, resistance, and opposition to normalizing power (Foucault, 1975; Heyes, 2007; Pitaloka & Hsieh, 2015). In *Discipline and Punish*, Foucault (1975) argues that bodies as sites of power do not exist as naturally given phenomena. Institutions such as armies, schools, and hospitals begin to see bodies as something that can be transformed, improved, used, and subjected, not simply punished or prohibited by sovereign power. Imagining of queerness and disability as embodied forms of deviance has been central to the oppression and marginalization of a wide range of people. Claims of disability have long been attached to queer sexualities in biomedical understanding of homosexuality and gender non-conformity as forms of mental illness and embodied perversion (Clare, 2001). Disability and sexual deviance are attached in some way to almost all forms of biomedically constituted marginalization.

In Foucault's (1978) term of disciplinary power, the word power contains "a whole set of instruments, techniques, procedures, levels of application, targets; it is a 'physic' or an 'anatomy' of power, a technology" (p. 215). Disciplinary power does not operate in a monolithic, top-down manner, but moves between anatomy and politics, between bodies and institutions in a variety of ways. These elements catch us up in the self-administration of normative ideals of bodies and identities (Draz, 2014) and form social beliefs about who we "really" are and how our bodies "really" work. Gendered restrooms, for example, are a manifestation of the social enforcement of the binary gender system.

In the Western discourse, biological sex—with additional considerations such as class and race—precedes the concept of gender and has been considered to be the point of origin, and natural limit, of an individual's social identity (Roscoe, 1994). In addition, biological sex is also thought to determine personality and character (e.g., women were naturally more nurturing, and men were more aggressive). This centrality model of biological determinism in respect to gender formation has received strong criticism. Among these early critics was the argument that is popularly known as the sociocultural construction of gender (de Beauvoir, 1949; Devor, 1989; Mead, 1935; Shapiro, 1991). Here, we then need to argue that each society and culture possessed different manners in operating sex and gender, and how the body is experienced by the society.

The practices and ideologies of gender and sexuality in Asia gained so much influence from its historical experiences—of colonialism, imperialism, war, and revolution, and the views and politics of political and religious elites, especially with regard to capitalist market systems, projects of modernity, and processes of globalization (Davies, 2010; Tao-Ming Huang, 2011; Yue, 2007, 2012). In some Asian countries, like Indonesia for example, the visible physical body in ascertaining

marriage legitimacy is of high importance. This example shows how body remains fundamental to one's notion of self and as such, a female cannot become a man, because a man is necessarily male, and vice versa. In addition, Asia's religious landscapes are rich and variegated and provide diverse concepts for understanding gender and sexuality. All of this background helps explain the variation in Asia with respect to the tenor and degree of relative equality (or inequality) characteristics of male–female relations; women's status; perceptions, experiences, and representation of femininity, masculinity, androgyny, and intersexuality; and the degree of legitimacy or stigma accorded to those who transgress one or another set of gendered or sexual norms (Peletz, 2007). Scholars argue that gendered subject positions have to be viewed as contingent, variable, and positioned by discursive structures, rather than as the permanent property of individuals. By viewing it this way, it will foster recognition of the constitutive relationship between structure and agency in gender formation (Davies, 2010; McNay, 2000; Parker, 2005).

Historically, transsexuality has often been fantasized to be, and thus described as, a kind of hypersexualization. This mode of thinking highlights the transbody as something akin to a fetish, therefore it is tied to aspects of bodily transition in particular, or transgender experience in general as motivated by a specific kind of sexual expression rather than a desire for a specific kind of gender presentation. This approach, however, has been disputed by transsexual communities. Transscholars such as Susan Stryker (1998, p. 147) note the power of performativity, arguing that, "transgender phenomena disrupt and denaturalize Western modernity's 'normal' reality, specifically the fiction of a unitary psychological gender that is rooted biologically in corporeal substance." The Queer movement, as described by Stryker and Whittle (2006), "has been tremendously influential within transgender studies because it imagines a post-identity world that is useful for promoting transgender social justice agenda" (p. 10). However, the term "queer" gives its focus mainly on breaking the hegemony of heteronormativity, but not on (trans) gender variance (Namaste, 1996).

In modern Asia, transnational flows of mobile knowledge have helped shape new sexual cultures and subjectivities. These notions of sexualities both reify and challenge the universality of Western sexual imperialism while insisting upon the particularity of the local with its hybridities and embedded histories. The rise of LGBTQ and women's festivals in Japan (1992), Taiwan (1993), and Hong Kong (1989) and the arrival of HIV/AIDS nongovernmental organizations created a fertile arena for developing queer cultural productions, especially in countries like Malaysia, Indonesia, and Singapore, where homosexuality remains illegal (Rich, 1999). This production of queer culture is consistent with Butler's (1989) concept of human variation and the revelation of "endless performativity," by which she means that the possible combinations and expressions of sex/gender/sexuality are not only not binary; they are in fact "limitless." Performativity is not the effect

of an internal identity, but rather the means by which an identity is repetitively constituted, "There is no core self but rather that the subject is constituted only in and through meaning systems, normative structure, and culturally prescribed taxonomies" (Valocchi, 2005, p. 756). Taking Butler's argument even further, Rubin (2003) and Namaste (2000) argue that queer theory should be challenged since by denying an internal notion of self, it denies transsexual and transgender people their dignity and integrity, and agency. Core identity is the "true self," "inner essence," or a deeply rooted sense of who the transgender are; "something internal that recognizably persists even while it may continuously and subtly alter" (Stryker & Whittle, 2006, p. 367).

In formatting and creating Asian queerscapes, Lionnet and Shih (2005) introduced the force of "minor transnationalism" to differentiate Asian approaches from the top-down, usually West–East and one-way centrifugal hegemony of major transnationalism, where Asian queer communities pushed together the multidirectional, bottom-up forces that have created new spaces of global exchange and participation without the mediation of the center. The movement took various ways, from sex tourism of gay Bangkok, the social movement of queer Taiwan, and the creation of cultural and media policies, as well as gay and lesbian entrepreneurship in Singapore (Yue, 2003, 2006).

However, some transgender theorists disagree with the concept of transsexuality as a "true self." Some Euro-American queer theorists reduce gender to biological sex and explained how the "true," "inner," or "trapped" self-referred to this core identity and explained a "life-plot" of cross-gender identification (*ibid.*). Schrock, Reid, and Boyd (2005) explained how male-to-female transsexuals' remaking of their gender identity required reshaping, redecorating, and retraining their bodies. Retraining of the body was linked to changes in role-taking and increases in self-monitoring so as to perfect their enactment of womanhood. Reconditioning of body movements and vocalizations then iteratively altered their own subjectivity. Further, feelings of authenticity increased when their outer appearance and behavior were aligned within inner definition of self. These transsexuals' understanding of identity and their success in assuming womanhood were thoroughly body-based, contingent upon a biomedical definition of the body. In this backdrop of biomedical hegemony, the CCA opens a discursive space for centering the voices of transgender communities in articulating their locally constituted and globally interlinked meanings of health. Moreover, the intersections of transgender identities and sex work offer entry points for the formation of new culturally constituted notions of health and health risks.

In Singapore, norms, access to health services, and structural contexts of health resources have changed over the years. During the 1950s, a leading medical practitioner and campaigner for sexual reform, Benjamin, controversially argued for the acceptance of "sex-change" surgery by distinguishing between transvestism and

transsexuality, "Transvestism [...] is the desire of a certain group of men to dress as women or of women to dress as men. It can be powerful and overwhelming, even to the point of wanting to belong to the other sex and correct nature's anatomical 'error.' For such cases the term transsexual seems appropriate" (Benjamin, cited in King, 1996, p. 86). Medical intervention was both diagnostic and curative. In the early 1950s, access to reconstructive surgery was highly dependent upon social class and social connections. While genital surgery did take place in the 1950s, it was unusual and most surgeons refused to perform these operations, leaving "treatment" to the field of psychiatry. As access to surgical procedures became more readily accessible during the 1960s, the term "transsexual" became restricted to individuals undergoing surgery, while the concept of transvestism applied to categorize practices of cross-dressing. While sex change surgeries are currently available in Singapore, their prohibitive price leads to many transgender participants seeking sex change surgery in neighboring Southeast Asian countries such as Indonesia and Thailand.

CULTURE-CENTERED APPROACH

The dearth in academic literature focusing on Southeast Asian transgender communities, their lived experiences, and the health needs of transgender sex workers points toward the relevance of a culture-centered study highlighting the narratives and lived experiences of transgender sex workers in the Southeast Asian contexts. Particularly relevant are the negotiations of transgender identities and sex work in the context of Singapore, constituted amid the intertwined relationships between local cultural practices and a Western cultural trope that is aligned with Singapore's adoption of globalization practices, financialization, and an overarching neoliberal framework of governance driven by the principles of the market. The CCA explores the ways in which erasures of community voices are structurally constituted, thus exploring the entry points for community-based meaning making, and articulating spaces for knowledge production that render impure the conceptual categories of the mainstream (Dutta, 2008). Community voices, located contextually, offer entry points into interpreting and transforming structures, thus offering frameworks for academic–activist–community collaborations anchored in the spirit of listening and dialogue. The presence of community voices in this sense disrupts the dominant narrative of health and risk, situating the risks of health amid structural and cultural constructions, and exploring the ways in which individuals and communities enact their agency amid the structural constraints they negotiate.

Meaning-making in the CCA rests heavily on the intersections of culture (local contexts where meanings are continuously negotiated), structure (institutional roles,

rules, and practices that either constrain or enable access to resources), and agency (the capacity to enact choices as individuals and collectives negotiate with structures) (Dutta, 2011). This theorizing of the intersection between structure–culture–agency has been used extensively in marginalized settings to cocreate spaces for listening to the voices of the margins (e.g., Basnyat, 2008; Dutta-Bergman, 2004a, 2004b). The discursive erasure of the margins is thus resisted through the collaborative politics of structural transformation.

The concept of culture in CCA emphasizes active participation of community members in the very construction of shared meanings, values, experiences, and practices, delving thus into a layered, dynamic, and dialectical understanding of culture. Cultural practices are expressed in the everyday enactments of agency, and are simultaneously transformed through these wide arrays of agentic performances. Community members participate in culture through shared meanings, and at the same time perform a wide array of forms of communication that bring into being new cultural possibilities. These shared meanings, values, experiences, and practices, in turn, constitute culture. This makes culture simultaneously stable and dynamic as it "draws from the past, constitutes the present, and is continually changing through the interactions with various social structures" (Dutta, 2008, p. 55).

METHOD

This culture-centered study has drawn data from the ground by conversing with transgender sex workers in Singapore, and by seeking to create collaborative entry points for transforming the structures that constitute the realms of health and well-being. The premise is that the sex worker community is the most marginalized among the transgender community, especially because of the laws governing sex work, the structural limitations on sex work, and the sites of violence constituted around sex work. Based on the framework of the CCA, we partnered with Project X, a local organization that serves transgender communities in Singapore, to help us recruit respondents, to collaborate on developing strategies for advocacy, and to develop advocacy interventions. Project X identified members of the transgender sex worker community to help us form an advisory board, and subsequently to serve on the advisory board to identify problems and develop solutions. Through a series of advisory board meetings, community participants articulated and prioritized their health-related concerns as a community, anchoring health in community needs and every day experiences. Four themes came up through the advisory board meetings and defined the scope of subsequent research undertaken by the team: SRS, hormone therapy, financial stability/insurance, and social support. These themes guided the questions asked for the in-depth interviews that we report in this chapter.

There were a total of 20 individuals who were interviewed for 90 minutes average, with interviews ranging from 60 minutes to five hours. Questions about their health needs and their experiences as sex workers guided the in-depth interviews, accompanied by cocreative strategies for mapping out solutions to the health problems identified by the participants. Respondents were a mix of preoperative, postoperative, and nonoperative individuals who self-identify as transgender and who perform sex work or have been sex workers at some point in their lives. Note the biomedical reference that is used as a framework for categorization, and that this emerged from the advisory board meetings, where the biomedical framework of identifying health needs was agreed upon as a strategy by community members.

Data Analysis

Consistent with other CCA projects (see Dutta-Bergman, 2004a, 2004b), the data was analyzed using the coconstructivist grounded theory approach, following the steps of open, axial, and selective coding (Charmaz, 2011). Line-by-line coding compels the researcher to stay close to the data and faithful to the CCA methodology of re-presenting the voices of the respondents. In axial coding, related codes that surfaced in open coding were grouped into conceptual clusters. Selective coding enabled us to synthesize the clusters into an analytic framework. The whole analytic process was continuously iterative as we moved back and forth between codes, data, notes, and the emerging analytic framework (Charmaz, 2003). Three of the themes related to health which emerged from the analytic process are discussed in the results part of this chapter.

ENACTING AGENCY AMID STRUCTURAL CONSTRAINTS

This section discusses three major themes that arose from the collected data. The "wrong body" narrative is the overarching thread that connects the themes, situating them within the broader ambits of experiences of the body. Culture is performed at the site of the body, and therefore is also negotiated and transformed through the presence of the body. This section opens up with a discussion on how our participants discovered being different at a young age and how they came to realize that they were born in the "wrong body." This is followed by their decision to shift to the "correct or ideal body" through hormone replacement therapy, and finally the ultimate transition from male-to-female through SRS. Sex work is situated amid this desire for the ideal body that, in turn, is situated amid a plethora of health risks. The third part deals with sex work as the means to finance their transition more than to supplement their day-to-day expenses. Across these narratives,

the experiences of everyday stigma are highlighted as entry points for addressing health and well-being of transgender sex workers.

Wrong Body Narrative

Jamie, 38, shared that she realized "being different" during primary school: "It started during primary school, when I was about 13-14. When I realized, I thought is there something wrong with me? Am I abnormal? Am I not acceptable?" June, 41, felt that she was different but did not know how to make sense of her feeling of being uncomfortable until somebody called him "*ah kua*." *Ah kua*, also *ah gua* or *ah qua*, meaning a man acting like a woman, an effeminate man or a male transvestite. June shared:

> I was born a transgender, become aware of my transgender status when I was in preparatory school and then knew what it means to be a transgender when someone used derogatory "*ah kua*" to describe me. And that time when they called me "*ah kua*" then I realized this is what I am, who I am. I'm actually very happy to find out finally who I am. To finally know because during my time, in the 1980s, so there's still no smart phones and computer's a luxury. So I cannot google why am I feeling different. Why am I feeling girl when I'm a boy.

Note here the articulation of identity tied to being called "*ah kua*." The label "*ah kua*" worked simultaneously to give June a sense of self, as a device for helping her figure out her identity, while simultaneously the label itself is stigmatizing. This experience of "being called names" reiterated throughout her life, and emerged across the interviews shared by the participants. The "wrong body" narrative thus was on one hand empowering as a tool for identity formation and articulation, and on the other hand, reproduced stigmatization of transgender individuals.

Respondents share being at a loss about their "true gender identity" as children, with the notion of "truth" situated in a binary. Living amidst a heteronormative Singapore society where one is either male or female, transgender children find it the most difficult figuring out who they are, and this identity struggle is an ongoing struggle especially in early life. The need to understand why they do not seem to fit in with others is high; it is in this context that participants share their experiences of labels. Not being able to explain what's going on outside the heteronormative gender classification is very common for transgender individuals. Catrine, 40, also felt the same way:

> I start to feel like a woman that was the age of about 12 or 13, around there. I feel very woman the feelings like more to woman like uh, I don't feel like a boy, I know that I'm born as a boy but I don't feel like I'm a boy. I feel like I'm a woman. I feel like something is in me, you know, and I look at myself in the mirror that I know that I'm a man, that I'm a boy. But I feel inside is I feel like more to woman, and I don't know the actual reason why I get this feeling actually, and I even sometimes I have I cry. Sit down and cry, you know, uh so

worried because I'm too confused, and I cannot concentrate to be as a boy. The feeling is not there so my mind set is everything is full of like a girl.

For Catrine, her identity is tied to her body as a site of meaning making, attempting to make sense of her feelings. Note here the juxtaposition of feelings within and the external appearance outside.

Suzi, 55, shared her experience, demonstrating the conflicting feeling of being true to one's feelings on one hand, and staying within the accepted gender on the other:

My story as a TG which started during pre-university, I feel that my body, there's a woman trapped in a man's body. So after my studies, I went to full time national service. I wanted to transform myself into a man, I don't want to be a girl but I couldn't make it. I have more interest in men than female.

Suzi's experience is negotiated amid her feelings closely situated in relationship to the structurally situated, and culturally constituted notion of men in Singapore at a certain age joining the national service (NS). Suzi's search for identity and her negotiation of feelings are constituted in the backdrop of her experiences with the NS.

In a generally conservative society like Singapore, societal and family pressure is commonly articulated among transgender individuals. Priyanka, 26, had conservative parents and for a long time until she turned 21, she inhibited from transitioning for the sake of her family. She noted how her experiences of her body were constituted amid societal norms and familial understandings, as well as her culturally constituted understandings of filial duties as a son.

I've been feminine since very, very young. But my parents were very much in denial that you know, I'm like that. But I know who I was. Just for my parents' sake I was doing what they were asking me to do, until a certain level of age, whereby, beyond, you know? I cannot fake myself anymore. So, yeah, break free.

Priyanka was 21 when she broke free, after her time with the army and after she was sent to Canada supposedly to disengage her from friends whom her family thought were bad influences on her. Instead of deterring her, the experience made her resolve stronger that she wants to be true to herself, and live the life of a woman. After coming back from Canada, her parents gave her an option and she opted to choose herself, true to the experiences of her body:

My parents gave me an option. Either you stay at home and be a boy, or you go out and be whoever you want to be. And I think through, I know what I wanted. With no money in my hand, I gave all the money that I earned in Canada to my parents. And said, this is for you all. Thank you for everything you've done, now I'll take care of myself and I left. Since the day I left until today, I've never regretted a single moment that I left the house.

Priyanka shares that her experiences of health were constituted amid the mental tensions she experienced in negotiating the familial pressures that are culturally constituted. Priyanka's every day negotiations of health were primarily in the stressors she felt in negotiating the cultural norms that played out in the form of familial pressures. She then depicts her narrative of enacting agency in choosing to leave the familial context and being true to herself (anchored in the experiences of her body).

Similarly, June experienced familial pressure from her relatives: "My father told me, my relatives ask 'why your son very soft?' They say 'Let's wait for NS, NS will toughen him up.'" NS enlists the male citizens of Singapore to a two-year compulsory military service. Mostly, families would suggest that the NS will toughen up the softies. Transgender respondents shared how this does nothing of that sort. For a number of them, the NS was even their turning point, giving them an identity-based anchor to "figure out" their identities. The experiences of being in the camp in NS acted as sites of negotiating the experiences of the body amid a structured framework of disciplining that worked precisely to enact masculine norms on the male body.

Sasha is among those who was not discouraged by her NS experience. She started to use hormones at 18 when she started her NS. "You see, people say when you serve NS, they will change you from a boy to a man, but not for me. It changed me from a boy to a woman."

> So, I'm the only girl down there inside the camp and I get special treatment. So, I'm the only one down there that you can see every single day with my make-up on, fresh manicure, and…and…because I just sit inside the office, doing office stuff, like receptionist, so I'm the only one who was allowed to wear hair extension like that. […] I wear female jeans, female T-shirt, and I bring female school bag, all of those female stuffs. So whenever I walk, when I walk inside the gate, you know whenever we walk into the gate, they will scan our ID, for attendance wise? Whenever they see me, they will say, 'Ladies first!'

Priyanka's experience was also very good, stating "It was one of the best things that ever happened in my life." It did not deter her from finally realizing her true identity.

> But the army is what really teach me about what life really is. Yeah I was feminine. Everybody knew about me in camp. But no one made fun of me, no one ill-treated or abused me. Nothing. They took care of me quite well. They always backed me up, if anyone ever tried to do anything, my camp-mates always backed me up. So yeah, army was a really good experience for me actually.

Both Sasha and Priyanka were 302s. Meaning, they were doing office work because they declared themselves as "gay" in camp. It was during her time at the army where she started to do sex work, and when she started taking hormones. Priyanka shared:

I declared gay in camp, in the army. So I was 302. 302s—they are eight to five. So, um, yeah so whenever in camp, the moment I go back home I cross-dress. I was working in a club. I was a door bitch there. You stand at the door. You walk people. But this club is very—um, how to say, it's very—they have all kinds of events every day. So every weekends. So it's like, you're always dressing up. So I was always cross-dressing for every single event. So it became a habit. It became me, my identity. So then—I started taking hormones. After I started taking hormones, um, I started seeing changes and I started doing sex work.

Legal Change of Gender

There is a generally positive sentiment articulated by the participants about the policy support in Singapore for transgender individuals. The ability to be able to change one's identity from male to female is considered very important for the participants, and they point toward various informal and formal structures that enable this transformation. In Singapore, an individual who has gone through SRS can get a new identity card and choose a completely new identity. Catrine shares:

> Yes the law accept us, the government accept us. That's the reason why they give us female IC (identification card) in Singapore, I can see that. I really I thank the god, thank the government for helping like people like us, sex change female IC. I really thank the government for this. Another thing I must thank the God lucky I was born in Singapore I'm so proud to be a Singaporean the reason why because other country the sex change they don't have privilege. You see they are holding a male IC.

This is why many transgenders in Singapore aim for sex change, to normalize their lives and to fit into the normative category of a woman. Maya, 20, is determined on going for SRS for her identity to be aligned with who she is.

> It [SRS] is very important because my IC can change into a female. That's very important. It's a big change because I can change my IC- I can travel easily. Meaning I won't be having an officer asking me so many questions. [...] I've been to Hong Kong once and they stopped me and I had to stand there for about forty minutes, the queue was stuck. When I went to Johor (Malaysia) and they stopped me, they made me go out of the car and have a talk with them. The officers had to go talk to them. [...] So basically if I am able to change to F (female), I can change my picture and everything and it wouldn't make it a hassle to travel.

For those whose identity cannot be curbed to conform to their biological gender, experiences in Singapore support the literature on altering the body instead as a corrective action. Going through the SRS thus is empowering, giving legal legitimacy to a transgender individual. Participants share the ways in which the surgery and the accompanying transformations of the body work as legally legitimating choices in Singapore. As a consequence, in much of the discourses voiced by the participants, SRS is an ongoing theme. Health is defined as going

through surgery that enables full transition to becoming female, enabling partici-
pants to secure legally legitimized identity. Narratives of health thus focus on the
wrong body, and health seeking constituted around correcting the wrong body.

Correcting the Wrong Body

Switching to the correct body entails a series of medical interventions. Just like
Sasha, other respondents disclosed how important it is for them to transition to
the female body. They spend a lot of money to look as female as possible. Hor-
mone replacement therapy and SRS go hand in hand in transitioning to the
desired body. Various works from different fields of study in early 1960s intro-
duced dysfunctional socialization as the cause of the transsexual "condition." These
bodies of work (Benjamin, 1966; Green & Money, 1969) introduced the notion
of gender into discourses of transsexuality, and significantly recognized gender
independently of biological sex. This theoretical shift accompanied the increas-
ing acceptance of reconstructive surgery, which at the same also strengthened the
role of the medical practitioner in carrying out the surgery. Elkins and King note,
"Thus, it was no longer necessary to claim a biological cause of transsexualism in
order to legitimize changing sex. If gender is immutable, even though psycholog-
ically produced, and if harmony between sex and gender is a precondition of psy-
chic comfort and social acceptability, it 'makes sense' to achieve harmony by alter-
ing the body" (1996, p. 94). The narratives shared by the participants foreground
hormone replacement therapy and SRS as two key sites where health is negotiated.

Hormone Replacement Therapy

Correcting the wrong body through hormone replacement therapy is achieved by
removing the male hormones and replacing them with female hormones. Maya
started early with hormone therapy and immediately had breast augmentation.

> I started hormones and cross-dressing when I was very young. I'm a pre-op. I really want it
> because I'm young I want to do it now. I can't, you know when I bathe, I look in the mirror
> and I feel less of a woman. I don't have it. I look in the mirror, I really want to be a woman.
> I want to change my body you know. My body you know, that's why I really want to do it.

The consumption of hormone is a must even for nonoperative transgender individu-
als like Maya. Nonoperative transgenders are those who self-identify as transgender
but do not intend to go through SRS. Taking hormones is very important for Maya
as she feels failing to do so will transform her body back into its masculine form:

> Yes, I have to [still consume hormone]. I have this mentality, If I run out of hormone, for
> example, I only left with 2 tablets, then 'shit, its gonna finish, its finish up, I'm gonna be a
> man tomorrow!'

Experiences of health are constituted amid seeking access to hormones, negotiating a health policy environment, and the costs of hormones.

Like Maya, Fazia shares the challenges she faces in securing access to hormones, noting the importance of hormones in her life so she could be closely aligned with her identity. Lata also discusses the role of hormones in enabling her to "feel like a woman." The effects of the hormone on the body are tied to feeling and performing like a woman. Cate shares how in addition to taking the hormones, she studies the behaviors and performances of women in public spaces so she could change her mannerisms. Hormones alter movement and bodily responses, which are complemented by performed identities of gender learned through everyday interactions. Participants share the struggles they experience in learning about hormones, in securing information about various forms of hormone replacement therapies, their costs and side effects. Moreover, for many participants, sex work is a means to secure access to financial resources to pay for the hormones, often constituting risks to health economically.

Sex Reassignment and Other Surgeries

Brinda shares, "sex reassignment surgery (SRS) is a very expensive procedure, and you need a lot of money to buy it." Although SRS is the legitimating device for many of the participants, securing access to SRS is a challenge, thus presenting a wide array of risks that transgender individuals participate in so they could have the economic access to SRS. Catrine went for breast augmentation first before she was able to save enough money for sex reassignment. She shares how she went for an expensive breast augmentation procedure and how she was envied by another transgender individual.

> Why is yours very shapy? It's very nice. You're very lucky, you have got a new product. After that I work some more, I go this sex trafficking work, work, work then save some more money, for my sex change save enough money and save enough really.

The desire for the "right body" becomes a health risk. Participants share the ways in which they are willing to put their bodies at risk to secure access to SRS. In addition to risks that are constituted in sex work, in some instances, accompanied by risks of violence in forms such as sex trafficking, participants share the risks that are attached to the procedure. Yet, they suggest that the desire to go through the surgery to be in the right body is often much stronger than the sense of risk.

Participants shared stories of seeking out SRS from other neighboring countries where the costs were cheaper, although the surgery might have greater risks. Catrine was aware of the risk, recalling how on the day she was scheduled for her surgery in Thailand, the transgender woman before her died of the procedure: "If I'm blessed, if the God blessed me, I would be like a reborn as a female after the

sex change like a reborn. If I'm not blessed something goes wrong, fate that will be the last is it next going to be me?" She said the risk was worth taking:

> When I came back from the Thailand to Singapore, I really feel very, very painful after the sex change. I was conscious really first is the things is that the nurse came in the ward after the sex change with a bandage everything they wake me up, Catrine, you're a woman now she say like that I'm so happy I'm still drowsy. I say, Ahhh, I want to smile. I'm smiling but it's drowsy but I didn't feel any pain the first thing. She say, okay you can touch the bandage. I really no see the bandage Oh! I feel it already like I'm conscious Oh! I'm a woman already.

Catrine recalled how penniless she was when she left home after her brother beat her up and the family found out about her sexuality. She was very eager to transition to a woman, in spite of her family disowning her. An older transgender sister whom Catrine fondly called "mommy" introduced her to sex work to help her finance her transition:

> This is what I can help you, it's the only way. Are you really do what mommy gonna do, the job? You must tell me from the heart because later you cannot say I'm the one who force you to do this job. This is the only chance that you can become fast what you need like ah you want to have a breast surgery. This is what I go through she say, so are you willing to? Yes of course, I really want to be woman. How fast I can be? I want to have a breast. I want to have a vagina. Okay, fine then she brought me to this East Coast, there is one old (sister), she is the oldest in Singapore.

Transgender Sex Work in Singapore

Sex work thus is constituted around the desires for bodily transformation. On average, transgender sex workers start before they turn 20. The early self-acceptance is punctuated by the decision to start taking hormones. Most of the time, this would also be the start for them to start with sex work to support the purchase of hormones. A number of participants mentioned doing sex work to finance the need for hormone therapy and the transition to become a woman. Citra talked about an older transgender sister she calls Mommy who helped her transition and accept herself and eventually introduced her to sex work:

> I have no choice that time. I have to become a woman so I make money to have a surgery. The surgery money is quite expensive. So that's the reason why I am a sex worker, I earn money.

As Priyanka earlier shared, the time she started taking hormones was also close to the time when she started with sex work. Priyanka felt the necessity to do it because of the cost of being the ideal body:

> Like social escort, for extra income. Because it's not cheap being a woman. For a woman to become a woman, you gotta change your whole wardrobe, you gotta start buying make-up, everything. So I started doing social escort, then I started step-by-step changing.

For Sarina, 40, sex work is her main source of income. Initially, she held normal day job until the company she worked for went bankrupt. She went broke and lost her flat during the economic crisis in 1997.

> I'm in my forties probably my final years working in this line. I've been in this contesting situation for like more than ten years and I work in various different places I've done street days, on line, massage, escorting give him a few.

Sarina feels that it is difficult also because of her age, "I was born when the time it was still conservative here." She adds that "Not everybody can be a sex worker."

> Even if you're sex worker it comes to the different situations whether you work in a brothel, a regulated one, an illegal one or your street base, you work independent or you do online thing or massage, it all has different experiences. I'm lucky enough to get the experiences each and every situation, so I'm in a better position sort of like to tell you the differences.

Sarina mentioned that in the online platform "you meet a lot of professionals white color people who want things to be discreet, who have exquisite taste. It's not the usual ones that you get to see on the street which is cheaper and a lot simpler."

This is corroborated by Priyanka's experience. She prefers to do social escort online where the rate is higher. Priyanka is very clear that she is doing it solely for the money even if, at this point in time, she has not decided whether she will go for SRS because she is unsure about the risks.

> It's more exclusive and high profile. You are giving discreet companionship to the man. So you are actually assuring the man that you know—by engaging me, your identity is safe and I'm safe. They are paying the amount. You wouldn't want to pay 300 for someone looking, I won't say ugly, but looking, you know, someone who has already slept with a few other men earlier. So you're paying a price for someone exclusive, who's giving her time. Her whole period of time just to you. For me, I'm very, I'm doing it only for the money, not for the pleasure. So I therefore, I don't want to be sleeping with too many men. Just one or two a day, that's it. Enough.

Similar to what Catrine said, for Priyanka, sex work is the means for her to be able to go for SRS. But for her, she does not want to go for surgery until she has saved a lot of money in the bank saying she wants her transition to be her "rebirth."

> Here's the thing. It may sound crazy, but to me it's not. Because I've told you people, they were shocked when I told I'm that. I plan to do my SRS only after having at least half a million in my bank account. Because there are transsexuals who go for the SRS and still do what they do. To me, I think SRS is a rebirth. Given the choice of being rebirthed, you don't want to live the same old life. You want to start a new life as a female. And females, men want to see you as a female, right? So men don't want you to be a prostitute as a female. So that's why, at least if I have a million in my bank account. It's gonna support me for the rest of the days and all. Whatever happens?

Challenges

The romantic notion of rebirth, however, is something that does not happen for everyone and this plays out in impacting the mental and emotional health of the transgender individual. Reya talked about not achieving the expectations of being a real woman. She shared about having friends who have "jumped off or take poison and take any chance any time anywhere and commit suicides they will take poison, all kind poison you know." She shares that this is because of the challenges that you face as a trans-woman.

> Yes, because we tried all our best to become a woman because our feelings is like a woman. They take all the pain and all the liberty to become a woman but end up because a while, we want to marry a man, fall in love with the man we want to fall in love with the man the main thing is that then love is for me so that is the main thing. And lastly in ending we find out that we go to all these pain and end up this what we get. The men do to us, is it? The ways, what shall we do? They become confused.

Participants share stories of love and betrayal, and unfulfilled expectations that impact their mental health and well-being, at times, leading to suicide. Mental health is a recurrent theme throughout the articulations. The stigma experienced by transgender sex workers often plays out intimately within their familial and romantic relationships. Manju shared, "The loneliness is difficult to manage and to cope with. Death then becomes the only choice. When family is not around, and you have been betrayed. Death seems a way to end the life and the pain that come with it." Similarly, Neera shared, "All the years have been so painful. Being called names, being looked down upon, as a weird. It really hurts. Then death appears pretty good."

Participants note that there is power in the ability to control the body and to align one's identity with the experiences of the body, and yet there are other challenges that are societal and cultural and are difficult to negotiate. The transgender body is a contested site, where society, biomedical doctors, and the community themselves negotiate the right to name the body and what is going on with the body. For many of the participants, the ability to enact their choices through changing their bodies is a sign of being able to own up and enact their agency. Yet, these choices are constituted amid structures, culturally situated notions of normativity, and communicative access to resources and information. For the participants therefore, a key health solution to the gaps they experience in access is the development of communicative resources, especially health information resources.

DISCUSSION

The link between bodies and subjectivities draws on the concept of an essential connection between body and self as discussed by de Beauvoir (1989) who noted,

"the body is the self, at least in terms of experience" (p. 29). Thus, bodies are not gendered solely by "cultural processes" as proposed by Butler. The body must also be seen as beyond a powerful symbolic of medium (reflecting culture), also as an active agent endowed with the capacity to participate in the creation of social meaning (Reischer & Koo, 2004), "Not that subjectivity is a feature of the body per se, but that bodies because they are constitutive of subjectivity and also mediate the relationship between person and world, necessarily participate in the agency of the person" (p. 307). Thus, together, bodies and subjectivity participate in the making of gender.

Medicalization and Rehearsed Narratives of the Wrong Bodies

The medicalization of trans-identity has been documented throughout history, although it is markedly more evident in the contemporary age of advancing technology. Historians of sexuality (Foucault, 1978; Weeks, 1977) have illustrated how medicine began to take an increasingly dominant role in understandings of sexuality during the 19th century. Related to transgender identities, medical perspectives on transgender have come to occupy a dominant position that has significantly affected how transgender is viewed and experienced within contemporary Western society and spreads out across the globe. As described by Ekins and King (2007), "[…] medical perspectives stand out as the culturally major lens through which gender blending may be viewed in our society. Other perspectives must take medical perspectives into account whether they ultimately incorporate, extend or reject them" (p. 75).

By the 1970s, surgical procedures had become the orthodox method of "treatment" (Cromwell, 1999). After surgery, people were encouraged to erase their preoperative identity and to carve out an entirely new one. However, the concept of gender dysphoria remains the key classificatory term within medical discourse and contemporary medical practice. Surgery continues to be central in the medical and psychological discourse on transgender identities and continues to operate within the hypothesis of the "wrong body." To date, the biomedical perspective perceives surgery as a solution to "gender dysphoria" in enabling the emergence of the "true" gendered self (Hines, 2009). Prosser (1998) suggests that the "wrong body" narrative reflects a genuine transsexual emotion. The narratives shared in this essay depict the ways in which the "wrong body" narrative resonates throughout the articulations shared by transgender sex workers in Singapore.

However, regardless of their ability to purchase SRS to claim their desired "biological" identity, sex workers are considered deviant (Samudzi & Mannel, 2016). Their experiences of sex work add additional layers of complexity to the local understandings of sex work related to health, gender identity, and transgender rights. In intimate relationships, transgender women often cite unprotected receptive sex as

a means of expressing intimacy and a way of distinguishing between more serious and casual partners or clients (Sevelius, Reznick, Hart, & Schwarcz, 2009). Furthermore, sex work is among the few situations where work is among the few opportunities where gender affirmation is most readily accessible to transgender women and, once again, [unprotected] receptivity during sex plays an identity-affirming role (Nuttbrock et al., 2009; Sevelius, 2012).

Discussion on transgender sex workers' bodies had been focusing on ideas around embodiment and gender performativity as a legitimate freestanding gender marker (e.g., embodying a female aesthetic, modifying the body through SRS, heterosexual sex and interactions) (Ocha, 2013; Ocha & Earth, 2013). Some aspects such as social structure and how it may shape identity and effects of stigma on the health of transgender sex workers are mostly overlooked. It is in this realm of social structures that the voices of the participants in our culture-centered project point toward opportunities of transformation. The structural contexts of the costs of SRS and hormone replacement therapy, accessibility to care, and accessibility to health information shape the everyday enactments of agency among the participants.

Negotiating Queer Identity in Singapore

In a country that criminalizes homosexuality, LGBT rights and liberation are negotiated precariously through activism, advocacy, queer consumption, and media culture. Since 1974, Singapore has led the region in gender reassignment surgery and conducted more than 500 operations in government-funded hospitals. Transgender individuals can legally change their gender identity, and in 1996 were permitted to marry legally. Efforts to shake off an authoritarian image and foster a creative economy have led to significant changes in sexual citizenship since the early 2000s, tied to Singapore's positioning as a cosmopolitan hub of global flows. Most remarked upon has been the government's new liberalized approach to public expressions of homosexuality while it simultaneously upholds legislation and policies that discriminate against gays and lesbians.

Understanding the Queer world in Singapore must consider the ideology of pragmatism as the conceptual framework for postcolonial governance in Singapore. This ideology embodies "a vigorous economic development orientation that emphasizes science and technology and centralized rational public administration as the fundamental basis for industrialization within a capitalist system, financed largely by multinational capital" (Chua, 1999, p. 59). This pragmatism rationalizes policy and structure in making domestic conditions favorable to all aspects of social life. Pragmatism is the "singular prerequisite" for the "political will to implement necessary changes…for continuous self-renewal to manage change and continuity" (Low, 2001, p. 437). Central to pragmatism is the logic of illiberalism

where implementation of pragmatisms is potentially always liberal and nonliberal, rational and irrational. Under this principle, a rational intervention in one special area of social life may turn out to be irrational when the totality of social life is taken into question (Chua, 1995, p. 69).

The prohibition of homosexuality is sustained by the British colonial legacy. Under Section 377 (Unnatural Offences) and Section 377A (Outrages on Decency) of the Penal Code, sodomy is charged as crime. These laws, as described by Leong (1997), lack "human rights" and "appear to be the last frontier in the Asian region for positive gay and lesbian development" (p. 142). Further, the logic of illiberal pragmatic institutionalized transgenderism does not recognize the long-held tradition of indigenous transsexualism or the progressive claims of sexual minorities, instead privileging neoliberal economic rationality. Moreover, the policy framework reflects the governance of gender transgression as a disease that can be medically corrected and socially heteronormalized.

The history of transgender community in Singapore can be traced back to the 1950s, where "ah qua" was a commonly accepted sexual figure. The "*ah qua*" is a local nativist transsexual who used to ply the sex trade in Bugis Street, one of the areas in Chinatown that was once an icon of exotic Singapore (Heng, 2001). Since the founding of Singapore in 1819, there has been a history of homosexuality. Not only did the migrants have sex with Hainanese boys, but seamen and soldiers in the Vietnam War looked for creature comforts (transvestites and transsexuals) at Bugis Street, an iconic space where drag queens and transsexuals solicited during the 1950s–1980s, when the soldiers came to Singapore for rest and relaxation (Ho, 2012). In his book, *Sisterhood: The Untold Story,* Joash Moo (1990) describes the meaning of sisterhood, "The sisterhood is a collective term for local transgenders who call themselves 'sister'. They are defined as 'transsexuals' or 'transvestites.' Transsexuals undergo surgery to change their gender. Transvestites dress up superficially to look like members of the opposite sex. They are not just 'gays.' Physically, they are men and women; psychologically they are not" (p. vii).

The policy implemented by the state in Singapore creates both avenues for expression and constraining structures that members of the transgender community have to negotiate. Negotiations of health are constituted amid their cultural versus sexual citizenship and amid experiences of hormone replacement therapy and SRS. Discussions about transgender spaces and movements point toward transgender spaces as sites of contestation, at once reifying cultural values and simultaneously offering transformative opportunities. What is worth noting in this chapter is the complexity in community articulations of cultural belonging and enactments of cultural citizenship. Through NS, for example, we learn about the ways in which the military becomes a site of masculine nationality and how marginalized gay soldiers appropriate its hegemony to create spaces of cultural belonging. Gay soldiers enact cultural citizenship by performing pragmatic

belonging in a heterosexist, patriarchal, and nationalist institution (Yue, 2012). For the participants in our culture-centered dialogues, the state-imposed structures are both enabling and constraining. Participants note the ways in which the structures limit their access to health and simultaneously offer entry points to legitimacy. Health, understood as economic access, defined the broader context of risks that participants negotiate in their everyday lives.

REFERENCES

Anderson, B. (1998). *The specter of comparisons.* London: Verso.

Basnyat, I. (2008). *Finding voice: Enacting agency for reproductive health in the context of culture and structure by young Nepalese women* (PhD thesis). Purdue University, West Lafayette, IN.

Benjamin, H. (1966). *The transsexual phenomenon.* New York, NY: Julian Press.

Blackwood, E. (2010). *Falling into the lesbi world: Desire and difference in Indonesia.* Honolulu, HI: University of Hawai'i Press.

Blackwood, E., & Johnson, M. (2012). Queer Asian subjects: Transgressive sexualities and heteronormative meanings. *Asian Studies Review, 36*(4), 441–451.

Butler, J. P. (1989). *Gender trouble: Feminism and the subversion of identity.* New York, NY: Routledge.

Charmaz, K. (2003). Grounded theory. In J. A. Smith (Ed.), *Qualitative psychology: A practical guide to research methods* (pp. 81–110). London: Sage.

Charmaz, K. (2011). Grounded theory methods in social justice research. In N. K. Denzin & Y. Lincoln (Eds.), *Handbook of qualitative research* (4th ed., pp. 359–380). Thousand Oaks, CA: Sage.

Chi Sam, H. (2010). *Transgender representations* (Master's thesis). National University of Singapore, Singapore.

Chua, L. Y. (1999). The cinematic representation of Asian homosexuality in the Wedding Banquet. *Journal of Homosexuality, 36*(3/4), 99-112.

Clare, E. (2001). Stolen bodies, reclaimed bodies: Disability and queerness. *Public Culture, 13*(3), 359–365.

Cromwell, J. (1999). *Transmen and FtMs: Identities, bodies, genders, and sexualities.* Champaign, IL: University of Illinois Press.

Davies, S. G. (2010). *Gender diversity in Indonesia: Sexuality, Islam and queer selves.* London, New York, NY: Routledge.

de Beauvoir, S. (1989). *The second sex.* New York: Vintage Books.

Devor, H. (1989). *Gender blending: Confronting the limits of duality.* Bloomington, IN: Indiana University Press.

Draz, M. (2014). Transitional subjects: Gender, race, and the biopolitics of the real. In N. Goswami, L. Yount, & M. O'Donovan (eds.), *Why race and gender still matter: An intersectional approach* (pp. 117–131). London: Pickering & Chatto.

Dutta, M. J. (2008). *Communicating health: A culture-centered approach.* London: Polity.

Dutta, M. (2011). *Communicating social change: Structure, culture, and agency.* New York, NY: Taylor & Francis.

Dutta-Bergman, M. (2004a). Poverty, structural barriers and health: A Santali narrative of health communication. *Qualitative Health Research,* 14, 1–16. 139.

Dutta-Bergman, M. (2004b). The unheard voices of Santalis: Communicating about health from the margins of India. *Communication Theory*, 14, 237–263.

Earth, B. (2006). Diversifying gender: Male to female transgender identities and HIV/AIDS programming in Phnom Penh, Cambodia. *Gender & Development, 14*(2), 259–271.

Elkins, R., & King, D. (1996). Blending genders—An Introduction. In R. Elkins & D. King (Eds.), *Blending genders: Social aspects of cross-dressing and sex changing* (pp. 1–4). New York, NY: Routledge.

Ekins, R. & King, D. (2007). *The transgender phenomenon*. London: Sage Publications.

Findlay, B. (1999). *An introduction to transgender women: An equality analysis*. Paper presented at the TransAction from the Justice and Equality Summit. Retrieved from http://www.citeseerx.ist.psu.edu/

Foucault, M. (1975). *Discipline and punish: The birth of the prison*. New York, NY: Random House.

Foucault, M. (1978). *The history of sexuality, Vol. I: An introduction*. New York, NY: Pantheon Books.

Green, R. & Money, J. (1969). *Transsexualism and sex reassignment*. Baltimore: Johns Hopkins University Press.

Heng, R. H. K. (2001). Tiptoe out of the closet: The before and after of the increasingly visible gay community in Singapore. In G. Sullivan & P. Jackson (Eds.), *Gay and Lesbian in Asia: Culture, identity and community* (pp. 183–203). New York, NY: Harrington Park Press.

Heyes, C. J. (2007). *Self-transformations: Foucault, ethics, and normalized bodies*. Oxford: Oxford University Press.

Hines, S. (2009). A pathway to diversity?: human rights, citizenship and the politics of transgender. *Contemporary Politics, 15*(1), 87–102.

Ho, A. K. (2012). How to bring Singaporeans up straight (1960s-1990s). In A. Yue & J. Zubillaga-Pow (Eds.), *Queer Singapore: Illiberal Citizenship and Mediated Cultures* (pp. 29–43). Hong Kong: Hong Kong University Press.

Israel, G. E., & Tarver, D. E. (1997). *Transgender care: Recommended guidelines, practical information, and personal accounts*. Philadelphia, PA: Temple University Press.

Jackson, P. A. (2011). *Queer Bangkok: Twenty-first century market, media, and rights*, Hong Kong: Hong Kong University Press.

Jackson, P. A., & Sullivan, G. (1999). *Lady boys, tom boys, rent boys: Male and female homosexuality in contemporary Thailand*. New York, NY: Harrington Park Press.

King, D. (1996). Gender blending: Medical perspectives and technology. In R. Ekins & D. King (Eds.), *Blending genders: Social aspects of cross-dressing and sex-changing* (pp. 79–98). New York, NY: Routledge.

Lai, F. (2007). Lesbian masculinities: Identity and body construction among tomboys in Hong Kong. In S. E. Wieringa, E. Blackwood, & A. Bhaiya (Eds.), *Women's sexualities and masculinities in a globalizing Asia* (pp. 159–179). New York, NY: Palgrave Macmillan.

Lenzi, L. (2015). Looking out: How queer translates in Southeast Asian Contemporary Art. *Intersections: Gender and sexuality in Asia and the Pacific*, 38. Retrieved from http://intersections.anu.edu.au/issue38/lenzi.pdf

Leong, L. W. T. (1997). Singapore. In D. West & R. Green (Eds.), *Sociolegal Control of Homosexuality: A Multi-nation Comparison* (pp.127–44). New York: Plenum Press.

Lionnet, F., & Shih, S. (2005). *On minor transnationalism*. Durham, NC: Duke University Press.

Low, L. (2001). The Singapore developmental state in the new economy and polity. *The Pacific Review, 14*, 411–441.

McNay, L. (2000). *Gender and agency*. Cambridge: Polity Press.

Mead, M. (1935). *Sex and temperament in three primitive societies*. New York, NY: William Morrow.

Moo, J. (1990). *Sisterhood: The untold story*. Singapore: Times Editions.

Namaste, K. (1996). Tragic misreading: Queer's theory erasure of transgender subjectivity. In B. Beemyn & M. Eliason (Eds.), *Queer studies: A lesbian and, gay, bisexual, and transgender anthology* (pp. 183–203). New York, NY: New York University Press.

Namaste, K. (2000). *Invisible lives: The erasure of transsexual and transgendered people*. Chicago, IL: University of Chicago Press.

Nemoto, T., Bodeker, B., & Iwamoto, M. (2011). Social support, exposure to violence and transphobia, and correlates of depression among male-to-female transgender women with a history of sex work. *American Journal of Public Health, 101*(10), 1980–1988.

Nuttbrock, L., Bockting, W., Hwahng, S., Rosenblum, A., Mason, M., Macri, M., & Becker, J. (2009). Gender identity affirmation among male-to-female transgender persons: A life course analysis across types of relationships and cultural/lifestyle factors. *Sexual and Relationship Therapy, 24*, 108–125.

Ocha, W. (2013). Rethinking gender: Negotiating future queer rights in Thailand. *Gender, Technology & Development, 17*(1), 79–104.

Ocha, W., & Earth, B. (2013). Identity diversification among transgender sex workers in Thailand's sex tourism industry. *Sexualities, 16*(195), 195–216.

Parker, L. (2005). *The agency of women in Asia*. Singapore: Marshall Cavendish.

Peletz, M. G. (2007). *Gender, sexuality and body politics in modern Asia*. Ann Arbor, MI: Association for Asian Studies.

Peletz, M. G. (2009). *Gender pluralism: Southeast Asia since early modern times*. Madison Ave, NY: Routledge.

Pitaloka, D., & Hsieh, E. (2015). Health as submission and social responsibilities: Embodied experiences of Javanese women with type II diabetes. *Qualitative Health Research, 25*(8), 1155–1165.

Prosser, J. (1998). *Second skins: The body narratives of transsexuality*. New York, NY: Columbia University Press.

Reischer, E., & Koo, S. K. (2004). The body beautiful: Symbolism and agency in the social world. *Annual Review of Anthropology, 33*, 297–317.

Rich, R. B. (1999). Collision, catastrophe, celebration: The relationship between gay and lesbian film festivals and their public. *GLQ: A Journal of Lesbian and Guy Studies, 5*(1), 79–84.

Roen, K. (2006). Transgender theory and embodiment: The risk of racial marginalization. In S. Stryker & S. Whittle (Eds.), *The transgender studies reader* (pp. 656–665). New York, NY: Routledge.

Roscoe, W. (1994). How to become a berdache: Toward a unified analysis of gender diversity. In G. Herdt (Ed.), *Thirs sex, third gender: Beyond sexual dimorphism in culture and history* (pp. 329–372). New York, NY: Zone Books.

Rubin, H. (2003). *Self-made men: Identity and embodiment among transsexual men*. Nashville, TN: Vanderbilt University Press.

Samudzi, Z., & Mannel, J. (2016). Cisgender male and transgender female sex workers in South Africa: Gender variant identities and narratives of exclusion. *Culture, Health & Sexuality, 18*(1): 1–14. Doi: 10.1080/13691058.2015.1062588.

Schrock, D., Reid, L., & Boyd, E. M. (2005). Transsexuals' embodiment of womanhood. *Gender and Society, 19*(3), 317–335.

Sevelius, J. M. (2012). Gender affirmation: A framework for conceptualizing risk behavior among transgender women of colour. *Sex Roles, 68*, 675–689.

Sevelius, J. M., Reznick, O. G., Hart, S. L., & Schwarcz, S. (2009). Informing interventions: the importance of contextual factors in the prediction of sexual risk behaviors among transgender women. *AIDS Education and Prevention, 21*(2): 113–27. Doi: 10.1521/aeap.2009.21.2.113.

Shapiro, J. (1991). Transsexualism: Reflections on the persistence of gender and the mutability of sex. In J. Epstein & K. Straubb (Eds.), *Body guards: The cultural politics of gender ambiguity* (pp. 248–279). New York, NY: Routledge.

Stotzer, R. (2009). Violence against transgender people. *Aggression and Violent Behavior, 14*(3), 170–179.

Stryker, S. (1998). The transgender issue: An introduction. *GLQ: A Journal of Lesbian and Gay Studies, 4*(2), 142–158.

Stryker, S., & Whittle, S. (2006). *The transgender studies reader.* New York, NY: Routledge.

Sultana, A., & Kalyani, M. K. (2012). Femaling males: Anthropological analysis of the transgender community in Pakistan. *The Journal of Humanities and Social Sciences, 20*(1), 93–108.

Tao-Ming Huang, H. (2011). *Queer politics and sexual modernity in Taiwan.* Hong Kong: Hong Kong University Press.

Valocchi, S. (2005). Not yet queer enough: The lessons of queer theory for the sociology of gender and sexuality. *Gender and Society, 19*(6), 750–770.

Weeks, J. (1977). *Coming out: Homosexual politics in Britain from the nineteenth century to present.* London: Quartet Books.

Winter, S. (2002). Transgender and society: An Asian perspective. Newsletter of the *Comparative and Historical Section of the American Sociological Association. 14*(3): 16–18.

Yue, A. (2003). Paging "New Asia": Sambal is a feedback loop, coconut is a code, rice is a system. In C. Berry, F. Martin, & A. Yue (Eds.), *Mobile cultures: New media in Queer Asia.* Durham, NC: Duke University Press.

Yue, A. (2006). The regional culture of New Asia: Cultural governance and creative industries in Singapore. *International Journal of Cultural Policy, 12*(1), 16–34.

Yue, A. (2007). Hawking in the creative city. *Feminist Media Studies, 4*(4), 365–380. doi:10.1080/14680770701631570

Yue, A. (2012). Queer Singapore: A critical introduction. In A. Yue & J. Zubillaga-Pow (Eds.), *Queer Singapore: Illiberal citizenship and mediated cultures* (pp. 1–25). Hong Kong: Hong Kong University Press.



Thanatopolitical Spaces and Symbolic Counterterrorism at the National September 11 Memorial and Museum

MAROUF HASIAN, JR., UNIVERSITY OF UTAH, SALT LAKE CITY, UT, USA AND NICHOLAS PALIEWICZ, UNIVERSITY OF LOUISVILLE, LOUISVILLE, KY, USA

The attacks of 9/11 have been compared with Nazi atrocities almost from the moment they occurred (Sterritt, 2013, p. 142). The very notion that an American site of memory—especially the National September 11 Memorial and Museum—might have anything to do with Nazi pasts may raise the ire of those who worry about too much universalization or generalization of traumatic memories. However, over the years, this is a subject that has been broached by a variety of elite and public social actors. For example, James Young, one of the leading scholars working in the areas of memory studies or Holocaust remembrances, recently delivered one of several lectures about the stages of memory. At that time he was invited to talk about memorials that have been influenced by the Holocaust. At the same time that he summarized some of the earlier arguments that appeared in such highly esteemed books as *The Texture of Memory* (Young, 1993) and *At Memory's Edge* (Young, 2000), Young reflected on his recent involvement with the Lower Manhattan Development Corporation (LMDC) as several different organizations sifted through various architectural designs for a renewed World Trade Center and the American 9/11 Memorial. Young opened his presentation with a story

about a reporter who contacted him not long after the design committee selected Michael Arad and Peter Walker's winning memorial design, "Reflecting Absence." The reporter politely introduced himself as a writer for a reputable magazine and asked quite straightforwardly, "Isn't this just another big Holocaust memorial?" (Young, 2015). Startled at first, Young admitted that there might be some similarities. He responded by observing that there is no way to get around the point that the 9/11 Memorial has been influenced by "knowledge and memory of the Holocaust" because "after the war there has been a preoccupation with absence, with the voids, and with loss." The aftermath of World War II was experienced by those who suffered through the carnage of massive tragedies, and Young thought it was quite evident that the 9/11 Memorial and Museum symbolized a related period of "irredeemable, inconsolable loss" (Young, 2015).

This obviously was just one of many ways to conceptualize the hallowed space that is now occupied by the National September 11 Memorial and Museum, but it is certainly one of the most controversial ones. In this chapter we build on the work of memory scholars who have studied "dark tourist" memorials and museums as we explain how these particular spaces and places have become contested "global memoryscapes" (Phillips & Reyes, 2011). Building off the work of Arjun Appadurai on various communicative and cultural "scapes," Phillips and Reyes (2011) defend the heuristic value of the concept of "global memoryscapes" as a way of capturing the transnational dynamics of the rhetorical practices and mobile memories that are associated with "movement of people, ideas, technologies, and messages across national boundaries…" (p. 2). Phillips and Reyes (2011) elaborate by noting that officials who may be in charge of museums, memorials, and other sites of memory often have to make decisions regarding the local or global nature of memoryscapes, and in some cases elites also must cope with "vernacular memory practices" that will provide the inventional resources for these national or transnational memoryscapes (p. 3). One of our contentions in this essay is that when national memorials link Holocaust memories to what happened on September 11, 2001, this inevitably creates both local and globalizing contests.

Many previous studies of the National September 11 Memorial and Museum often focus attention on the motives and interests of local stakeholders, the families of the victims who died during the attack on the Twin Towers, or the nationalistic nature of this unique site of memory, but cultural critics and others are just beginning to think about the universalist, cosmopolitan, or globalized features of this locale. Was it possible, in the same way that the U.S. Holocaust Memorial has become a didactic site for the intellectual study of many genocidal memories, that the National September 11 Memorial and Museum could be linked to transcendent issues outside of the U.S.?

No doubt some of these attempts to broaden the potential symbolism of the National September 11 Memorial and Museum have to run up against patriotic—and exclusionary—attempts to focus primary attention on "American" suffering or victimization as well as American exceptionalist behavior during the global war on terrorism. Note, for example, how at various times this site has been called a reminder of Osama bin Laden's terrorist barbarism, a place of commemoration for rescue efforts, a symbol of national resilience, a mausoleum, and a site for local rejuvenation of Lower Manhattan. When President Barack Obama (2014) came to this place in order to help dedicate the opening of the Museum, he stated, "here we tell their story, so that generations yet unborn will never forget. ...A nation that stands tall and united and unafraid—because no act of terror can match the strength or character of our country" (para. 4). No wonder that nationalist sentiments like this led Holland Cotter of the *New York Times* to wonder whether this particular museum was going to be "a historical document, a monument to the dead or a theme-park-style tourist" attraction? (para. 3). All of this was taking place during a time when some victims' family groups were trying to use a rhetoric of American innocence (Donofrio, 2010) as a way of understanding these traumatic events in monolithic ways.

While countless journalists and bloggers were convinced that there was a dominant *American counterterrorist* "story" that was being told by those who designed, developed, and maintained this site, the complex nature of these particular places, as well as the competing goals of various stakeholders that were expressed for more than a decade, ensured that many other narratives would shadow these hallowed spaces. Long before the opening of the museum in May of 2014, local, national, and international audiences had witnessed conflicts over how to grieve, endless debates over designs, partisan rancor, and even some physical inundation from Hurricane Sandy. This, we argue, is why this site needs to be considered another global memoryscape.

Was Cotter (2014) right when he commented that a "new story" is being told at Ground Zero? It is possible that some parts of this new story involve the negotiation of ideological boundary-work that contributed to the development of this intriguing site of memory? More specifically we ask this question in this chapter: Are there more globalized, more cosmopolitan features of this particular global memoryscape that can be fruitfully linked to broader concerns regarding Holocaust or genocidal memories?

With this in mind the rest of this chapter begins by providing a brief rhetorical history that explores the question of whether the architects, designers, funders, and other stakeholders in the debates over these sites' trajectories have shared Young's interest in seeing parallels with the Holocaust. At the same time we wonder whether the Holocaust linkages that are presented by scholars, journalists,

or other social actors have impacted the ways that visitors and commentators view Ground Zero?

WHAT MOTIVATES THOSE WHO FIND PARALLELS BETWEEN HOLOCAUST REPRESENTATIONS AND THE NATIONAL 9/11 MEMORIAL AND MUSEUM

In fascinating ways these attempts to recontextualize this memorial and museum as another Holocaust site differ from the ways that some other American sites of memory have taken international incidents and made them "our" own. As Ehrenhaus (2001) once noted in his own study of the "American Holocaust," different U.S. generations use selective interpretations of historical mass-mediated events that may take place elsewhere as they form their own presentist memories. This leads us to ask whether some observers write or talk about the National September 11 Memorial in ways that signal that there are some historical parallels that should *not be* drawn? Are there times when visitors are willing to acknowledge that pedagogical lessons should be taught about the horrors of the Holocaust at the same time that they argue that this particular site is not the place to perform globalized didactic memory-work? When theorists, planners, and laypersons are trying to respect and revere "the" American story that is being told at the National September 11 Memorial and Museum, is there room for discussion of other, more polysemic tragedies, other historical horrors, etc.? Or are those attempts viewed as anti-American, lacking in reverence, or "liberal" attempts to hijack the National September 11 Memorial and Museum?

At first glance one could argue that from an affective standpoint, a visit to the National September Memorial or Museum triggers some of the same reflective, dark thoughts that one gets when one visits the U.S. Holocaust Memorial Museum. How has all of this rhetorically constituted dark tourism impacted the evolutionary development of this hallowed ground, and will U.S. audiences—who are used to hearing narratives about American exceptionalism (see Ivie & Giner, 2009)—respond favorably when they hear observers making comparisons with other catastrophic events? More specifically, are patriotic American audiences comfortable when they hear historical comparisons being made between the deaths that occurred during the terrorist attacks of 9/11 and other massive loss of life? When New Yorkers and other Americans visit this site and mourn the more than 2,900 who died during the attacks on the Twin Towers, the Pentagon, and elsewhere, we wonder whether they are interested in joining Professor Young and linking together 9/11 commemorative acts with World War II Holocaust remembrances.

As Bowman and Pezzullo (2009) note in their study of thanatopolitical dimensions of tourism studies, the study of "dark tourism" is an increasingly popular academic approach to the study of tourist sites because it invites researchers to pay attention to the politicized role that the "disgusting, the abject, and the macabre" play in places that also include the "picturesque, the romantic, and the sublime" (p. 187). In this particular case, we are convinced that tales of American victimization and talk of the need for constant securitization of this site aid the cause of those who find parallels between the Holocaust and 9/11.

This chapter—which traces decade-long parallels that have been made between the 9/11 Memorial and Museum and the Holocaust that have appeared in hundreds of newspapers, journal articles, popular magazines, and web sites—leads us to conclude that sometimes commentators even appropriate phrases like "Never Again" as they use this sacred site as a forum for commenting on the continuing dangers that are posed by Al-Qaeda and other organizations. Although local communities living next to this memorial have often complained about all of the gates and fences that surrounded this site, many other commentators have viewed Ground Zero as a place that could still be targeted by terrorist extremists, groups that can be characterized as contemporary Nazis.

A critical ideological review of much of the architectural and public debates that circulated between 2001 and 2014 illustrates how talk of the World War II Holocaust impacted everything from the choice of architectural designs to the curatorial decisions that were made about what to display in the National September 11 Museum. Again, an incredibly contentious global memoryscape.

As we argue in more detail below, in a plethora of ways this move toward linking 9/11 to the Holocaust may be a part of broader 21st-century securitization concerns. The constant worries that are articulated about potential future terrorist attacks have made it easier to draw symbolic and historical linkages with Holocaust events, sites, and remembrances. From a tourism standpoint, there is no doubt that this connection transforms the architectural and geographic landscape of memory into a place of remembrance that commodifies death and disaster. As Lew (2003) once noted in an editorial reflection, 9/11 has "probably damaged the global travel and tourism more than any other single economic sector" (p. 1). Provide the right counterterrorist rhetorics and put on display the right affective responses to this (in)security and tourism to this area will once again flourish.

Now that the National 9/11 Memorial and Museum is open to the public, we are also interested in investigating how this centerpiece of 9/11 memory has itself become a place of tourism; and as such, we wonder how Holocaust analogies and securitization concerns have produced unique and affective objects of commodification. As we intend to demonstrate, a substantial amount of anecdotal and other evidence indicates that more than a few are now connecting 9/11 with the

Holocaust, and this in turn creates a tourist subject that is simultaneously attracted to death and disaster.

All historical comparisons and memorialization parallels have their limits, and those who seek to connect the horrors of the World War II Holocaust with the tragedies of September 11, 2001 have to always be mindful that many visitors to the renovated areas around Ground Zero may want to prioritize the traumas and the losses that were suffered by Americans on September 11, 2001. In other words, families of the victims, and first responders, for example, don't mind hearing stories about other tragedies like the Shoah—as long as they feel that none of this detracts from the display of individual heroism and the uniqueness of the "American" 9/11 tragedies.

We want to continue our critique in this chapter by providing readers with a brief summary of the theoretical importance of dark tourism and thanatopolitics, and then we apply some of those conceptual insights as we write about how social agents have circulated counterterrorist securitization rhetorics that have invited us to link together the horrors of the Holocaust with the tragedies of 9/11.

DARK TOURISM AND THE ROLE THAT THANATOPOLITICS PLAYS IN MEMORYSCAPE PRACTICES

The concept of thanatopolitics (the ideological usages of death) provides a heuristic way of understanding select American usages of the National September 11 Memorial's "heterotopic" (Foucault, 1967/1998) spaces. Many classical architectural forms of monuments and museums provide us with uplifting, epic messages about a nation's civil religion (Bellah, 1967), but more postmodern ways of thinking about design—as displayed in places like Daniel Libeskind's Berlin Memorials—often showcase what Stow (2012) calls a "pornography of grief" (p. 689). In some situations traumas can be healed by active forgetting, but at other times visitors are looking for "a form of *álaston pénthos*—mourning without end—which focuses on the injustices perpetrated against the nation, at the expense of any consideration of the nation's possible role in generating that perceived injustice" (Stow, 2012, p. 690).

Thanatopolitics thus refers to the way that contemporary audiences memorialize their dead in *strategic and deadly ways* that often illustrate the ideological usages of the symbols associated with dark bodies and other abject objects. When Foucault (2003a, 2003b, pp. 259–262) and Agamben (1998) used the term "thanatopolitics" they often underscored the ways that the living used recollections of death as a way of reminding us of the importance of coping with unpunished killing. Unlike discourses of "biopolitics" that referenced the need for recording

births or the monitoring of the reproductive habits of populations, thanatopolitics is an appropriation of grief, death, and disaster that helps with the governance of communities (see Murray, 2008).

Urban memoryscapes provide intriguing sites of thanatopolitical memory because they may involve everything from city landscaping to the thematic planning for cemeteries. Memoryscapes are those sites of memory that have to do with the reimagining and reinvention of a variety of spaces and places, from the gentrification of suburbs to the communities that are formed by those who engage in "dark tourist" visits to former prisons, concentration camps, or genocidal forests. Oftentimes these private or public memoryscapes, regardless of scale, are participatory as well as epistemic in nature, where urban publics are involved to either acknowledge, or contest, particular representations of that area's intellectual histories and public memories. As Professor Haskins (2008) explains in her essay in *Global Memoryscapes*, some memorials that are key parts of these sites of memory can be "magnets" of political meaning that are "inscribed on the landscape or conveyed through memorial artefacts" (p. 50).

All of this dark tourism may have destructive as well as constructive features. As Lennon and Foley (2000) note in their book, *Dark Tourism*, visitors are drawn to places associated with death and disaster, in spite of the commodification of knowledge, the anxieties, and the doubts that might be produced by those visits. Work done on frightening or unsettling geographies of tourist spaces such as the Korean Demilitarized Zone (Bigley, Lee, Chon, & Yoon, 2010) or Jim Crow-era tourism (Algeo, 2013) remind us that dark tourist sites attract attention because doubts, anxieties, or fears are commodified affects consumed by the tourist visitor. Is it possible that building particular types of memorials or museums *helps allay* some of these worries?

At the September 11 Memorial Museum, which recently opened to the public in May of 2014, visitors do not only see uplifting images of patriotic rebirth. They also see horrific signs of devastation—displays of mangled cables that broke during the attacks on the Twin Towers—while they hear the recorded voices of victims who left messages for their loved ones just minutes before they died. All of this provides examples of what Stone and Sharpley (2008) called an encounter with some of modernity's failures.

Like other places of remembrance that offer thanatopolitical feelings as well as products, people will come from near and far to feel connected with the 9/11 victims who were said to have been targeted for their ideological belief in the Anglo-American system of capitalism (Žižek, 2002). In theory, the failure to appreciate the American way of life is linked to misunderstandings of U.S. cultures by foreigners, which in turn fuels the rise of Jihadism and emboldens those who follow in the wake of the 9/11 attacks.

If one focuses on the trees, the open spaces, the water around the famous "voids" at this particular memoryscape, one might conclude that the developers of the 9/11 Memorial and Museum are inviting New Yorkers to think about the importance of biopolitical rebirth and rejuvenation, but we contend that all of this needs to be juxtaposed with the more thanatopolitical spaces of remembrance that also remind visitors of the terrorist dangers that attend life *after 9/11*. The dark tourism of some of the underground spaces below the Pavilion, for example, distributes an affective force of victimage that faithfully represents the entire nation's worries. While some critics argue that this creates "neurotic subjects" (Isin, 2004) that sustain a "productive economy of fear" (Crandall & Armitage, 2005, p. 30), others contend that all of this display of abject objects helps visitors remember what Ground Zero was really like on September 11. Yet, as De Goede (2008) noted in another context, all of this talk of death and destruction constitutively creates a problematic "subject of risk," a person "who is governed through 'anxieties and insecurities,' striving to attain the impossible in 'absolute security [and]… absolute safety'" (p. 161).

"NEVER AGAIN": THE SACRED AND SECULAR DIMENSIONS OF THE 9/11 MEMORIAL AND MUSEUM'S SECURITY APPARATUS

Phillips and Reyes argued in 2011 that global memoryscapes involve memories and practices that move, and are in contact with, other forms of remembrance (p. 13), and we are convinced that when Professor Young was making scholarly statements about some of the striking resemblances that existed between the remembrances of the Holocaust and recollections of the events of 9/11, he was taking a stance that reflected the arguments of many of those involved with this site's planning and development. For example, in 2005 and 2006, The LMDC expressed an interest in the formation of an "International Center" (IFC) that would tell visitors who came to the National September 11 Memorial about how the events in 9/11 could be contextualized as a part of linear historical trajectories that included references to a host of genocidal pasts. Explicit linkages were made to the wiping out of Native Americans in America, the horrors experienced by African-Americans during the Jim Crow years, and the destruction wrought by the Nazi Holocaust (see Colon, 2005). What complicated matters, as Potts (2012) has observed, is that part of this "dark tourism" also involved situations where those who care about private grief may end up standing beside voyeuristic visitors or purveyors of commodified cultures (p. 233).

Some of the groups representing the surviving family members who lost loved ones on 9/11 considered the plans for the IFC to be politically motivated activities,

and they articulated their belief that these globalization plans would detract from the reflection and the reverence that they felt needed to be reserved for those who died on 9/11 (see, for example, Burlingame, 2005).

Many supporters of the IFC and some of these other cosmopolitan projects were convinced that early planners were signaling how they felt about the architectural representation of trauma and the processes of mourning and the potential linkages between the Holocaust and the 9/11 Memorial when they chose two Israeli Americans, Daniel Libeskind and Michael Arad, as the chief architects. Ben-David (2003) of *The Jerusalem Post*, for instance, argued that Libeskind was being lauded as chief architect of the reconstructed World Trade Center master plan in large part because of his Jewish background. His parents, after all, were Holocaust survivors and he had already received accolades for his proposed "Holocaust tower" that would be a part of the displays at the Berlin Jewish Museum (para. 10). Form and substance came together in the mind of some of these journalists, and Ben-David went on to argue that Ground Zero's plans "thematic links to Libeskind's Holocaust-related work was duly noted," and "for the most part in approval" (Ben-David, 2003, para. 14).

These types of arguments invited readers and potential visitors to think about how the U.S. September 11 Memorial and Museum might have something to do with traumas that may have been suffered by European or Israeli audiences. More than a decade after the attacks on the Twin Towers, as millions of Americans prepared themselves for the emotional opening of the September 11 Museum, Sofer (2013) recalled:

> How fitting that both of the major architects in this project are Israeli citizens. Israeli-American architect Daniel Libeskind, son of Holocaust survivors, has created the master plan for reconstruction. …As heirs to our national experience of survival, they might have had an advantage. (para. 8)

The resilience of New Yorkers, as well as the American nation, could now be reconfigured as newer examples of *globalized* survival in the face of mounting international threats to survival. This supports Professor Kappler's (2016) claim that "…the meanings that memoryscapes take on are by no means fully and unambiguously inscribed in the site itself, but determined by a number of contextual contexts, which impact the ways in which societies related to them through their stories" (p. 5).

For many of the participants in these debates about the future of Ground Zero, securitizing these hallowed grounds, in order to prevent future terrorist attacks, would help atone for previous mistakes. Moreover, thanatopolitical commentary on the evil nature of the September 11 attacks helped to underscore the perceived need for vigilance, counterterrorist decision-making, and constant surveillance (police and military). When journalists wrote about the fences and the

security around this 16-acre area, or when bloggers over the years wrote to tell others about their visits to the National September 11 Memorial, they rarely failed to mention the fences or the airport-like security apparatus that greeted visitors and raised some eyebrows. The architects, the politicians, and the bureaucrats, and the security organizations that were charged with distributing and monitoring the flow of visitors may have had their own disagreements, but they closed ranks when they talked about the constant threat of Jihadist terrorism or the carnage of 9/11.

Most of the time the need for securitization and militarization in the wake of Al Qaeda attacks was taken as a given, and various organizations and stakeholders simply disagreed about who was responsible for preventing any future loss of life in these areas. For example, although the New York Port Authority technically owns the September 11 Memorial site, the New York Police Department (NYPD) has also claimed that it is their duty to make sure that the public is safe and secure, and they have responded to this mandate through the provision of ramped up security technologies such as closed circuit cameras. These jurisdictional squabbles about security are nothing new (see Messing, O'Neill, & Fasick, 2013), and some of these anxieties can be traced back to the commentaries that were written about lax security that were produced by the 9/11 Commission.

We share the views of those who argue that all of this focus on security, and the need for resilience, has much to do with the fact that many guards, developers, journalists, and other commentators want to make sure that Lower Manhattan "never" experiences another 9/11 type attack. Since 2001 New York's Port Authority and the NYPD have produced many texts and videos that invite readers and viewers to image the memorial as a protected space, a place that would be off-limits to foreigners who threatened America's shores. In some of the geopolitical imaginations the security guards who worked with the NYCP were part of the tip of the spear in the metaphoric war that was being fought against terrorism.

These securitization features of these types of symbolic counterterrorist discourses created subject positions and identities in imaginary geopolitical worlds that allowed those who guarded these hallowed grounds to think of themselves as fellow warriors who protected the Homeland at the same time that U.S. conventional forces or Special Operations units fought enemies overseas. In other words, the massive security apparatus that surrounded the Memorial before May of 2014 provided the guards with a second chance to make amends for not preventing the attacks on the Twin Towers or the Pentagon. As Forest and Johnson (2012) note, there may be a not-so-hidden motive operating here behind this securitizing agenda, in that these securitization measures put on display the resilience of the New Yorkers as well as the perseverance of the nation. By regulating strict security access points, covering the memorial space with closed circuit cameras, and physically walking the spatial arena with heavy ordnances, security personnel and others who supported these securitization efforts could create the impression that they

were working to eliminate any existential or future risk of having terrorists slipping through any post-9/11 security gates.

"Homeland security" takes many forms, and the securitization of the 9/11 Memorial could be linked to many transcontinental nationalistic acts of defiance. Even years after the event, generations of Americans were willing to tolerate some loss of their freedoms in order to protect families and friends from harm. Forest and Johnson (2012) get to the emotive power of some of these rhetorical linkages when they explain:

> Strict access-control at the WTC site provides atonement for security personnel and police, as proxies for airport checkpoint screeners. The conscientious application of an airport-like security protocol is a chance to symbolically "get it right;" to implement security measures conscientiously that might have prevented the September 11 attacks. (p. 408)

In Radzik's terms, such atonement seeks to repair the social contract between security and society: that in exchange for inconvenience, limits on certain liberties, and reduced personal privacy, society will be protected from violent harm (quoted in Forest & Johnson, 2012, p. 409). Given these psychological and sociological linkages, we can readily understand why both planners and visitors would put up with security price-tags that suggest that securitization costs take up approximately $12 million of the $60 million annual operating costs of the memorial (*CBS News*, 2012).

We would go so far as to argue that some promoters of securitization at the 9/11 Memorial and Museum have found a way of ensuring that the trope "never again" can have an American inflection, that particularizes the horrors of 9/11. Securitization practices thus become didactic acts of commemoration that allow New Yorkers to rationalize—and justify—high levels of security. As Forest and Johnson elaborate, securitizing the 9/11 Memorial sites operates under the assumption that oftentimes social agents "have the moral responsibility to act" in ways that counter perpetrators' deeds (Forest & Johnson, 2012, p. 408). In sum, post-9/11 heightened levels of security can be understood as a means for atoning sins wrought by forces of evil that have "slipped under the radar" during times of appeasement or insecurity.

Yet as Houdek (2016) has recently argued in an essay on the "rhetorical force" of some global memoryscapes, the "fluidity of archival memory and its openness to emergence and even contradictory social and political uses points toward processes of interpretation and meaning making" (p. 4). The heightened levels of security at National September 11 Memorial and Museum have led some to question whether these measures are actually necessary, and in some cases critics wonder whether all of this securitization makes visitors feel any safer. Vanhoenacker (2012), for example, argues that while the security may be comforting for the 9/11 family members and survivors, "it's time for a freedom-loving people to consider the purpose and

impact of such security measures" (para. 4). Interviewing a number of people who have researched the topic, he noted that some, like counterterrorism fellow Max Abrahms, contend that "although the memorial's 'extra psychological importance' warrants heightened security, 'it's now clear that sleeper cells are not infesting our country…al-Qaeda can hardly generate any violence at all'" (Vanhoenacker, 2012, para. 6). In other words, what if all of these securitization displays contributed to fear mongering or threat inflation?

However, for others, these trials and tribulations revive memories of other, more globalized historical tragedies. Clearly, talk of "never again" raises implicit or explicit references to other atrocities, the Holocaust, or other genocides, and the ideologically charged thanatopolitics serves to refute the claims of skeptical viewers or listeners.

Skeptics who worry about all of this dark talk of renewed attacks or critique the need for counterterrorism in Lower Manhattan often complain about the politicization of a site that is supposed to be set up for commemoration of the dead, and some argue that treating the 9/11 Memorial as some fortress does little to aid the cause of those who actually fight the Taliban or Al Qaeda. Mueller (2006), a counterterror expert, argued that the threat of another terrorist attack on New York City is greatly exaggerated and that all of this wasteful spending "produce[s] widespread and unjustified anxiety" (p. 1). A year later, Sedgwick (2007) complained that local politicians were using "terrorist events as excuses to do what [they] wanted to do anyway" (p. 439).

Other critics argue that all of this misplaced or (over)emphasis on security detracts from the real purposes of having the 9/11 Memorial in the first place. As early as 2003 Schneier characterized all of the performances of the guards and checkpoints as a type of "security theater" (p. 38), and he criticized these activities as intrusive, pointless, or ineffective. "The best memorial to the victims of 9/11," argued Schneier (2003), would be to "forget" most of the "lessons" of 9/11. "It's infuriating," he said (quoted in Mann, 2011, para. 2). In other words, the didactic or pedagogical functions of the museum needed to take a backseat to the reverential functions of these sacred grounds in order to help traumatized publics move on with their lives. Whether these terrorist threats were real or imagined, we can appreciate why Janz (2008) characterized some of this as evidence of the nation's post-9/11 "topophobia" (p. 191).

Scholars are not the only critics who have complained about some of this dark tourism and the securitization of Ground Zero. Security efforts at the World Trade Center site have been so intense that a writer for the *New York Times* reported that a group of Lower Manhattan residents, who have called themselves the WTC Neighborhood Alliance, recently prepared to sue the NYPD for its interference with their day-to-day life. To these potential litigants the Memorial's security apparatus will "leave the center in 'fortress like isolation' and the area around it 'as

impervious to traffic as the Berlin Wall'" (Dunlap, 2013, para. 4). Again, all of this referencing of the Cold War years, or talk of a "fortress," helps with intentional or unintentional symbolic linking of World War II events to 9/11 tragedies.

While officials have responded to this type of criticism by arguing that the World Trade Center is still "a potential terrorist target," residents, such as Ms. Perillo, who has lived across from the WTC for over 30 years, commented, "'I live in the City of New York'—not 'on campus' or in a gated community. I do not want to prove who I am to come home to my own apartment" (quoted in Dunlap, 2013, para. 19). Interesting enough—perhaps providing some legal evidence of the pervasive nature of the support for securitization—in February 2014, the WTC Neighborhood Alliance lawsuit was dismissed by New York Supreme Court Justice Margaret Chan. She wrote that "The WTC site does not resemble 'a walled city at all,'" even though she recognized that "the security checkpoints and vehicle-screening areas were 'somewhat uninviting'" (Peltz, 2014, para. 2). Hearing that their neighborhood would turn into a "gated community plagued by traffic jams an pollution from tourist buses," the WTC Neighborhood Alliance stood by their statement that, "The Trade Center will effectively be turned into a walled fortress, devoid of any local traffic and accessible only to those willing and able to get through guarded checkpoints" (Peltz, 2014, para. 8–9).

In sum, the security propositions advanced by the NYPD and the Port Authorities have been contentious to say the least, and these organizations have gone through their own struggles over who has jurisdiction. While there are some critics and local residents who object to some of this securitization, the symbolic power of atoning for real or imagined threats resonates with many Americans who "never" want to see a repeat of 9/11.

This site of memory is obviously not the only place that has been securitized. Ensuring "homeland security," after all, has become a centerpiece for regional, national, and international posttraumatic commemoration. The securitization of Ground Zero has become a globalized tourist attraction in itself, even though the "tourist gaze" (Cornelissen, 2005; Urry, 1990) is largely reversed in such a way that the *tourist* is the one being watched. Similar to the way British media functioned as an "organic" (De Jager, 2010) or "autonomous" (Smith, 2005) vector for the constructed representations of South Africa's tourist industry, the securitization of Ground Zero is "prov[ing] to be simultaneously 'alluring' and 'frightening'" (Hammett, 2014, p. 223).

Is it possible that these affective displays of fear and anxiety have been commodified in such a way that they have become part of the attraction *itself*? Indeed, as our evidence in the following section reveals, many have made sense of the 9/11 tragedy through the mnemonic frame of the Holocaust. What might be called the "transnationalization of the Holocaust" provides with a unique, if startling, instance of dark tourism.

The Transnationalization of the Holocaust: Rethinking the Boundaries of Commemoration

Although the vast majority of commentators have focused on the American features of 9/11 horrors, there have always been a vocal minority of observers who have presented us with more generalizable, or more universal or cosmopolitan messages. "This is like the Holocaust," a witness said to a *Toronto Sun* reporter the day after the attacks (Sterritt, 2013, p. 142). A week later, a *Washington Post* columnist by the name of Cohen (2001) found rays of hope for the nation's future by recalling "the people who survived the Holocaust and made a life for themselves" (para. 6). Like those imprisoned in Adolf Hitler's death camps, an Ohio newspaper observed, Americans could not control the enormity that had befallen them, but they could control their *response* to it (Sterritt, 2013, p. 142).

Our study of securitization and the parallels that have been made between the Holocaust and the 9/11 events indicates that these symbolic linkages can take many forms, and all of this speaks to the ways that select usages of historical memories can be appropriated and deployed for presentist needs. As Ehrenhaus (2001) once noted, "Holocaust memory has a crucial role in American national identity that extends beyond American Jewish community to the larger, predominantly Christian population" (p. 332).

Is it possible that other social actors and audiences want to supplement these types of messages by going beyond American national interests in representations of 9/11? We are convinced that it is fair to argue that the National September 11 Memorial and Museum may have become a Judeo-Christian site of secular and sacred memory, a place of reverence that also has more polyphonic dimensions that need to be explored. We agree with Kansteiner's (2014) argument that when we study some genocidal memories "we are engaged with violent pasts that we find disturbing, fascinating, and intellectually challenging" (p. 403).

The multiple 9/11 attacks and the Holocaust have been connected almost from the beginning to the debates about this memorial and museum. In some cases these linkages were made while simultaneously articulating nationalistic aspirations, while at other times they appear in more transnational forms.

As noted earlier, the very choice of architects sent signals about the linkages that could be made between Nazi decision-making in Berlin, forensic architecture in Israel, and the 9/11 tragedies, and this was a topic that continued to be discussed for many years.

At the same time, historical linkages can be made between these two events that involve the crafting of related victimization narratives that explain the role of evil in the world. For example, there is no shortage of commentators who have implied that Nazi extremists share commonalities with Jihadist extremists, and

this allows some to see how Jews around the world and New Yorkers were both victims of terror that could only be explained under the heading "pure evil."

This relationship, that sutures together shared histories of victimage, has established a Manichean, good–evil dichotomy that has been used to justify controversial agendas, policies, and wars. This builds on earlier figurations. In one key fragment of his book, *Good Muslim Bad Muslim*, Mahmood Mamdani reflected on some of other historic parallels:

> The lesson of Auschwitz remains at the centre of post—9/11 discussions in American society. An outside observer is struck by how much American discourse on terrorism is filtered more through the memory of the Holocaust than through any other event. Post-9/11 America seems determined: "Never again." Despite important differences, genocide and terrorism share one important feature: both target civilian populations. (Mamdani, 2001, para. 4)

Carr (2008) went even further and averred that 9/11, much like the Eichmann trials, became an iconoclast modern media event that helped publics make sense of this thanatopolitical horror by juxtaposing it with something else that some felt was comparable in nature.

These mnemonic frameworks, filled with related traumatic tales, similar villains, and readily identifiable victims, can be thought of as examples of what Huyssen (2003) calls the "transnationalization of the Holocaust" (p. 154). In some situations the Holocaust becomes both a particularized, unique event and a more universal and mobile yardstick for measuring unmitigated evil (Steinweiss, 2005). For instance, in an article entitled, "The Greater the Evil, the More it Disarms," that appeared in *Time* magazine just days after the attacks on the Pentagon and Twin Towers, Krauthammer (2001) complained about Americans' lack of vigilance against demonic antagonizers. "The [hijacked airplane] passengers' seeming passivity is reminiscent of the Holocaust" (para. 2). He went on to claim that "not since the Nazi rallies of the 1930s has the world witnessed such celebration of blood and soil, of killing and dying" (Krauthammer, 2001, para. 4). The alleged celebration of jihadists over the deaths of supposedly rich Americans in the Twin Towers allowed readers to be transported back in time, where some too easily looked away when confronted with the dark, brooding omnipresence of earlier Nazi years.

Oftentimes, scholars who write about the planning and development of the National September 11 Monument or Museum realize that some of the affective nature of this place has to do with the ways that visitors or pundits think about the role of evil in the world. To Holland (2009), some representations of 9/11 events have become "somatic markers" for pure evils that are similar "to the Holocaust" (p. 289), and all of this has come about because of the "elevated" framing of 9/11 to a "position of Absolute Evil" (p. 287). Holland, among others, appears to be

inferring that 9/11 is connected with the Holocaust in metaphysical, as well as existential ways. Diken and Lausten (2004) similarly remark that, "…9/11 is a sacralized event; it is sublimated and elevated to a level above politics, dialogue, and humor in a way reminiscent of the Holocaust" (p. 89).

Remembrances of the Holocaust are of course not the only World War II events that remind Americans of the dangers of appeasement or the need for vigilant surveillance. Wallance (2013) has remarked, "only a major terrorist strike on American soil will convince the public to accept the kind of intrusive surveillance that, in the first instance, might have prevented the attack" (para. 15).

America's post-9/11 security measures that are prominently displayed at the National September 11 Memorial and Museum can be viewed as a part of complex textual and visual memoryscapes that historically link together America's entry into World War II, Auschwitz, and Ground Zero. No wonder that some contend that the rhetoric about the dangers of contemporary terrorism is a "language of apocalyptic and holy war," that is also "nostalgic in its appeal to WW II through appeals to both Pearl Harbor and the Holocaust" (Grant, 2005, p. 54).

Those who would like to form even earlier historical linkages to the horrors of 9/11 can use mnemonic markers for remembering the centuries of struggles of Jewish communities in the Middle Eastern Holy Land, where Zionists fought their own terrorists and dealt with the age-old religious conflicts between Israel and Arab Palestinians. Churches, states, and other institutions can use a host of heterotopic permutations to explain why both the American and Jewish nations need to remember their common, transnational bonds and struggles. MacDonald (2008) averred several years ago that:

> 'America-as-victim' was not a popular image until after 9/11, when stories of Holocaust survival helped make sense of American vulnerability and anger. …That Israel and the USA are innocent of any wrongdoing, and possess special unique characteristics, is taken-for-granted. (pp. 1107, 1109)

The secular and the sacred blur together as members of several nation-states forge similar identities as their political and geographical imaginations invite them to contextualize 9/11 in select, but politicized ways.

We have also found that Ground Zero has become an incredibly emotive site for some because it allows the personal to become political as various individuals explain their own connections with the Holocaust and 9/11 image events. In her recorded entry that was written in autobiographical form just days after 9/11, Holocaust scholar and professor Baer (2002) remarked:

> So many sad stories, so many eerie parallels to the Holocaust in terms of the consequences of hatred, racism, and religious fanaticism…Trauma at home. Women standing on the street in New York City with photos of their missing husband or son or daughter. Such a low-tech approach to finding the missing after such high-tech terrorism, reminiscent of

the searches conducted for loved ones in displaced persons camps in the aftermath of the Holocaust. (pp. 164, 166)

Some of those who had lived through the horrors of the Holocaust also came forward and acted as contemporary witnesses who could speak to the problems associated with fighting existential evils. Wiesel, for example, in February 2002, taught these pedagogical lessons to an audience at Eckard College in Florida:

I know what it means to face danger. ...It takes so little if we are not careful for terrorists to annihilate all that we who believe in civilization have tried to build. ...Now we know that evil has power and we now know that power must be countered. (quoted in Lapeter, 2002, para. 9)

Although perceptions regarding the similarities between Israel and the U.S. may have been below the surface prior to 9/11, the lingering emotional turmoil wrought from this "day of terror" may have triggered new affective identifications between these two supporting nations. Consequently, this emotional identification is being used to justify heightened security measures in the Middle East and abroad, in airports, and at the National 9/11 Memorial and Museum. If one looks at this from a heterotopic, geopolitical vantage point, one could argue that the security measures taken at Ground Zero are not so different from the way that Israel is protecting its borders and air spaces from non-Jewish nations.

Many academics, perhaps sensing that some elites and publics are willing to "see" 9/11 through the lens of Holocaust remembrances, have disagreements about whether this is a constructive way to think about reverence, collective memory, and victimage. Carr (2008), Jenkins (2004), and Sterritt (2013), in their own ways, warn readers of the potential problems that come from overlooking key existential differences between the World War II Holocaust and 9/11 events. Besides the obvious point that the 9/11 terrorist attacks killed about 3,000 people and the Holocaust killed somewhere between 6 and 11 million people, there are some other issues of representation that have been raised. Sterritt (2013) argues that while visual footage from the Holocaust was not released until after World War II, the images of 9/11 were immediately circulated in a host of mass-mediated venues, offering viewers "instant access" to the horrors of this day (see also Virilio, 1984, 2002). This might indicate that collective traumas for different historical periods might not be that related. Sterritt (2013) however, concedes that in spite of these reservations many see these symbolic linkages:

Both atrocities, the protracted one of the Holocaust and concentrated one of 9/11, produced widely seen images, and both did so despite limitations of visibility built into their material conditions—the concealment and secrecy with which the Holocaust was carried out, and the suddenness and localness of the Twin Towers' destruction. Once put into circulation, the images have proved enduring. (p. 143)

We would also argue that the *reactions* to all of this apparent concealment have also been enduring, as we witness how all of the thanatopolitical worries at Ground Zero have manifested themselves in so many securitizing ways.

CONCLUSION

Only time will tell if all of this talk of Holocaust analogies and dark tourism at the National September 11 Memorial and Museum will resonate with American audiences. At the time of the opening of the Museum portion of this 16-acre site there were mini-debates about a seven-minute video showing Brian Williams talking about Islamic fundamentalists, the crass materialism of the gift shop that tries to raise money to help pay for the operating costs of these grounds, and complaints about the burial there of the ashes of many of the unknown 9/11 dead. The Museum had a commemorative exhibition but it also included a more controversial room that served as a repository for some 14,000 remains that are still unidentified by experts (Cotter, 2014). It will be interesting to see if these debates about remains turn into globalized discussions regarding repatriation of human remains.

Many visitors have already talked of how moved they were by their visit to these hallowed grounds, and some openly talked about how they wiped away their tears when they left the museum. However, there are also indications that some of the thanatopolitical messages of these grounds bring uncertainty and anxiety. In one *New York Times* article, entitled, "As 9/11 Museum Opens, These New Yorkers Will Stay Away," Feuer (2014) noted that, "some people said they did not need a public exhibition to remind them of a personal tragedy that they could not forget. Others simply said they would not find healing or relief at the memorial—only more pain" (para. 3).

Yet for millions of potential visitors, traveling to this site was almost obligatory, a vicarious—and nationalist—way of recalling the horrors of that day and revering the dead.

Regardless, there is no question that past and present darkness continues to haunt this famous place. In one of the most trenchant summaries of the opening of the September 11 Museum, Cotter (2014) chronicled his own "descent into darkness" (para. 6). He explained that while the museum begins at the plaza stage—where visitors are confronted with "steel trident columns that were the signature features of the twin tower facades" (para. 7)—its journey takes visitors 70 feet below ground, "where the foundations of the towers met raw Manhattan schist" (para. 4). Beyond the atrium and below the plaza level, the memorial leads visitors "out of the range of natural light, and not so neutral in feeling" (Cotter, 2014, para. 7), where visitors can hear recordings of the 9/11 narratives giving "urgent accounts of catastrophe" that "crowd the air" (para. 10). And of course,

there is the exposed slurry wall, which was built as a foundation to the WTC and prevented the Hudson River from flooding Ground Zero even after the attacks. And then, after following a ramp down even further underground, readers are told that visitors discover the "Missing" posters and vernacular objects that painted the city immediately after the attacks. The museum ends "at bedrock," where visitors have an option of visiting the galleries of those who died or "a disturbingly vivid evocation of the events themselves" (Cotter, 2014, para. 15).

While the vast majority of visitors so far have expressed their admiration of the aesthetics and reverential nature of these spaces and places, others are not so sure. As mentioned earlier, many are not happy that the remains of their loved ones may be turning into a "dog and pony show" (Farrell, 2014, para. 8). One survivor mentioned that the museum "was made for people who don't really know what 9/11 is about." Another blithely stated he "won't visit it anytime soon" because "it promises to be filled with gawking, ghoulish out-of-towners who will overwhelm the New Yorkers, who lived through the sorrow of those days and will have a hard time getting in" (Feuer, 2014, para. 13).

It is our hope that this chapter's transglobal reading of the 9/11 Memorial and Museum informs critics about how affective displays of fear and anxiety are appropriated to sustain biopolitical and thanatopolitical goals. As such, future researchers may want to question how places of tourism produce particular kinds of subjects and theorize about how these subjects speak about political economies that sustain their articulatory functions. As we have demonstrated, the 9/11 tourist, and the post-9/11 subject, is much like the subject De Goede's (2008) had once rendered visible: A securitized subject governed by insecurities about our traumatic past and our uncertain future. This exceeds Lennon and Foley's (2000) conceptualization of the dark tourist because it historically displaces the Holocaust and transantionalizes its trope of victimization to sustain thanatopolitical force.

Moreover, the National 9/11 Memorial and Museum inverts the tourist gaze unto the touring subject and thus appears to take dark tourism to the next level, one perhaps not anticipated by Lennon and Foley (2000) or Bowman and Pezzullo (2009). We thus encourage future research that analyzes this emerging phenomenon and considers the thanatopolitical dynamics of space at other places of tourism to trace the production and maintenance of subjects within their historical, and sometimes transnational, assemblages.

In conclusion, we are led to wonder whether the day will come when future generations argue that the September 11 Museums appears to be just another type of Holocaust Museum, one that fails to maintain the precarious balance between reverence for American losses and the recognition of more transnational, cosmopolitan recognition of distant suffering. Until then, we are left to trace the bundle of relations that have created this thanatopolitical landscape and inform critics about how tourism and geography have changed since 9/11. Will this particular

memorial and museum ever open its gates to new cartographies of commemoration that don't depend on economies of fear to draw in the tourist?

REFERENCES

Agamben, G. (1998). *Homo Sacer: Sovereign power and bare life*. (D. H. Roazen Trans.). Redwood City, CA: Stanford University Press.

Algeo, K. (2013). Underground tourists/tourists underground: African American tourism to Mammoth Cave. *Tourism Geographies, 15*(3), 380–404. doi:10.1080/14616688.2012.675514

Baer, E. (2002). Fallout of various kinds. In J. Greenberg (Ed.), *Trauma at home: After 9/11* (pp. 158–167). Lincoln, NE: University of Nebraska Press.

Bellah, R. N. (1967). Civil religion in America. *Daedalus, 96*(1), 1–21.

Ben-David, C. (2003, September 26). The man at Ground Zero. *The Jerusalem Post*. Retrieved from *Lexis Nexis*.

Bigley, J. D., Lee, C.K., Chon, J., & Yoon, Y. (2010). Motivations for war-related tourism: A case of DMZ visitors in Korea. *Tourism Geographies, 12*(3), 371–394. doi:10.1080/14616688.2010.494687

Bowman, M. S., & Pezzullo, P. C. (2009). What's so "dark" about "dark tourism"? Death, tours, and performance. *Tourist Studies, 9*(3), 187–202. doi:10.1177/1468797610382699

Burlingame, D. (2005, June 7). The great Ground Zero Heist. *The Wall Street Journal*. Retrieved from http://online.wsj.com/news/articles/SB111810145819652326

Carr, S. (2008). Staying for time: The Holocaust and atrocity footage in American public memory. In C. Lee (Ed.), *Violating time: History, memory and nostalgia in cinema* (pp. 57–69). New York, NY: Continuum.

CBS News. (2012, September 10). Some 1uestion 9/11 Memorial's $60M annual cost. *CBSNews*. Retrieved from http://www.cbsnews.com/news/some-question-9-11-memorials-60m-annual-cost/

Cohen, R. (2001, September 18). Tears of a nation. *The Washington Post*. Retrieved from http://www.washingtonpost.com/archive/opinions/2001/09/18/tears-of-a-nation/6060fa7f-cc43-401c-8132-337519fa8cd1/

Colon, A. (2005, June 17). Make WTC more than 9/11 memorial. *The New York Sun*. Retrieved from http://www.nysun.com/new-york/make-wtc-more-than-9-11-memorial/15620

Cornelissen, S. (2005). Producing and imagining "place" and "people": The political economy of South African international tourist representation. *Review of International Political Economy, 12*(4), 674–699.

Cotter, H. (2014, May 14). The 9/11 story told at bedrock. Powerful as a punch to the gut: Sept. 11 Memorial Museum at Ground Zero prepares for opening. *The New York Times*. Retrieved from http://www.nytimes.com/2014/05/14/arts/design/sept-11-memorial-museum-at-ground-zero-prepares-for-opening.html

Crandall, J., & Armitage, J. (2005). Envisioning the homefront: Militarization, tracking and security culture. *Journal of Visual Culture, 4*(1), 17–38. doi:10.1177/1470412905050636

De Goede, M. (2008). Beyond risk: Premeditation and the post 9/11 security imagination. *Security Dialogue, 39*(2/3), 155–176. doi:10.1177/0967010608088773

De Jager, A. E. (2010). How dull is Dullstroom: Exploring the tourism destination image of Dullstroom. *Tourism Geographies, 12*(3), 349–370. doi:10.1080/14616688.2010.495757

Diken, B., & Lausten, C. B. (2004). 7-11, 9/11, and postpolitics. *Alternatives: Global, Local, Political, 29*, 89–113.

Donofrio, T. (2010). Ground Zero and place-making authority: The conservative metaphors in 9/11 families' 'Take back the memorial' rhetoric. *Western Journal of Communication, 74*(2), 150–169. doi:10.1080/10570311003614492

Dunlap, D. (2013, November 13). Residents suing to stop "Fortresslike" plan for World Trade Center. *The New York Times*. Retrieved from http://www.nytimes.com/2013/11/14/nyregion/residents-suing-to-stop-fortresslike-security-plan-for-world-trade-center.html

Ehrenhaus, P. (2001). Why we fought: Holocaust memory in Spielberg's *Saving Private Ryan*. *Critical Studies in Media Communication, 18*(3), 321–337. doi:10.1080/07393180128089

Farrell, S. (2014, May 10). In "ceremonial transfer," remains of 9/11 victims are moved to memorial. *The New York Times*. Retrieved from http://www.nytimes.com/2014/05/11/nyregion/remains-of-9-11-victims-are-transferred-to-trade-center-site.html

Feuer, A. (2014, May 16). As 9/11 Museum opens, these New Yorkers will stay away. *The New York Times*. Retrieved from http://www.nytimes.com/2014/05/17/nyregion/9-11-museum-not-a-must-see-site-for-all-new-yorkers.html

Forest, B., & Johnson, J. (2012). Security and atonement: Controlling access to the World Trade Center Memorial. *Cultural Geographies, 20*(3), 405–411. doi:10.1177/1474474012455000

Foucault, M. (1967/1998). Other spaces. In J. D. Faubian & P. Rabinow (Eds.), *Foucault: Aesthetics, method, and epistemology* (pp. 175–185). New York, NY: The New Press.

Foucault, S. (2003a). Security, territory, population: Lectures at the College De France, 1977-1978. In P. Rabinow & N. Rose (Eds.), *The essential Foucault: Selections from essential works of Foucault, 1954-1984* (pp. 259–262). New York, NY: The New Press.

Foucault, M. (2003b). Society must be defended: Lectures at the College de France, 1975-1976. In P. Rabinow & N. Rose (Eds.), *The essential Foucault: Selections from essential works of Foucault, 1954-1984* (pp. 294–299). New York, NY: The New Press.

Grant, A. J. (2005, March). Ground Zero as holy ground and prelude to holy war. *The Journal of American Culture, 28*(1), 49–60. doi:10.1111/j.1542-734X.2005.00153

Hammett, D. (2014). Tourism images and British representations of South Africa. *Tourism Geographies, 16*(4), 221–236. doi:10.1080/14616688.2012.762688

Haskins, E. V. (2008). Russia's postcommunist past: The Cathedral of Christ the Savior and the reimagining of national identity. In K. R. Phillips & G. M. Reyes (Eds.), *Global landscapes: Contesting remembrance in a transnational age* (pp. 46–79). Tuscaloosa, AL: University of Alabama Press.

Holland, J. (2009). From September 11th, 2001 to 9-11: From void to crisis. *International Political Sociology, 3*, 275–292. doi:10.1111/j.1749-5687.2009.00076.x

Houdek, M. (2016). The rhetorical force of "global archival memory": (Re)situating archives along the global memoryscape. *Journal of International and Intercultural Communication, 9*(3), 204–221.

Huyssen, A. (2003). *Present pasts: Urban palimpsests and the politics of memory*. Redwood City, CA: Stanford University Press.

Isin, E. F. (2004). The neurotic citizen. *Citizenship Studies, 8*(3), 217–235. doi:10.1080/1362102042000256970

Ivie, R. L., & Giner, O. (2009). American exceptionalism in a democratic idiom: Transacting the mythos of change in the 2008 Presidential Campaign. *Communication Studies, 60,* 359–375. doi:10.1080/10510970903109961

Janz, B. (2008, June). The terror of the place: Anxieties of place and the cultural narrative of terrorism. *Ethics Place and Environment, 11*(2), 191–203. doi:10.1080/13668790802252389

Jenkins, K. (2004). Ethical responsibility and the historian: On the possible end of a history "of a certain kind." *History and Theory, 43*(4), 43–60.

Kansteiner, W. (2014). Genocide memory, digital cultures, and the aesthetization of violence. *Memory Studies, 7*(4), 403–408.

Kappler, S. (2016). Sarejevo's ambivalent memoryscape: Spatial stories of peace and conflict. *Memory Studies,* 1–14. doi:10.1177/1750698016650484

Krauthammer, C. (2001, September 24). The greater the evil, the more it disarms. *Time.* Retrieved from http://content.time.com/time/magazine/article/0,9171,1000889,00.html

LaPeter, L. (2002, February 22). Now we know evil has power. *St. Petersburg Times.* Retrieved from http://www.sptimes.com/2002/02/22/SouthPinellas/_Now_we_know_evil_has.shtml

Lennon, J., & Foley, M. (2000). *Dark tourism: The attraction of death and disaster.* New York, NY: Continuum Press.

Lew, A. (2003). Debating tourism after 9/11. *Tourism Geographies, 5*(1), 1–2. doi:10.1080/1461668032000034024

MacDonald, D. B. (2008). Bush's American and the new exceptionalism: Anti-Americanism, the Holocaust and the transatlantic rift. *Third World Quarterly, 29*(6), 1101–1118. doi:10.1080/01436590802201063

Mamdani, M. (2001, November 7). Uganda: good Muslim or bad. *All Africa.* Retrieved from http://allafrica.com/stories/200111070111.html

Mann, C. (2011, December 20). Smoke screening. *Vanity Fair,* December 20, 2011. Retrieved from http://www.vanityfair.com/culture/features/2011/12/tsa-insanity-201112

Messing, P., O'Neill, N., & Fasick, K. (2013, November 23). NYPD vs. Port Authority in WTC power struggle. *The New York Post.* Retrieved from http://nypost.com/2013/11/23/truck-off-nypd-vs-port-authority-in-wtc-power-struggle/

Mueller, J. (2006). *Overblown: How politicians and the terrorism industry inflate national security threats, and why we believe them.* New York, NY: Free Press.

Murray, S. J. (2008). Thanatopolitics: Reading in Agamben a rejoinder to biopolitical life. *Communication and Critical/Cultural Studies, 5*(2), 203–207. doi:10.1080/14791420802024350

Obama, B. (2014, May 14). President Obama speaks at 9/11 museum dedication: A sacred place of healing and hope. *The White House Blog.* Retrieved from http://www.whitehouse.gov/blog/2014/05/15/president-obama-speaks-911-museum-dedication-sacred-place-healing-and-hope

Peltz, J. (2014, February 6). Judge tosses suit over World Trade Center security. *Associated Press.* Retrieved from http://bigstory.ap.org/article/judge-tosses-suit-over-world-trade-center-security

Phillips, K. R., & Reyes, G. M. (2011). Surveying global memoryscapes: The shifting terrain of public memory studies. In K. R. Phillips & G. M. Reyes (Eds.), *Global memoryscapes: Contesting remembrance in a transnational age* (pp. 1–26). Tuscaloosa, AL: University of Alabama Press.

Potts, T. J. (2012, December). "Dark tourism" and the Kitschification of 9/11. *Tourist Studies, 12*(3), 232–249.

Schneier, B. (2003). *Beyond fear: Thinking sensibly about security in an uncertain world.* Göttingen: Copernicus Books.

Sedgwick, M. (2007). Overblown: How politicians and the terrorism industry inflate national Security Threats, and why we believe them. *Terrorism and Political Violence, 19*(3), 439. doi:10.1080/09546550701476125

Smith, A. (2005). Conceptualizing city image change: The 're-imaging' of Barcelona. *Tourism Geographies, 7*(4), 398–423. doi:10.1080/14616680500291188

Sofer, B. (2013, August 16). Elul at Ground Zero. *Jerusalem Post.* Retrieved from http://www.jpost. com/Opinion/Columnists/The-Human-Spirit-Elul-at-Ground-Zero-323180

Steinweiss, A. (2005). The Auschwitz analogy: Holocaust memory and American debates over intervention in Bosnia and Kosovo in the 1990s. *Holocaust and Genocide Studies, 19*(2), 276–289. doi:10.1093/hgs/dci023

Sterritt, D. (2013). Representing atrocity: September 11 through the Holocaust lens. In D. Bernardi (Ed.), *Hollywood's chosen people: The Jewish experience in American cinema* (pp. 141–158). Detroit, MI: Wayne State University Press.

Stone, P., & Sharpley, R. (2008). Consuming dark tourism: A thanatological perspective. *Annals of Tourism Research, 35*(2), 574–595. doi:10.1016/j.annals.2008.02.003

Stow, S. (2012, September). From upper canal to lower Manhattan: Memorialization and the politics of loss. *Perspectives on Politics, 10*(3), 687–700. doi:10.1017/S1537592712001703

Urry, J. (1990). *The tourist gaze: Leisure and travel in contemporary societies.* London: Sage.

Vanhoenacker, M. (2012, September 10). Do you have a photo ID young man? *Slate.* Retrieved from http://www.slate.com/articles/life/culturebox/2012/09/sept_11_memorial_does_the_world_ trade_center_site_really_need_so_much_security_.html

Virilio, P. (1984). *War and cinema: The logistics of perception.* New York, NY: Radical Thinkers.

Virilio, P. (2002). *9/11.* New York, NY: Verso Press.

Wallance, G. J. (2013, September 13). The American public will tolerate intrusive surveillance, but only if they are convinced the threat justifies it. *The Jerusalem Post.* Retrieved from http://www. jpost.com/Opinion/Op-Ed-Contributors/The-American-public-will-tolerate-intrusive-sur veillance-but-only-if-they-are-convinced-the-threat-justifies-it-326295

Young, J. E. (1993). *The texture of memory: Holocaust memorials and meaning.* New Haven, CT: Yale University Press.

Young, J. E. (2000). *At memory's edge: After-images of the Holocaust in contemporary art and architecture.* New Haven, CT: Yale University Press.

Young, J. E. (2015, July 15). James Young: The stages of memory and the monument: From Berlin to New York. *YouTube.* Retrieved from https://www.youtube.com/watch?v=1wWK36TVPP8

Žižek, S. (2002). *Welcome to the desert of the real! Five essays on September 11 and related dates.* New York, NY: Verso.

Glocalization and Popular Media: The Case of *Akosua* Political Cartoons

JOSEPH ODURO-FRIMPONG, ASHESI UNIVERSITY COLLEGE, ACCRA, GHANA

Within international media studies, scholars now accept the concept of glocalization (Robertson, 1997) as a framework more capable of exploring nuanced analyses of "ambiguities or interstitial spaces" (Ashcroft, Griffiths, & Tiffin, 2000, p. 23) within global–local media interactions (Kraidy, 2003; Lee, 2005) than media imperialism and globalization theses. As Rao (2011) aptly argues, glocalization's appeal lies in its "conceptual elasticity [which allows for the]... ability to understand [that] locales (global, regional, national, provincial, local) overlap and mutually influence practices, contexts, and identities" (p. 157). In spite of the above, however (and perhaps as a result of the difficulties in operationalizing the concept), not many scholars in the discipline have demonstrated the utility of the concept. In this chapter, I contribute to the extant glocalization scholarship in international media research and African popular media literature by using the concept to explore aspects of the work of the Ghanaian cartoonist *Akosua*. Specifically, I examine *Akosua*'s effective articulation of her sociopolitical critiques of Ghanaian life via a creative blend of global cartooning conventions with Ghanaian cultural communication aesthetics. In doing so, I show how the concept allows us to comprehend the artist's work as *sui generis* in terms of explicating unique Ghanaian political and sociocultural experiences with cartoons. This chapter's attention to exploring the popular media genre of Ghanaian cartoons via the glocalization concept contributes to my prior effort of applying

insights of the theory to elucidate *hiplife*, a popular Ghanaian music genre that is a reappropriation of U.S. rap music (Oduro-Frimpong, 2009). Cumulatively, my broader goal is to engender scholarly interest in and establish a research agenda in "popular glocal media studies": a proposed subdisciplinary field in international media research which aims to draw scholarly attention to investigate the complex dynamics of popular glocal media formats.

In the sections below, first, I explain glocalization in greater depth through an extended discussion of prior works within international media research. Here, the discussion—aimed at orienting us to the utility of the concept—focuses more on the details of the global–local interconnections investigated by these studies. Second, I provide background information on *Daily Guide*, the newspaper that publishes *Akosua*'s cartoons. Third, I provide short discussion about the history of political cartooning in Ghana as well as political satire in general to ground the significance of *Akosua*'s glocalization strategies. Next, I tease out and discuss accepted cartooning conventions that the artist uses to localize her work. In this same section, I explicate the specific Ghanaian communicative aesthetics in *Akosua*'s works that cumulatively make them a distinctly Ghanaian cultural genre. Finally, I conclude with an evaluation of the effectiveness of *Akosua*'s strategic use of the global format of political cartoons in communicating her specific Ghanaian concerns.

GLOCALIZATION AND INTERNATIONAL COMMUNICATION RESEARCH

The preference for the glocalization concept, in international communication research, lies in its "definite conceptual advantages in general theorization of globalization" (Robertson, 1992, p. 33). One such advantage is the thesis' effectiveness as an analytical tool "to account for new cultural forms emerging at the intersections of the global and local [as well as] to counter the frequently expressed thesis that global flows…results in homogenization" (Rao, 2011, p. 158). We observe the evidence of the concept's leverage in Moran's (2006) work on "global expansion of children's television series" in the case of *Sesame Street* in Spain. In this research, Moran (2006) makes explicit how the expansion of a U.S. show such as *Sesame Street* was not "just" implanted into Spain but was localized to take into account "what it means to be Spanish" (p. 298). Clearly, Moran's (2006) work exemplifies "the proces[*sic*] of glocalization whereby a Spanish program has been influenced by both global and local forces" (p. 298). The theoretical force of glocalization is also witnessed in my research on Ghanaian hiplife music exploring the "different and practical aspects of glocalization" (Robertson, 1997, p. 41) to demonstrate that the music is not a mere copy of the U.S. variety (Oduro-Frimpong, 2009). In doing so, I show the distinctness of this contemporary Ghanaian music genre in terms of

artists' creative blend of certain Ghanaian sociocultural practices (naming practices and verbal indirection) with aspects of U.S. rap aesthetics. I demonstrated how the framework allows us to see Hiplife as both creative and authentic hiphop variant in its own right. Last but not least, Wasserman and Rao (2008) show the utility of the glocalization framework within their research on the practice of global journalism ethics in South Africa and India. Acknowledging the ubiquitous impact of media globalization processes in the Global South, these scholars reveal how such developments have not homogenized the practice of global journalism ethics in South Africa and India. Thus, in postapartheid South Africa for example, in spite of the "influence of globalization on journalism ethics" (Wasserman & Rao, 2008, p. 170), journalists practice these values within "the philosophy and goals of the New Partnership for African Development (NEPAD) and the African Union" (Wasserman & Rao, 2008, p. 172). In India as well, the local practice of global journalism ethics is steeped in local realities. Thus, whereas in the West, the use of hidden cameras is the last resort, in India journalists routinely resort to hidden cameras to capture evidence in view of blatant corruption within the deep corridors of powers.

What this brief discussion on the use the glocalization concept in these past research shows is that the concept allows for a "rearticulation of the global in the local context and local responses intertwined with global influences" (Wasserman & Rao, 2008, p. 172). Beyond the above, I argue that the discussion on the use of the concept in the various contexts allows us to gain "deeper knowledge about [some of] the actual modes through which humans 'imagine and form' their everyday lives" (Meyer, 2015, p. 164). It is this dual aspect of the concept that justifies my preference for its application to a case of *Akosua*'s cartoons. In the next section, I provide a brief background of *Akosua* and the newspaper *The Daily Guide*.

Akosua and Daily Guide

Akosua's true identity is not generally known in Ghana. However, what is certain is that the artist holds a Bachelor's degree in fine arts from the Kwame Nkrumah University of Science and Technology in Ghana and a Masters' degree from Royal College of Art, Kensington, United Kingdom. *Akosua* appears in *The Daily Guide*, one of the five privately owned newspapers produced daily except on weekends. This newspaper is one of the few private newspapers that are widely read in the country. Western Publications Ghana Limited publishes the newspaper, established in 1999. The paper aims "to promote democracy in Ghana through objective and creative journalism which will inform, entertain and educate their readers" (*Daily Guide*, Mission Statement). In spite of its claim to be objective in its journalistic practices, the newspaper can be said to be sympathetic to the opposition National Patriotic Party (NPP), one of the two largest

political parties in Ghana. However, the paper appears to be more objective in its reports than other newspapers sympathetic to the NPP. *Daily Guide*'s creative delivery of news stories clearly straddles the divide between a tabloid and serious newspaper. In spite of this ambiguity, the paper is believed to be "the next strongest national daily [coming] a distant second" to the government-owned *Daily Graphic* (Kafewo, 2006, p. 21). Through my field research on Ghanaian media for the past eight years, I am aware that one of the main reasons for the paper's popularity is the daily cartoon feature, *Akosua*. In the next section, I briefly discuss Ghanaian political cartoon history as well as political satire as a way of making us appreciate both the global and local influences on *Akosua*'s work.

ON POLITICAL CARTOONS AND SATIRICAL CRITIQUES IN GHANA

A coherent history of cartooning in Ghana as well as the genre's entanglement with key sociopolitical debates is yet to receive scholars' focused attention (for notable exceptions, see Crobsen's [1984] work that uses poems and cartoons to reflect on Ghana's "retrogressive politics" from 1957 to 1981 [and beyond]; Jallow's [2014] work on *Ghanatta*'s cartoons [from 1961 to 1966] about Kwame Nkrumah, Ghana's first president; and Oduro-Frimpong's [2014] work on *Akosua*'s cartoons in Ghana's Fourth Republic). This situation is surprising as a pedestrian observation of this Ghanaian art form—at least from 1957 to 2016—shows a wealth of cartoons capturing Ghanaian sociopolitical realities. Furthermore, and especially within Ghana's Fourth Republic (beginning 1992–2016), one witnesses a clear surge in political cartoons/caricature than previous epochs in the country's sociopolitical history. Beyond *Akosua*, some of the prominent contemporary cartoonists in Ghana's Fourth Republic include *Tilapia, T-Spoon, Anadan, The Black Narrator, Daavi, Makaveli,* and *Bright Tetteh Ackwerh*. In addition to political cartoons, there has been and continues to be a tradition of using satire (or satirical humor) for social and political criticism. Within formal Ghanaian academic works, one can cite Kwabena Sakyi's (1915) satirical play *The Blinkards*, a biting critique of Ghanaians (or Africans) who uncritically accept foreign values and practices through a total rejection of their cultural traditions. Also, in Ghanaian popular culture one finds the use of "musical satire" as in Ghanaian highlife music where artists use folktales to criticize despotic acts (Yankah, 1995). Furthermore, one notes Kwesi Yankah's satirical writings such as *Abonsam Fireman* (in the Catholic Standard in the 1970s) and *Woes of a Kwatroit* (in the *Weekly Mirror* from 1986 to 1996). In these works, the author severely lampooned the idiotic actions of the military regimes at the time as well as certain irresponsible Ghanaian social behaviors. Within Ghana's Fourth Republic, there is steady upsurge in online satirical news (such as *yesiyesi.*

com, screwlife.com, and *Inside the News with Mpakoo*) dealing with contemporary Ghanaian sociopolitical foibles. The above discussion is to situate *Akosua's* cartoons as part of a long tradition of creatively blending global and local formats to articulate local concerns. In the sections that follow, I tease out and discuss the particular global and Ghanaian communicative aesthetics, which *Akosua* uses to address her audience.

Universal Cartooning Convention in *Akosua* Cartoons

In critically examining *Akosua's* cartoons, one certainly observes that they are situated within universally accepted conventions of political cartooning. Some of these conventions include use of a pseudonym, captioning, allusion, exaggeration, and symbolism. Below, I discuss the artist's skilful use of such conventions in one of her works:

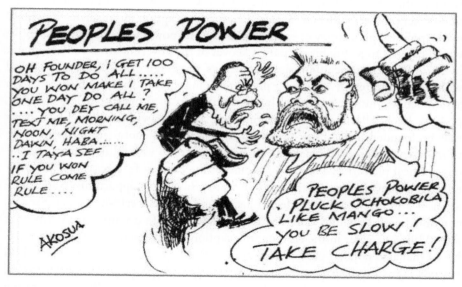

Figure 6.1: Peoples Power.

In this strip, the giant God-like character yells to the diminutive character: "In the name of the people...persecute our political opponent(s) with alacrity... You are too slow. Take charge!" [*People power. Pluck ochokobila like mango. You be slow. Take charge!*]. The tightly clutched, tiny character replies in frustration: "Oh Founder, I have 100 days to accomplish all these. Do you want me to take just a day to accomplish these requests? You have been calling me, texting me, morning, noon, night, dawn, why?? I am just fed up. If you want to rule, come and do it yourself" [*Oh Founder, I get 100 days to do all...You won make I take one*

day do all? You dey call me, text me, morning, noon, night, dawn, haba...I taya sef. If you won rule come rule].

The context of the cartoon references the beginning of bitter relationship between former presidents of Ghana, Jerry John Rawlings and Atta Mills. The context of this sour relationship can be traced from Atta-Mills' entrance into Ghanaian politics. Briefly, Rawlings handpicked him as his political successor and warded off stiff internal opposition from some old vanguards in the party. However, when he became president, and perhaps to assert his independent political identity, Atta Mills completely alienated Rawlings from his government.

The cartoon captures Jerry Rawlings' public and strident criticism of Atta Mills' inability and/or unwillingness to prosecute people Rawlings considered as his political enemies within the first hundred days of Atta Mills' presidency. In presenting this thematic issue, the artist uses the cartoon convention of caption evident in the boldened *"People's Power."* The caption encapsulates Rawlings' public political philosophy of exercising dictatorial power on behalf of the people, which he used to justify his military takeover of the government of Hilla-Limann in 1979. With historical hindsight, Rawlings' discharge of the "people's political wishes," manifested in "curtailing press freedom, gross human rights abuses such as 'abduction, murder, mayhem, [and] destruction of property'" (Oquaye, 2004, p. 400). Especially in popular imagination, and even within the political party that he founded, these facts have weakened Rawlings' moral authority to claim to represent ordinary Ghanaians. Yet he continues to evoke this mantra in various political platforms. Thus, *Akosua's* use of the caption feature of *People's Power* effectively conveys two key things. The first is Rawlings's opportunistic appropriation of a morally bankrupt idea to justify and pursue a selfish agenda. Second, combined with Rawlings' domineering caricature and (a deemphasized) aspect of Atta Mills' character in the cartoon, the caption and the general drawing crystallize a Ghanaian popular public perception of Rawlings. Specifically, this perceived persona is his overbearing personality within Ghana's political landscape as well as his raucous critique of all who disagree with him. In effect, *Akosua's* use of the above-discussed cartoon strategies symbolically captures the perceived public persona of Rawlings as dictatorial bully. As well, the seeming placating attitude of the minuscule Atta Mills character "in Rawlings" hands symbolically captures Atta Mills' public character as a peaceful politician (sometimes to a fault) interested in peaceful negotiation.

Another important accepted cartoon convention in *Akosua's* work is the use of a pseudonym. Thus, just like most African cartoonists, *Akosua* is a pseudonym. However, unlike other cartoonists I am aware of, besides signing each work piece with *"Akosua,"* the artist sometimes manifests the pseudonym in two ways. The first is a female child with spiky plaited hair and an oversized pencil. Below I

discuss this personified pseudonym evident in Figure 6.2: *Sheep Matter* depicting a legal courtroom scene.

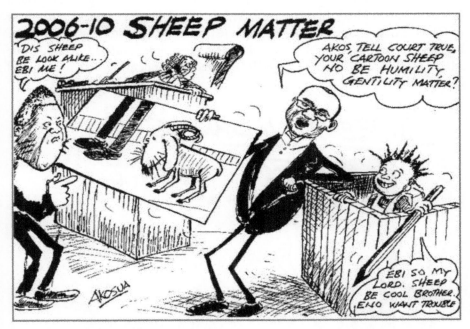

Figure 6.2: Sheep Matter.

Here, the complainant points to an artwork held by a defense lawyer and asserts: "This sheep is my look alike...It is me!"—['*Dis sheep be look alike...Ebi me!*—]. The lawyer then asks: "Akos, tell this court the truth: Is the subject of your cartoon regarding the sheep not about humility and gentility?" [*Akos, tell court true, your cartoon sheep no be humility, gentility matter?*] Akos, with a mischievous smile responds that "It is so my Lord. All Sheep are very gentle companions. They don't want trouble" [*Ebi so my Lord. Sheep be cool brother. Eno want trouble*]. The cartoon satirizes a defamation case that one Mr. E. T. Mensah (a Member of Parliament) filed against *Akosua* and *Daily Guide*. This case was subsequently dismissed for failure to concretely prove defamation. In this cartoon (just like Figure 6.3: *Supreme Warning*), in spite of penning her pseudonym at the end of her cartoon, *Akosua* personifies her alias in the form of a young and witty female.

At other times, the manifestation of *Akosua*'s pseudonym in her work comes in the form of an anthromorphic bird (which sometimes provides a meta-commentary on issues within the cartoon). An example of this bird is seen in Figure 6.4: "*Martrys: Memories...*," which recaptures one key aspect of the

bloody heydays of Jerry John Rawlings' Provisional National Defense Council (PNDC): the abduction and subsequent murder of three High Court Judges— namely Justice Sarkodie, Justice Agyepong, and Justice Koranteng-Addow (who was a nursing mother). In this cartoon, *Akosua*'s bird-persona, under the auspices of Ghana's democratic Fourth Republic, tearfully but resolutely asserts that the barbaric abduction and reckless execution of these personalities (including one Major [rtd] Acquah) should never be allowed to happen ["Oh abduction and kaput…Never again!"]

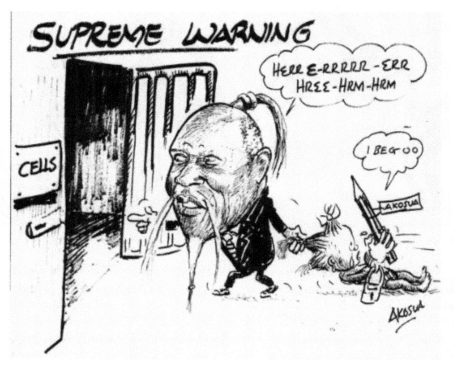

Figure 6.3: Supreme Warning.

What this analysis shows is that *Akosua* uses the global conventions of caption (indirect), allusion, exaggeration (caricature), symbolism, and pseudonym to articulate specific Ghanaian issues dealing with his advocacy for due process and issues around (suppression of) press freedom. In the next section, I closely examine how *Akosua* does not blindly use accepted cartoon conventions but rather appropriates them in consonance with Ghanaian communicative norms. Thus, the artist's works can be described as a distinctly Ghanaian cartoon media.

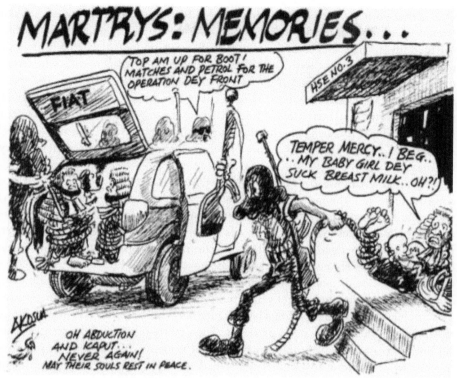

Figure 6.4: Martrys: Memories….

"Cultural Reconversion" in *Akosua* Cartoons

In examining the gamut of *Akosua*'s works, one observes a "cultural reconversion" (Garcia Canclini, 1992) of accepted cartoon conventions through specific Ghanaian sociocultural aesthetics. Yet the "transformed" works simultaneously retain the features of both the global and the local. Below, I examine three key elements of such cultural resources evident in her works: (innuendos through) allusions, circulating popular catch phrases, and varying Ghanaian lingua franca.

As previously noted, per standard cartooning conventions, most artists tag their pieces with pseudonyms and *Akosua* is no exception. However, the artist's pseudonym borrows from Ghanaian cultural practice of naming people according to the day they were born. Specifically, the artist's pseudonym draws from an Akan day-name for females born on Sunday. In consonance with this female name, the artist (who is in fact a male) sometimes represents this feminine identity in her cartoons and on television. In speculating why I think *Akosua* adopts this "voluntary condition of being other" (Newell, 2013, p. 5), I can propose three reasons.

One is that perhaps *Akosua* wants this female identity to be consistent with Akan (stereotyped) ideas of female indirect communicative style in public that is particularly indirect, witty, and sometimes caustic. Second, perhaps the artist wants this identity to be consistent with "traditional association of women with wit, fertile memory and traditional wisdom in Africa" (Yankah, 1995, p. 76). The other possible reason can be attributed to Ghana's current political environment where in spite of constitutional guarantee of free speech, exercising this right attracts violent retribution. Thus *Akosua's* consciously enacted anonymity is perhaps also a necessary response to the precarious nature of democratic political life in contemporary Ghana.

As already discussed, *Akosua* uses certain indirect rhetorical strategies to communicate her themes. One such tactic is the use of (innuendos through) allusions. This tactic in cartooning is not unique. However, *Akosua's* use of innuendo, which involves insinuated reproofs without specifically identifying a target, is also an acknowledged feature of public communication. For the Akan, *akutia* (innuendo) is also stereotypically assigned to women. Just like Akan public communicative ethos of *akutiabo* (communicative act of ambiguous innuendo use), *Akosua* is vague with her target's information and uses certain disguising strategies or clues, such as misspellings (see Figure 6.4 where *"martyrs"* is intentionally misspelt) to allude to an issue or target. Such strategic clues, however, provide subliminal context to interpret her messages (Yankah, 1995). Here, by presenting her work without any explicitly marked features, *Akosua* can wiggle out of any accusation of maliciously referencing a particular person or incident. One such visual allusion strategy through caricature is seen in Figure 6.5: *"Check-Up Return Show."* The cartoon depicts a bespectacled gentleman who seemed to have hurriedly hopped out from a just-landed airplane wearing stripped underwear and a workout t-shirt. Here, it is clear the gentleman is eager to prove (at least through the inscription on his workout shirt) to the press audience that he was energetic and healthy in the past, and is currently enjoying this state of affairs which will continue into the future ["Energy! Past Present Future"]. By demonstrating his ability to do a "Ghanaian jumping jacks" timed to an actual local rhyme "kye-kyekule," some audiences of this spectacle exclaim "you have stamina" [wo y3 vim], while others praise the gentleman's demonstrated robust health which will, presumably, enable him to tackle whatever tasks that lie ahead ["Comprehensive! You are ripe for the season"].

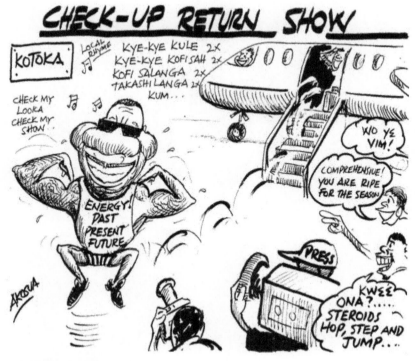

Figure 6.5: Check-Up Return Show.

The context of the cartoon was ex-president Mills' return from the United States after a "medical check-up" on June 12, 2012. Prior to his departure, the president had been conspicuously absent from important fora and also silent on key national issues. As a result, popular rumor contended that he was either gravely sick or dead. It was during this period of official silence on the president's actual health status that he called a press conference and informed the nation that he was about to travel to the United States specifically for a routine "medical check-up." When the president returned and got off the plane at the Kotoka International Airport, he offered a feeble jog, ostensibly to indicate his clean bill of health. Popular critical reaction to the President's "show" at the airport argued that his overeagerness to demonstrate his healthy status sought to mask an obvious untruth about his actual status. Thus, on various social media websites, such as *WhatsApp* and *Facebook*, this critique manifested in circulation of satirical photo-shopped images. An example is where the President's head was superimposed onto the image of the young and obviously fit Italian footballer Mario Balotelli, and caustically captioned (Figure 6.6) "I'm Fit Woaaa!! Balo Atta" [meaning: I am indeed very fit, Balo Atta].

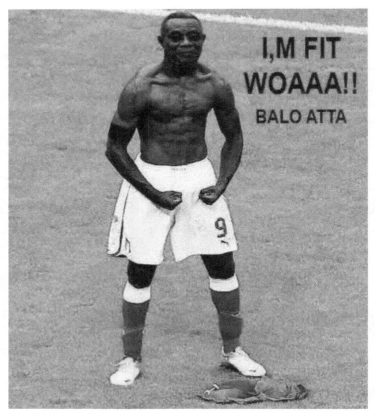

Figure 6.6: I'm Fit Woaaa!!! Balo Atta.

The cartoon "*Check-Up Return Show*" was thus an innuendo on the president's health and how unnecessary it was for him to have demonstrated how fit he was at the airport, especially from an obviously recuperating person. In the cartoon thus, no names were mentioned. However, at least, for those who knew the president, as well as the "performance" incident, one can strongly argue the cartoon was an innuendo critique of the president's actions.

The second allusion strategy that *Akosua* uses to index incidents or person-alities is the appropriation and use of circulating popular catchphrases in Gha-naian sociopolitical oral discourse as captions for her works. Some of these terms include "*All Die Be Die*" "*Gargantuan,*" "*Woyome,*" "*Pink Sheet,*" "*Chop Chop,*" "*Dumso-Dumso,*" "*Tweaaa,*" "*E Dey Be K3k3,*" "*Greedy Bastards,*" "*Babies with Sharp Teeth,*" "*Evil Dwarfs,*" "*Sakawa Budget,*" "*Akonfem Politics,*" and "*Ayaricough.*" These phrases, within popular oral discourse, are mnemonic expressions that ordinary Ghanaians use to simultaneously capture and access condensed significant socio-political issues. Thus the terms firmly index a rich oral archive on contemporary

Ghanaian sociopolitical political issues. In view of *Akosua's* university education and the relatively high illiteracy rate in Ghana, one can surmise that her artistic appropriation of these popular terms as captions to adumbrate her visual depictions is highly strategic. Here, one can argue that this strategy is to "signal solidarity with the broad masses of people"—and also—reduce social distance (Yankah, 2011, p. 6) between the cartoonist and audiences. The third dimension of *Akosua's* use of allusion is in the form of lyrics from popular music genres in Ghana such as highlife, hiplife, reggae, and protestant church hymnals. Here, the artist uses the lyrics to ventriloquize thematic messages in her work. An example of this "lyrical allusion" is seen in Figure 6.7: *Change Petrol Wahala.*

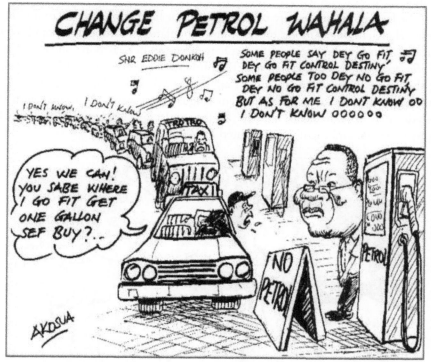

Figure 6.7: Change Petrol Wahala.

The cartoon is set against the background of some of the lyrics of a classic Ghanaian Highlife music titled "Destiny" by the late Senior Eddie Donkor. The song is about how "some people claim they can control destiny" [*Some people say dey go fit, dem go fit control destiny*]. However, the singer expresses his doubt when it comes to such claims since he does not "really know if this is achievable" [*As for me I don't know oooooo*]. Against this background of doubt, a taxi driver, the first in a seemingly long queue, at a fuel station that has "No petrol," angrily asks the

attendant (who is in the likeness of the late President Mills) by the name "Yes We Can!" whether he "knows where he can get at least a gallon [of gas] to purchase" [*Sabe where [he] go fit get one gallon sef buy?*]. To this question, "Yes We Can!" replies with bemused silence.

Here, by alluding to and using these lyrics, the cartoon highlights failure of and doubt about the National Democratic Congress government's promise to ensure the continued provision of certain basic social services that ease the life of the ordinary Ghanaian. All these disguising devices are used in public and political communication as well as in Ghanaian popular culture. The use of these rhetorical devices in *Akosua*'s work is in tandem with Ghanaian indigenous ways of communicating indirectly and with discretion (Yankah, 1995).

The last significant feature of *Akosua*'s work is her use of various common but major Ghanaian *lingua franca* to frame and articulate circulating and popular narratives within Ghana's sociopolitical sphere. Thus, in her cartoons, such as Figure 6.8: *Boom's Crucifixion*, the artist uses Pidgin English, a nonstandard English variety that sometimes includes a mix of any of the Ghanaian local languages. This predominantly popular urban Ghanaian language is mostly "associated with the less educated in [Ghanaian] society" (Huber, n.d.) and is accessible to both the highly educated and the not so educated in Ghana.

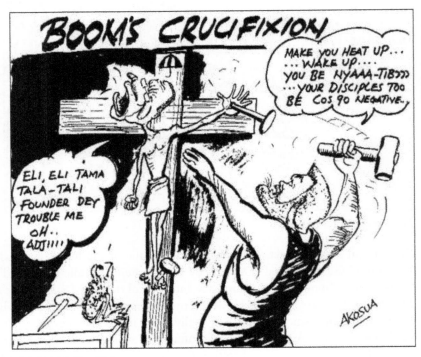

Figure 6.8: Boom's Crucifixion.

In this cartoon, Boom, the crucifier (with a semblance to ex-president Rawlings), asserts in Pidgin English: "You should heat up…[and] wake up. You are extremely timid and slow. And your disciples too are worthless" [*Make you heat up…Wake up. You be nyaa-tibɔɔ. Your disciples too be COS 90 Negative*]. The one being crucified yells "*Eli, Eli Tama Tala Tali. Fonder dey trouble me. Oh adjiii*"—My Lord, my Lord, why have you forsaken me? Founder is troubling me (said with a shrill cry of pain "adjiii" which is an Akan word). This cartoon was a sequel to Figure 6.1: *Peoples Power* where the artist satirized Rawlings' public critiques of his political protégé, Atta Mills, for not using all means to imprison people Rawlings considered his enemies. Here the cartoon alludes to the false charges that resulted in Christ's public execution on a cross. In doing so, the artist evokes a similar parallel to visually castigate, as highly unfounded and premature, Rawlings' actual public insults of Atta Mills (barely less than three months into his presidency) as a nonperforming president surrounded by incompetent ministers of state.

CONCLUSION

In this chapter, I have demonstrated how *Akosua*'s works empirically elucidate the glocalization concept in terms of how the cartoons are created out of the fusion of global cartoon conventions with local Ghanaian communicative norms to enunciate certain Ghanaian sociopolitical concerns. Doing so necessitated focusing on seemingly mundane aspects of the artist's work rather concentrating on the big issues highlighted in the cartoons (for example, authoritarianism, critiques of the justice system, lack of press of freedom and insecurity [at least for cartoonists]). This attention on the "ordinary" characteristics of the cartoons allows us to focus and explore the subtle processes involved in local negotiations of global phenomena so as to make them relevant in their new contexts. Here, it is instructive that as scholars we should also take the everyday seriously. The mundane is not only a "crucial site of cultural importance" (Fiske, 1995, p. 335) but also provides us with the grounded examples with which to interrogate our "serious" theoretical concepts.

In concluding, I answer a lingering question that I encounter regarding whether *Akosua*'s adoption of the global format of political cartoons helps her to be more relevant or appreciated in Ghana's public sphere. In answering this question, I am aware of the position that due to the high illiteracy rate in Ghana and its impact on the interest in newspapers, *Akosua*'s aforementioned strategy caters mostly to "a few literate elites." Inasmuch as I am sympathetic to this view, it is actually myopic, as it does not take several issues into account. One faulty assumption in the above perspective equates *Akosua*'s cartoons to written texts, which requires certain amount of formal education. As is clear, *Akosua*'s messages

are also visually mediated and not solely based on written texts. Furthermore, the artist's works are now part of morning newspaper review at some local language radio stations like *Adom F.M.* and *Peace F.M.* These reviews thus verbally mediate the messages in *Akosua*'s works to audiences not proficient in standard English, making nonsense of the view that one can access the artist's messages only through reading. In my assessment, I argue that *Akosua*'s strategic localization of the global format of political cartoons to mediate her issues and thus make it accessible to the ordinary Ghanaian makes her to be appreciated in Ghana. The evidence of her relevance, in my view, beyond audiences' avid interest in her works, lies in how she has inspired a whole new generation of recent cartoonists.

REFERENCES

Ashcroft, B., Griffiths, G., & Tiffin, H. (2000). *Post-colonial studies: The key concepts.* New York, NY: Routledge.

Crobsen, K. (1984). *Power to the people: Reflections on retrogressive politics.* Accra, Ghana: (n.p.)

Fiske, J. (1995). Popular culture. *Critical Terms for Literary Study, 2*, 321–335.

Garcia Canclini, N. (1992). Cultural reconversion. In G. Yúdice, J. Flores & J. Franco (Eds.), *On edge* (pp. 29–43). Minneapolis, MN: University of Minnesota Press.

Huber, M. (n. d.). Ghanaian Pidgin English. Accessed at http://lingweb.eva.mpg.de/apics/images/0/00/SurveyGhana.pdf.

Jallow, B. G. (2014). From Saint to Devil: The visual transformations of Kwame Nkrumah in *Accra Evening News* Cartoons, 1961–1966. *Stichproben: Wiener Zeitschrift für kritische Afrikastudien, 13*, 79–103.

Kafewo, S. (2006). *Research findings and conclusions.* African Media Initiative, Ghana Way Forward, BBC World Service Trust.

Kraidy, M. M. (2003). Glocalization as an international communication framework? *Journal of International Communication, 9*(2), 29–49.

Lee, A. Y. L. (2005). Between global and local: The glocalization of online news coverage on the trans-regional crisis of SARS. *Asian Journal of Communication, 15*(3), 255–273.

Meyer, B. (2015). *Sensational Movies: Videos, Vision, and Christianity in Ghana.* Berkeley, CA: University of California Press.

Moran, C. K. (2006). The global expansion of children's television: A case study of the adaption of Sesame Street in Spain. *Learning, Media & Technology, 31*(3), 287–300.

Newell, S. (2013). *The power to name: A history of anonymity in colonial West Africa.* Athens, OH: Ohio University Press.

Oduro-Frimpong, J. (2009). Glocalization trends: The case of Hiplife music in contemporary Ghana. *International Journal of Communication, 3*, 1085–1106.

Oduro-Frimpong, J. (2014). "'Better Ghana [Agenda]'?: Akosua's Political Cartoons and Critical Public Debates in Contemporary Ghana (pp. 131–153). In S. Newell & O. Okome (Eds.), *Popular Culture in Africa: The Episteme of the Everyday.* London: Routledge.

Oquaye, M. (2004). *Politics in Ghana, 1982–1992: Rawlings, revolution, and populist democracy.* Accra: Tornado Publications.

Rao, S. (2011). Glocal media ethics. In R. S. Fortner & P. M. Fackler (Eds.), *The handbook of global communication and media ethics* (Vols. I & II). Oxford: Wiley-Blackwell.

Robertson, R. (1992). *Globalization: Social theory and global culture.* Newbury Park, CA: Sage Publication.

Robertson, R. (1997). *Comments on the global triad and glocalization.* Paper presented at the Globalization and Indigenous Culture Conference, Institute for Japanese Culture and Classics, Kokugakuin University, Tokyo.

Wasserman, H., & Rao, S. (2008). The glocalization of journalism ethics. *Journalism, 9*(2), 163–181.

Yankah, K. (1995). *Speaking for the Chief: Okyeame and the politics of Akan royal oratory.* Bloomington, IN: Indiana University Press.

Yankah, K. (2011). *Dzi Wo Fie Asem: Rhetoric and the politics of Expediency.* Occasional Lecture under the Auspices of the Ghana Academy of Arts and Sciences, June 22, 2011.

The Silesians in a Global Perspective: Communication with the Dominant Group in the Local and National Context

MARIA SZMEJA, UNIVERSITY OF SCIENCE AND TECHNOLOGY, KRAKÓW, POLAND

The limits of my language means the limits of my world (Wittgenstein, 2012, p. 64, Proposition 5.6). This quote by Ludwig Wittgenstein is often recalled in theoretical discussions about communication. It is especially apt considering the problems of Silesians, a borderland group: they live at the German–Polish–Czech border, in other words, at the Slavic and the Germanic border. Their communication with the dominant national group has always been difficult. The Silesians are culturally and linguistically distinct. They have always encountered limits and communication problems in contacts with their neighbors.

In this chapter I address communication problems between the Silesians and the dominant group. The Silesian language, an ethnolect, is difficult to understand by people from outside Silesia; it is not uniform and Silesians themselves have trouble with its codification. The Silesian ethnolect is a mixture of Polish and German. It has no written form and its structure is different from Polish which makes it difficult in communication outside the group. It follows Polish language grammar rules, while its lexis is intermingled. Apart from Polish archaisms, there are also German words inflected according to Polish rules or with Polish suffixes. Some phrases, e.g., devoted to technology and administration, exist only in the

German version acquired while the Silesians lived in Germany. Both dominant groups (German and Polish) treated the ethnolect with contempt; both of them considered it as a version of their own language that was damaged and polluted by foreign influence. I will demonstrate the communication challenges in the Silesians' fight for the group's rights. The discrepancy in perspectives of dominant group and the Silesian minority is so considerable that it creates communication barriers. I will concentrate on the challenges posed by this gap. To address these issues I examined a variety of texts including websites, newspapers, and museum exhibits between 2000 and 2016. I analyzed websites of Silesian's language associations: Danga and Pro Loquele Silesiana and internet pages of Silesian Autonomy Movement (Ruch Autonomii Śląska-RAŚ) and the Association of the Population of a Silesian Origin (Stowarzyszenie Osób Narodowości Śląskiej-SNOŚ). I observed marches organized by RAŚ. My data also include the local press and professional publishing on Silesian history. I attended exhibitions: The Grandfather from the Wehrmacht and the History of Silesia (in newly opened Silesian museum in Katowice). I collected materials until achieving saturation of the sample.

HISTORICAL BACKGROUND

The history of Silesia is complicated as it unfolded within the Silesian, Czech, and Austrian duchies, the German monarchy, and the German state.[1] Following World War I, Silesia was divided between Poland and Germany. Silesians living in the borders of different states did not experience the direct influence of the rulers for a long time. They lived in their own local communities until the mid-19th century, when Chancellor Otto von Bismarck began to unite the country and create the modern German nation. A wide range of expectations, obligations, and limitations was imposed on Silesians then. For instance, employees were granted the right to receive pension, health and accident insurance, but in return they were obliged to comply with the rigid rigors imposed by the state (Davies, 1991, pp. 150–168). Apart from compulsory schooling and military service obligation, they were also required to speak German (Dziewulski, 1972, pp. 68–101; Gawrecki, 2011, p. 62). Those who lived in the rural communities, among similar people, had no need to learn the foreign language. For an average Silesian inhabitant, German as a language was not necessary for social functioning. But it was required that all the people working in industrial cities switch to the language and the way of communication outside their local community. This, of course, was not easy, as many people knew enough language only for basic communication which created numerous problems. The limits of the Silesians' world broadened, though only partially. German was necessary only in the work environment. For this reason, German technical and organizational terminology was acquired,

especially when industry started to develop rapidly and experts from the heart of Germany arrived in Silesia. They looked down on the Silesians, especially on the workers. Not only were they unqualified, but also it was difficult to communicate with them (Dziewulski, 1981, pp. 40–93), whereas the educated Silesians discovered the richness of German culture in which they actively participated becoming Germanized (Dziewulski, 1981).

A similar situation occurred in Silesia after World War I in 1921 when the eastern part of the region was allocated to Poland. The Polish civil servants and engineers arriving in Silesia perceived the Silesian ethnolect as "a strange incorrect Polish" (Kopeć, 1986; Meisner, 1981). The ones who started speaking Polish and got involved in Polish cultural circles were considered lost to the group. They spoke Polish, understood Polish culture, and moved within its scope. Just as their ancestors in Germany, they stepped out of the Silesian group (Kopeć, 1986).

How did the Silesians see this? In their history, they had always been dominated by the stronger national groups living next to them. Both in the German and Polish times, the situation was similar. There were, of course, some forms of contestation of the situation, or even resistance against it, but they were doomed to failure. In the modern German times, especially in the Nazi era, all forms of opposition or attempts to emphasize a different identity or culture were punished by a death sentence (Lesiuk, 1981, pp. 321–375). Since 1936 the Silesians presented their cultural image in a way that complied with the expectations of German authorities. First names, last names, and geographical names were changed into ones which sounded German. Speaking Silesian, called *wasserpolnisch*, "diluted Polish," was forbidden (Madajczyk, 1996, p. 121). In 1945, when almost the whole of Silesia was allocated to Poland by postwar accords, the region was Polonized through methods similar to the earlier Germanization. Again, first names, last names, and geographical names were changed, and German as a language was forbidden (Madajczyk, 1996, p. 121). Additionally, the Silesians were "nationally verified"; they had to prove not only their command of Polish, but also the knowledge of Polish culture. When they failed to do so, they were resettled to Germany[2] (Misztal, 1990). Thus, the communication with the dominant group amounted to the unconditional subordination and submission.

HOW CAN THE SILESIANS WIN POLITICAL AND SOCIAL ACCEPTANCE?

This short historical introduction is essential to understand the present-day situation. First of all, democratization of social life after 1989 made it possible for the Silesians to publicly express their distinctiveness. While this distinctiveness is not

commonly accepted, it is now manifested. Previously, Silesians were subordinated to either German or Polish. Thus, they could not be themselves, they were not allowed to communicate in their own language, their cultural code was seen as incomprehensible and scorned, and the customs were perceived as obscure. They contested the obligatory assimilation by maintaining their Silesian identification as ethnic. They could maintain it while being forced to choose either the Polish or German nationality nonreflectively (Szmeja, 1997; Szramek, 1934).

Why do the Silesians maintain their separate ethnolect? Even though the Silesian ethnolect was forbidden both in German and the Polish People's Republic times, it remained a form of communication within the group (Furgali ska, 2010; Linek, 2014, pp. 21–38). Nowadays, the activists of the Silesian movement intensively strive for recognition of the Silesian ethnolect as a regional language. Associations such as Danga, or Pro Loquela Silesiana work on codification of the methods of sound notation that are different from the Polish ones. This is essential to the next step: introduction of the language to schools. At the same time, too strong pressure on using the group language is also problematic. It results in narrowing the cognitive perspectives, cultural monotony, the lack of confrontation with others, and other limitations. The positive aspect of intensive contacts within the group is the rise in the awareness of the belonging to the group and the enforcement of the cultural standard.

The question can always be asked of a minority group whether it would not be more practical to switch to Polish? Would it be easier for the children to complete education if they spoke fluent Polish? There is no educational opportunity in Silesian because there are no schools or teachers capable of teaching in this language. So why is the ethnolect so important? Basically, the Silesians need Silesian to maintain the awareness of their group distinctiveness. Most definitions of nation, ethnic, or national group emphasize the distinctive cultural features of a group, including its language. This is one of the basic criteria used to define themselves. The language differentiates the group from others, allows exclusive communication within the group, and strengthens cultural specificity (Nash, 1993, pp. 3–7; Weber, 1978). Language is also a means of communication that helps draw lines between groups: the ones who speak the same language live within the similar cultural symbolism and understand the world in a similar way (Barth, 1994).

The problem which makes Silesian dialogue with the dominant group difficult is that in the past the Silesians were unwilling to pursue higher education. Secondary education meant stepping out of the group: switching the language and the customs would bring acculturation. The parents made sure their children had a specific profession, which would help them find a job without leaving the local community (Rauziński, 1997, pp. 13–18). There were no elites who would express the group's interests. There were no politicians who would fight for the right position of the Silesians in the Polish or German state. Both in the Polish

and the German times, the Silesians locked themselves up in their communities away from the unfriendly surroundings. A few politicians who originated from the Silesian group were active in the Polish or German political scene and therefore automatically entered those cultural circles. In the long history of the group there was no party advocating for the Silesians' interests or activists speaking on behalf of the group. The missing element were the bicultural people who would be faithful to their mother culture, not lose their Silesian identity and still be able to communicate with the dominant group. Furthermore, the Silesian ethnolect is a colloquial language that does not have many words, phrases, and terms, which are necessary to describe complicated social reality. The ethnolect is not lexically rich. It lacks abstract and scientific (physical, mathematical, chemical, philosophical) words, and is suitable to discuss mainly day-to-day matters. If the lexis is enriched, the Silesian ethnolect will remain colloquial. Codification procedures concern this form of language—the language of everyday problems expressed in the group. No attempts have been made to shape a literary form. Lexical borrowings, when its own neologisms have not appeared, do not enhance communication. So not only the codification, but also the enrichment of the ethnolect should be the target of the leaders who want it to become something more than just a local dialect.

The ethnolect is still important for the group because using it makes them feel safe. The ones who communicate in Silesian share similar culture and value system. They belong to their own group. The communication in this language is different than in the language of the hostile dominant group.

The Nature of Silesian Communication

Silesians are proud of their language and its command is regarded as a significant criterion of the group affiliation. In this section I will show how Silesians strive to overcoming reservations and embarrassment about the ethnolect. They try to make the language operative in the region and even the second official language.

For the Silesians, the exclusiveness of the language, its poor understanding by the people outside the group, creates feelings of trust and safety. It became clear during the National Census in 2002 and 2011. Full-scale action propagating the declaration of Silesian nationality in the census was successful thanks to the use of the ethnolect. Even the people who were not certain of such self-determination changed their mind when the argument was presented in their own language. It was expressed in statements such as: *niy ma gańba być Ślunzokiem* (there is no shame in being a Silesian), *Jo zech Ślunzok* (I am a Silesian). The turnout was significant: in 2002, 173,000 people declared to be Silesians, and in 2011 the number was up to 849,000. Between the two censuses there was also an increase in the dissemination of their own language among the Silesians.

Speaking the ethnolect has become fashionable among the educated Silesians who emphasize their roots. They organized to work on the codification of the language to encourage national declaration in the census. Silesian publications and publications in Silesian have appeared. The books written in Silesian, even though there is no official codification, are extremely popular (Furgalińska, 2014; Melon, 2014, 2015). These are crime novels set in Silesia and concerning Silesian history, myths, funny stories, and jokes. There are translations of classical literature into Silesian ethnolect, which proves the increasing levels of education among Silesians—they know literature and can translate it (Kadłubek, 2013; Syniawa, 2014). Obviously, such publications do not appear on the reading list of an average group member. This is rather a pun of educated people who want to challenge their translation skills and adapt Dante to the ethnolect. The Silesians have become active in the local and national media. Both in the social and traditional media there are people explaining the ideas and aims of the group.

The Silesian activists started a Facebook page in Silesian which enabled exchange of information in this language. This is a huge achievement as it is particularly attractive for the younger generation. At the least, Facebook connects all the generations of Silesian inhabitants. The online communication helped a lot in the agitation before the 2011 census. Now it is a forum for exchange of information and comments on the legal aspect of claiming an ethnic minority status.

The Silesians are lobbying the government for a minority status. With the support from the MPs from their region, they have submitted a citizen-initiated bill to amend the Act on National and Ethnic Minorities in Poland. Its public hearing took place in the Sejm (the lower chamber of the Polish parliament), but even with the declared support of the MPs, the case got stuck in the parliamentary commission. For now there are no apparent results of these actions but the issue of Silesia crossed the regional borders and reached the national scope. A handful of activists were mobilized to communicate strategically and start a dialogue.

The Global and Local Scope

The Silesians are fully aware of their rights. The Silesian elites constitute a minor group but its members are young and well-educated. When they go abroad, they compare themselves and the rights they have with minorities in other countries, e.g., the Basques, or the Germans in South Tyrol. They engage in dialogue with the dominant group, demonstrate their distinctiveness and campaign for acknowledgment as a national or ethnic minority, rights to parliamentary representation, and the right to use their language in public and to learn it in school.

They fight for equality in many ways by appealing to commonly applicable rights, such as human rights, the right of association, the right to civil liberties, and the freedom of movement. They are aware that even though they are a minority,

in a democratic environment they are not constrained or subjected like they were in the past. At the same time, they follow the law precisely[3] and meticulously. For example, after their campaign for a national group status was harshly criticized by the authorities, they undertook a laborious legal action. The representatives of one of the organization, the Silesian Autonomy Movement (*Ruch Autonomii Śląska*), were the initiators of the efforts to register the Silesian nation in the District Court in Katowice on June 26, 1997. First, the court accepted the petition and registered such a group as a Silesian nation, but after the appeal from the province governor in Katowice the court dismissed the petition on October 24, 1997. Later on March 18, 1998, the Highest Court decided that it is impossible to legally register the Silesian nation because such a nation does not exist. When this legal recourse did not succeed, the Silesians took the actions beyond the region. They turned to international experts and the Silesian Autonomy Movement appealed to the European Court of Human Rights in Strasburg, which sustained the decision of the Polish Court justifying that Polish law does not foresee such a form as a registration of a nation (Szmeja, 2004).

The actions of the Silesian Autonomy Movement are supported by a number of minor organizations which play an active part in numerous spheres. For instance, the Association of the Population of a Silesian Origin (*Stowarzyszenie Osób Narodowości Śląskiej*) in Opole promotes Silesian culture through their own publishing house. Books and periodicals published by them are distributed not only in Silesia, but also outside the region. Similarly the language associations, such as Danga, Pro Loquela Silesiana, try to popularize the Silesian language beyond the region. Elocutionary contests organized by the Upper Silesian Union (*Związek Górnośląski*) are broadcasted on the television as a titbit. Such small steps allow the Silesians to cross the border of their region. Every year at the beginning of July thousands of participants take part in the *March for the Autonomy* (*Marsz Autonomii*) which is becoming even more popular every year. Next, on the last Saturday of every January the *March on Zgoda* (*Marsz na Zgodę*) is organized. The route leads to the place where in 1945 in the empty premises of "Zgoda" plant, Silesians were kept captive only because they did not have Polish citizenship and had lived within German border until the end of World War II. There is evidence that proves that approximately 2500 people lost their lives in this camp. This march is to commemorate the death of these people and the Polish policy toward the Silesians.

There are also supraregional actions to spread the idea of gaining subjectivity by the Silesians. On July 9–10, 2015 the Silesian Autonomy Movement and the Free European Alliance held an international conference, *Silesia in Europe, Europe in Silesia*, in the town of Rybnik. The activists from different minority groups in Europe participated in this conference to advise what the Silesians should do to win acknowledgement of the dominant group and the right position in Europe. Thanks to this, the problems of Silesia gained supralocal dimension.

To become the hosts of the region, the Silesians want to reactivate the autonomy which the region had in 1920–1939. Obviously, the reactions of the dominant Polish ethnic group are negative. The conviction that Silesia will separate from Poland is widespread. The endeavors to obtain the status of an autonomous region are carried out through spreading knowledge about what autonomy is and convincing politicians of this idea. The step of crossing the boundaries of their own culture requires a lot of strategic communication skills: presenting an idea, choosing the arguments, selecting appropriate language for the message. Here, unfortunately, Silesians have problems constructing an effective message. This presumably results from relatively low education. The elite of the group is a really narrow circle of people, and those who have humanistic education is even fewer. They seem to believe the autonomy is a well-understood idea, and the reluctance of the politicians to implement it is caused by their own ill will. They are not aware that the national autonomy Silesia enjoyed before World War II was not a countrywide practice and is not commonly known now. The majority of Silesians and their activists do not explore the broader history and do not understand that before World War II the rates of illiteracy were 33% of the population in 1921, and 23% in 1931 (Landau & Tomaszewski, 1984, pp. 240–242). At that time, many illiterate people had very limited knowledge of other regions as poverty and the lack of means of transportation restricted travel beyond one's own village. To the inhabitants of the Polish eastern frontier, Silesia in the west was a distant and unknown territory. The prewar education was burdened by the regime propaganda. This explains why many Poles today think that the autonomy postulate implies the separation of Silesia and consequently concerns about a dissolution of the country are widespread. This misconception is often shared by the people in power who do not know history well enough.

Mainstream media do not provide information about the cultural specificity of the region. The official history presents Poland as culturally homogeneous. Polish populist politicians appealing to the idea of homogeneous national culture perceive any kind of distinctiveness as a threat and try to eliminate it. As pointed out by Margaret Archer, the myth of cultural integration is so strong that people do not know that different social and cultural phenomena are not identical in both groups (Archer, 1996, pp. 1–21). The ethnic Poles are not able or willing to accept Silesians' different perception of the world, different construction of the reality, and a different identity. This is the reason why the Silesians should, for now, concentrate on explaining their ideas, rather than on putting them into action. So the above-mentioned problem reappears: there are not many people who could be able to do it. The elites of the group are sparse; there are no talented politicians, publicists, or local activists among them who could explain and persuade the dominant elites. Evidently, there is a small group of enthusiasts of the Silesian movement but these are not professional politicians, but only local activists. They have not been

able to construct an effective and sustained communication campaign. Additionally, when the well-educated people speak for the Silesian ideas, they appear to be unconvincing and inauthentic, because of the stereotype of a Silesian as a manual laborer, such as a minor, steelworker, or cleaner. The Silesians are thus limited by prejudices and stereotypes held by the dominant group as demonstrated by Robert Rauziński (1997).

Silesian Activism

In addition to legal campaign for formal acknowledgement of their group as a nation, Silesians engage in media activism. After various contacts and consultations with the representatives with other minorities in Europe (the Basques, the Scots, the Catalans, the Frisians, and the Sothern Tyrolean), they started a large-scale information campaign about their situation. The Silesians have learnt from these groups how to emphasize their cultural and historical distinctiveness and how to communicate it to others. There are historical pieces written by young Silesians where they disclose the history of the region from the perspective of the indigenous group. Additionally, they also refer to works of well-known scholars. For example, the undisputable authority in historical affairs of Central Europe, Norman Davis, when writing about the universities founded there cites sources which mentioned that in Prague four nations were educated: the Czechs, the Silesians, the Bavarians, and the Saxons (Davies, 2003, p. 155). They also mention a 16th-century figure of Anselmus Euphorinus who studied at the Kracow Academy, went down in the history as a Silesian, not a Pole (*Tuus et suus, Anselmus Ephorinus, Silesius non Polonus*). These are presented as strong arguments for the distinctiveness of Silesia. But ethnic Poles do not give them much credence. The Silesians who want to demonstrate their distinctiveness even reach for contributory arguments, not valid from historical points of view. Comparing the national declarations from the 16th century with the contemporary ones is a methodological mistake. In the past, the nations in contemporary sense did not exist. Hence the affiliation to a particular group indicated only the region of origin, but not the nationality in 21st-century sense. However, presenting such arguments by the Silesians makes people think, and broaden their knowledge. At the same time, the Silesians learn not only about their situation, but also the situation of other minority groups and the dominant group. Therefore, the local problems acquire a global dimension. This illustrates Roland Robertson's assertion that globalization involves linking of localities as well as an "invention of locality" (Robertson, 1996, p. 35). Following Robertson, Silesians' assertion of their identity is not a reaction against or in tension with the global but rather it is an expression of global dynamics.

In Poland, where the number of minority and ethnic group members is scarce and amounts to 3.6%, it is difficult for particular groups to fight for their rights (stat.gov.pl). The Silesians invoke the case of another minority group, the Kashubians, whose distinctiveness is accepted. The Kashubians are acknowledged as a language minority. Their history and cultural specification is to some extent similar to the Silesian one, because for many centuries the Kashubians also lived outside the Polish state. However, they did not reject the identification with the Polish nation, emphasizing only the cultural differences. This is a different situation than the Silesian one.

What Meaning Do They Constitute?

Why do the Silesians have to work hard to explain not only the difference in the past of the group, but also the cultural context? Silesian activists, who are aware of their imperfections in communicating with the dominant group, have managed to enlist people with strong academic positions who explain the history of the region. A historian living in Silesia, Ryszard Kaczmarek, is the author of a book *The Poles in Wehrmacht* (*Polacy w Wehrmachcie*), which tells the story of the Silesians (and not only) who during World War II had to fight in the German army (Kaczmarek, 2010). This interesting and controversial work helps to understand the situation of the borderline group and the social realities in which they lived. This book tries to convince the ethnic Poles that the Silesians did not always (or rather rarely) had the power to decide their fate and their actions. For example, Silesians suffered repercussions from ethnic Poles in 1945 as a result of being forced to fight in World War II by the German authorities and not for their own cause.

The group's past is also communicated through exhibitions of photos and documents relating to Silesia which are widely reported on in the media. A recent exhibition *The Grandfather from Wehrmacht* (*Dziadek z Wehrmachtu*, 2015) showed photos, war letters, frontline maps, and army documents of the Silesians conscripted to the German army during World War II. The exhibition circulates around Silesia and in the future will be presented in the capital city. Both ventures, the book and the exhibition, clearly aim to inform and explain to Polish inhabitants why the Silesians have a different past from the rest of Polish residents, and why the Silesians fought on the other side of the front line. Such an indirect form of communication is very apt because it emotionally involves either the ones to whom it concerns or the ones who receive it. There is no direct confrontation of opposite positions. But the Silesians watching this exhibition are often emotionally touched; they talk about the death of loved ones at the front, their sufferings, and that the group's self-determination was always curtailed.

Of course, it takes a lot of time too for the information to reach and convince the representatives of the dominant group. The situation was completely different than when politicians from all the parties in Poland protested against the exhibition in the Silesian Museum in Katowice presenting the multicultural heritage of Silesia which led to the dismissal of the director who dared to show the Silesian point of view. After long disputes, the museum was finally reopened, but it presents the history and culture of the region in a way that is agreeable to the majority but not genuine from the Silesian perspective. This is also how the ethnic Poles, the dominant group, want to see the Silesian region.

Some teachers joined an information campaign about the specificity of Silesia. Teaching children tolerance for diversity and making them interested in a different culture brings results after many years. It seems that Silesian teachers can show non-Silesian children the origins of Silesian culture and thus open them up to cultural diversity. Silesians are also currently working on their group image. They want to be perceived as culturally and historically different, fighting for the autonomy of the region, determined, and yet law-abiding and loyal to the country. This is a difficult message in a country that perceives itself as monocultural.

Silesian Activism from the Perspective of Sociological Theory?

Undoubtedly, when we talk about communication of the Silesian minority with the ethnic majority, we are dealing with relations between a subordinate and dominant group. Here, the concept of internal colonialism by Michael Hechter (1977) is useful. He used the term to describe a situation in which one group imposes their cultural patterns and economic system on other groups living in the same society. In his model of social development, Michael Hechter emphasized the asymmetrical imbalance of power between the groups. In such a society the center dominates politically over the peripheries and exploits them materially. Consequently, there is further uneven economic development which divides societies into those advanced and more economically developed and those that are disadvantaged. Originally accidental superiority of one group over another reinforces the existing inequality of the resources and power distribution. In this situation, the dominant group, the one that is located in the political, economic, and cultural center, pursues possible stabilization and monopolization of its predominance. It does this through the appropriate definition of political objectives of the whole society and the institutionalization of the existing system of social stratification. Its main effort is to regulate social structures so as to reserve the privileged positions for the members of the dominant group and oust members of the dominated group.

Silesians do not quite fit to this model, because the region has always economically dominated the rest of Poland. Even now, when heavy industry (mining, metallurgy) is not a mainstay of the economy, this region is functioning well. However, the cultural and political predominance can be sensed and raises the opposition of Silesians who are no longer willing to assimilate to the dominant group. Instead, the Silesians are trying to communicate to the dominant group that they have their own culture that includes the ethnolect, history, and aspirations to autonomy. As remarked by Michel Hechter, this is difficult because "Communication within collectivities generally occurs within the context of social institutions: neighbourhoods, workplaces, schools, churches, social and recreational clubs, and the host of voluntary associations to which individuals may typically belong" (Hechter, 1977, p. 42).

Homi Bhabha provides a postcolonial perspective on the impact of a dominant group on a subordinate group (Bhabha, 1990, pp. 1–8). Bhabha notes that this relation is important for the nation's way of speaking about itself, the way it narrates their story. It is not sufficient that the Silesians define their own group as a nation, they must convince the group that dominates them. In his interpretation of Tom Nairn, Homi Bhabha points out that

> to encounter the nation *as it is written* displays a temporality of culture and social consciousness more in tune with partial, over determined process by the textual meaning is produced through the articulation of difference in language; more in keeping with the problems of closure which plays enigmatically in discourse of sign. (…) Traditional histories do not take the nation at its own word, but, for the most part, they do assume that the problem lies with the interpretation of "events" that have a certain transparency or privileged visibility. (Bhabha, 1990, pp. 2–3)

Additionally, it is the "canonical cultural center" that is attractive to the writers from peripheral groups. They want to imitate it somehow, if not in the content, so at least in the form. Thus, the cultural specificity of speaking about regional issues, about a distinct nation is lost. It is not a cultural diffusion, as some would define it, but voluntary compliance and voluntary adoption of the standards of the dominant group. Peripheral subordinate groups should seek their own way of expression to keep their own representations of their own culture.

Communication between Silesians and the Ethnic Majority

Communication flows in both directions between Silesians and the ethnic majority. The Silesians demonstrate their different tradition and culture in a very committed way. They reach to the written history and *oral history* to convince Poles of a specific culture that they developed on the border. The ethnic majority definitely rejects the Silesian message and sees Silesian culture as a variation of Polish

culture. They present a past which defines Silesians as belonging to Poland, but simultaneously as not of Poland.

Means of Communication

The Silesians use a wide range of artistic means: comic books, posters, press releases, and books.

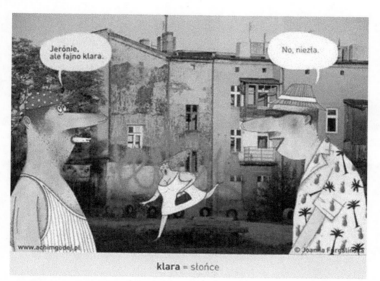

Figure 7.1: Klara by Joanna Furgalińska (2016).

The cartoon in Figure 7.1 presents a Silesian in a beret and with a cigarette in his mouth saying to an ethnic Pole wearing a hat and sunglasses: "What a nice klara." The ethnic Pole answers: "Yeah, not bad." The Silesian is talking about the sun, *klara,* and the ethnic Pole understands *Klara* as a female name—the picture illustrates a completely different meaning of words in Polish and Silesia ethnolect.

Silesians affirm their language. Silesian television TVS's presenters host their programs in the ethnolect, the Piekary Radio broadcasts exclusively in ethnolect. Teachers are encouraged not to forbid children to use ethnolect at school. Schools have classes about the history and culture of the region in the ethnolect.

Silesian also use social media (Facebook, Tweeter) to promote their ideas. They have websites informing about their activity such as www.autonomia.pl, www.zg.org.pl, www.danga.pl, www.facebook.com/silesiana.org, www.facebook.com/ruch.autonomii.slaska (a Facebook page in Silesian).

Silesian appears on the streets manifesting their aspirations.

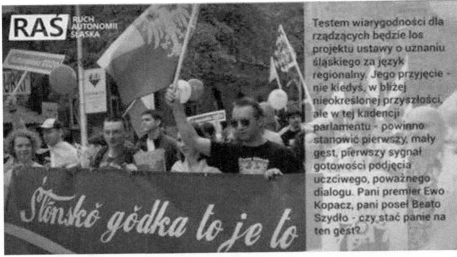

Figure 7.2: A Manifestation to Support for Ethnolect Codification (Wojnar, 2016).

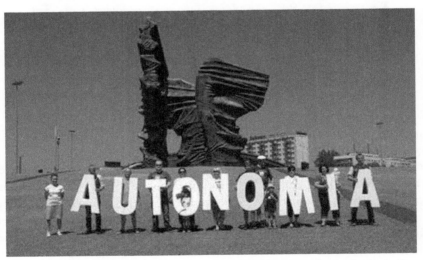

Figure 7.3: A Group of Activists Manifesting the Will of the Autonomy for the Region in Front of the Monument to the Silesian Uprisings (Wojnar, 2016).

Silesians publicly present and affirm their different past as exemplified by showing their version of history. Silesians also refer to their own symbols which are different from ethnically Polish ones such as the flag in the colors of yellow and blue in Figure 7.4 or the group emblem in Figure 7.5.

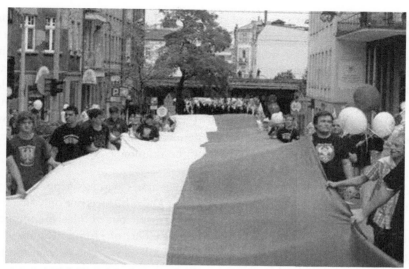

Figure 7.4: A Silesian Flag (www.autonomia.pl).

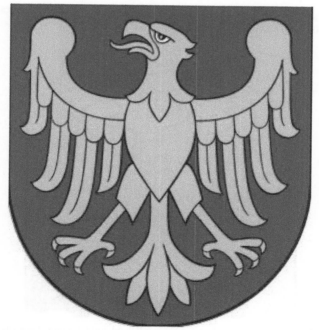

Figure 7.5: The Eagle as the Emblem of the Silesian Region (Łukasz Wojnar Stowarzyszenie Osób Narodowości Śląskiej—The Association of the Population of a Silesian Origin).

The ethnic majority uses a variety of scare tactics in opposition to the question of national autonomy. The majority is often unaware of the history of the region and is afraid of Silesia breaking away from Poland. For example, one of the opposition politicians called Silesians' actions "a camouflaged German option." The overtone of this statement was that Silesians, like The German Fifth column,[4] are not loyal to Poland. This statement demonstrated the threat from the historical enemy of Poland—the Germans. The ethnic majority also contested the exhibition showing the history of Silesia prepared for the Silesian Museum and dismissed its director. Only one vision of the past recognized by the dominant group is accepted and differing regional perspectives are rejected.

Articles in the local press portray Silesian activists as thugs supported by the German Government or as persons who do not know history, but only "make up" their history of the region. The national press is suspicious of Silesians' intentions in the coverage of their appeal to the European Court of Human Rights for the recognition of the Association of Population of a Silesian Origin or their meetings of the representatives of other minority groups in Europe. The press argues that these groups, especially the Basques or the Irish, train the Silesian to act against the state. In promajority portals in Silesia and in the regional press, panels of experts present historical links between Silesia and Poland.

Figure 7.6: The Map of Two Neighboring Countries: Poland and Germany, Silesia Is Still Embedded in Poland but Is Being Torn Out (www.lospolski.pl).

All government offices and official sites in Silesia display only Polish national emblem: a white eagle on a red background, a white and red flag as in Figure 7.7.

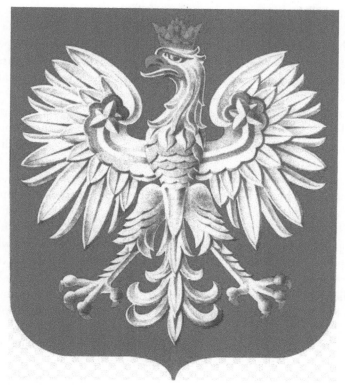

Figure 7.7: The Emblem of Poland: A White Eagle on a Red Background (www.prezydent.pl).

The Silesians direct their messages to their ethnically Polish neighbors so that they acknowledge and respect their differences. They turn to the government leaders to persuade them to grant greater civil liberties to the group. They also communicate with European institutions in their efforts to achieve ethnonational freedom. Their appeal to the European Court of Human Rights in Strasbourg gave the Silesian activities a European dimension, beyond the local one. Silesians' communication campaign crosses the borders of their community, region, and country. Silesians' efforts have a global dimension in that they are part of a global process of groups claiming their cultural minority rights. Through this process, culturally particular rights become universal rights. Silesians also communicate with the members of their own group that they are determined to fight for their rights as an ethnic minority and a nation. It musters other Silesians into action, gathers them around a particular purpose, improves the flow of information within the group, allows them to develop a common strategy. Silesians' ethnic and national identity is undoubtedly getting strengthened; the people who have not been fully convinced are changing their minds.

The ethnic Poles, in turn, communicate not only to the Silesians, but also other ethnic and national minorities, that they themselves set the rules in the legal and cultural sphere and that other groups may gain access only when given permission. The ethnic Poles do not have to appeal to Europe or the world because they are the dominant group in a country where minorities account for only about 3.6% of the population. Silesians total to 2.2% of 38 million Polish citizens. It is very hard for such a small ethnic group to challenge the dominant group to consider their desires and expectations. What is the result of this asymmetrical communication?

The Silesians' campaign is directed at multiple audiences including ethnic Poles, the international European community, and their own group; it thus has a transnational dimension. As Silesians try to convince their opponents, they have to construct convincing and persuasive arguments. They are thus developing better communication skills. They also develop more in-depth knowledge of their own history and build stronger Silesian identity. Silesians have to use diverse strategies in their appeals to the dominant group and consider which symbols will be well received, and which ones will arouse controversies. For example, they juxtapose the emblem of Silesia, the Piast eagle, with the Polish royal the Jagiellonian Eagle, but not with the stylized German eagle. Of course, they omit the common symbolism, which can be the similarity in the language, because they want to emphasize the differences.[5]

The communication directed to their own group is unambiguous and consistent. They emphasize the specificity of Silesia and their unique history and their distinct experiences such as the national verification, displacement, deprivation of property while passing over the history of the Polish state. Oral history and personal family histories are considered most desirable and reliable. Especially the memories of the Tragedy of Silesia mentioned by the oldest members of the group are treated as evidence of the Poles' prejudice against the native inhabitants of Silesia. The phrase "the Tragedy of Silesia" has been introduced recently to concisely name the events that took place in Silesia after the invasion of first the Soviet, and later the Polish troops. It highlights the domination over Silesia and subjection of the inhabitants to repressions for having lived in the German state. Rapes, displacement, detention (1945–1947), deprivation of property, deprivation of civil rights (1949), these are the events which the Silesians want to remind the Poles who either diminish or ignore them. The commemoration of the Tragedy of Silesia consists of a solemn march in January from the city center of Katowice to the Zgoda Camp in Świętochłowice where, among others, Silesians were imprisoned. These marches began in 2009 and are very disconcerting for the representatives of the dominant group.

The ethnic Poles take a paternalistic stance toward Silesians and do not take into account their feelings. For example, they claim age-old Polish identity of the region and reproach them for their actions during World War II. The phrase "a

camouflaged German option" communicates aversion toward Silesians for their supposed bonds with the enemy and the fear of the Germans and the potential attack from their side. The rhetoric is obvious: the Silesians have a lot of sins on their conscience and should not claim any rights. Any reproaches from Silesians are displeasing. Any wrongdoing on the part of the ethnic Poles against Silesians is minimized or even ignored. It is common to explain that the Silesians know the history too little (because they are poorly educated) and should listen to the wiser, i.e., the representatives of the ruling elite of the country, who know how to interpret the history. If the Silesians do not accept this version, they prove their links with the Germans, the enemies. It sounds like a dominant postcolonial message toward the subordinated. The Silesian arguments are completely ignored. The currently ruling party as well as all the opposition parties are unanimous in their view of Silesia. Silesians are not "real" Poles, and should not be trusted. Their requests for regional autonomy or recognition as a minority do not deserve consideration.

What is the supralocal, supranational result of the message? First of all, the Silesian issue has a global dimension. The appeal to the European Court of Human Rights in Strasbourg draws attention to how Poland is governed and the attitude toward the minority groups. The contacts with other minorities in Europe taught the Silesians how to strive for their case. The mobilization of Silesians in the National Census in 2011 showed that they have finally the courage to stand up to the dominant group and define themselves in their own terms. This is significant progress.

SOCIAL CONTEXT

Understanding of communication between two individuals or social groups has to take into account the social environment in which they are located. Andrew Tudor's communication model drew attention to the social determination of the communicator and the recipient of a message (Tudor, 1970, pp. 92–104). According to Tudor, both the communicator and the recipient take a specific social position which determines both the choice of the medium and the language of the medium and culturally determines certain sets of values. Therefore, both the Silesians and the ethnic majority know very well what the other party might claim, what to expect from the social base, and which media to use. These are not casual conversations or argument-based discussions. Those in power know at the start of a dialogue which expressions and positions the group expects; they know what they have to say. Similarly, the Silesian leaders are aware of the range of the problems that can occur and what they can afford to say in their negotiations with the other side. They are also aware what kind of behavior is expected from them by their own group. That is why the dialogue is not very effective. Poles have always

looked down on Silesians, paternalistically and indulgently, because they know that they themselves are strong and can dictate the terms, make arbitrary decisions, and assert their vision of history.

On the other hand, the Silesians seem to ignore the wider society. Their message aims only at those in power: the provincial governor, the prime minister, or the officials of the Ministry of Administration and Digitization (Internal Affairs in the country). They do not attempt to convince their fellow citizens of the validity of their claims to specificity. Maybe they are right, but there might be more effective communication if they address their arguments to average citizens. Silesians seem to believe that the history of their region should be known by everyone and that the interest in Silesia should be widespread throughout the country. This is a mistake, because just as they themselves ignore historical events in other parts of Poland, the majority ignores what happened and is happening in Silesia. The leaders of the group have made a great effort to convince all (or maybe just the majority of) Silesians to the need to strive for the status of a national minority. They succeeded in this. They could not, however, persuade the ethnic majority. When they assert a positive identity, this message is not well received by the ethnic majority. For example, Silesians point out that their region was the first to undergo capitalist development that made it more advanced than the rest of the country. This is a fact the dominant group does not appreciate.

By invoking values beyond local ones, e.g., human rights or European regulations, the Silesians want to improve their status. This is right, because they actually are treated badly. The question is whether they can effectively communicate their aspirations and needs. It seems that the comic books and drawings can entertain only those who use the ethnolect, so they aim at their own group. The demonstrations showing Silesian flag and emblem, the marches of the Autonomy and on Zgoda former camp also take place in the region, namely in Silesia. Polish residents learn about them from flashes on TV; these are random news and often presented in a sensational tone that is not always true-to-life.

FINAL EFFECT

It can be said that both groups communicate past each other only focusing on the perspective and in reactions of their own group and not the partner in dialogue. Neither group tries to act in the symbolic universe, i.e., the system of the values and symbols of the other group. Silesians react with embitterment and postwar trauma of repolonization. Throughout the communist period, i.e., under the People's Republic of Poland, they were forced to hide their distinctiveness and lived in fear of deportation from the country or imprisonment. Owing to the democratic changes and the Polish membership in the European Union, the Silesians feel more

confident and openly appeal for their rights. On the other hand, the ethnic majority interpret the situation differently. As noted by Elizabeth Hałas, the myth of a cultural community is used by all the members of the European Union, but they always have in mind only their own culture (Hałas, 2014). It is similar with Silesians and Poles, conducting the dialogue with reference to the global rights; they focus on very particular issues and their solutions. Unless external mediators make both sides realize that they need to be open to the arguments of the interlocutors, the dialogue will be condemned to repeat the same arguments in vain. It can be also said that modern democracy in Poland has lasted for a short time. Only the first generation has been experiencing it in practice: we all learn, we all make mistakes. Placing the Polish–Silesian dispute in a supralocal, European sphere will help to solve it in a milder manner. These cultural differences related to the European perspective can help in finding common cultural traits, and help mutual understanding.

NOTES

1. Between 1772 and 1795 Poland was divided by three neighboring countries: Austria, Prussia, and Russia. The reason for this was supposed to be Poland's inability to undertake reforms, although historians argue about this. The first partition took place in 1772 when Russia, Austria, and Prussia occupied only the border areas. The second partition happened in 1793 when Prussia and Russia took over large areas in the east and west of the country, reaching even to the center. Eventually in 1795 the third partition divided the country between Russia, Austria, and Prussia which meant that Poland ceased to exist as a sovereign country for 123 years until 1918, when the modern Poland gained back its independence.

2. The national verification of Silesians was conducted by Polish authorities since March 22, 1945 (so before the war ended!) until 1949, when it was decided that the Silesians who stayed in Poland and did not declare to go abroad are actually Poles.

3. The difference in approach to law by the inhabitants of the former areas under foreign partitions (Russian, Prussian, Austrian) is celebrated in the story of the 19th-century folk hero, Michał Drzymała, who wanted to build a cottage. Unfortunately this was against the law as the land he bought from a German merchant did not have the possibility to build a house by a non-German (a Pole in this case). To get away with this, M. Drzymała put up a wagon to live in. The law did not prohibit living in a wagon, and despite the hostility of Prussian clerks, he kept on living in the wagon. The law was strictly adhered to. If such a situation had happened in the Russian partition, the farmer would have been sent to Siberia or killed instantly. If it had been in Galicia (the Austrian region inhabited by Poles was called Galicia), the farmer would have bribed the clerks and there would have been no problem anymore. The Silesians living for generations in the rule of law are accustomed to act in accordance with the law and believe that on this basis they will prove their case.

4. The Fifth Column in Polish territory referred to those Germans who, as Polish citizens supported Hitler's policy and worked to the disadvantage of the country they lived in. They were considered traitors.

5. Linguists agree that Silesian language is a Slavic language which contains many archaisms of Polish language, but is enriched with German phrases with the advent of industrial lands in Silesia in the mid-19th century. The structure and syntax of the language are the same as in Polish.

REFERENCES

Archer, M. (1996). *Culture and agency: The place of culture in social theory.* Cambridge: Cambridge University Press.

Bhabha, H. (1990). *Nation and Narration.* London: Routledge.

Barth, F. (1994). "Enduring and emerging issues in the analysis of ethnicity" in H. Vermulen & C. Govers, C. (Eds.), The Anthropology of Ethnicity. Beyond Ethnic Groups Boundaries (11–33). Het Spinus. Amsterdam.

Davies, N. (1991). *Boże igrzysko.* Kraków: Znak.

Davies, N. & Moorhouse, R. (2003). *Mikrokosmos : portret miasta środkowoeuropejskiego : Vratislavia - Breslau – Wrocław.* Kraków: ZNAK.

Dziewulski, W. (1972). *Dzieje ludności polskiej na Śląsku Opolskim od czasów najdawniejszych do Wiosny Ludów.* Opole: Instytut Śląski.

Dziewulski, W. (1981). Dzieje Górnego Śląska w latach 1816-1847. In F. Hawranek (Ed.), *Dzieje Górnego Śląska w latach 1816-1947* (pp. 40–93). Opole: Instytut Śląski.

Gawrecki, D. (2011). W poszukiwaniu górnośląskich tożsamości. In J. Bahlcke, D. Gawrecki, & R. Kaczmarek (Eds.), *Historia Górnego Śląska. Polityka, gospodarka i kultura europejskiego region* (pp. 57–72). Gliwice: Dom Współpracy Polsko-Niemieckiej.

Hałas, E. (2014). Mit wspólnoty kulturowej w relacjach międzynarodowych. In G. Michałowska, J. Nakonieczna, & H. Schreiber (Eds.), *Kultura w stosunkach międzykulturowych* (pp. 33–45). Warszawa: WUW.

Hechter, M. (1977). *Internal colonialism The Celtic fringe in British national development, 1536–1966.* Berkeley, CA: University of California Press.

Furgalińska, J. (2010). *Ślónsko godka: Ilustrowany słownik dla Hanysów i Goroli.* Warszawa: PWN.

Furgalińska, J. (2014). *Achim godej: Ślónsko godko dla Hanysów i Goroli.* Warszawa: PWN.

Furgalińska, J. (2016) "Klara" (photograph). In J. Furgalińska, *Achimowy kalyndorz.* Katowice: Achim Godej.

Kaczmarek, R. (2010). Polacy w Wehrmachcie. Kraków: Wydawnictwo Literackie.

Kadłubek Z. (2013). "Prōmytojs prziby / Ajschylos ; ślōnskŏ translacyjŏ." Katowice: Wydawnictwo XX wieku.

Kopeć, E. (1986). *"My i oni" na polskim Śląsku.* Katowice: Wydawnictwo Śląsk.

Landau Z. & Tomaszewski J. (1986). "Zarys historii gospodarczej Polski 1918–1939." Warszawa: Książka i Wiedza.

Lesiuk, W. (1981). Śląsk Opolski w latach 1921–1939. In F. Hawranek (Ed.), *Dzieje Górnego Śląska w latach 1816-1947* (pp. 321–375). Opole: Instytut Śląski w Opolu.

Linek, B. (2014). *Polityka antyniemiecka na Górnym Śląsku w latach 1945–1950.* Opole: Instytut Śląski w Opolu, Dom Współpracy Polsko-Niemieckiej.

Madajczyk, P. (1996). *Przyłączenie Śląska Opolskiego do Polski: 1945–1948.* Warszawa: ISP.

Melon, M. (2014). *Komisorz Hanusik: Piyrsz kryminalno komedyjo we ślónskiej godce.* Kotórz Mały: Silesia Progress.

Melon, M. (2015). *Komisorz Hanusik we tajnyj sużbie ślónskiej nacyje.* Kotórz Mały: Silesia Progress.

Misztal, J. (1990). *Weryfikacja narodowościowa na Ziemiach Odzyskanych.* Warszawa: PWN.

Nash, M. (1993). *Ethnicity and nationalism.* London: Pluto Press.

Rauziński, R. (1997). Poziom wykształcenia społeczeństwa Śląska Opolskiego 1946–1996–2000. *Śląsk Opolski, 2*(25), 13–18.

Robertson, R. (1996). Glocalization: Time-space and homogeneity-heterogeneity. In M. Featherstone, S. Lash, & R. Robertson (Eds.), *Global modernities* (pp. 25–43). London: Sage.

Szmeja, M. (1997). Czy Ślązacy mogą czuć się Polakami? In M. Kempny, A. Kapciak, & S. Łodziński (Eds.), *U progu wielokulturowości: Nowe oblicza społeczeństwa polskiego.*Warszawa: Oficyna Naukowa.

Szmeja, M. (2004). Czy Ślązacy są narodem? *Przegląd Polonijny, 3*, 73–84.

Szramek, E. (1934). Śląsk jako problem socjologiczny. *Roczniki Towarzystwa Przyjaciół Nauk na Śląsku, IV.*

Syniawa M. (2014). "Dante i inksi. Poezjo w tłumaczeniach M. Synawy." Kotórz Mały: Silessia Progress.

Tudor, A. (1970). Film, Communication and Content." In J. Tunstall (Ed.), *Media Sociology* (pp. 40–50). London: Constable.

Weber, M. (1978). Ethnic group in: Economy and society. In G. Roth & C. Wittich (Eds.), *Economy and society* (Vol. 1, pp. 389–395). Berkeley, CA and Los Angeles: University of California Press.

Wittgenstein, L. (2012). *Tractatus Logico-philosophicus.* Warszawa: PWN.

Wojnar, Ł (Photographer) (2016, February 20). *A Manifestation to Support for Ethnolect Codification.* Personal Communication.

Wojnar, Ł (Photographer) (2016, February 20). A Group of Activists Manifesting the Will of the Autonomy for the Region in front of the Monument to the Silesian Uprisings Personal Communication.

Other

Dziadek z Wehrmachtu (doświadczenie zapisane w pamięci). 2015. Wystawa przygotowana przez Dom Współpracy Polsko-Niemieckiej w Gliwicach oraz Genius Loci Stowarzyszenie- e Duch Miejsca, Andacji Ośrodka "Karta" i Dom Spotkań z Historią w Warszawie (*The Grandfather from the Wehrmacht (experience preserved in memory),* 2015, exhibition prepared by House for Polish-German Cooperation in Gliwice and the Genius Loci Association-Spirit of the place, the Archive of Oral History by The KARTA Center Foundation and The History Meeting House in Warsaw). www.stat.gov.pl.

Communicative Forms of Indigenous Dwelling: The Digitalization of the Forest and Native Net-Activism in Brazil

ELIETE DA SILVA PEREIRA, UNIVERSITY OF SÃO PAULO, SÃO PAULO, BRAZIL AND MASSIMO DI FELICE, UNIVERSITY OF SÃO PAULO, SÃO PAULO, BRAZIL

After the advent of digital networks and the increase in the potential of territorial connections (Geographic Information System) and of the biodiversity, the digitalization process has assumed the significance of a new dwelling condition. This presents itself as a reticular ecology which connects in a more intense form, through digitalization, biodiversity, animals, objects, people, information (Di Felice & Lemos, 2014). In Brazil, in the last decade, indigenous peoples have been connecting to digital networks and have experienced an interesting process of the appropriation of the technologies of information and communication which allow for the expansion of their territories beyond their frontiers and far beyond the historical and geographical isolation.

The indigenous people, a total of 869,917 (IBGE Census, 2010), 0.47% of the Brazilian population, are divided into 240 peoples, with around 180 languages.[1] Of this total, 324,834 Indians live in urban centers, and the majority of them (572,083) live in rural areas[2] distributed into 697 Indigenous Territories (*Terras Indígenas* in Brazilian Portuguese),[3] demarcated by the Brazilian state for their exclusive use (ISA, 2011). A concentration of this indigenous population, 433,363 people, is mainly found in the area marked by the occurrence of Amazonian vegetation, in

the area of *Amazônia Legal*, consisting of the states of Acre, Amapá, Amazonas, Mato Grosso, Pará, Rondônia, Roraima, Tocantins, and part of Maranhão.

There are no actual systematic data about this population's access to the Internet,[4] but significant experiences show that these are responsible not only for a process of translation and visibility of knowledge and local culture, resulting in the fortification of their cultural heritage, but, at the same time, for the establishment of an important process of the alteration of the dwelling experience of these people (Pereira, 2012). By connecting to digital networks, an indigenous population expands its territory and its ecosystem, extending it by means of a meta-geographical dynamism which connects to other peoples and other global cultural contexts. Thus is created a complex ecology which unites reticularly the people involved, their cultures, their territories, and their biodiversity, to digital informational circuits through a singular techno-communicative dwelling.

To reflect on the significances of this new connective ecology, this chapter will analyze some constitutive aspects of the digitalization process. In particular, how the interaction of these people with global technologies reconfigures experiences in their territories in a dwelling perspective (Di Felice, 2009; Heidegger, 1971). This process expresses a new ecological condition of these indigenous peoples and of the forest itself associated to their net-activism.[5] This activism developed through and in digital networks and through the use of devices and collaborative platforms, which, for example, have shown to be fundamental allies for the development of new forms of protagonism. Two cases will be analyzed to visualize the dynamics of the digitalization of the forest and the innovative experiences of net-activism of the indigenous populations in partnership with nongovernmental organizations.

The first case is the Mawo project for the implementation of a Center of Digital Documentation of the Ikpeng Culture, developed by the Ikpeng people of the Xingu Indigenous Park in Mato Grosso State with the support of the Catitu Institute, a Brazilian nongovernmental organization. The second is the Cultural Map Project developed by the Surui Paiter people of the Indigenous Territory Seven of September (Rondônia), which offers a cartographic visualization of their territory. Using Google Earth to map their lands and to protect them from deforestation, through the support of Google Outreach, social arm of Google, the Surui Paiter have monitored, photographed, and registered the actions of deforestation in their lands, making this information available on the internet and activating a network of governmental and nongovernmental institutions.

Far from being just a consequence of the utilization of a new technology, the digitalization of the territories and indigenous cultures configures itself as a qualitative ecological alteration of their proper dwelling conditions. Therefore, the understanding of this phenomenon requires prior reflection about the concept of dwelling and its relationship with the ecology of communicative interactions.

COMMUNICATIVE FORMS OF DWELLING: ECOLOGICAL-TECHNO-INFORMATIVE COMPLEXITIES AND DYNAMICS

Dwelling in its Western urban form, spread through the entire world, coincided with the experience of building boundaries and linguistic, architectural, and territorial identities. The birth of the cities in their identity and architectural specificities transformed the relationship between subject and environment through the gradual process of electrification and computerization of the territory and local cultures. In contrast with the past, the experience of dwelling and the meaning of locality today are plural and complex through media dynamics.

The concept of dwelling was analyzed by Heidegger, for the first time, in the text "Building Dwelling Thinking." The German philosopher proposed to confront two questions: what is dwelling and in what way is building a part of dwelling? To the first question, Heidegger responds refuting common sense, which would see dwelling as simply a consequence and an end of building, thinking that the two activities, dwelling and building, are two diverse realities and separate from each other. Preferring a concept contrary to this reasoning, the German philosopher inverts the terms and describes building as a form of dwelling itself, this thinking based on the etymology of the two concepts, suggested by the ancient German words *bauen* (building) and *baun* (dwelling, retain, stay). Analyzing the first concept, relative to the concept of building, Heidegger arrived at three conclusions:

1. Building is really dwelling.
2. Dwelling is the manner in which mortals are on the earth.
3. Building as dwelling unfolds into the building that cultivates growing things and the building that erects buildings. (...) We do not dwell because we have built, but we build and have built because we dwell, that is, because we are dwellers. (Heidegger, 1971, p. 96)

To explain the question, relative to the essence of dwelling, Heidegger develops the concept of *Geviert* (*the fourfold or quadrature*) in which the Being is described from its dwelling condition and of its relations with heaven, earth, mortals, and the divine: "*The fundamental character of dwelling is this sparing and preserving*. It pervades dwelling in its whole range. That range reveals itself to us as soon as we reflect that human being consists in dwelling and, indeed, dwelling in the sense of the stay of mortals on the earth. (...) This simple oneness of the four we call *the fourfold* (Geviert)" (Heidegger, 1971, p. 105).

In Heidegger's perspective, the Being is unique as plural, while it develops and exists as it dwells, that is, as it performs the quartering (*geviert*), developing thus

its condition not from a supposed metaphysical essence, but from its performance as project and as possibility.

In the perspective of the German philosopher, thus, the characteristic of dwelling is not found in a residence, in a being, but in its quality of relating and of communicating. This relational and communicative ontology is expressed also through the concept of *Dasein, Being there*[6] which expresses this dynamic and historical element and, therefore, not conceptual or metaphysical, of Being. It expresses a dimension of possibility and continuous overtaking. The perspective of relational ontology and of *Dasein* brings us to a refusal of any kind of definitive and conceptual essence and that opens us to a relational and ecologic perspective—constituted of a particular kind of ontology that is—only in that it relates and transforms itself.

> Dasein (…) expresses well the fact that existence is not defined as overtaking, which transcends the given reality in direction to possibility, but that this overtaking is always overtaking of something, it is always concretely situated, that is, it is there. Therefore, existence, being there, being in the world, are synonyms. All three concepts in fact say that man is situated in a dynamic manner, which is in the world of could being, or yet (…) in the form of project. (Vattimo, 1963, p. 22)

Consequently, the quadrature (or *the fourfold*), more than representing a form not rooted and self-referential being, raises significant implications quite unprecedented within Western thinking. If in fact the human "being there" encounters the world through things, thereby the quadrature is reproduced, the things, like the spaces, are no longer definable by themselves. We thus find the second important significance of dwelling in its ecological and not human-centric dimension, which in contemporary techno-mediatic circles interrogates us about the significances which take over our symbiotic relations with informational networks, our techno-psychic circuits, our informative geographies, and our distant proximities.

The lack of separation among space, man, and quadrature opens up the possibility of thinking of dwelling as a result of an ecological interaction, plural and dynamic, which depends, unavoidably, on the communication between the diverse elements. It is an expression of an ecology that involves individuals, devices of connectivity, informative circuits, and territorialities.

It is possible to conceive a nonorthodox interpretation which explains the contemporary "being-there" of the indigenous peoples in their digitalized villages as the fulfillment of a techno-human communicative quadrature. Within this quadrature, heaven and earth, divines and mortals are freely understood by means of emerging and ancestral forms and significances, at the same time.

In fact, the culture of dwelling as a communicative practice finds a fertile common land in the cultures of the indigenous peoples of the Amazon. Principally for those who still maintain their traditional systems of thinking, this ability to communicate between humans and nonhumans, territories, animals, plants, and

spirits has always existed. And their way of characterizing their proper concept of communication and Dwelling descends from the notion of "person." Since Marcell Mauss (1974), the notion of person linked to time/space evokes its articulation in ways of organized thinking and action. The various ethnographies produced in these indigenous societies indicate their particularities: the principles of production/fabrication of a person involve an ability to communicate, corporally and cosmically, transitive of interspecies (between the same species) and beyond species (in the extraordinary case of shamans), situated within their evolving ambience.

This non-Western idea of person production is related to the body, as was already pointed out by the anthropologist Eduardo Viveiros de Castro (1996). The body as a perspective axis of a humanity divided not exclusively into humans, but to beings which assume the positions of people in accordance with their clothes/bodies, delineates a multinaturalism (only one culture in various natures) in contrast with Western multiculturalism (one nature within a multitude of cultures).[7] The Amerindian perspectivism, or the indigenous point of view, as a pronominal position, is associated with the corporal variety of animals, plants, and humans (Viveiros de Castro, 1996). The point of view is in the body. This understanding of the body evokes a difference in perspective between humans and animals which is not only physiological, but overall is based on the ways and means of being, in the forms of predation and of affinity.

This perspective on the subject, marked by a corporal "discontinuity" present in the Amazonian cosmologies, also points to a sense of "continuity" complementary to considering a unique "humanity" between humans and animals. Consequently, this concept of "humanity" presents itself as distinct in that historically elaborated by Western thinking, because it is not expressed as a characteristic exclusive of "humans," but also is a common condition of the other beings (animals, plants, etc.). The corporal distinction marked by different perspectives is only transcended by shamans and by mythical narratives, which belong to a time in which existed permeability between human and nonhuman worlds.

Besides this indigenous perception about communication between diverse alterities, which form a social plural, and not exclusive to humans, the proper Amazonian forest is composed of a complex universe, a network of networks, delimited by a variety of ecosystems, modulated by innumerable biological, cultural, and social diversities. Although its planetary relevance has been assigned to a place in the imaginary world of "Amazonia," the lungs of the earth, its contribution seems to increasingly transcend the respiratory organ, earning it a decisive role in regional and global climate regulation (Nobre, Sellers, & Shukla, 1991). For the researcher Antonio Nobre of the National Institute of Space Research, the Amazonian forest is a source of highly complex nanotechnologies whose functions have not yet been completely studied by science. For the maintenance of these nanotechnologies of the Forest, the contribution of the indigenous people

and the traditional communities, dwellers of the region and holders of traditional knowledge acquired through the interaction with this territory, had and still has a significant role.

With the increase of new informational and communication technologies and the devices for connectivity and monitoring, the indigenous peoples have improved the practices to protect the forest, at the same time that, they have innovated by including them into their traditional communication systems. The native world with its knowledge and highly ecological practices has established itself with the new digital technologies, complexifying, thus, their territorial perceptions and their communicative forms of Dwelling (Di Felice, 2009), shamanistic, transspecies (Moreira, 2014), multinatural (Viveiros de Castro, 1996). Therefore, the communicative forms of dwelling are understood as the practices and significances originating from the symbiotic interactions and the poetics of subject-media and territories, and it inserts itself into the interior of a transdisciplinary optic of environmental studies, informational, social, and communicative.

The strict relation between the means of communication, informational architecture and the dwelling ecological condition manifests itself with clarity since the passage of orality to written technology, which started to multiply itself territorially, making dwelling a dislocating practice. This reproduces itself in its written project version and of the regulatory norms of space and of diverse forms, acquiring with electricity and with its digital reproduction new dimensions and larger proportions (Di Felice, 2009). As has been observed more than once by McLuhan (1964), such techno-communicative transformations should not be understood from an evolving and diachronic form: mediatic technologies tend, in a general way, to coexist, dialoging among themselves and reciprocatively retransmit. However, the communicative technologies which contribute to the process of informational construction of dwelling are, in fact, contemporary, turning the experience of territoriality into something plural and dynamic.

Understanding dwelling as a communicative practice (Di Felice, 2009) requires considering the implications of communicative technologies in the construction of spatialities, starting from the relations between subjects, technology, and territory. It is thus possible to distinguish, in diverse contexts specific to dwelling communicative conditions: the *empathic dwelling* (in which the subject projects itself over space, transforming the written text into architecture), the *exotopic dwelling* (in which space, electrified and mobile, becomes external and independent of the subject, presenting itself, as in the case of cinema and of the industrial metropolitan space, as autonomous and autopoietic), and the *atopic dwelling* (in which space, information, databases, the mobile devices of communication, geographic informational systems, and people interact while digitalized, experiencing unprecedented dynamics).

It is in this sense that the notion of dwelling, as a communicative form of atopy expressed in its digital version, seems to us fertile to analyze and understand the significances of the digitalization of the Forest associated with the emergence of digital activism of the indigenous Brazilian peoples.

DIGITALIZATION OF THE FOREST AND INDIGENOUS NET-ACTIVISM MAWO—DIGITAL DOCUMENT CENTER OF THE IKPENG CULTURE

The Ikpeng are survivors of a tragic destiny which marked the lives of the Brazilian indigenous people. When they arrived at the Xingu Indigenous Park[8] in 1967, accompanied by the Villas Boas brothers, they had abandoned in a hurry the place where they lived on the margins of the Jatobá river. They were little more than 50 people, thin and ill, who had escaped from the pressure of the advance of miners on their lands. At that time, their territory had not been delineated and the Brazilian state, under a military dictatorship, viewed the presence of these populations as an obstacle to unstoppable progress, and their assimilation into the national society as something inevitable and a question of time. In 1962, in the recently created Xingu Indigenous Park, the Ikpeng, known to be a restive people and warriors, were just a specter of the fame they once had, becoming from that moment a people exiled from their lands.

Currently the Ikpeng are more than 400 people who are asserting the return to their old lands close to the Jatobá River. The Ikpeng say that on the margins of this river are buried the placentas of their ancestors.

This collective desire was documented in a video directed by Karané Ikpeng and by the documentarist Mari Correa, K. Txicão, and K. Txicão entitled "Pirinop—my first contact" (2007).[9] In this video, the Ikpeng youth in conversation with the elders reconstruct a striking moment of the collective memory of this people: the first contact with the white man in the old place where they lived, the transfer of the Ikpeng to the Xingu Indigenous Park, and the visit to their lands on the margins of the Jatobá river. Their audiovisual narrative is marked by their perspective about the contact and otherness.

Besides this documentary, the Ikpeng youth in partnership with the project Video nas Aldeias (Village Videos),[10] a Brazilian nongovernmental organization dedicated to the formation of indigenous video makers, have produced other initiatives of the digital registry of the Ikpeng culture.

In 2009 the Association of the Moygu Village of the Ikpeng people, with the support of the Catitu nongovernmental organization, developed a project for the research and documentation of the Ikpeng culture. It is housed in a bilingual and

digital database called *Ukpamtowonpïn* Mira Iwonpot (Origin of the world: Ikpeng language and culture vocabulary). A group of Ikpeng youth, acting as researchers of their culture, started to register with the help of the elders, custodians of the older knowledges, the terms and expressions of their people,[11] adopting their own etymological criteria and categories. Besides registering in audio recordings the songs, the narratives, the myths, and the history of the old, they transcribed and provided this material in a digital database which also contains: photos, films, books, drawings, texts, maps, and all kinds of documents, oral or written, about the Ikpeng culture produced by themselves and/or by external researchers.

The whole process of registering and classifying this digital archive was accomplished by them with the help of an external technical consultant. This process turned into a large laboratory of intercultural translation. In an intense exchange of perspectives, the nonindigenous knowledge—permeated by the technical knowledge of the methodological criteria of classification—and that of the Ikpeng, formed by their language and thinking and transmitted orally, were elaborated for the construction of this multimedia database.

After the development of the database and the digital archive, this initiative resulted in the inauguration of the Mawó House of Culture[12] in 2010. It is a physical space in the Moygu village of the Ikpeng people, in the Xingu Indigenous Park, a center of memory, formation, research, registry, and divulgation of the Ikpeng culture, also housing a nucleus of audiovisual production and of diverse digital content. Created to stimulate the Ikpeng youth to valorize their language and the richness of its knowledge, the center for documentation has transformed itself into a new space for the transmission of knowledge and cultural practices, capable of enabling access to the Ikpeng cultural heritage by actual and future generations.[13] To divulge this work, the Ikpeng people have developed the site in Portuguese, http://www.ikpeng.org/, also together with the Catitu Institute, with the support of Petrobras and the Ministry of Culture of the Brazilian government. The site presents the projects accomplished and in progress in the village, data specific about the Ikpeng culture, and a small store offering CDs with the registry of songs, books, and videos produced by them.

During the construction of the Mawo Project, over five years, the Catitu Institute, partner of the Project, produced the documentary "Project Mawo—House of the Ikpeng Culture," which "depicts the implementation process, methodology and development of the Center of Documentation of the Ikpeng Culture for the divulgation amongst the communities engaged in initiatives for the promotion of their culture and the public in general."[14] The film is an audiovisual report of this innovative collective work of the Ikpeng people, constructed through encounters with the technical consultants, in the village, in the Xingu Indigenous Park, and in São Paulo, where the Ikpeng youth involved in the project visited museums and a public TV, were acquainted with the database, and dialoged with the historians

and researchers. In scenes already back at the village, in a space with computers, Ikpeng youth and external researchers debate how to translate expressions of the native language, consulting each other, indicating the comparative exercise that permeates the whole project. It is an exercise dense and reflexive, provocative of a feeling of belonging to a singular world characterized by its capacity for plural and intercultural references. For the old chief Melobô, the project provides the possibility of keeping forever the history and the language of his people, a vivid point and necessary for those younger and for future generations. In the words of Maiua Ikpeng, a teacher at the indigenous village school, "The Mawo are a point of encounter of the new with the tradition." This "new" configures itself precisely in a space of research and formation, where they promote video workshops on sound capture and digital initiation, which resulted in the production of the documentary "Som Tximna Yukunang" (Recording the Sound) about the initiation ritual of the Ikpeng children, and the CD Yumpuno Eremr, with the songs of this ritual.[15]

The importance of the audiovisual in the constitution of the project of the Mawo Cultural House refers to what we call "native media," the mediatic language which adapts itself immediately to the oral constitution of these societies, translating itself into a powerful cultural mediation of large diffusion between these peoples. The expressive capacity of the images produced by the Ikpeng people encompasses some of the fundamental components of the indigenous communication: orality and corporeality. With the audiovisual production, these peoples have passed from oral language directly to the audiovisual mediatic, inciting changes in their social position (from "receptors" to content producers), in form (from ethnographic documentaries, the various styles of audiovisual production, as the performance of their mythical narrative), and in the content (from "pure Indians" projected and silenced by the national society to "real subjects," contemporary producers of narratives which describe their cultures). The way the Ikpeng, and many other indigenous peoples, produce digital content in following the connection process for the registration of their ways of life also indicates a fertile action of diplomacy. It removes the local cultures from their historical isolation and surpasses the geographical limits of their lands delimited by the Brazilian state, projecting them into global networks and connecting them to other cultures. They perceive, thus, that their narratives have become enunciatory discourses of their ethnic identities. The choice of myth to be represented, the ritual or any aspect of the group to be filmed and digitalized is something which directly affects what the group thinks about you and what you want to think about it. Thus, the audiovisual production, like the photos and drawings, digitally available, reveal themselves as a mirror and a self-reflection, creators of multiple revealing images of the techno-imaginary-intersubjective recognition of its otherness and singularity.

This digitalization process of the Ikpeng culture has been the result of an audio-visual and digital net-activism of this people, in that their language and narrative are perpetuated and made present for future generations. More than a simple instrument of "communication," the digital technologies (computers, cameras, among other equipment connected in a network), in interaction with these people, become technologies of a particular type of relational memory, capable of connecting their cultures with the outside as crucial vectors for enunciating and experimenting with languages and performances. At the same time, this digitalization seems to act as a triggering element of another order of the territorialization of the space of this people, which associated to the cultural and symbolic dimension the dislocating and connecting power of digital networks, realizing new ecological–communicative interactions. These new interactions acquired through the process of digitalization, besides connecting, linking, and transmitting their cultural specifics, realize a new ecology that alters their dwelling conditions, which we can describe as atopic (from the Greek a-topos, out of place, indescribable place) in which "atopy is not a non-place, but another ecosystem, constructed through the fertile interactions of informational technologies, territorialities, and lives" (Di Felice, 2009, p. 298). Thus, the digital media lead to an atopic form of being and of interaction in the world through the communicative technologies that may disseminate their traditional knowledge based on their sustainable relation with nature, the visibility of their difference, and the network action among these people.

Suruí Paiter Cultural Map

Like the Ikpeng, the Surui Paiter originated in the region which is comprised of the Brazilian state of Matto Grosso. Although still in the 19th century, they fled from their original lands, because of conflicts with non-Indians, migrating to the state of Rondônia. In their escape, they confronted other indigenous peoples and non-Indians, besides suddenly encountering, at the beginning of the 20th century, the devastating effects of progress and modernization in the region: increase in the nonindigenous population attracted by the construction of the Madeira-Mamoré railroad and by the exploration of rubber. Besides the growth in mineral exploration and the advance of agrarian frontiers, these factors are multiplicators of the conflicts with groups of miners, farmers, among others (ISA, 2011).

Since then, this people, currently consisting of 1,171 persons (Funasa, 2010), distributed into 25 villages in the Indigenous Territory Seven of September (with 247,196 hectares), continue to suffer from the deforestation around their territory and with the illegal invasion of its land. In 2007, in an unprecedented initiative, they started a partnership with Google Earth, through the initiative of their leader, Almir Narayamoga Suruí, who on learning of Google through the internet, managed to visit the headquarters of Google in the United States to elaborate

in conjunction, a series of actions which could unite traditional knowledge and technology, in the territorial and environmental management of their indigenous territories. At the time, the Suruí Paiter were uniting to develop the Territorial Management Plan of the Indigenous Territory Seven of September, or better known as the 50 Year Plan of the Suruí. The first joint action was the development of the Suruí Paiter Cultural Map, a cartographical reconstruction of their territory, utilizing the tools of Google Earth, Picassa, Google Docs, and YouTube. The Google Earth team, headed by Rebecca Moore, went to the Indigenous Territory Seven of September to teach the young Suruí Paiter how to take photos and record videos with the objective of collecting histories from the elders, the living memory of the community, photograph and film its territory and its biodiversity, and consequently, arrange all the material in the Digital Map. The traditional territorial perception reconstructed by means of the technological interactions, originated by an intercultural network of interactions between this indigenous people and the Google team, was translated through a process of digitalization of the territory which made possible the inclusion of the Suruí Paiter territorial cosmological perception into the digital cartographical representation. In the words of Rebecca Moore, it was a meeting of knowledges; Google supplied the technology, and the Suruí with the knowledge of the forest.

Starting from this Map the territory was delimited into its geographic and physical components, but amplified and reelaborated, adding the immaterial and particular modes of the Suruí Patier cosmology. This spread the content and ecologies online, giving it a unique narrative and a connective aesthetics. The Digital Map is situated in a hybrid and communicative location, shifting between the place and the symbolic and, through the communicative technology, the global.

The Suruí Cultural Map is accessible online through Google Earth. On Youtube there are two videos which present this experience. One produced by Denise Zemekhol (ZDfilms), with the participation of the Google team involved in the project with the Suruí Patier, with testimonials by Almir Suruí and the indigenous youth, with images of the workshops which resulted in the Cultural Map. The second video, made by the Suruí themselves, narrated by Almir Suruí and by the participating youth of the project, is visualized as an interactive and immersive experience (3D) of the Suruí territory. It presented the territory through their symbolic and ecological references. It intertwines the Suruí people, the animals, the plants as represented by photographs and drawings made by the youth and children and reconstructed in the digital imagery and symbolical space.

Through this Suruí Patier digital narrative provided by the Cultural Map and by digital networks, we can connect to the complex reticular ecology of this people, which includes the physical space, the forest, the symbolic and immaterial space. This digital ecology, instead of presenting itself as a technological external imposition, expresses the reticular complexity of the ecology of the Suruí Patier

and their profound ties with the dwelling environment. It is important to consider here that for the indigenous peoples, the forest is not only seen as something external to them, as an "available resource." For the Suruí Patier, and for various indigenous peoples, to live in the forest is to depend on it on all its levels, acknowledging that the respect to its elements converts into a basic relational coexistence standard. An example is their interaction with the fruit of the açai tree, in place of expressing just a subsistence relationship, also enables communication with the spirit world, performing a reticular ecology that unites in an interagent dwelling of the plant and animal world with the spirit world.

Besides the Cultural Map in partnership with Google, the 50 year Territorial Management Plan of the Indigenous Territories Seven of September also includes the realization of the Surui Carbon Project, which aims to unite the environmental conservation of this territory with cultural strengthening. It allocates resources from the sale of carbon credits for the financing of activities for the protection and fiscalization, as in the purchase of equipment. The project has provided the Suruí with a pioneering role as the first people in the world to have a carbon certification. In the words of Almir Suruí, the carbon project and the technologies of communication convert into an alliance of his people with the world. "Our hope is that we can unite virtually and in person, and we can find and implement solutions together."

Such a communicative and connective action conforms to a reticular activism which condenses all networks inscribed or activated in it, and produces new ecological senses and aesthetics of the Suruí Paiter people. An intercultural dialogue is concretized with the new communication and information technologies and the digital networks, forming in this symbiosis a new communicative form of Suruí Peltier atopic dwelling. It is indicative of the process of transformation of locality by means of inclusion of their point of view in interaction with the digital technology and its environment. It potentialities the digital ecosystemic dimension, in which what is to be digitized and constituted in networks "are not just the informative flows exchanged among humans, but the entire context, its own ecology, the territory and the environment created, in this way, a reticular process dislocating and ecosystemic" (Di Felice, 2011–2012, p. 17).

The Significance of the Digital Indigenous Culture

The advent of digital networks and digital informative architectures has boosted in recent years, worldwide, a process of transformation that overcomes the socio-communicative aspects to levels of more profound changes that refer, among other things, to the digitization process of territoriality, ecosystems, and their populations. It is, indeed, a change that reaching its visible face, the communicative sphere, reaches a higher level of complexity, extending through its connective and reticular characteristic to the same dwelling dimensions.

The digitalization process in its most advanced stage (broadband, wifi communication, digital networks, Internet of Things) with its connecting power besides expanding local cultures (Bhabha, 1994) is responsible for the creation of a complex communicative ecology that surpasses the very idea of *mediascapes* (Appadurai, 1996) and the media as an extension (McLuhan, 1964) to present itself as a connective ecology, whose analysis requires a complex reflection to put in discussion the same geographical idea of space or the same opposition between local and global.

By understanding the new relationship of the indigenous peoples to their territories mediated by digital technologies, it is considered, therefore, that, among other existing experiences, the two digitalization cases of the indigenous peoples Ikpeng and Surui Paiter point to a process of informatization of forests and the cultures existing in them. Their significance is the alteration of the entire ecosystem that, while connected to digital information systems, are moving beyond their physical and traditional boundaries, placing on it a new goal of geography that is infogeographical and glocal.[16] "Once digitally reproduced the space, transforming the same into information, is configured as the formation of an informational dwelling, post-architectural and post-geographic which multiplying the meanings and interaction practices with the environment, leads us to dwell in different natures and worlds within which we move computationally" (Di Felice, 2009, p. 22).

In fact, the symbiosis between these peoples, their cultural specificities, digital media and its territories, reveals a new ecology delineated by these new informational dynamic (Pereira, 2013). The analysis of this transformation process is even more interesting if we consider the cultural characteristics of some of these people of the Amazon who have a very communicative and ecological specificity traditionally characterized by a kind of reticular interaction that provides for free movement and transit between the various elements (animals, humans, plants, and spirits).

In the Amerindian perspective, as underlined by Eduardo Viveiros de Castro (1996), it is common in the indigenous conception of the ecology that, the difference from positivist and European cultural tradition of the social sciences does not separate the human nature (body-environment) and technical (corporeality), extending thus citizenship to nonhuman groups, whether animal, plant, mineral, spirits, or deities.

The digitization of the forests is therefore here interpreted also as evidence of the crisis of sociological and modern European cultural imagery that is characterized by an idea of anthropocentric and limited society, the "*societas*," circumscribed and defined within the architectural walls of the polis. Successively "societas" became national states inhabited by individual actors, the enlightened *citoyen*, the historical subjects that in the course of fulfilling their destinies, entertain instrumental relationships with nature and the technical.

It is evident, as in the complex ecological contexts of those people currently permeated by digitally and connective informative flows, the dichotomies (local–global, rural–urban, archaic–modern, technology–culture) proper to modern social thought, which so marked the research and social analysis in the past decades, are a result inadequate for describing and understanding these new informational processes. Finally, such experiences express the need for an enhanced consideration of such ecologies through dialogical and nondialectical relationship between the culture, the environment, the imaginary, the digital technologies, as presented lucidly by the French sociologist Michel Maffesoli:

> For paradox that is not the smallest, this old thing which is the tribe and those old forms of solidarity that are those experienced in everyday life, carried out as close as possible, are born, are expressed, comfort themselves, thanks to the various electronic networks. Hence the definition I suggested of postmodernity: synergy between the archaic and technological development. Certainly, it should be remembered that the archaic—in its etymological sense, that which is first, essential—sees a multiplication of its effects by the new interactive communication modes. (Maffesoli, 2010, p. 45)

The Indigenous digitalizing process in the Amazon is not the same, so only the important word making process of these people, who, in following the advent of digital media, provided to the sectors historically marginalized, through free access to informational circuits, new visibility and the power to carry out through digital networks, their diplomacy, starting to play an active role within the public sphere and of Brazilian society. Much more than this, such a process should be understood as the diffusion of a new type of ecology no longer oppositional nor anthropocentric, whose comprehension requires us to rethink the fundamental concepts of space, technology, nature, and society. The indigenous digital ecology is configured, in fact, as an informative dwelling condition characterized by a net-activism that continuously shifts the various human elements, technologies, plants, animals, beyond their limits and toward an informational becoming. The significance of this interaction requires the elaboration of a new idea of activism capable of overcoming their subjective dimension, and opening themselves up to an ecological–dwelling dimension resulting from the digitalization and connection process.

NOTES

1. Linguists classify the languages spoken by the indigenous Brazilian people into two large groups, Tupi and Macro-Jê, and into nineteen distinct linguistic families which do not fit into these two groups (ISA, 2011).
2. Some of them form that which specialists call "isolated indians," nomads, comprised of small groups with which the National Indian Foundation (Funai), Brazilian institute responsible for indigenous politics, has not yet established contact. It is not known who they are, how many

there are, or other data which would inform about the way of life of these groups. Unless they are concentrated, above all, in the Amazônia Legal area, and have been escaping the advance of the loggers and miners in the near past.

3. Since then, it is important to consider that "Indigenous Territories" (*Terras Indígenas* in Brazilian Portuguese) is a political and juridical term instituted by the Brazilian State and does not coincide with the notion of territory of the diverse native people, given that "territory refers to the construction and experience, culturally variable, of the relation between a specific society and its territorial base" (Gallois, 2004, p. 37). Although since the Constitution of 1988, the Brazilian state recognizes the land traditionally occupied by the native people, conferring unto them original rights and the exclusive collective use of the territory and the natural resources and minerals existent there, a continuous invasion of their lands, by loggers and miners exists.

4. The first data were presented, in 2001, by the Center for Social Politics of the Getúlio Vargas Foundation (Neri, 2003), which identified an index of 3.72% for digital access of the indigenous populations from a total of 12.46% of the Brazilian population that has access to a computer, and 8.31% that has access to the Internet. Such an index is not detailed. It is more than 10 years old, and reflects a lack of data and estimates about the digital participation of the indigenous populations, but indicates a very small rate of indigenous users in the total universe of the rest of the country (Pereira, 2013, p. 1868).

5. There is a clear difference here between the indigenous cyberactivism and net-activism of these populations. The indigenous cyberactivism is associated with the exclusive action of these populations in cyberspace (Pereira, 2013). While the indigenous net-activism involves a "network of networks," digital interactions of these people are with their cultures and their territories. The indigenous net-activism is, therefore, an indicator of the digitalization process of the forests and cultures of these peoples. We will better develop this notion in the light of the case studies presented in this chapter.

6. The translation of the concept of *Dasein* is indeed controversial. Herein we refer to the translation proposed by Gianni Vattimo that, by expressing a dynamic dimension, nonessentialist of being is its specific historicality, is added to the verb being the adverb of locality, *Being there.*

7. For details, see: http://hemisphericinstitute.org/hemi/en/e-misferica-101/viveiros-de-castro.

8. Idealized by the activist brothers Cláudio and Orlando Villas Boas, the Xingu Indigenous Park represents the largest socioenvironmental reserve in the world. Situated in the northeast of the state of Mato Grosso, it was created in 1961, the first of its kind in Brazil, as a protetected environmental and sociocultural area. Cut by the Xingu river and by various tributaries, the park comprises 2,642,003 hectares. Currentlly around 5,500 Indians from fourteen ethnic groups live there, representing an expressive linguistic mosaic of Brazil.

9. Vídeo available on Youtube : https://www.youtube.com/watch?v=dU6k_YQloOQ.

10. The partnership with Vídeo nas Aldeias has resulted in the following videos, directed by Natuyu Yuwipo Txicão, Kumaré Ikpeng e Karané Ikpeng: Marangmotxíngmo Mïrang—From the Ikpeng Children to the World (2001) and Moyngo—The Dream of Maragareum (2000), and the collective work with the Kisêdjê e Kuikuro people, SOS Rio Xingu (1995).

11. The language of the Ipkeng people belongs to the Karib linguistic family, close to those spoken by the people of the north of the Amazon.

12. According to the Ikpeng, in one of their myths, in the time in which there were no divisions, when the sky was low and only night existed, « Mawó » was one of the first persons to give names to all things.

13. http://institutocatitu.org.br/projetos/mawo/. Accessed on: August 25, 2015.

14. http://institutocatitu.org.br/projetos/mawo/. Accessed on: August 25, 2015.
15. Video available: https://vimeo.com/channels/institutocatitu/73651321. This project counts on the sponsorship of the Petrobras Cultural Program and of the PDPI (Demonstrative Project of the Indigeneous People/Ministry of the Environment of the Brazilian government), besides the support of the Embassy of Norway, the Socioenvironmental Institute, and the Indian Museum (Project for the Documentation of Indigenous Cultures e Languages).
16. We refer to the *glocal communicative phenomenon* as that intrinsic to digital networks. It is local because the viewpoints of these groups, as well as their territories are disseminated and digitally connected and simultaneously global because networks deterritorialize their local cultural references. We were inspired by the term "glocal" by Roland Robertson (1992) that adopts to describe the trends of *homogenization* and *heterogeneity* apparently opposed, but which are complementary and interpenetrating, questioning thus the dichotomies between local and global. Robertson extends the term "glocal," presented in the *Oxford Dictionary of New Words*, in which the term is mentioned as based on the Japanese notion dochaku, "live in their own land," the adoption of agricultural principles to local conditions. The derivation of this Japanese word "dochakuka" relates to the idea of "making something indigenous" (Robertson, 1992, p. 252), significance quite valid about these glocal, informative, and intercultural processes experienced by the indigenous peoples in the Brazilian Amazon.

REFERENCES

Appadurai, A. (1996). *Modernity at large: Cultural dimensions of globalization*. Minneapolis, MN: University of Minnesota Press.

Bhabha, H. (1994). *The location of culture*. New York, NY and London: Routledge.

Correa, M., Txicão, K., & Txicão, K. (2007). Pirinop, My first contact. Retrieved from https://www.youtube.com/watch?v=dU6k_YQloOQ

Di Felice, M. (2011). Redes digitais, epistemologias reticulares e a crise do antropomorfismo social. [Digital networks, reticular epistemologies and the crisis of social anthropomorphism]. In: *Revista USP*, São Paulo, n. 92, p.9–19.

Di Felice, M. (2009). *Paisagens Pós-urbanas—o fim da experiência urbana e as formas comunicativas do Habitar*. [Post-Urban Landscapes—the end of the urban experience and communicative forms of dwelling]. São Paulo: Annablume.

Di Felice, M, & Lemos, R. (2014). *A Vida em Rede*. [The life in a network] Campinas: Papirus.

Gallois, D. (2004). "Terras ocupadas? Territórios? Territorialidades?" [Occupied lands? Territories? Territoriality?] In: *O desafio das sobreposições terras indígenas & unidades de conservação da natureza*. São Paulo: ISA.

Heidegger, M. (1971). *Poetry, language, thought*. (A. Hofstadter, Trans). New York, NY: Harper & Row.

Ikpeng People. Retrieved from http://ikpeng.org

IBGE—Instituto Brasileiro de Geografia e Estatística (2010). Censo Demográfico—2010. Rio de Janeiro: IBGE

Fundação Nacional de Saúde. FUNASA, Brasília, 2010. http://www.funasa.gov.br/site/

Instituto Catitu. [Catitu Institute]. Retrieved from http://institutocatitu.org.br/projetos/mawo/

Instituto Socioambiental. (2011). *Povos indígenas no Brasil 2006/2010* [Indigenous peoples in Brazil 2006/2010]. São Paulo: ISA.

Maffesoli, M. (2010). *Matrimonium: petit traité d'écosophie*. [Matrimonium: small treaty of the ecosophy] Paris: CNRS Editions.

Mauss, M. (1974). *Sociologia e antropologia* [Sociology and anthropology]. São Paulo: EPU/EDUSP.

McLuhan, M. (1964). *Understanding media: The extensions of man*. New York, NY: McGraw-Hill.

Moreira, F. C. (2014). *Redes xamânicas e redes digitais: Por uma concepção ecológica da comunicação*. [Shamanic networks and digital networks: Towards communication ecological] São Paulo: Universidade de São Paulo.

Neri, M. C. (2003). *Mapa da Exclusão Digital* [Map of digital exclusion]. Rio de Janeiro: FGV/IBRE, CPS.

Nobre, C. A., Sellers, P. J., & Shukla, J. (1991). Amazonian deforestation and regional climate change. *Journal of Climate, 4*, 957–988.

Pereira, E. S. (2012). *Ciborgues indígen@s.br: A presença nativa no ciberespaço* [Indigenous cyborgs.br: Native presence in cyberspace]. São Paulo: Annablume.

Pereira, E. S. (2013). Latin America| Indians on the network: Notes about Brazilian indigenous cyberactivism. *International Journal of Communication, 7*, 14. Retrieved from http://ijoc.org/index.php/ijoc/article/view/2182

Robertson, R. (1992). *Globalization: Social theory and global culture*. London: Sage Publications.

Suruí Tribe. (2007). *Suruí cultural map*. Retrieved from https://www.youtube.com/watch?v=jqiCW-cBsHP4

Vattimo, G. (1963). *Essere, storia e linguaggio in Heidegger* [Being, history, language in Heidegger]. Turim: Filosofia.

Viveiros de Castro, E. (1996). Os pronomes cosmológicos e o perspectivismo ameríndio [The cosmological pronouns and Amerindian perspectivism]. In *Mana* (Vol. 2, no. 2). Rio de Janeiro.

Strategic Communications
in Crisis

Telling the Story of Ebola: Cosmopolitan Communication as a Framework for Public Relations in Local–Global Contexts

NILANJANA BARDHAN, SOUTHERN ILLINOIS UNIVERSITY, CARBONDALE, IL, USA

The Ebola outbreak of 2014 started as a local phenomenon in west Africa and gradually took on global proportions. The world took little notice while the outbreak was contained within west Africa, even as hundreds were succumbing to the virus; however, Ebola became a major news story as soon as the virus spilled over into North America (specifically the U.S.) and Europe. How such local–global crises are publicly narrated and framed by sources considered globally powerful and credible has significant implications for action (or inaction) on the ground, and for how much attention the world pays. In cases such as this one, governmental and relevant nongovernmental actors are considered to be primary sources of information, and their public relations discourse (e.g., news releases produced for the media and other stakeholders/publics) can play a critical role in how a crisis is perceived and addressed (Bardhan, 2002). The representations highlighted play a role in shaping the meanings of the crisis, and of the organizations, cultures, countries, and people involved. These meanings have consequences from a social/global justice perspective.

This chapter brings together concepts from intercultural communication and public relations to examine the social/global justice and local–global dimensions of the 2014 Ebola outbreak, as it was represented through news releases (public relations discourse) disseminated by Doctors Without Borders (*Médecins Sans Frontières*), a high-profile transnational nongovernmental organization engaged in humanitarian medical aid work across cultural borders. In most reports and accounts of global health crises, Doctors Without Borders (henceforth DWB) is mentioned along with organizations such as the World Health Organization (WHO) and Centers for Disease Control as a credible and legitimate source of information from a site of crisis. How did such a high-profile organization choose to narrate the complicated local–global dimensions of this health crisis, and how are culture, identity, and power treated in its public relations discourse about Ebola?

Bardhan and Weaver (2011) have noted major gaps in the public relations body of knowledge regarding the complexities of globalization and culture. First, while the industry has "gone global," and is engaged in constructing meanings about proliferating transnational issues (e.g., Ebola, global warming, world trade), little theorizing exists about the relationship between globalization (as a phenomenon) and public relations. It is mostly assumed that a neoliberal economic agenda is the natural stage for global practice, and little attention is paid to the intensely unequal nature of globalization (Bardhan, 2013; Curtin & Gaither, 2012). Second, the concept of culture is not treated in a complex enough manner (Bardhan, 2012). Culture is conceived as static and simplistically equated with country (e.g., Russian culture, Nigerian culture, and so on). As a result, the local–global tensions of culture and cultural flows have not been topics of much focus. Third, since the social scientific (functional) paradigm dominates public relations research, a critical cultural perspective has been slow to develop (Curtin & Gaither, 2012). Finally, due to its for-profit origins, the mercantile focus remains strong in public relations scholarship. The fact that public relations is increasingly a part of the mix in communication for social justice and transformation needs to be brought to the forefront (Hodges & McGrath, 2011).

Keeping these shortfalls in mind, I put select public relations literature in conversation with the concept of cosmopolitan communication (Sobré-Denton & Bardhan, 2013) from intercultural communication scholarship to examine how DWB represented the 2014 Ebola health crisis and its own efforts in west Africa (mainly Guinea, Liberia, and Sierra Leone) via its public relations communication. Cosmopolitan communication is a world- and other-oriented form of communication that is dialogic, hopeful, deliberate, and attentive to the local–global complexities of culture and communication (Sobré-Denton & Bardhan, 2013). It is also a concept that helps draw out the ethical and critical dimensions of issues. I highlight the value

of using cosmopolitan communication as a guiding framework for analyzing and producing public relations communication in local–global contexts.

PUBLIC RELATIONS, GLOBALIZATION, AND INTERCULTURAL COMMUNICATION

The modern public relations industry emerged in the U.S. around the beginning of the 20th century in the context of increasing industrialization within a capitalist economy, a democratic political system, and a vigorously investigative press culture. The profession grew out of a felt need to help mostly for-profit clients advocate their points of view. The goal of public relations is to build mutually beneficial relationships between clients and their significant stakeholders/publics (Cutlip, Center, & Broom, 2000). The industry also grew in other parts of the Western world such as the United Kingdom, Australia, and New Zealand, and over the last two decades or so, it has become increasingly global in scope. This obviously has a lot to do with how the world has changed during this time frame. The rapid spread of market globalization and Western-style democracy after the end of the Cold War has made trade and diplomatic relations between countries more frequent and immediate than ever before (Taaffe, 2004). Speedy advances in communication technologies and travel have further propelled the global growth of the industry, and multinational companies, nonprofit and nonstate organizations and movements are all employing public relations to communicate about and advocate for issues and clients.

Although public relations began in the for-profit sector, the scope of the industry has widened to include a wide variety of organizations, several of which are in the transnational realm. Public relations beyond the national context involves the following types of organizations and dynamics: international organizations such as the United Nations; transnational economic transactions such as those carried out by multinational corporations and regional alliances such as ASEAN and the European Union; trade organizations such as the World Trade Organization; intergovernmental relations which include diplomatic relations and political activities such as alliance formations; and interactions among people from different countries and cultures through tourism, sports, education, and other such activities (Culbertson, 1996, p. 2). To this list may be added the international media, international labor groups, think tanks, and religious organizations. In the social justice domain, examples of transnational and nonstate organizations include environmental groups such as Greenpeace, and humanitarian aid groups such as DWB, Amnesty International, and Red Cross.

Nonstate transnational organizations have become increasingly vocal and powerful in global policy matters (Daugherty, 2001; Vogl, 2001). They can significantly impact government, policy, and business. Furthermore, the manner in which they represent issues and cultures plays a significant role in shaping intercultural perceptions. During transnational crises, such as the recent case of Ebola, fear tends to propel cultural prejudices to the forefront and blame attribution is rampant. In such situations the public relations communication, the representations produced by powerful encoders, and the meanings constructed by various stakeholders are important to unpack using communication theories and models that can tackle the complexity of intercultural meaning production across national and cultural borders (Bardhan, 2002). From a social justice perspective it is necessary to hold communicators, who generate particular representations, accountable for the real impacts their work has on real bodies, on policy-making, and on intercultural perceptions. Socially responsible representations need to be recognized and damaging representations need to be critiqued.

To highlight the social/global justice dimensions of public relations communication, practitioners need to be held accountable as cultural intermediaries. Borrowing this notion from Bourdieu, Hodges (2006) introduces it to public relations scholarship to make the case that like other similar influential professions such as advertising and marketing, public relations practitioners are engaged in a complex process of meaning transaction and production. They mediate between the production and the consumption of public relations texts, which also tend to be cultural texts. This approach to public relations is useful for "opening up the links between culture and economy, production and consumption," and demonstrating how "the social make-up of practitioners, their values and motivations, and the wider workplace cultures they inhabit shape the cultural practices they perform" (Edwards & Hodges, 2011, p. 5). This includes the production and dissemination of public relations texts. Cultural intermediaries are intercultural players within the five moments of the circuit of culture in the culture–economic model of public relations.

The culture–economic model of public relations, developed by Curtin and Gaither (2007), is a critical cultural model equipped to tackle the local–global and transnational complexities of public relations communication. The model focuses on representation and meaning production, and is useful for examining how cultures, identities, power, and difference play out in public relations discourse. It comprises a circuit of culture with five overlapping moments—representation, regulation, production, consumption, and identity. Representation is the manifest outcome of the intended (encoded) meaning behind public relations texts (e.g., a news release or brochure). However, meanings are produced not just through textual representation alone but also involve the overlapping moments of regulation, production of texts, consumptions of texts and identities. Regulation refers

to the formal and informal controls that shape the public relations practices of a particular organization, and how those controls shape ideas of what is right and what is wrong. For instance, the manner in which a news release is encoded will be influenced by the regulations in place (e.g., certain writing styles and formats are standard in the industry). Production refers to the actual encoding of the messages and imbuing them with meaning. Variables such as resources available, organizational culture, and logistical constraints influence this moment. Consumption refers to audience decoding of public relations messages. Identity refers to the meanings of various cultural identities that emerge, including meanings about the organization's identity, from the entire process (Curtin & Gaither, 2007). This model allows us to see public relations as "dynamic, discursive, and polysemic" and "examine public relations as a boundary-spanning, meaning-making, and culture-producing enterprise" (Bardhan & Weaver, 2011, p. 7).

The culture–economic model and the notion of cultural intermediaries, when combined with the concept of cosmopolitan communication, allows us to examine the ethical implications and local–global dimensions of public relations discourse. This combination allows us to hold public relations communicators (or cultural intermediaries) morally responsible for the manner in which they encode, produce, and disseminate their messages, and are accountable for the resulting representations of issues and cultures. Therefore, I use this combination as a guide to analyze the public relations discourse produced by DWB in its communication with the media and relevant stakeholders during the 2014 Ebola health crisis.

THE CASE: EBOLA AND DOCTORS WITHOUT BORDERS

The geographic scale of the 2014 Ebola outbreak was a shifting scale, and it had two main intertwined trajectories—the outward spread of the virus itself and the aid operations and public relations discourse of DWB. First, the geographic scale of the outbreak itself was regional/local (west Africa) to global. By January 2015, 24 cases had been reported in the West—10 in the U.S. and 14 in Europe. The virus also spread to Nigeria and Mali in Africa ("How many Ebola patients," 2015). Second, the geographic scale of the operations of DWB was also regional/local to global. While the organization itself is global, the response for Ebola in west Africa was organized from European and U.S. operational centers and the public relations communication flowed from regional/local (west Africa/Europe/U.S.) to global. The content for the communication came from west Africa but was distributed mainly from the U.S. and Europe. When these two trajectories are combined, it becomes evident that the Ebola phenomenon cannot be geographically mapped in a simple linear fashion. It is perhaps best to approach it as global–local dialectic—the global and local work simultaneously in complex intertwined ways.

Ebola

Although the Ebola outbreak in west Africa grabbed global attention in August 2014, the reality was that the outbreak had begun in Guinea, Liberia, and Sierra Leone in March that year. In fact, there is nothing recent about Ebola. It was first diagnosed in humans in 1976 in the Democratic Republic of Congo, and there have been several outbreaks over the last four decades in various parts of Africa. The recent outbreak, however, killed more than all the others combined (Chan, 2015). Until this outbreak, Ebola was regional to Africa with some activity reported in the Philippines. There was one scare in Hamilton, Canada, in 2001 but that subsided quickly when it was found that the case was not Ebola related. There was another minor scare in the U.S. in 1989 when monkeys shipped from the Philippines were suspected of carrying the virus but the strain was found to not be deadly to humans. For the rest of the world, Ebola was an all-African health problem (Dmyterko, 2013).

Ebola, so far, has no cure. Diseases without cures produce fear, uncertainty, and border anxiety (Gilman, 1988). Until 2014, Ebola was a far-away disease in remote parts of Africa, and the rest of the world did not think the virus would spill over. A boundary was constructed between the "non-Ebola Us" and the "Ebola Other" to allay fears of contamination. The Western world with advanced medical resources gave no priority to developing a vaccine. It was not a profitable venture (Chan, 2015). The age-old binary of the advanced West and backward Africa was driving how the world perceived and responded to Ebola. To the Western world, there was nothing surprising about Ebola being in Africa since for centuries, it has represented Africa to itself "as an incubator for disease, poverty, famine and a host of other terrible afflictions" (Dmyterko, 2013, p. 3).

But this changed in 2014 when the boundary was disrupted. Two U.S. aid workers contracted the virus in late July and were sent back to the U.S. Soon after, Liberian national Thomas Eric Duncan became the first person to succumb to Ebola on U.S. soil. Two nurses who had cared for him tested positive but survived. The world woke up and finally took notice. The WHO declared the situation to be a Public Health Emergency of International Concern on August 8, 2014. By this time, hundreds had already succumbed to Ebola in west Africa (Chan, 2015; "Pushed to the limit," 2015).

The Western media response was not surprising. Other pandemics in the past (e.g., AIDS/HIV) have been depicted as killers from far-away places (Bardhan, 2002). Ebola fit right into this overarching frame that the media were familiar with. Stereotypes of Africa, irresponsible and sensational press coverage, "healthy Us vs diseases Them" narratives, border anxiety, fear of contamination, and suspicion of all immigrants from Africa were some of the general characteristics of media discourse. Furthermore, the coverage was influenced by the sensational and

morbid depictions of Ebola in past (Western) popular media such as the 1994 bestseller *The Hot Zone* by Richard Preston, the 1995 book *The Coming Plague* by Laurie Garrett, and the Hollywood production *Outbreak* starring Dustin Hoffman. These cultural texts had already primed Western audiences on how to perceive the pandemic ("Time to put Ebola in context," 2010).

In 2014, the news media picked up where these texts had left off, "...complete with alerts, warnings, and breaking news...showing us people lying dead in the streets in Liberia and telling us the story of hospitals refusing patients, schools closing, and children orphaned" (Ratzan & Moritsugu, 2014, p. 1213). Border anxiety was high. For example, there were reports of colleges in Texas refusing applicants from Nigeria and schools in New Jersey banning students from Rwanda unless they were quarantined for 21 days (Karamouzian & Hategekimana, 2015). In Dallas, immigrants from various parts of Africa reported being stigmatized in daily interactions and their children being labeled "Ebola kids" in school (Herskovitz, 2014).

The surge in media attention lasted for a few months. It subsided as soon as no more U.S. or European cases were being reported. By December 2014, Ebola was a fading story. At the time of writing (Spring/Summer 2015), the situation has stabilized or declined in west Africa. However, Ebola has not disappeared, and the already meager health and public service resources in this region have been stretched further ("Pushed to the limit," 2015). There are reports of flights to the region being suspended, foreign companies cutting back on personnel, and commerce and agriculture being adversely affected (Chan, 2015). Since the conscience of the Western world was jolted by this crisis, some Western-funded vaccine trials have been initiated ("Pushed to the limit," 2015). But there is no vaccine till date, and Ebola is not a major story anymore in the West. It has gone back to Africa.

Doctors Without Borders

Doctors Without Borders was the first humanitarian aid organization to be on the ground in Guinea in March 2014 to provide emergency response to the outbreak. It had also been on the ground during previous outbreaks of Ebola. With the surge in global communication technologies in the 1990s, DWB has extensively used public relations to call attention to crises, speak out about human injustices, promote its various missions, build its own image, and engage in advocacy (DeChaine, 2000). In the case of the Ebola crisis, DWB played the role of a significant cultural intermediary, and was involved in all the five moments of the culture–economic model. Therefore, it is appropriate to analyze its public relations communication to understand how a nonprofit transnational aid organization globally perceived to be a credible source decided to tell the story of Ebola to the rest of the world,

and critique the nature of the intercultural discourse about identities, power, and cultural politics it produced.

Doctors Without Borders was established in 1971 in France by a group of journalists and physicians. No organization of this type had existed before. It is more than just a humanitarian aid organization and prefers to characterize itself as a movement and its work as activism (Beardsley, 2014). According to its charter, "MSF provides assistance to populations in distress, to victims of natural or man-made disasters, and to victims of armed conflict. They do so irrespective of race, religion, creed, or political convictions" ("Charter," n.d., para. 2). The movement characterizes itself as neutral, independent, impartial, ethical, accountable, and committed to *témoignage* or "bearing witness to injustice" (Wieners & Kitamura, 2014, para. 22).

While it started out with limited resources in its earlier decades, DWB now operates on a budget of about $ 1.2 billion per year and has a volunteer base of 30,000 physicians, nurses, logisticians, and other locally recruited staff. It operates in close to 70 countries. It has five operational centers in Europe, chapters around the world, and the majority of its volunteers are local recruits with local knowledge. Ninety percent of its funding comes from a loyal base of five million private donors. Due to its decentralized nature, it is able to move fast at times of crises (Fox, 2014). Redfield (2013) describes it as a "global, shifting organization" (p. 3). While it has experienced some "institutional thickening" over the last four decades, the organization constantly attempts to minimize bureaucratization by "maintaining a culture of internal argument and critical reflection" (Fox, 2014, p. 5). Furthermore, while "it is determined to live up to its collective self-definition as a movement," it is also "determined not to succumb to romantically heroic, evangelical, or ideologically partisan notions of humanitarianism" (Fox, 2014, p. 5).

As a first responder to Ebola, DWB was vocal about its frustration at the lack of response from the world community, especially after repeated appeals for help to entities such as WHO, UNICEF, the UN, and various governments with resources. According to its spokespersons, the international response to Ebola was "slow, derisory, irresponsible" (Chan, 2015, p. 105). By November 2015, the organization had spent $143 million of its own funds and lost several of its own workers to the virus (Wieners & Kitamura, 2014). In comparison, the inadequate response from the rest of the world was a sad testament to the lack of empathy for cultural others in dire need in a "distant" part of the world.

Cosmopolitan Communication as a Framework for Intercultural Public Relations

Ebola is mobile and so is DWB, and both have local and global dimensions. What is needed to make sense of how one mobile entity told the story of a mobile phenomenon are theories/models that are equipped to tackle the fluid

local–global dialectic involved. According to Martin and Nakayama (1999), the notion of dialectics is useful for tackling the messiness of the intercultural communication process. It helps us see the relationship between opposite-seeming ideas and forces (e.g., local and global) in ways that are dialogic and relational rather than purely oppositional (i.e., local is the opposite of global). The concept of cosmopolitan communication (Sobré-Denton & Bardhan, 2013) from intercultural communication scholarship, combined with the culture–economic model (Curtin & Gaither, 2007) of public relations, is a conceptual framework I found suitable for analyzing the local–global dialectic involved in DWB's public relations discourse about Ebola.

One of DWB's main challenges and goals is how to be local and global at the same time, and operationalize this guiding philosophy in its day-to-day work:

> This dilemma emanates from MSF's "without borders" vision and founding commitments. It calls for balancing and blending universalism with respect for particularistic differences within and between the many societies and cultures in which MSF works, and also between MSF's international sections and its multinational personnel. (Fox, 2014, p. 6)

Ebola, in a clinical sense, is universal. Yet the ways in which it manifests itself in various locales, and the cultural practices and beliefs that impact what it means, how it spreads, or is contained, are local issues. To tackle the messiness of the local–global dialectics of this case and the actors involved, we cannot put the universal in stern opposition to the particular (Eagleton, 1990).

To put the universal in conversation with the particular in intercultural communication contexts involving local–global dialectics, Sobré-Denton and Bardhan (2013) offer the notion of cosmopolitan communication. Cosmopolitan communication, in their view, entails navigating the dialectic to unpack how the global is in the local and the local can become global and engaging in communication that addresses this complexity in an ethical manner. The concept challenges methodological nationalism, or the tendency to equate country with culture, and emphasizes that there are many issues that cannot be resolved by one country or culture alone, i.e., issues that are transnational in scope. Cosmopolitan communication forefronts social and global justice goals and "*is a world- and other-oriented practice of engaging in deliberate, dialogic, critical, non-coercive and ethical communication*" (p. 50, italics in original). It entails seven assumptions:

1. It is world- and other-oriented
2. It strives towards mutuality
3. It is attentive to power inequities
4. It actively engages borders
5. It invests in a dialogic, emancipatory and non-oppositional view of cultural difference

6. It sees critical self-transformation as a key goal
7. It is hopeful and deliberate (Sobré-Denton & Bardhan, 2013, pp. 49–50)

Some or all of these assumptions can be operationalized and applied to communication texts and discourse for the purpose of analyzing how these texts represent local–global dialectics and play a role in producing meaning in intercultural contexts.

Combining the assumptions of cosmopolitan communication with the culture–economic model of public relations involving the five moments (representation, regulation, production, consumption, and identity) allows us to ask the following questions regarding DWB's public relations discourse about the 2014 Ebola outbreak:

1. Was the local–global dialectic represented in the discourse? If yes, in what ways?
2. How were various cultural identities represented in relation to Ebola, including the identity of DWB?
3. Who were the main actors (sources) used in the discourse?
4. Did the discourse mainly emphasize collaboration or contention at a time of crisis? How was difference represented?
5. What were the social/global justice components of the discourse? Were the messages dialogic, world- and other-oriented, hopeful, and emancipatory? Was attention paid to power inequities?

While I focus on representation in my analysis, I do engage the other overlapping moments for a more holistic picture. Using the above questions as guides, I now turn to the details of the Ebola story that DWB decided to tell the world through its public relations discourse.

Telling the Story of Ebola

News releases constitute a primary form of communication in public relations. They represent an organization's point of view on issues, are directed at the media and primary stakeholders/publics for a given issue, and are usually triggered by "real-time" events on the ground. Releases from high-profile sources can be powerful in shaping the tone of media coverage. Media coverage, in turn, influences leaders and policy makers (Bardhan, 2002). News releases may be distributed directly through mail and e-mail, through PR wire services, or posted on the organization's website. The latter technique is popular since it allows the media and relevant stakeholders (in the case of Ebola: leaders, potential volunteers, and organizations/governments in a position to make a difference) to directly pick up the

releases they need. This is especially true when it comes to popular and high-profile sources such as DWB. Organizations often employ media monitoring services to gauge to what extent their releases are picked up and used by the media. But the goal of this study was not to assess the reach of DWB's news releases since it can be safely assumed that they were a credible go-to source for the media and stakeholders around the world during the Ebola crisis. The goal was to analyze and critique the news release discourse itself.

A single news release cannot give us a sense of how the story about an ongoing issue is constructed; however, the collection of news releases about an issue, treated as an unfolding narrative, is useful for making sense of how a story is told. Therefore, I used the DWB website to collect all the news releases posted about Ebola, starting with its announcement to the world on March 31, 2014, forecasting the dire nature of the outbreak. The last news release, at the time of writing, was posted on May 9, 2015, a little more than a year after the onset of the crisis. A total of 23 news releases were posted during this time frame. Only two were posted between March and August 2014. The main bulk of the releases clustered between September and November 2014. They slowed down in December 2014, and only three releases were posted between January and May 2015. A clear beginning, middle, and tentative conclusion emerged from the news release discourse during this time frame. The overall narrative involved three clear acts or phases. I followed a "close reading" approach which, according to Brummett (2010), is a "mindful, disciplined reading of texts in context which aims to get beneath the surface of texts to highlight socially shared meanings in order to produce a critical analysis" (p. 9). The following is what emerged.

Act 1: An early warning. Doctors Without Borders was alerted in early 2014 about Ebola in Guinea and immediately mobilized to the location. It made a production decision on March 31 to publicly announce through a news release that a dire situation was unfolding in Guinea, and that the world needed to pay attention and get involved. It followed the protocol (regulation moment) of news release writing which adheres to the news writing style (the who, when, why, what, and how of a story) and promotes the work of the client. Another production decision was made on June 23 to again urge the world to help and to report the deteriorating situation on the ground. During this time, hundreds in west Africa had succumbed to the virus.

The first release is titled "Guinea: Mobilization against Ebola epidemic" (2014). The title, which is what usually grabs the attention of the media and stakeholders, does not indicate the severity of the situation on the ground. However, the tone of the release itself is urgent. It reports that DWB "was facing an unprecedented epidemic" in terms of magnitude and distribution of cases. The release describes the organization's efforts to check the spread of the virus and treat patients, the meager resources in place, and the resources still urgently needed.

It reports that there is no known vaccine for Ebola. It mentions that DWB had intervened in Ebola cases in Africa before but that this outbreak was much more complicated because of the geographic location and density of population escalating the risk of transmission. No information is provided on how the virus transmits but the isolation theme, or the need to isolate infected patients, is prominent. The release ends with a plea to the WHO and to Guinean authorities to get more involved. The then-current number of cases and deaths are reported. All the main actors (sources cited) are DWB Western (nonlocal) staff.

The gap of nearly three months before the next release on June 23 is a significant production/timing decision. It is evident from this release that DWB had been reaching out to the world (with little success) for more help. But at a time when hundreds were losing their lives, the lack of public communication is surprising. The June 23 release has a very urgent title: "Ebola: Massive deployment needed to fight epidemic in west Africa" (2014). It leads with a statement about how DWB had reached its limits, how "the epidemic is out of control," and the need for "massive deployment of resources by regional governments and aid agencies." The "real risk of it spreading to other areas" is emphasized, the spill over into Liberia and Sierra Leone is noted, and the total number of cases is reported. Local anxiety about Ebola, fear, suspicion of health facilities, and the lack of sufficient information about how the virus spreads are emphasized. The efforts and resources being provided by DWB constitute the bulk of the release, and the failure of the world to get involved is bemoaned and criticized. The release positions DWB as the heroic lone fighter, the only aid organization involved in the effort to spread information and curb the deadly virus.

While these two releases are early warning calls to the region and the world to get more involved in west Africa, they mostly describe the situation on the ground and construct DWB's identity as that of a lone crusader in an exploding humanitarian crisis. The local–global nature of Ebola and the possibility of it spilling out to the world are mentioned as is the need for the world to collaborate, care, and get involved locally. No local voices/sources from communities in west Africa, especially of those affected, are included. Doctors Without Borders speaks for them. This is a notable production decision. The lack of local community voices results in discourse that fails to put a human and local face to the virus and ends up primarily representing the heroic role of DWB.

Act 2: Pleas, protocols, and the need to allay fear. The next release was a lengthy one and was posted after another gap of two months on September 2, after the virus had crossed over to the U.S. It focuses on a speech to the UN by DWB's International President Dr. Joanne Liu, urging the world to become more involved. After this release, two clear themes emerged in all the news releases until the end of November—the protocols for safety followed by DWB and the need to not

spread fear and panic through unnecessary quarantines and vague protocols in various countries, especially the U.S.

The September 2 release has an urgent title: "Global bio-disaster response urgently needed in Ebola fight" (2014). It begins with the admonishing words "World leaders are failing to address the worst ever Ebola epidemic..." and emphasizes the need for help from countries with resources. The release reports Dr. Liu's denouncement of world inaction despite repeated pleas from DWB in an exploding situation: "Six months into the worst Ebola epidemic in history, the world is losing the battle to contain it...leaders are failing to come to grips with this transnational threat" (para. 4). She calls the global lack of attention the "global coalition of inaction" (this is a phrase that appears in later releases during this time frame as well) and states: "Rather than limit their responses to the potential arrival of an infected patient in their countries, they [countries] should take the unique opportunity to actually save lives where immediately needed, in West Africa" (para. 6).

The bulk of the release focuses on the needs on the ground and what the world can do to help. Graphic words describe how people are "dying in their villages and communities" and how "highly infectious bodies are rotting in the streets" (para. 10). Doctors Without Borders is described as "fighting a forest fire with spray bottles," and Dr. Liu is quoted as saying: "The clock is ticking and Ebola is winning. ...The time for meeting and planning is over. It is now time to act. Every day of inaction means more deaths and the collapse of societies" (para. 13). The globally interconnected nature of Ebola is highlighted, and the need for the global and the local to work together to save lives and protect societies is emphasized. This message appears in several releases between September and December.

The rest of the releases during this time frame highlight two clear themes—DWB's safety protocols for its own staff and volunteers and the need to not spread fear and panic and deter volunteers from other countries from helping in west Africa. In September and October, releases announced the cases of three staff members, two in the U.S. and one in France, who were feared to have contracted the virus. Only one of these cases (in the U.S.) was later confirmed. In all of these releases, DWB stresses its protocols for workers upon return to their home countries and the safety measures and training provided to them while on site. According to Director of Operations Brice de le Vingne, "MSF applies very strict protocol of protection for its staff—before, during and after their time is a country affected by the current Ebola outbreak" ("Ebola: MSF staff member infected," 2014, para. 3).

The tone of these releases is defensive, as though attempting to persuade stakeholders, especially potential volunteers, that they should not be afraid of working for DWB. Great details are provided on these protocols and safety measures, and it

is pointed out that a majority of those who had contracted the virus were national workers (in communities in west Africa) due to factors beyond the organization's control (e.g., unsafe rituals and burial methods in communities). Uncertainty is expressed about how the international workers feared to have contracted the virus may have been affected. All international workers are reported as being treated in Europe or the U.S. Nothing is mentioned about the treatment of local infected staff.

The second theme is related to the first one, and it emphasizes the importance of not spreading panic through unclear protocols in home countries of those returning from west Africa. The focus is on the U.S. and its unclear protocols and overinsistence on quarantines. It is expressed that if the U.S. panics and has unclear protocols then this would affect the response of other countries as well, thereby deterring volunteers from going to west Africa. Sophie Delaunay, executive director of DWB-USA, is quoted: "Ebola must not be guided by panic in countries not overly affected by the epidemic. ...Any regulation not based on scientific medical grounds, which would isolate healthy aid workers, will very likely serve as a disincentive to others to combat the epidemic at its source, in West Africa" ("Ebola: Quarantine can undermine," 2014, para. 3).

A strategic production decision was made when a release titled "Statement from Dr. Craig Spencer" (2014) was posted on November 11. Dr. Spencer, a U.S.-based DWB staff member, had become infected by Ebola but had recovered. In his statement, he praises the efforts of DWB in west Africa and urges the media, various stakeholders, and the world community to not panic and to join the effort: "Please join me in turning our attention back to West Africa, and ensuring that medical volunteers and other aid workers do not face stigma and threats upon their return home. Volunteers need to be supported to help fight this outbreak at its source" (para. 7).

A couple of sporadic releases during this time frame reported a decline in the number of cases in Liberia and the Democratic Republic of Congo. These releases contained strong cautionary words warning that the outbreak was far from over. A couple of releases announced international partnerships for the development of treatments and vaccine trails. In these releases DWB stresses that these treatments should be widely available and affordable where most needed. One release in late October reported on a high-level meeting convened by the WHO, and the spokesperson for DWB emphasized the need to "incentivize" the development of vaccines and treatments. This message suggests that monetary incentives are needed to incentivize those in the world community with resources to step in during a time of a humanitarian crisis.

This act of the Ebola story is marked by constant news release production about the outbreak. As in the first act, the actors (sources cited) are all DWB staff. The need for the world community to care more and collaborate to resolve this transnational health crisis is constantly mentioned, the slow response is repeatedly

criticized, and local–global interdependencies are highlighted. Doctors Without Borders' identity as the lone crusader working with little help from the world continues to be emphasized. While west Africa is constructed as the victim of an uncaring world, no local voices are included.

Act 3: Fade out. The Ebola story began to fade fast in December. Only two releases were posted during this month. There were no more reports of cases in Western countries. The first release reports on how the international response had been slow and insufficient and how the national governments of Guinea, Liberia, and Sierra Leone had taken the lead in fighting Ebola assisted by nongovernmental organizations with limited resources and organizations such as DWB. International President Dr. Joanne Liu is quoted as asking: "How is it that the international community has left the response to Ebola—now a transnational threat—to doctors, nurses and charity workers?" ("Ebola: International response slow," 2014, para. 5). The release reports that the virus had by no means been defeated and that resources and means to spread information were still very limited. Another release in December reported on a U.S.-backed initiative to encourage Ebola-related research but cautioned that these initiatives should not end up simply rewarding pharmaceutical companies unless lifesaving drugs could be made accessible and affordable.

Only three releases were posted between January and May 2015. The first one announced the cessation of a drug trial (led by Oxford University and the pharmaceutical company Chimerix) in Liberia due to the declining number of Ebola cases. The release explains that not enough patients were available for successful trials. It states that while the decline in Ebola cases is good news, DWB is determined to remain involved in medical efforts dedicated at producing successful results for vaccines and other medicines. The last two releases complete the fade out. Doctors Without Borders summarizes its efforts in west Africa over the past year, reports the number of lives saved and lost, decries the inaction of the world, and reflects on what it could have done better. With the words "global failures have been brutally exposed in this epidemic," the releases caution that the outbreak cannot be declared over since new cases had been reported in Guinea and Sierra Leone, and urge the continuation of a search for vaccines and better treatment. Henry Gray, head of Ebola operations, is quoted: "Quite simply, we were all too late. …The world—including MSF—was slow to start the response from the beginning. That lesson has been learned, at the cost of thousands of lives, and we can only hope it will prevent the same thing from happening in the future" ("MSF welcomes news," 2015, para. 7).

The overall narrative ends in a reflective tone which is characteristic of DWB's organizational culture of self-reflection and self-critique. There is an expression of hope that valuable lessons have been learned from this transnational crisis, lessons which will help prevent the loss of lives in less powerful and developing parts of the

world in the future. But the strong words of criticism for the slow global response seem to cut against that hope. Doctors Without Borders' voice once again emerges as prominent as the story fades out, and we are left wondering about the lives and thoughts of the people of the region who still remain vulnerable to a virus without a cure for which there seems to be no global or regional strategy in place. Would the story have faded out in this way if the epicenter of the virus had been somewhere in the Western world?

CONCLUSION

The Ebola-related news release discourse produced by DWB tells the story of disease and crisis in west Africa and the inaction of the rest of the world. The organization's efforts in the midst of this transnational humanitarian crisis are represented as heroic. While the overall discourse does not focus on culture per se, we can draw some conclusions about its assumptions about culture. The globally interconnected nature of cultures/countries today is central to this story. The discourse highlights that in a highly mobile world, disease travels easily and epidemics cut across cultural/national borders. Therefore, while it is crucial to respect cultural specifics in the context of epidemics, it is also necessary to grasp the overall interconnected picture and act for the good of all societies. The local and the global are treated as a dialectic, working simultaneously in complex ways. What happens in west Africa in the context of Ebola is very relevant to the rest of the world, and how the world reacts impacts west Africa. The common enemy is Ebola, not west Africa. For Ebola, the world is an interconnected space and the virus recognizes no "here" and "there" as humans do. Therefore, the world must act accordingly. This is the deliberate message of the discourse.

The discourse aligns with the assumptions of cosmopolitan communication to the extent that it engages borders, addresses the local–global dialectic in relation to Ebola, and is world- and other-oriented. It is deliberate in its message and focus, and difference is treated as something that needs to be engaged with to find solutions to problems that cut across cultural/national borders. In its overall message about the need for intercultural collaboration and the need to understand the world as an interconnected space, the discourse does not downplay the difficulties involved. This is where the social/global justice and critical component of the discourse become evident. The fact that we live in a highly unequal world where there are those who are resource rich (the West) and those who are marginalized (the rest) due to post/colonial cultural/economic politics and cultural stereotypes is made evident in the strong critique aimed at the slow response of the world community. Power inequities are highlighted along with the message that we need to share and care across cultural borders, especially during times of transnational

crises. The need for critical self-transformation in how the world as a whole sees itself in relation to particular others (west Africa in this case) is highlighted. The tendency to see countries as water-tight units in a highly interconnected world is challenged. The discourse emphasizes that we cannot afford to wait for a transnational problem to arrive at the national doorstep to take action and to consider it to be real. Instead, the message is to proactively engage with the cultural other across national/cultural borders in order to address issues that concern all cultures. This is a world- and other-orientation that recognizes that the self/local and other/global are intertwined in the transnational realm.

While at an overarching level DWB played the role of a social/global justice-oriented cultural intermediary, other aspects of the representation, identities, and production/regulation choices involved in its news release discourse require critique. Following the protocols of news releases writing (regulation and production moments), the narrative continuously champions the heroic work of DWB, and contrasts it to the inaction of the rest of the world. There is no emphasis, however, on how to generate dialogue with others in the world community to fight Ebola—just criticism of their inaction. The discourse accomplishes what most public relations discourse aims to do—advocate for and promote the client, and forward the client's agenda. The identity of DWB as the hero in this crisis is promoted and all other actors, especially the world community (other countries, aid organizations, media), are represented as inadequate and morally inferior in their response to the crisis.

Second, the discourse itself, while critiquing the inaction of the Western world, did not pick up momentum until the virus spilled outside west Africa. For example, more releases about the dire situation could have been sent out between March and August 2014. Hundreds of lives had been lost by August 2014 in west Africa, but only two releases documented this catastrophe. This was a poor production choice that needs to be questioned. Third, local voices from west Africa, the epicenter of Ebola, are missing from the discourse. Doctors Without Borders' Western staff speak for west Africa. This does not allow for empowerment of local points of view. While the local and the global, at one level, are argued to be interconnected, the discourse does not privilege the local in its choices of sources cited. West African communities are represented as powerless and voiceless victims and, ironically, Africa's identity is once again diminished.

Overall, the local–global dialectic emphasized by DWB in its public relations discourse about Ebola did not have the desired impact of rallying the world. Of course, it must be noted here that its communication with stakeholders was not the only factor that played a role in determining how the world responded. That said, its communication cannot be disregarded either given its high-profile status as a credible source during global health crises. The global (the world, primarily the resource-rich West) did not respond to the local (west Africa) in a humane,

timely, and empathetic manner. The desired perception of global interconnectedness was not achieved since actors outside west Africa, operating in their own local contexts, were unable to see the self in the other and connect meaningfully with west Africa. Perhaps a discourse that had included more west African voices could have helped humanize Ebola in a manner that would have resonated better with others around the world and challenged age-old stereotypes of "distant Africa." That is, discourse which aims to arouse empathy and reduce the gap between the self and the other may have been more effective in this particular context. While a castigation of world inaction was necessary, simply castigating without inviting dialogue and collaboration may not be so effective for closing cultural and perceptual gaps. Finally, DWB could have focused less on promoting its own image as the lone savior, and made a more concerted effort to communicate the global ramifications of the outbreak before Ebola spilled outside west Africa.

In conclusion, DWB's public relations discourse about the Ebola outbreak was admirable at some levels. It "bore witness" to the injustice of inadequate global response in the face of a humanitarian crisis and followed several of the tenets of cosmopolitan communication. But it fell short in other ways. Through writing this chapter, it has been my goal to demonstrate that organizations engaged in transnational public relations communication are always inevitably involved in representing the relationship between the local and the global. No matter how progressive an organization perceives its own identity to be, it should constantly remain vigilant of its own discourse. The choices made during the process of representation and the voices privileged influence stakeholders in how they think about issues, cultures, and difference and what actions they do or do not take. Representations can be progressive or they could end up entrenching the same old identities, differences, ideologies, and power inequities that continue to make this world the sharply unequal playing field that it is. From a social/global justice and cosmopolitan communication perspective, public relations practitioners working globally and transnationally should strive to perform as ethical cultural intermediaries and always keep in mind that the discourses they produce impact intercultural perceptions in ways that can empower or destroy real lives and communities.

REFERENCES

Bardhan, N. R. (2002). Accounts from the field: A public relations perspective on global AIDS/HIV. *Journal of Health Communication, 7*(4), 221–244.

Bardhan, N. R. (2012). Culture as a "traveling" variable in transnational public relations: A dialectical approach In D. Waymer (Ed.), *Culture, social class and race and in public relations* (pp. 13–30). Lanham, MD: Lexington Books.

Bardhan, N. R. (2013). Constructing the meaning of globalization: A framing analysis of *The PR Strategist. Journal of Public Relations Research, 25*(3), 1–20.

Bardhan, N., & Weaver, C. K. (2011). Introduction. In N. Bardhan & C. K. Weaver (Eds.), *Public relations in global cultural contexts: A Multi-paradigmatic approach* (pp. 1–28). New York, NY: Routledge.

Beardsley, E. (2014, October 9). Doctors without borders changed the way we heal the world. *National Public Radio*. Retrieved from http://www.npr.org/sections/goatsandsoda/2014/10/09/354754651/doctors-without-borders-changed-the-way-we-heal-the-world

Brummett, B. (2010). *Techniques of close reading*. Thousand Oaks, CA: Sage Publications.

Chan, J. (2015). Scaling up the Ebola response: What we learned from AIDS activism. *Journal of AIDS and HIV Infections, 1*(1), 104–109.

Charter (n.d.). *Doctors without borders*. Retrieved from http://www.doctorswithoutborders.org/about-us/history-principles/charter

Culbertson, H. (1996). Introduction. In H. Culbertson & N. Chen (Eds.), *International public relations: A comparative analysis* (pp. 1–13). Mahwah, NJ: Lawrence Erlbaum Associates.

Curtin, P., & Gaither, K. T. (2007). *International public relations: Negotiating culture, identity, and power*. Thousand Oaks, CA: Sage.

Curtin, P., & Gaither, T. K. (2012). *Globalization and public relations in postcolonial nations*. Amherst, NY: Cambria Press.

Cutlip, S., Center, A., & Broom, B. (2000). *Effective public relations* (8th ed.). Upper Saddle River, NJ: Prentice Hall.

Daugherty, E. (2001). Public relations and social responsibility. In R. Heath (Ed.), *Handbook of public relations* (pp. 389–401). Thousand Oaks, CA: Sage Publications.

DeChaine, D. R. (2000). Humanitarian space and the social imaginary: Médecins Sans Frontières/Doctors Without Borders and the rhetoric of global community. *Journal of Communication Inquiry, 26*(4), 354–369.

Dmyterko, V. (2013). *Predator virus: Media's shaping of Ebola in the western public mind*. Retrieved from https://www.ucl.ac.uk/sts/prospective/bsc/Victoria_Dmyterko_ebola_essay

Eagleton, T. (1990). *The ideology of the aesthetic*. Oxford: Basil Blackwell.

Ebola: International Response Slow. (2014). *Doctors without borders*. Retrieved from http://www.doctorswithoutborders.org/article/ebola-international-response-slow-and-uneven

Ebola: Massive Deployment Needed to Fight Epidemic in West Africa. (2014). *Doctors without borders*. Retrieved from http://www.doctorswithoutborders.org/news-stories/press-release/ebola-massive-deployment-needed-fight-epidemic-west-africa

Ebola: MSF Staff Member Infected. (2014). *Doctors without borders*. Retrieved from http://www.doctorswithoutborders.org/news-stories/press-release/ebola-msf-staff-member-infected-liberia

Ebola: Quarantine can Undermine. (2014). *Doctors without borders*. Retrieved from http://www.doctorswithoutborders.org/article/ebola-quarantine-can-undermine-efforts-curb-epidemic

Edwards, L., & Hodges, C. (2011). Introduction: Implications of a (radical) socio-cultural turn in public relations scholarship. In L. Edwards & C. Hodges (Eds.), *Public relations, society & culture* (pp. 1–14). London: Routledge.

Fox, R. C. (2014). *Doctors without borders: Humanitarian quests, impossible dreams of Médecins Sans Frontières*. Baltimore, MD: Johns Hopkins University Press.

Gilman, S. L. (1988). *Disease and representation: Images of illness from madness to AIDS*. Ithaca, NY: Cornell University Press.

Global Bio-disaster Response Urgently Needed in Ebola Fight. (2014). *Doctors without borders*. Retrieved from http://www.doctorswithoutborders.org/news-stories/press-release/global-bio-disaster-response-urgently-needed-ebola-fight

Guinea: Mobilization against Ebola Epidemic. (2014). *Doctors without borders*. Retrieved from http://www.doctorswithoutborders.org/article/statement-dr-craig-spencer

Herskovitz, J. (2014, October 5). *Reuters*. Retrieved from http://www.reuters.com/article/2014/10/05/us-health-ebola-usa-immigrants-idUSKCN0HU00120141005

Hodges, C. (2006). "PRP culture:" A framework for exploring public relations practitioners as cultural intermediaries. *Journal of Communication Management, 10*(1), 80–93.

Hodges, C., & McGrath, N. (2011). Communication for social transformation. In L. Edwards & C. Hogdes (Eds.), *Public relations, society & culture* (pp. 90–104). London: Routledge.

How many Ebola Patients have been Treated Outside Africa? (2015, January 26). *The New York Times*. Retrieved from http://www.nytimes.com/interactive/2014/07/31/world/africa/ebola-virus-outbreak-qa.html?_r=0

Karamouzian, M., & Hategekimana, C. (2015). Ebola treatment and prevention are not the only battles: Understanding Ebola-related fear and stigma. *International Journal of Health and Policy Management, 4*(1), 55–56.

Martin, J. N., & Nakayama, T. K. (1999). Thinking dialectically about culture and communication. *Communication Theory, 9*(1), 1–25.

MSF Welcomes News. (2015). *Doctors without borders*. Retrieved from http://www.doctorswithoutborders.org/article/msf-welcomes-news-liberia-ebola-free-while-urging-continued-vigilance

Pushed to the Limit. (2015). *Doctors without borders*. Retrieved from https://www.doctorswithoutborders.org/sites/usa/files/msf143061.pdf

Ratzan, S. C., & Moritsugu, K. P. (2014). Ebola crisis—communication chaos we can avoid. *Journal of Health Communication, 19*, 1213–1215.

Redfield, P. (2013). *Life in crisis: The ethical journey of Doctors without borders*. Oakland, CA: University of California Press.

Sobré-Denton, M., & Bardhan, N. (2013). *Cultivating cosmopolitanism for intercultural communication: Communicating as global citizens*. New York, NY: Routledge.

Statement from Dr. Craig Spencer. (2014). *Doctors without borders*. Retrieved from http://www.doctorswithoutborders.org/article/statement-dr-craig-spencer

Taaffe, P. (2004, Winter). The future of global public relations: An agency perspective. *The Strategist, 10*(1), 22–23.

Time to put Ebola in Context. (2010). *Bull World Health Organ, 88*, 488–489.

Vogl, F. (2001, Spring). International corporate ethics and the challenges to public relations. *The Strategist, 7*(2), 19–22.

Wieners, B., & Kitamura, M. (2014). Ebola: Doctors without borders shows how to manage a plague. *Bloomberg Business*. Retrieved from http://www.bloomberg.com/bw/articles/2014-11-13/ebola-doctors-without-borders-shows-how-to-manage-a-plague

The Sinking of a Ferry, Sinking of Public Confidence: A Comparative Analysis of Government Crisis Management Cases

MOON J. LEE, UNIVERSITY OF FLORIDA, GAINESVILLE, FL, USA

Crisis strikes without any clear warning and major accidents/disasters are bound to happen. However, when a natural disaster or fatal accident happens, sometimes the public's anger and blame quickly shifts from what caused the crisis to those who are expected to end the crisis and ease the pain and suffering of people affected by the crisis. This is due to the perception (real or imagined) of having mishandled the crisis.

Crises are unexpected events that cause negative consequences from loss of tangible/intangible resources to loss of lives. Boin (2008) sees a crisis as an extreme situation that threatens core values or life-sustaining systems (from Christensen, Lægreid, & Rykkja, 2013). It requires an urgent, coordinated response from affected individuals, organizations, governments, and sometimes the international community as it unravels rapidly and with substantial uncertainties (Eriksson-Zetterquist, 2009).

At times of major crisis/disaster, people turn to their governments for leadership, direction, and order (Boin, 1998; Christensen et al., 2013). However, depending on the scope of the crisis and the level of preparedness of the respective government(s),

the crisis can turn into a tragedy that should have been avoided. This is what happened in South Korea on April 16, 2014: The sinking of the Sewol Ho ferry (Sewol). This is considered "one of the worst peacetime disasters" in South Korean history (The New York Times, April 11, 2015), shocking the entire country and reverberating the world over. Out of 476 passengers and crew on board, a total of 295 passengers were found dead with 9 missing. Approximately two thirds of them (183 people) were high school students on a field trip. In the end, it led to the suicide of the associate principal of the high school from where most students came, criminal prosecutions of the captain and crew members, the fall of a family-owned conglomerate, the death of the owner of the ferry company, the resignation of the prime minister, restructuring of the Korean National Coast Guard, a tearful apology from the president, the inconsolable grief of devastated families, and widespread mistrust of the government's ability to handle a future crisis/disaster among the Korean people. On that tragic day, when the Sewol Ho sank with 304 lives, so did the public's confidence in the government's handling of a major crisis.

Many missteps took place before, during, and after the crisis. In the end it is considered among the worst "man-made" disasters and could have been prevented if only adequate safety measures were in place (Dostal, Kim, & Ringstad, 2015). By reexamining what happened and how the Korean government responded to the crisis in comparison to how similar high-profile crises were handled elsewhere, governments should be able to prevent or minimize future casualties and loss of resources in other crisis situations. In this chapter, a careful analysis of the sinking of the Sewol Ho was done in comparison with a similar case, the sinking of a Swedish ferry in 1994 (the Estonia), to assess similarities and contrasts of best and worst practices of government crisis management in a global context.

THE SINKING OF SEWOL HO

The Sewol Ho ferry left port at 9:00 pm, heading to Jeju Island in the South Sea of the Korean peninsula, on April 15, 2014. The first distress call was made at 8:55 am on the morning of April 16, 2014. Although the first coast guard boat arrived at the site approximately 30 to 40 minutes later (Chosun Ilbo, April 2014), the ferry eventually capsized and submerged under the water over a period of one and a half hours, leaving many of the passengers trapped in their quarters, too late to escape.

Amid the chaos, it is believed that the passengers were repeatedly told to stay put and remain in their quarters (New York Times, April 2015). Video and audio recordings from those victims' last moments surfaced later on the Internet, corroborating the fact that the crew repeatedly broadcasted instructions to "stay put." Some cellphone footage showed that the passengers did not seem to realize the seriousness of the situation until it was too late to escape the sinking ship

(New York Time, April 215). On the other hand, the captain and his crew members left the ferry without providing any further instructions and were among the first to be rescued (Chosun Ilbo, April 2014). Although two other countries (i.e., the U.S. and Japan) offered help on the rescue operation, the South Korean coast guard declined the offers (The Hankyoreh, April 2014) despite failing to rescue the majority of the passengers. Amid the chaos, President Park was absent for the initial seven hours of the crisis, raising the public's eyebrows and creating lingering suspicion about her whereabouts.

Korean Government Crisis Responses

Initial Confusion, Misinformation, False Information: Lack of Information Management and Coordination

One of the major challenges in government crisis/disaster management is the difficulty in communication and coordination among multiagency or governmental units (Christensen et al., 2013). Although substantial effort has been placed toward multiagency planning and response in the past, particularly in the U.S. since 2001 (after the September 11 terrorist attack), multiagency coordination turns out to be difficult in many countries (see Eyerman & Strom, 2008). This seems to be rooted in each agency's/unit's tradition of working alone while having separate responsibilities (Eyerman & Strom, 2008). This was the case in the sinking of Sewol.

Initially, various units in the Korean government created multiple headquarters in response to the accident, causing a major problem in coordinating communication between themselves and creating confusion among the units (Suh, 2014). Approximately 4 hours into the rescue operation, the Central Disaster Management Headquarters (CDMH) mistakenly reported that a total of 368 passengers were rescued when in fact more than 300 were reported missing (Suh, 2014). It took several hours to correct the information and a full day for all the involved government units to establish the Pan-Government Accident Response Headquarters (PGARH) that unified the rescue operations and communication (Suh, 2014). However, by then, it was too late for any meaningful rescue operation. To make the situation worse, the head of the state, President Park, was absent in handling of the crisis during the initial seven to eight hours of the crisis, creating substantial criticism from among the public (Suh, 2014).

Shifting Blame: Government or Media?

The blame for the accident was quickly placed on the captain and his crew members who departed the ship first, followed by the owner of the company the ship was operating under. For example, President Park quickly placed blame on the captain and crew by publicly condemning them to "the death sentence" on national

TV (Kim & Yoo, April 16, 2014, Reuters). The captain was later found guilty of gross negligence and given 36 years of imprisonment. Each of the other 14 crew members were jailed for up to 30 years on charges spanning from negligence to abandonment.

The blame was then also placed on Yoo Byung-Eun, the owner of the shipping company, for the company's unethical business dealings that breached the safety of the ship. He went missing shortly after the crisis and was later found dead. Investigations found that the company often underreported the amount of cargo the ship was carrying and overreported the ship's capacities to the Korean Register of Shipping to get approval for renovations to increase carrying capacity (Suh, 2014). It was also found that the company bribed commissioners in the Incheon Coast Guard for its renovation of the Sewol Ho (Dostal et al., 2015).

The media heavily relied on the information government officials provided without independent fact-checking, particularly during the initial stage of the crisis and quickly blamed the captain and crew members for "abandoning" the ship and the owner of the ferry company (Chunghaejin Shipping, the holding company of the Sewol) for unethical business practices. However, the media later shifted its focus to the South Korean government's mismanagement of the crisis (Dostal et al., 2015).

Several allegations related to the government's attempt to control the news coverage of the crisis surfaced. The president of KBS (Korean Broadcasting Services), a state-sponsored TV station, for instance, was accused of interfering with the news coverage of the sinking of the Sewol Ho during and after the crisis (Choi, 2014). The question about whether the media coverage of the crisis was heavily influenced by government officials has raised much doubt on the government's sincerity and the news media's symbiotic relationship with the South Korean government and its censorship.

Lack of Preparedness and Lack of Government Assistance to Those Affected by the Crisis

The confusion during the initial stage of the crisis was attributed to the lack of preparedness on the part of the government. Information dissemination, communication coordination, and rescue operations were done by the seat of their pants. The rescue operation was conducted without much success and accurate information surrounding the victim's list. The updates on information about what was going on and care for the victims' families were absent, with no direct communication line established between the government and victims' families.

It took five days for the town of Jindo (the nearest town to the accident site), where many of the families of the missing and deceased came to find out about

their loved ones, to be declared a special disaster zone (Dorof, 2014). No orchestrated assistance for the survivors was provided such as care for the physical and psychological impacts of the trauma that the survivors were experiencing. Shortly after being rescued from the sinking ferry, the vice principal of Danwon high school (where the majority of the victims were from) committed suicide for suggesting the field trip to Jeju Island, reflecting the lack of physical and psychological assistance from the government to those who were grieving from the traumatic experience/loss (Dorof, 2014; Lee & Cho, 2014). The captain of the first coast guard ship sent in the rescue operation was found guilty of negligence and making false reports (Park & Hancocks, April 16, 2015). In the end, South Korea's National Assembly voted to restructure several government institutions including the coast guard over the failure of the rescue operation (Dostal et al., 2015). However, the public remains very unsatisfied over the adequacy of Korea's workplace and public safety culture (US Department of State, 2014).

The Sewol Ho, originally built and operated in Japan for almost 18 years before it was sold to Chonghaejin Marine Co., Ltd., was modified to carry more passengers and cargo than would be safe (Dostal et al., 2015). The inspectors from the Korean Register of Shipping inspected and approved the modifications to add two more floors of passenger space and to expand the Sewol's cargo space that were later found to be unsafe (Suh, 2014). It was found that the inspectors received bribes from the company owner to pass the inspections. Some strongly attribute the tragedy of the sinking of the Sewol Ho to the diminished role of the state in safety regulation and oversight and the state's delegation of the rescue operation to a private salvage firm (Suh, 2014).

Now and Then: The Families Demand and the Government Reacts

One year later, the South Korean government formally announced that it would try to raise the 6,825-ton ferry that sank (New York Times, April 22, 2015) with the projected cost of $74.6 million. The South Korean government hired a Chinese salvage company for the operation that was scheduled to start in May of 2016 and end by late July (Asia, April 16, 2016). However, the controversy surrounding the mishandling of the crisis, investigations of negligence, and compensation for the victims' families continue to put into question the effectiveness of the government's management of the crisis, in the postcrisis stage. The families of the victims and the missing continuously demand an independent investigation of the actual cause of the accident (Ryall, April 16, 2015) and wider and systematic approaches to prevent a similar disaster (Dostal et al., 2015). However even a year after the crisis, no independent investigation was launched (Rayll, April 16, 2015) due to the refusal of the ruling party, Saenuri, to grant a special committee its full investigation authority (Transport Workers Solidarity Committee's Report, 2014).

Furthermore, there have been some concerns raised regarding how the government has dealt with the victims' families. Suh (2014) reported that the police often monitored the victims' families and supporters and blocked them from meeting with the president. Meanwhile, orchestrated efforts were put forth to spread negative rumors about the victims' families and their supporters. They were portrayed as being unreasonable and even crazy through astroturfing on social media.

The biggest question is what was learned from this crisis. How do we prevent a crisis like the tragedy of Sewol Ho from happening again and how should we better manage such a crisis to minimize the negative impacts in the global scale? The main concerns raised were those regarding the South Korean government's readiness for disaster responsiveness, safety regulations (Dostal et al., 2015), close ties between the government and conglomerates (Felden, 2014), and the news media's various misreporting and lopsided news coverage (Kim & Kim, 2014).

Media and the prosecutors of the captain and crew members speculated and presented three direct causes for the accident: a sudden turn (Yonhap News, April 2014), overloading of cargo (Campbell, May 2014), and lack of blaster water (Choe, May 2014). However, in the larger societal context, the accident was due to the classic elements associated with a "man-made disaster waiting to happen": (a) corruption, (b) lack of government information coordination and rescue operations, and (c) lack of enforcement of safety regulations.

Comparative Analysis of a Similar Disaster, Swedish Estonia Ferry Sinking

There are striking resemblances and differences between this South Korean crisis and the Swedish "Estonia" ferry sinking that claimed 852 lives in the Baltic Sea, in 1994. Similar criticisms and concerns were raised on how this Swedish crisis was handled by the Swedish government two decades prior to the South Korean crisis. These include a lack of preparedness, lack of information coordination, failure of crisis management systems, lack of information provided by the government agencies, and lack of sensitiveness and care for the victims and their families over the salvage of the wreckage and bodies of the victims (Larsson & Nohrstedt, 2002).

The Estonia was built and operated by the Finnish company (Rederiaktiebolaget) for 13 years before it was bought by the Estonian company (Estline Maritime Company). The Estonia departed from Stockholm at 1:15 am on September 27, 1994 and the first mayday call was made at 1:22 am, after the ship's bow visor was hit by a wave and torn off (Dostal et al., 2015). The ship sank less than 30 minutes later and the first rescue helicopter arrived more than an hour later at 3:05 am (Dostal et al., 2015). Although other civilian/fishing boats arrived at the scene of the accident earlier than the helicopter, the rescue operations were not well coordinated and some argued that this lack of coordination prevented them from further rescue operations (Larsson & Nohrstedt, 2002; MarEx, 2014). The biggest

challenge seemed to be organizing the rescue operation among many agencies. In this case, it was even more difficult to coordinate as at least three countries were involved. The site of the accident was in an international maritime territory (Larsson & Nohrstedt, 2002).

Although the passengers were from different parts of the country and even other countries, similarities to the Sewol Ho crisis existed in that one particular town lost a large number of its population (Larsson & Nohrstedt, 2002). In the handling of the public's information needs, the grief, and the aftermath of the accident became a very critical issue for local authorities. Although the Swedish government established information channels with the media and other affected governmental units within a day, information was given "in an ad hoc fashion" and it was unable to respond to the flow of media inquiries or provide any specific information to those who were in desperate need of determining the status of their loved ones (Larsson & Nohrstedt, 2002). Similar to the South Korean case, for several days, it was reported that no substantial information about victims was provided, yielding "a long period of confusion" regarding the victims' identities (Larsson & Nohrstedt, 2002). However, unlike the South Korean case, Larsson and Nohrstedt (2002) and others (e.g., Dostal et al., 2015) concluded that local authorities and community organizations (e.g., social services, psychology teams, voluntary organizations, etc.) worked well together, once established.

The most crucial fallout from the rescue operation seems to have been that the Swedish rescue organization, SOS Alarm, did not receive its alarm until it was too late (about 6 hours later) and no central government's disaster relief centers were established during the night of the accident (Larsson & Nohrstedt, 2002). One major criticism regarding the government management of the crisis was that the government decided to rescind its original promise to salvage the ship that was made early in the crisis, leading to public outcry and protests against the government's decision (Larsson & Nohrstedt, 2002). Another criticism was over the misleading coverage of the media: Media focused its coverage more on the confrontation between the government authorities and the victims' families rather than on the issues that were discussed (Larsson & Nohrstedt, 2002).

In the end, the Joint Accident Investigation Commission reported that the accident was due to extreme weather conditions, ruling out any speculation about possible corruption, failure on the part of the crew, or any clear-cut regulatory failure (Dostal et al., 2015). Regardless of the conclusion of the report, the criticism around how the Swedish central government handled the crisis, particularly at the initial stage of crisis development, casts doubt on its ability to deal with future crises (Larsson & Nohrstedt, 2002).

Managing high-profile and high-casualty crises like the Sewol Ho and the Estonia is a challenging task that ends with no winners, in any case. However, the focus of crisis management is not only to avoid further casualty and loss of resources

for immediate results, but also to prevent any future crises. There are striking resemblances between these two crises; the nature of the crisis (i.e., ferry sinking), initial failure of central crisis management systems, lack of information coordination among government officials at local, state, and the national levels within 24 hours of the accident, failure of orchestrated national/international rescue operations, and significant loss of human life. On the other hand, there are sharp contrasts between these two crises: (a) the causes of the crisis and crisis type, (b) effective multiagency/unit coordination and information exchange, (c) treatment of victims' families and friends and postcrisis management, (d) safety deregulation and safety privatization, and perhaps (e) cultural/political system differences.

Causes of the Crisis and Crisis Type

According to Situational Crisis Communication Theory (SCCT), there are three different types of crisis: accidental, preventable, and victim crisis. The accidental type of crisis are those caused by technical errors while preventable crises are those caused by human errors/misdeeds. On the other hand, victim crises are those caused by external factors like a natural disaster (Coombs, 2012). SCCT posits that publics tend to attribute the most responsibility to preventable crisis, followed by accidental crisis and then victim crisis.

Dostal et al. (2015) describe the Estonia case as a "black swan" accident ("worst-case scenario") due to extreme weather conditions and the Sewol Ho case as the worst man-made disaster. Following their logic and the classification of SCCT, the Estonia case could be classified as a victim crisis and the Sewol Ho case as a preventable crisis that results in the most attribution of responsibility from the public. Indeed, although the initial crisis response from the Swedish government received much criticism from the public, the crisis management at the local level was recognized as a success. The Korean government's responses during and after the crisis continues to be criticized for its poor management.

Effective Multiagency/Unit Coordination and Information Exchange

Challenges associated with multiagency/unit coordination and information exchange, particularly during and immediately after the crisis, were commonly experienced in previous cases; e.g., the 2005 London Bombings (Eyerman & Strom, 2008), the 2011 Norway terrorist attacks (Falkheimer, 2014), and the 1994 Swedish sinking of the Estonia. However, these governments seemed to be able to overcome the problems rather quickly and establish the chain of command to mobilize resources and coordinate the efforts among many different agencies to deal with the crises (e.g., the 2005 London bombing). Eyerman and Strom (2008) argued that this rebound was possible through strong familiarity with roles and responsibilities, a quickly established command and control system, and mutually agreed aids that

were quickly established. However, when it fails, it results in escalating the crisis situation(s) regardless of the type of crisis. This seemed to be the case in the 2014 South Korean sinking of the Sewol Ho crisis as well as other cases, such as the 2003 Hong Kong SARS outbreak (Lee, 2007) and the 2005 U.S. Hurricane Katrina disaster (Cole & Fellows, 2008).

Treatment of Victims' Families and Postcrisis Management

In both crises, the government was initially criticized for not managing the crisis properly and not putting the victims and victims' families as the top priority during the crisis (Dostal et al., 2015). However, crisis management does not end immediately after the crisis is contained. The rebuilding of the public's confidence, thorough investigation of the crisis, easing of the pain and anguish of victims and their families, helping the nation to go through the grieving process together, bringing unity to the country, and implementing proper measures to prevent future crises should be done during the postcrisis stage.

The fact that the Swedish government tried to establish a direct communication line with the relatives of the victims during the crisis, followed by their decision to fund the organizations of the victims' families after the crisis (Dostal et al., 2015), shows the government's genuine care for the victims and victims' families. Furthermore, the Swedish government implemented several initiatives such as the Estoniasamlingen website, a national online archive for the sinking of Estonia, and Analysgruppen, an independent review group to study how various individuals and groups/organizations behaved during and after the crisis (Dostal et al., 2015). These initiatives reflect the transparency of the Swedish government and its willingness to share resources available to anyone to learn from the crisis and prevent any future crises like the sinking of Estonia.

Safety Deregulations and Safety Privatization

Several scholars raised the concern for deregulation and privatization of the public safety system as one of the major indirect causes for the sinking of the Sewol Ho (e.g., Dostal et al., 2015; Suh, 2014). According to the U.S. Department of State's report (2014), under the pressure of foreign investment and the U.S.–Korea Free Trade Agreement (KORUS FTA), President Park initially put deregulation as one of the country's top economic priorities. However, after the tragedy of the Sewol Ho, the public's concern for "the adequacy of South Korea's workplace and public safety culture" was raised, resulting in President Park's pledge to overhaul the entire safety system of the country (U.S. Department of State, 2014).

Early in 2015, the South Korean legislature (Korean National Assembly) approved a new anticorruption law (antigraft law) among government officials and some other nongovernmental officials including private school teachers and

journalists (Kwaak, March 2015). Although this is a good step toward tackling corruption in the country where bribery ("gift-giving") is considered a norm in the society, the actual impacts of the law remain to be seen since this is not the first anticorruption law passed in the Korean National Assembly.

Dostal et al. (2015) called for several steps to improve South Korea's low safety standards such as expansion of available resources for the safety system and the shift of the national audit body to the legislative branch. However, fundamental changes at individual, local, state, and national level are called for in preventing future man-made disasters like the sinking of the Sewol Ho in South Korea. The privatization of safety inspection institutions without proper checks and balances creates safety breaches everywhere waiting to be unleashed. Not every accident and disaster becomes a government's fault regardless of how it comes about, but when the proper enforcement of law and order and collective investment for ensuring safety measures are neglected, the government's accountability is called for.

Cultural/Political Differences?

The Sewol Ho tragedy has stirred many speculations as to why it appears that no attempts among the passengers, particularly those high school students, were made to escape from the sinking ferry. Some popular media attributed it to the culture of "obedience" and "compliance" rooted in Confucianism, but Mar (2014) sharply criticized this type of speculation by stating, "Poor communication, disorganization, and complacency—compounded with fumbling bureaucracies and the lack of protocol and proper training—resulted in a botched rescue mission that has South Korea reeling. But to theorize that the high death toll is linked to a perceived cultural flaw or deficiency is a lazy journalistic shortcut. It fits a stereotype." The concern with this type of "stereotyping" and "culture blaming" "places blame back on the victims and their families," said Jaehwan Cho, a South Korean reporter (Mar, 2014). Dostal et al. (2015) sharply criticized Korean media's lack of discussion on institutional failure while placing blame on individuals' unethical and unprofessional behaviors, shifting the public's attention from questioning the government's accountability to punishing individual actors.

One of the distinctive differences found in the comparative analysis between the Sewol Ho case and the Estonia case is about how individual Swedish municipal government units and different organizations like large hospitals and radio-stations organized crisis and information services quickly at the local level in the Swedish case and this multiagency coordination and cooperation were done smoothly despite many different organizational cultures intersecting (Larsson & Nohrstedt, 2002). On the other hand, no such coordinated efforts seemed to be reported in the South Korean case. Perhaps, this difference might be due to the differences

in two countries' political systems: South Korea's political system heavily relies on the central government while the Swedish government seems to be a decentralized and localized system where local governments exercise a certain level of autonomy from the central government in dealing with their own governance. Perhaps, it could be seen as a cultural difference deeply rooted in the concept of hierarchy emphasized in the Korean tradition.

Principles of Effective Government Crisis Management/Communication

There are several principles identified for effective government crisis/disaster management based on this comparative analysis. Those are (a) quick, open, and direct communication, (b) continuity and accuracy of information, (c) establishing direct communication lines with those who are affected by the crisis and sincerity of communication, and (d) ensuring safety regulations and enforcement to prevent future crises.

Quick, Open, and Direct Communication (QODC)

One of the key principles of successful crisis management is quick, direct, and open communication during and after any crisis. Chen (2009) assessed the Chinese government's handling of the 2008 Sichuan earthquake and praised the Chinese government for its open, timely, and direct communication with the public. Chen (2009) suggested "the communication mechanism already built into the government system" as a major contributing factor for its successful crisis communication and management. Although this raises some speculation about the heavily state-controlled media being utilized mainly for advocating the Chinese government's intentions (i.e., preserving positive images of the government), the Chinese government's efforts to establish open and timely communication seem well received by the Chinese public and scholars (Chen, 2009). Similarly, the Swedish central government established information channels with the media rather quickly, although at the beginning of the crisis, only ad hoc information was provided due to Sweden's inability to contend with the public's quantity of information demand.

On the other hand, the 2005 Hong Kong government's dealing with the SARS outbreak was considered a major failure in crisis management/communication due to slow and reactive responses from the government, a lack of transparency, and inconsistent messages (Lee, 2007). Unfortunately, in the case of the Sewol Ho crisis, the South Korean government was unable to coordinate and meet the public's information demand while providing inaccurate information and inconsistent descriptions of what was happening to the publics in the midst of the most heightened anguish and disbelief of the unfolding situation.

Continuity and Accuracy of Information (CAI)

The importance of the continuity and accuracy of Information is paramount when a crisis involves loss of lives. Thus, the Korean government's failure to provide continuity and accuracy of information is reflected threefold: (1) in their initial misreporting of how many passengers were rescued in the midst of the rescue operation, (2) having no official channel established with the media to provide accurate updates on the status of rescue operations, and (3) having made no attempt to establish a direct communication line with the families of the passengers. In this respect, the Swedish central government also experienced difficulty meeting the public's information needs, particularly regarding accurate information about survivors and the deceased.

Establishing Direct Communication Line and Sincerity of Communication (DCL/SC)

Establishing direct communication with, showing care for, and providing tangible/intangible resources for those who are directly affected by the crisis (i.e., victims and affected families/communities) are important principles of effective crisis communication. Such efforts convey that the government is not only taking on its responsibility in protecting its citizens, but also genuinely caring for its citizens' well-being.

Sincerity of communication must be conveyed to the public, particularly in the face of a major crisis. If not, the public's trust and support will dissipate rapidly in a crisis that is already volatile and unstable. The 2005 Hong Kong government's dealing with the SARS outbreak is an example of how the government failed to convey its sincerity to the people. Lee (2007) criticized the Hong Kong government, particularly Chief Executive Tung Chee Hwa and other government officials like Margaret Chen, the Director of Health, for the government's error in judgment, defensive attitude, and being apathetic toward the public's health. Its slow and reactive response to the crisis escalated the situation that claimed 299 deaths, 1,755 people infected, and an estimated loss of 38 billion dollars (Lee, 2007). Like Hong Kong, the South Korean government's gross failure of the crisis management/communication, including the failure of the rescue operation, affected the public's opinion of the government. For example, President Park's approval rating plummeted to 46% from 61% in June 2014 after the crisis with no sign of improvement (Kim, June 2014) and to the lowest approval rating of 34% by August 2015 (Kim, September 2015).

On the other hand, the Chinese government's crisis communication/management in dealing with the 2008 Sichuan earthquake was considered a success with the goal of conveying the government's compassion and empathy for the victims while actually enhancing the government's "image and accountability" (Chen,

2009). The Swedish government's responses, particularly after the crisis, conveyed the government's care for those who were directly and indirectly affected by the sinking of the Estonia. However later in the postcrisis stage, their decision to rescind the original promise was sharply criticized by some relatives of the victims.

Ensuring Safety and Enforcement of Safety Regulations

Perhaps, one of the most important lessons to learn is how to ensure safety in society by enforcing safety regulations and anticorruption laws that are in place. Law without enforcement, privatization without proper checks and balances, and deregulation without proper supervision may well lead to another tragedy like the sinking of the Sewol Ho. Promulgating the newly passed anticorruption law is the first step, but enforcing the law to bring meaningful changes in society requires individual as well as collective responsibility of society.

CONCLUSION

The tragedy of Sewol resulted from corruption, close ties between the South Korean government and conglomerates, failure of safety inspections, individuals' reckless economic pursuits and negligence, deregulation, and government mismanagement of the crisis (Dostal et al., 2015; Suh, 2014). In the end, the Korean government's crisis management/communication was a complete failure in the eyes of the public. On the other hand, the sinking of the Estonia, although there are striking similarities in certain aspects, is considered a better handled government crisis management case, particularly after the crisis.

In a crisis, no matter how the crisis is perceived by the public, the safety of the people directly affected by the crisis should be the top priority. The best crisis responses are ultimately the ones that communicate that the government is doing its best to garner the public's safety and well-being. Kaman (2007) argued that governmental crises and their management of the crises establish the public's "accumulated collective memories" and these memories will serve as a critical reference point in the evaluation of the next crisis and the government's crisis management effectiveness. In other words, how people perceive the crisis and consequential judgments toward their government's crisis management will influence their judgments of the next crisis and its effectiveness of the government's crisis management, affecting the public's confidence in the government's ability to protect its own people. Who would have predicted that this mismanaged tragic crisis would help lead President Park to her impeachment case two years later? On December 9, 2016, the South Korean Parliament voted to impeach the country's first female president in connection with a "confidante"

who had excised a great deal of influence and caused systemic corruption in South Korea's political and economic landscape. Suspicions over her seven missing hours during the sinking of Sewol Ho resurfaced amid the scandal, helping lead Parliament to support the impeachment (Steger, December 19, 2016). Steger (2016) argued, out of the list of grievances against Park's administration, the sinking of the Sewol Ho tops all other gross incompetence and negligence of the Park administration's ability to govern.

At the end of the day, merely punishing those who are individually held to account and superficial remedies that are implemented by the government, such as a tearful apology to save face, will not prevent another tragedy like the sinking of the Sewol Ho. Many of the previous crises in South Korea, such as the Daegu Metro fire in 2003, the Sampoong department Store collapse in 1995, and the Seongsu Bridge collapse in 1994, share several major common characteristics in the systematic failure of the South Korean government's crisis management/communication: lack of or breakdown of the national crisis management system, lack of communication/information management, and failure of governmental enforcement of safety regulations/deregulation to prevent future crises. Preventing future disasters/crises cannot be addressed in an isolated or individualistic fashion. It calls for fundamental changes in society where not only individual actors are held responsible but the government is also responsible for safety regulations and the enforcement thereof.

In this chapter, the comparisons were drawn between two similar high-profile cases that were managed differently in two different countries in two different time periods. Striking resemblances of similar challenges were identified as well as many differences of how the crisis was managed before, during, and after the crisis. Rather than drawing a simplistic conclusion that one was handled right and the other was not, these cases should be examined in the global context. The world is facing unprecedented interconnectivity as well as major crises that call for global responses and collective preparedness. Global warming, terrorist attack, and refugee crisis are a few examples that are affecting the global community on a large scale, suggesting that no one is immune from their impacts. Multiagency coordination has proven to be very challenging among governmental agencies even within one government. Multinational coordination to manage global crises is far more challenging. The principles of effective crisis/disaster management should be applied through global alliance and collective learning from how different crises were handled in different countries. It helps us manage current crises while at the same time helping to prevent or prepare for future crises effectively, not only among individual countries, but also in global unity.

REFERENCES

Asia. (2016, April 16). Two years after tragedy, cranes brace to raise Sewol ferry in South Korea. *Asia*. Retrieved from http://www.straitstimes.com/asia/east-asia/two-years-after-tragedy-cranes-brace-to-raise-sewol-ferry-in-south-korea

Boin, A. (2008). Editors introduction: Fundamentals of crisis development and crisis management: An introduction to critical crises readings. In A. Boin (Ed.), *Crisis Management* (Vol. 1, pp. 195–207). London: Sage.

Campbell, C. (2014, May 2). Reports: The South Korean Ferry Sank because it was dangerously over-loaded. *Times*. Retrieved from http://time.com/85501/sewol-ferry-overweight-south-korea/

Chen, N. (2009). Institutionalizing public relations: A case study of Chinese government crisis communication on the 2008 Sichuan earthquake. *Public Relations Review, 35*(3), 187–198. doi:10.1016/j.pubrev.2009.05.010

Choe, S. (2014, May). Captain and 3 Officers Charged with Murder in Korean Ferry Sinking. *The New York Times*. Retrieved from http://www.nytimes.com/2014/05/16/world/asia/captain-and-3-officers-charged-with-murder-in-korean-ferry-sinking.html?hpw&rref=world&_r=1

Choi, S. (2014). *Boundaries between programming genres and media type: A case study in South Korea* (pp. 1–19). KBS Broadcast Research Institute.

Chosun Ilbo. (2014, April 30). Fishermen rescued half the survivors of ferry disaster. *Chosun Ilbo*. Retrieved from http://english.chosun.com/site/data/html_dir/2014/04/30/2014043001670.html

Christensen, T., Lægreid, P., & Rykkja, L. H. (2013). After a terrorist attack: Challenges for political and administrative leadership in Norway. *Journal of Contingencies and Crisis Management, 21*(3), 167–177. doi:10.1111/1468-5973.12019Cole, T. W., & Fellows K. L. (2008). Risk communication failure: A case study of New Orleans and Hurricane Katrina. *Southern Communication Journal, V 73*(3), 211–228. doi:10.1080/10417940802219702

Coombs, W. T. (2012). *Ongoing crisis communication: Planning, managing, and responding* (3rd ed.). Thousand Oaks, CA: Sage.

Dorof, J. (2014, April 20). Stop Blaming South Korea's Culture for Last Week's Ferry Disaster. *Vice. com*. Retrieved from https://www.vice.com/en_us/article/ppmkqz/stop-blaming-south-koreas-culture-for-last-weeks-ferry-disaster.

Dostal, J. M., Kim, H., & Ringstad, A. (2015). A historical-institutionalist analysis of the MV Sewol and MS Estonia tragedies: Policy lessons from Sweden for South Korea. *The Korean Journal of Policy Studies, V30*(1), 35–71.

Eriksson-Zetterquist, U. (2009). Risk and organizing—The growth of a research field. In B. Czarni-awska (Ed.), *Organizing in the Face of Risk and Threat* (pp. 9–24). Cheltenham: Edward Elgar.

Eyerman, J., & Strom, K. J. (2008). Multiagency coordination and response: Case study of the July 2005 London Bombings. *International Journal of Comparative and Applied Criminal Justice, 32*(1), 89–109. doi:10.1080/01924036.2008.9678779

Falkheimer, J. (2014). Crisis communication and terrorism: The Norway attacks on 22 July 2011. *Corporate Communications: An International Journal, V19*(1), 52–63. doi:10.1108/CCIJ-08-2012-0053

Felden, E. (2014, May 15). A troubled nation: South Korea after the Sewol. *DW.* Retrieved from http://p.dw.com/p/1C0RZ

Kaman Lee, B. (2007). The HKSAR government's PR sense and sensibility: Analysis of its SARS crisis management. *Asian Journal of Communication, 17*(2), 201–214. doi:10.1080/01292980701306621

Kim, J. (2014, June 5). South Korea poll offers fresh mandate for Park to speed reform. *Reuters*. Retrieved from http://www.reuters.com/article/2014/06/05/us-southkorea-election-idUSKB-N0EF02E20140605#AEbewqULtwhRlfwJ.97

Kim, J., & Yoo, C. (2014, April 16). More than 300 people missing after South Korea ferry sinks—coastguard. *Reuters*. Retrieved from http://uk.reuters.com/article/2014/04/21/uk-korea-ship-idUK BREA3F02420140421

Kim K. and Kim I. (2014, May 10). Why are Sewol families so angry with the media? *The Hankyoreh*. Retrieved from http://english.hani.co.kr/arti/english_edition/e_national/636360.html

Kim, S. (2015, September 3). South Korean President Park's approval highest in year and a half. *Bloomberg Business*. Retrieved from http://www.bloomberg.com/news/articles/2015-09-04/south-korea-president-park-s-approval-highest-in-year-and-a-half

Kwaak, J. S. (2015, March 3). South Korea lawmakers approve anticorruption law. *The Wall Street Journal*. Retrieved from http://www.wsj.com/articles/south-korea-lawmakers-approve-anticorruption-law-1425387240

Larsson, L., & Nohrstedt, S. A. (2002). Does public relations make a difference? A comparative analysis of two major Swedish crisis. In D. Moss & B. DeSanto (Eds.), *Public relations cases: International perspectives* (pp. 113–129). USA & Canada: Routledge

Lee, B. K. (2007). The HKSAR government's PR sense and sensibility: Analysis of its SARS crisis management. *Asian Journal of Communication, V17*(2), 201–214. doi:10.1080/01292980701306621

Lee, S. Y. (2014, April 18). 침몰 당시 구조하러 온 미군 헬기, 우리 군이 돌려보내. *The Hankyoreh* (in Korean). Retrieved fromhttp://www.hani.co.kr/arti/politics/politics_general/633290.html

Lee, W. and Cho, C. (2014, April 20). [Ferry Disaster] Families under tremendous emotional stress: As hopes for miracle fade, families clash with police, attempt to visit Cheong Wa Dae in protest. *The Korean Herald*. Retrieved from http://www.koreaherald.com/view.php?ud=20140420000208.

Mar, K. (2014, April 25). Culture blaming and stereotyping in the South Korean ferry tragedy. *Times*. Retrieved from http://time.com/75742/south-korea-ferry-asian-stereotypes-culture-blaming/

MarEx. (2014, October 7). The legacy of the MS Estonia tragedy. *The Maritime Executive*. Retrieved from http://www.maritime-executive.com/article/The-Legacy-of-the-MS-Estonia-Tragedy--2014-10-07

Park, M., & Hancocks, P. (2015, April 16). Sewol ferry disaster: One year on, grieving families demand answers. *CNN*. Retrieved from http://www.cnn.com/2015/04/15/asia/sewol-ferry-korea-anniversary/

Ryall, J. (2015, April 16). Families demand answers over South Korea ferry disaster on one-year anniversary. *The Telegraph*. Retrieved from http://www.telegraph.co.uk/news/worldnews/asia/southkorea/11540995/Families-demand-answers-over-South-Korea-ferry-disaster-on-one-year-anniversary.html

Steger, I. (2016, December 9). A Korean ferry tragedy two years ago helped lead to a vote to impeach President Park Geun-hye today. *Quartz Media*. Retrieved from https://qz.com/858952/the-sewol-korean-ferry-tragedy-two-years-ago-helped-lead-to-a-vote-to-impeach-president-park-geun-hye-today/

Suh, J. J. (2014, September). South Korea: Still stonewalling about the Sewol. *Foreign Policy in Focus*. Retrieved from http://fpif.org/south-korea-still-stonewalling-sewol/

The New York Times. (2015, April 11). Ferry disaster in South Korea: A year later. *The New York Times*. Retrieved from http://www.nytimes.com/interactive/2015/04/12/world/asia/12ferry-timeline.html?_r=0

Transport Workers Solidarity Committee. (2014, August 4). *Safety Regulation Still Lagging 100 Days After Korean Ferry Disaster*. Retrieved from http://www.transportworkers.org/node/1405

U.S. Department of State. (2014, June). *Department of State: 2014 Investment Climate Statement*. Retrieved from http://www.state.gov/documents/organization/229185.pdf

Yonhap News. (2014, April 17). '세월호' 침몰, 급격한 방향전환이 원인으로 드러나 ['Sewol' capsizing: a sudden turn is revealed to be the cause]. *Yonhap News* (in Korean). Retrieved from http://www.yonhapnews.co.kr/local/2014/04/17/0805000000AKR20140417040400054.HTML

Environmental and Social Justice

Environmental Nonprofit Organizations and Networked Publics: Case Studies of Water Sustainability

RAHUL MITRA, WAYNE STATE UNIVERSITY, DETROIT, MI, USA

Globalization has heralded the emergence of "networked publics"—stakeholders who span both local geographies and global media spaces—that large nonprofit organizations (NPOs) and for-profit corporations alike must pay heed to in order to be successful (Boyd, 2011; Ito, 2008; Pal & Dutta, 2008a; Sedereviciute & Valentinia, 2011; Waters, Burnett, Lamm, & Lucas, 2009). Such stakeholder networks, connecting the local and global, are crucial for organizations centered on environmental sustainability, given that issues of climate change, resource conversation, and pollution (among others) are far-reaching in impact and scope. Environmental NPOs must build and sustain global structures, connections, and processes, but they also need to seek out and work with entities in particular localities for different projects (Hopke, 2016; Mitra, 2013; Sun, DeLuca, & Seegert, 2015). This chapter thus draws on two case studies to examine how environmental NPOs negotiate complex local/global flows critical to their work.

Specifically, I compare the global/local outreach, deliberation, and mobilization efforts of two environmental NPOs based in the U.S., and focused on water sustainability. Case 1 is the North American arm of a multistakeholder initiative

concerned with establishing norms and guidelines for global water stewardship ("Aqua"); case 2 is a well-connected watershed use and water technology nonprofit ("WaterNet"), located in the Great Lakes region. By selecting NPOs concerned with the sustainable management of water resources, this chapter continues the recent spotlight of interdisciplinary research on the complications afforded by the simultaneous scarcity and abundance of water in the natural environment (e.g., Druschke, 2013; Sprain, Carcasson, & Merolla, 2014). Moreover, these cases exemplify the complex intersection of local places and global spaces that contemporary NPOs must navigate, given the ubiquity of water resources for human life, coupled with context-specific institutional ties and discursive formations guiding social behaviors related to water consumption. While Aqua and WaterNet are both concerned with water sustainability, they have very different functions and stakeholder outreach activities (i.e., deliberation of water use standards, and networking to encourage socioeconomic investment in water, respectively). Thus, they provide a useful comparison and contrast to consider how water-focused NPOs must communicatively negotiate local/global contexts and practices.

My analysis draws from research on networked publics, organizational studies, and environmental communication. Of particular interest is how water-themed NPOs like Aqua and WaterNet seek to connect local, site-specific publics through discourse in the global space of water sustainability activism, to accomplish the nonprofits' goals of global conservation. I argue that the two cases indicate a complex process of stakeholder engagement of networked publics, which emphasizes both grassroots, place-based collaboration and the global management of common resources. This local/global dialectic highlights how such discursive formations are simultaneously competing and reinforce each other, helping the NPOs engage publics with different underlying motives (e.g., activists, corporations, governments). A second crucial dialectic is evident, in that corporate interests and capitalist principles of administering resources are often privileged in the NPOs' discourse, even as they also seek to empower local communities and activists, and emphasize common interests, crises, and opportunities that seemingly transcend capitalist valuation of resources. Rather than consider these dialectics in overly puritan tones of black-and-white and hasten to condemn the NPO's "hypocrisy," a pragmatic tone of analysis that recognizes the polyphony of organizational discourse, especially on complex issues such as environmental sustainability, might be in order (Christensen, Morsing, & Thyssen, 2013; Mitra & Buzzanell, 2015).

In the remainder of this chapter, I first discuss the notion of networked publics that span both local places and global spaces, with particular focus on the implications for sustainable organizing movements and NPOs. Then, I outline the two case backgrounds and describe my methods of data collection. Finally, I use examples from the two water-themed NPOs to illustrate their processes of global outreach, deliberation, and grassroots mobilization.

LITERATURE REVIEW

Networked Publics

The ongoing interconnection of technologies, people, information, and places worldwide has given rise to what is often termed the "network economy" or "network culture" of the present era. Scholars such as Manuel Castells (2010) have argued that network economies connect core nodes in ever-denser ties, enhancing the centrality of such nodes further, while simultaneously highlighting the role of peripheral locations, technologies, and actors that support this intricate web of ties. Studies of local/global networks have been interdisciplinary in scope, ranging from a focus on the material linkages that connect actors with resources (e.g., roads, telecom fiber and other physical infrastructure for transferring capital, labor, and various raw inputs for industrialization) to the informational ties that constitute and reify imagined communities that were once isolated (e.g., global broadcast of ethnic media, teleconferencing across organizational actors and stakeholders) (Appadurai, 1996; Baym et al., 2012; Boyd & Ellison, 2007; Diani, 1992; Parks, 2011; Varnelis & Friedberg, 2008). Of overarching concern in such studies is how the interconnection of people, capital, material, and information has shaped how we see ourselves as individuals and as communities, in both the local context and broader global sense. Accordingly, Ito (2008) introduced the term "networked publics" to describe the "linked set of social, cultural, and technological developments that have accompanied the growing engagement with digitally networked media" (p. 2).

Building on this definition, Boyd (2011) argued that, "Networked publics are publics that are restructured by networked technologies. As such, they are simultaneously (1) the space constructed through networked technologies and (2) the imagined collective that emerges as a result of the intersection of people, technology, and practice" (p. 39). This (re)definition of "networked publics" is in line with Boyd's roots as a communication scholar, to focus on the underlying implications of network structures for stakeholder interaction, community building, and issue deliberation (see also Boyd & Ellison, 2007). For the purposes of this chapter, it highlights two key aspects of networked publics—the continual contestation of the "imagined collective" (across space and time) to frame meaning, and the construction of particular global spaces or "niches" that exist seemingly apart from local places rooted in geography but are nevertheless dependent on such places for meaning-making. At stake, then, is more than just the connection of territories and communities via mediated tools (e.g., global conglomerations like Australian media mogul Rupert Murdoch's News Corporation), but recognizing that networked publics exist both because of and in spite of globalization. That is, networked publics are shaped by mediated tools, but also by the broader socioeconomic systems

that shape these tools in the first place (e.g., capitalism), even as they also generate resources, connections, and societal systems that contest their legitimacy (e.g., Indymedia connecting grassroots communities that emphasize "globalization from below") (Ganesh, Zoller, & Cheney, 2005).

The first aspect of relevance—namely, the *contested* creation of imagined networked publics—is in line with work by Nancy Fraser (1990), Michael Warner (2002), and others, who recognize that even as vast swathes of the population might constitute a public sphere for the deliberation of policy and practice, there always exist undercurrents and niche publics that represent alternative (usually marginalized) interests. These counterpublics might be strengthened by the networked world economy and information system, which allows previously isolated groups and nodes to (re)connect with likeminded allies, and thus pose an effective challenge to mainstream hegemony (Self, 2010). For instance, Mitra and Gajjala (2010) explored networked agency in seemingly far-flung publics of queer South Asian bloggers, which allowed them to not only recover a form of lost collective agency, despite their geographical isolation, but also reconstitute themselves as networked (counter) publics capable of challenging heteronormative and often homophobic depictions of queerness.

The second aspect of relevance pertains to Boyd's (2011) recognition that networked publics cocreate specific spaces of operation that connect, yet exist seemingly apart from, the material places wherein they are themselves located. Scholars of contemporary social movements and activist organizations have especially noted this "in-betweenness" of global activism, whereby previously far-flung and isolated activists actively construct and reify a global space for their joint operations, to express solidarity, exchange resources and information, and even form a gathering-house for potential recruits (Bennett, 2003; Diani, 1992; Varnelis & Friedberg, 2008). Empirical examples abound, ranging from the widespread connections enabled by network technologies to Indymedia's collaboration and organization efforts during the Seattle WTO protests (Pickard, 2006), to the more mundane, ongoing efforts of activists across the U.S. and Mexico to support the Zapatista movement (Atkinson, 2009). Critical scholars articulate cautious optimism, noting that even as such co-constitution of global space to voice dissent allows activists to find new direction for the social movement, opening up this space to newer actors who might not be as invested in the social justice component also brings with it the possibility of cooptation (Pal & Dutta, 2008a, 2008b). That is, engendering global spaces of operation for networked publics might also result in an ongoing tussle with more powerful forces of the status quo that seek to destabilize these fledgling spaces, and even negate the validity of lived experiences emanating from geographically rooted places precisely because they remain disparate and marginalized.

Nonprofit Organization Networks

Operating in a hypermediated network society has both risks and benefits for organizations, whether they are corporate or nonprofit. On the one hand, it is much harder for organizations to control their preferred identity, image, and discourses owing to the fragmented online media environment (Bennett, 2003; Gilpin, 2010; Walton, Cooley, & Nicholson, 2012). On the other hand, these connections across various networked publics also offer organizations advantages of scale, pace, and audience depth, which can be useful in situations like crisis communication (Veil, Buehner, & Palenchar, 2011) or even for everyday stakeholder engagement (Waters et al., 2009). Organizational communication scholars have traced the import of networked technologies and publics in two broad ways—first, in terms of the impact of social media and networks on everyday organizational practices, paying attention to both the objective and subjective characteristics of media technologies (e.g., Treem & Leonardi, 2012); and second, conceptualizing organizations themselves as networked publics, so that the goal of management becomes to coordinate emergent and institutionalized knowledge networks (e.g., Contractor & Monge, 2002; Xia, Yuan, & Gay, 2009). This latter stream of research is particularly relevant for this chapter, especially scholarship focusing on NPOs and community engagement.

Scholars of social networks have identified several key aspects of NPO organizing in the contemporary network society. For instance, Vaast (2004) argued that the use of intranet technologies allowed local communities to form stronger bonds with remote members, and realize operational efficiencies, so that they reorganized as "networks of practice." Looking at the precise context of international NPOs active in the social justice arena, Stohl and Stohl (2005) theorized that such entities fulfill key "structural holes" that are left vacant in the global institutional system, owing to lack of policy or political will. In doing so, such nonprofits strengthen their own role within the global network, but also reinforce the network itself and individual nation-states. More recently, Cooper and Shumate (2012) drew on the concept of "bona fide groups" to conceptualize a bona fide network perspective to interorganizational collaboration, rooting it in the intricate network of gender-based violence NPOs in Zambia. They asserted that membership in such networks were fuzzy and dynamic, rather than concrete and fixed in time; the localized structural environment shaped particular configurations of interorganizational collaboration while restraining others; different, multiplex ties were evident among NPOs in the network; and the collaborative outcomes shaped both individual NPOs and the broader network profoundly. Moreover, O'Connor and Shumate (2014) examined how nonprofits and their corporate partners were arranged in particular networks, with varying degrees of closeness and centrality, depending on the issues both parties held salient—arguing for a long-term

model of "symbiotic sustainability" (see also Shumate & O'Connor, 2010). It then becomes useful to trace how such networked organizing practices shape NPOs in the environmental sustainability space.

Sustainable Organizing and NPO Networks

Sustainable development is commonly taken to be development that meets our present economic and social needs, without impinging on the needs and prosperity of future generations—what is commonly referred to as the "Brudntland definition" (World Council for Economic Development, 1987). While sustainable organizing has long constituted an interdisciplinary area of research, organizational and environmental communication scholars focus on the role of message production, interpretation, and coordination in shaping social and institutional practices toward more sustainable actions (Mitra & Buzzanell, 2015). A recent review suggests that organizational communication scholars have focused on four broad aspects of sustainability—long-term organizational viability, environmental corporate social responsibility, corporate communication on environmental impacts, and the resilience of complex adaptive systems (Mitra, 2017). The actions of NPOs centered on environmental sustainability—especially in global interorganizational networks—is thus underexplored, despite their growing prominence.

Nevertheless, we may piece together some key communicative practices of environmental NPOs, which have to negotiate complex local and global flows of capital, stakeholders, and ecologies. Key among these practices are the constitution, framing, and coordination of messages related to environmental resources for various audiences, which are often intertwined processes. For instance, deliberating what sustainability means for different resources and local contexts, and how such guidelines may be applied for global monitoring, is a central concern for environmental nonprofits. Sun et al. (2015) traced the challenge for different environmental organizations in Utah (USA) to coordinate together, taking advantage of the cohesive social network ties that bound them together, but also having to cut out the "noise" and clamor that accompanied these dense networks. Similarly, Hopke (2016) examined the structure and communication content of translocal antifracking activist organizations, that allowed networked publics to emerge and resist mainstream frames, which characterized hydraulic fracturing (or fracking) as entirely unproblematic.

The characterization of sustainability and environmental resource management as a "civic science" (Bäckstrand, 2003) blends the deliberative and outreach processes at hand, while reframing the role of scientific experts, policymakers, nonprofits, and regular citizens in these processes. Thus, rather than seek to "talk down" to communities via experts, environmental NPOs must engage them from the start of the planning and advocacy process, and reach out to various actors

throughout the implementation of sustainability programs. Mitra (2013) used a critical dialogic perspective to examine how prominent activist group 350.org mobilized its local/global network to protest the Keystone XL pipeline project in the U.S. and organize its "Connect the Dots" campaign to raise awareness about climate change. Specifically, 350.org and its network of activists conegotiated naming particular identities (e.g., grassroots activist versus elite policymaker), processes (e.g., gradual versus ongoing climate change), and concepts (e.g., scientific versus experiential evidence), and shifted across these tensional poles to be most effective at environmental activism.

In the next section, I present two case studies of environmental NPOs centered on the sustainable management of water resources that must negotiate both local place-based meanings and global spatial flows.

Case Studies of Local/Global Negotiation by Water-Themed NPOs

Case studies have long been used to examine the deeper particularities of social and organizational practices. Stake (2000) notes that case studies may be both representative of broader trends and/or highlight unique situations and oddities that delimit general rules; in either role, they are crucial to theory building and application. Organizational communication scholars like May (2012) argue that case studies allow for a grounded examination of the communicative practices and structures that constitute organizational reality. They permit us to consider actual challenges and contingencies facing organizations—which may not be revealed through other methods, such as experimental research, surveys, or interviews with practitioners from different contexts. Importantly, a case study may involve different modes of data collection, such as participant observation, interviewing, surveys, or document analysis (Stake, 2006).

Accordingly, this multicase study examines how two environmental NPOs, both centered on sustainable management of water, negotiate the ongoing local and global complexities related to their work. As Stake (2006) notes, multicase studies are concerned with the "quintain," or "object or phenomenon to be studied…[with an eye toward] what is similar and what is different about the cases in order to understand the quintain better" (p. 6)—here: the negotiation of local/global issues and actors by environmental NPOs. Thus, it is through both a careful deconstruction of case particularities and a reconstruction of the quintain that a suitably nuanced picture emerges. In this instance, a focus on water-themed NPOs is particularly relevant to the communicative negotiation of local/global issues by environmental nonprofits. Although water remains bountiful in the natural world (i.e., covering about 71% of the earth's surface), the access to and availability of freshwater remains scarce, and closely tied with social and environmental justice issues. Moreover, conditions of drought, floods, water pollution, and other crises have been cause for significant

human suffering and dispute in the world. Sprain et al. (2014) thus highlight the importance of communicative design, both in shaping public deliberations on water management and in enabling ongoing engagement with communities and institutions for sustenance. Meanwhile, Druschke (2013) points out that community conceptualizations of water and watershed areas are closely linked to local discourses, despite their global ramifications, so that discussions of how water-themed NPOs address issues of water management must necessarily consider glocal issues—in keeping with our previous discussion of networked publics.

Below, I consider both case studies one by one. Pseudonyms—"Aqua" and "WaterNet"—have been used to protect identities of all individuals interviewed. Data for the Aqua case study is drawn from participant observations of several stakeholder meetings over 2011–2012, and thematic analysis of the organizations' white papers, website, and publicly available research reports (including comments by stakeholders). Audio recordings of the stakeholder meetings were made available, and subsequently transcribed for thematic analysis. The data for the Aqua case amounted to around 100 pages, in roughly 12 size font. For the WaterNet case study, data was culled from interviews with the organization's staff and several partners, white papers and research reports produced by the organization, and participant observations at its annual two-day conference. Select addresses and speeches at the Conference were audio-recorded and transcribed for thematic analysis, brochures and pamphlets produced by both WaterNet and its partners were also collected for analysis, and photographs were taken of the public proceedings (including research and commercial posters by WaterNet's partners). The data for the WaterNet case study amounted to roughly 150 pages. Although qualitative research methods, and the case study approach in particular, do not lay claims to either generalizability or exhaustive samples (May, 2012; Stake, 2000), the data corpus is thus of sufficient size and complexity to warrant theorizing on the communicative strategies enacted by both water-themed NPOs to engage their networked publics across local/global contexts.

Case 1: "Aqua"

Aqua defines itself as "a multi-stakeholder initiative whose mission is to promote responsible use of fresh water that is socially beneficial, environmentally responsible and economically sustainable." This is, in fact, the first line of introduction in the report of its North America Regional Initiative (NARI) Report's first public meeting, held late October 2011. The NPO is a truly international organization, set up as a multistakeholder initiative originally by a gathering of high-profile well-connected nonprofits, and acquiring over time the recognition from both national governments and powerful corporations to work closely with activist groups, NPOs and local communities to help negotiate thorny issues related to

water management. In this case study, I examine how Aqua negotiated the complexities of local/global contexts, as it sought to draft a global Water Stewardship Standard (WSS) with multiple stakeholders. The WSS itself was described as: "an international, ISEAL-compliant, standard that defines a set of water stewardship principles, criteria, and indicators for how water should be stewarded at a site and watershed level in a way that is environmentally, socially, and economically beneficial." From the start, it was evident that Aqua's toughest challenge (both in NARI and other regions) was coordinating with diverse stakeholders, with various interests, and deliberating a meaningful WSS—even as this diverse stakeholder base was also its main indicator of legitimacy.

Globally Networked Deliberation

NARI organized its first stakeholder meeting, with representatives from industry, nonprofits, universities, and government agencies, at a mid-sized U.S. city in the Midwest in late October 2011, to solicit feedback for the first draft of its WSS, which was available online. Following this meeting, a report was published on the Aqua website. Aqua also joined with various nonprofits to organize online webinars so that stakeholders who could not travel to specific locations might be able to offer feedback; I attended two such webinars during April 2012, organized with the noted sustainable business networking group 2 degrees. Also in April 2012, NARI organized a public meeting with various stakeholders at a large Canadian city; another public meeting was organized at a large city on the U.S. east coast, which I attended remotely. In May 2012, NARI joined with a team of the U.S. Federal Advisory Committee on Water Information to organize a roundtable, also on the U.S. east coast. After each of these meetings, reports were published online based on stakeholder inputs. Aqua also enabled an online survey for stakeholders to post feedback on the WSS, which was active till mid-June 2012. Moreover, NARI and representatives from some other Aqua cells organized a panel session at a prominent water sustainability conference in the U.S. Midwest in October 2012. By the next month, the WSS drafting committee (DC) issued a detailed response, with changes made to the first draft, stakeholders' comments, and specifying the changes accomplished. Thereafter, the beta version of the WSS was released in early March 2013, and made available for public review online through the end of 2013. This release signaled the end of Phase I centered on public meetings, and the onset of Phase II, so that the WSS was being tested at different water sites across the world to refine its viability.

Grassroots Outreach and Collaboration

Of the various rhetorical themes emphasized by the deliberative processes surrounding the WSS, perhaps most prominent was the focus on "ground up" growth and local organizing. In line with the characterization of sustainability as

a "civic science" (Bäckstrand, 2003), links and ties with various for-profit, non-profit, and governmental organizations are stressed (including WaterNet, discussed below), both in terms of gaining strategic inputs for fine-tuning the WSS and for actually implementing the standard. The public meetings are designed to facilitate dialogue with various actors: going beyond "the room" or circle of stakeholders physically present at a particular venue, soliciting "public comment" in nonthreatening ways (e.g., having smaller group breakout sessions on particular topics during the offline meetings), providing reports (in languages other than English as well) to all attendees and then making these freely available online. Each meeting report starts by acknowledging the support of strategic partners, and ends with a two-page list of all the represented organizations attending. During the webinars, the Aqua Chairman would emphasize the 15-member constitution of the WSS DC, taking care to emphasize their membership in various organizations and citizenship in different countries, so that they act as "funnels" for distilling inputs from yet other, broadly located global stakeholders. These conditions were not synchronous (e.g., during the webinars, usually the Chair would describe the process till date for about 30 minutes, after which he would answer questions submitted by stakeholders during his talk), and depended on issues of technological access (e.g., high-speed web connections and computer infrastructure), but they did attempt to reach out to the general public nevertheless.

Dialogic Communication—Centering Place

By stressing repeatedly, in various forums, that "water is a shared resource," with both "shared risks" and "shared opportunities," Aqua justified a dialogic mode of deliberation. In the very first NARI meeting, Aqua detailed over an entire page the "value" of the WSS to various stakeholders (including other NPOs, the government, academia, local communities, specific companies, and particular sectors). Throughout its reports, white papers, and public meetings, this theme of regional *place-based* and bottom-up application was emphasized. Even as Aqua states being committed to "dialogue with local neighbors" of particular water areas (both smaller farmers and larger organizations) so that "collective action" can be taken, its stakeholders continually pushed the NPO for a clear recognition that localized sector-specific considerations (like agriculture, manufacturing, and the beverage industry) would be taken into account, repeatedly bringing up the importance of third-party verifiers for these specific locations. Accounts of ongoing and future field trials in different parts of the world were centered; while these are repeatedly mentioned in the public meetings and webinars, representatives from collaborators in Latin America and Australia were on hand at the October 2012 conference to detail these ground-up growth processes.

Contesting Spatial Concepts

Crucially, the deliberations at Aqua indicate an ongoing process of contesting, and renaming in some instances, concepts and terms adopted by the WSS. Whereas the WSS' initially drew on the language of global institutions, like the United Nations or World Trade Organization, this terminology also emphasized spatial generalizability over place-based specificity—which was vocally rejected by Aqua's stakeholders. For instance, stakeholder complaints pushed the DC to rename "areas of influence," borrowed from the U.N. Global Compact, to "spheres of influence," with separate recognition for hydrological and sociocultural impacts, leading to a much more nuanced understanding of water stewardship. The DC also refined its definition of "water stewardship," following stakeholder observations that it focused too much on resource management, and not enough on public accountability or long-term health of the watershed system. Stakeholders further pointed out that "important water areas" had different territorial meanings in different languages, prompting the DC to revise it to "important water-related areas."

Finally, the deliberation process involved the semantic networking of existing categories and actors—for instance, with stakeholders pushing for clarification on how the WSS would define "indigenous people" (i.e., if it would link to the Global Compact definition, or articulate an alternative based on local communities' self-concepts), how the WSS would apply in different nations and draw on these various national standards (even as stakeholders called for rigorous baseline "implementation guidelines" for different regions and sectors regardless of these national standards), and calling for linking the WSS to future standards on "promoter" guidelines, pharmaceutical effluents, and so on. Aqua's stakeholders also had much to say on the avowed scope of the WSS; even as they emphasized the importance of local/regional/sectoral issues, they pushed for the centering of "impact" and "action," rather than just "process" or "effort" on the part of governments and corporations. Thus, they called for a tighter definition of "indirect water use," and more clarification on related supply chain issues, so that a "meaningfully relevant" standard could be drafted across local contexts for global sustainability.

Case 2: "WaterNet"

WaterNet is a U.S.-based nonprofit, headquartered in the Great Lakes region, with a mission to connect corporations, higher education, nonprofits, and government agencies to capitalize on "the business of water" (*from its website*). Its climb to prominence was the stuff NPO fairy tales are made of, from its humble beginnings as an underfunded water conservancy nonprofit, to eventually cultivating strong bipartisan ties with policymakers and close connections with both large and small regional companies. The NPO's home base had once been at the

vanguard of American manufacturing, since relegated to a second-tier Rust Belt city, and WaterNet used this narrative history to effectively frame investment in water stewardship technologies as the panacea for rejuvenating the area. This case study draws from interviews with WaterNet staff, clients, and partners, as well as textual analysis of promotional material (e.g., brochures, pamphlets, newsletters), and participant observation at its two-day annual conference, to illustrate how the organization negotiates its local roots and global ambitions.

Grassroots Entrepreneurship

As an NPO with the avowed goal to "convening the region's existing water companies and research clusters, developing education programs to train our talent, and building partnerships that cut across all sectors and geographic boundaries" (Website), WaterNet repeatedly highlights the entrepreneurial spirit of water and its member organizations. For instance, its president described his own work building the organization and its network as entrepreneurial: "I almost look at myself as an entrepreneur, not in the traditional sense of a for-profit business, but it doesn't matter whether it's for-profit or not-for-profit, you're starting up a brand new organization, and with that, you literally have to do everything just like any entrepreneur." In retelling this "origin story" of WaterNet to prospective clients and partners, he highlighted the power of grassroots entrepreneurship for sustainability. Describing a recent (successful) meeting with a representative of a large department store chain, WaterNet's Director of Communications and Membership noted,

> We sat down for half-an-hour, 45 minutes, and Aaron [the President] told her the story of the inception of WaterNet and how we kind of uncovered this water cluster that's always sort of existed here, but nobody really knew about it—then discovered that, yes, it could be a big economic driver, and there's lots of opportunities for partnerships and using that sort of pool of knowledge to help everyone succeed. And as I was watching the situation unfold, I could see this gal just starting to get really excited about it, and her whole face kind of changed, and she's nodding along with what Aaron is saying and really kind of—taking the bait isn't really what I want to say [LAUGHTER] but—

Thus, in positioning both itself and water stewardship in terms of discovering new economic opportunities, WaterNet sought to achieve strategic buy-in and legitimacy from stakeholders that traditionally favor free market enterprise and profit maximization over other discourses.

Glocal Research and Development

WaterNet and its stakeholders noted the importance of research and development (R&D) in its everyday work, which they were careful to frame both in terms of local placement and generating local opportunities, and shaping global policy on

resource management. This was especially evident in the discourse surrounding its newly constructed Global Water Center in its home city, meant to act as an accelerator program for research and commercialization initiatives. During the conference, the Center was described as the "embodiment" of WaterNet's goals, "merging the entrepreneurial spirit and large backing, to enable [Home City] to compete with other cities." In its newsletter, WaterNet expected the Center to "provide resources and expertise that are not presently available anywhere else in the world." The NPO emphasized how the Center and members' research initiatives would develop local talent and expertise among workers for the fledgling water industry, so that linkages with institutions of higher education were particularly strategic. Headline speakers at the conference also described their engaged learning and research projects in faraway locations, such as India, Africa, and China, to emphasize reaching out to youth and the next generation of STEM workers through internships, grants, and study opportunities. The CEO of one member organization noted that it was crucial to deal with the existing talent shortage, both locally and globally, and educate students about the high wages possible in green jobs related to water technologies. Another partner noted:

> Our mission is to unlock the potential of people. So, it doesn't matter what stage you are in your career—whether you're a student or whether you're mid-stage or later stage or a boomer who's retired and trying to find the next big thing for yourself—the worst thing on the planet is wasted talent, and part of the problem there is just connecting people with [their talents], raising awareness that there's opportunities for talent, and then helping people identify with the things that they're really passionate about and capable of.

Another member spoke about talent development in terms of building a "water machine" that connected water, energy, and health holistically.

Place-Based Branding

The theme of branding, especially related to place, was center-stage in WaterNet's discourse. At the conference, staff members were handing out free mugs with the WaterNet logo, which is a stylized depiction of the first letter of [Home City]. The organization has a deep connection with its home city, and although it was "going global" with several new projects underway (e.g., the Global Water Center), the organization engaged in deep reflection to abide by this connection. Its president noted:

> We will continue with great pride to talk about the fact that we are from [Home City], and even when we start putting our things out there—and our logo, as an example, where—if you look at it, it looks like a wave, but more importantly, it looks like an [X], and when we were going through the original design of it, we thought early on what happens if we expand and grow beyond the seven counties, and do we simply flip that around and take on a [X] for something [else] like that, and when we were going through that effort this

summer, I really looked at it, and I said, no we need to keep that just as it is, and it really is that tie back to our headquarters and our base being here in [Home City], and that's important to us, because one of the things that is key is economic development within this region.

For WaterNet, this place-based branding helped cultivate close ties with local universities and policymakers, as when the Mayor of the city (present at the conference) renamed a major thoroughfare to reflect the region's increased focus on water stewardship, or when local universities converged to open extension centers and research offices at the new Global Water Center. Local connections were also emphasized elsewhere, with other international research and service sites, so as to create a global network of local water clusters.

Connector across Networks

Finally, networking was omnipresent in WaterNet's discourse, as both a microlevel practice and macrolevel organizing metaphor. The NPO's president emphasized, "We're *connectors*. We're the ones that are out there being able to know all the various different players whether they be in industry or academia or utilities, whether they be in Milwaukee or in Chicago or Singapore or Beijing or Paris, and our job is to be able to connect people who've got ideas with those who are looking for answers." This self-identification as "connectors" recalls Stohl and Stohl's (2005) recognition of how international NPOs serve as valuable nodes filling structural holes, to facilitate institutional action related to water management.

Making these connections was, in fact, crucial for each of WaterNet's three key concerns of economic development, talent development, and technology development—a stance that is shared and widely supported by its members. For instance, one conference participant said he was impressed by WaterNet's ability to partner with disparate actors, share know-how around the latest technologies, gain new insight into resource management issues related to water, and how to better frame water sustainability issues for investors. This positive impression translated into a commitment to join the multistakeholder initiative that WaterNet was convening in the Great Lakes region, as a permanent member and sponsor. As noted earlier, corporate, government, and higher education partners lined up to connect with each other, with aspirations to create a pipeline of highly skilled workers and managers, from the universities to policymaking and industry, with WaterNet filling the structural hole at the hub to connect these different entities. The NPO also liberally used networking terms, such as describing its home city as the "hub" of a new "water economy," or when different conference speakers tied their localized work in various parts of the world back to WaterNet's activities, thereby further burnishing its local and global reputation as a "connector." Rather than a global network restricted by the boundaries of a single city (however much it emphasized

place-based branding), WaterNet advocated the formation of connected clusters or, as one conference speaker put it, "smart networks" for diverse regions and stakeholders. These smart networks were designed to be "transitioning systems as societies morphed from highly centralized formations to less," and utilized principles of "flexible, adaptive design" and systemic operations/resource management.

DISCUSSION

Networked publics offer special challenges and opportunities for environmental NPOs, which must engage local stakeholders by emphasizing place-based discourses but also highlight broader systemic connections at the global level. Negotiating these local/global dialectics for such NPOs, given the complex nature of environmental problems like climate change, pollution mitigation, and management of natural resources, requires concerted effort among diverse stakeholders impacting the ecosystems at stake. In this chapter, I used a multicase study (Stake, 2006) of two water-themed NPOs—Aqua and WaterNet—to trace how these nonprofits negotiate local/global flows in their deliberation, stakeholder engagement, and audience outreach efforts. Findings indicate that Aqua prioritized globally networked deliberation processes (rather than purely local consultations), grassroots collaboration and outreach with local partners, dialogic communication that centered place, and contested spatial concepts to privilege local/place-based meanings. Meanwhile, WaterNet found it useful to elevate the virtues of grassroots entrepreneurship in its water management discourse, glocal R&D processes and facilities, place-based branding to help both itself and its partners, and saw itself as an invaluable connector across various institutional networks.

On the one hand, this chapter demonstrates that both NPOs found it necessary to identify as both local and global in scope, activities, and identity vis-à-vis their diverse stakeholders, despite the potential contradictions at stake. Recognizing that these stakeholders were neither isolated nor a homogeneous bloc, but connected through multiplex ties—both strong and weak, tangible and intangible, material and informational—the NPOs found it prudent to discursively emphasize their position in key "structural holes" (Stohl & Stohl, 2005) that was able to mobilize both local action and global policymaking. Such seemingly paradoxical identity management allowed Aqua and WaterNet to generate and facilitate the transfer of creative ideas, meaningfully capture economies of scale as their networks grew larger and more webbed, and help produce mature and efficient networks of practice (rather than simply connecting disparate entities with media technologies) (e.g., Druschke, 2013; Hopke, 2016; Mitra, 2013). Positioning themselves vis-à-vis their networked publics thus involved much more than recognizing the mediated networks and technology webs at stake; it meant that both Aqua and

WaterNet had to deftly manage their organizational discourse in ways that they were simultaneously connected to stakeholders with potentially competing interests, fulfilling their agendas and finding a way to articulate common concerns even when their interests were at odds with each other. Rather than a liability, straddling both local/global contexts became an immeasurable strategy for these NPOs to mobilize their networked publics on the issue of water management.

Nevertheless, these case studies would seem to uphold the concerns of critical scholars of globalization in that, even as Aqua and WaterNet emphasized ostensibly participatory discourses of deliberation and building grassroots connections, both NPOs played up neoliberal agendas of business development, entrepreneurship, and corporate growth that privileged efficient management of water resources (and potentially downplayed social justice). For instance, while Aqua's organizational discourse and stakeholder deliberations highlighted the concerns of indigenous people, they mostly focused on regulatory regimes and corporate promoters of water management. Meanwhile, WaterNet hardly ever concerned itself with issues related to water scarcity and/or access for marginalized communities, despite the lip service paid to connecting broad, networked publics, and tended to focus on the "blue economy" of water for entities that could afford to play by market rules.

Despite these concerns, scholars such as Christensen et al. (2013) argue that we ought to recognize and take heart from the polyphony of organizational discourse. That is, all discourse—even discourse seemingly generated by a single organization with little attempt at soliciting stakeholder participation—is fragmented and contains multiple voices, the voices of stakeholders that have percolated through broader social systems to shape the discourse at hand. Moreover, even as corporatist discourse would seem to uphold neoliberal values, they also serve to continually hold their producing organizations accountable for specific actions; as society evolves, its underlying values change accordingly, and so must the organizations at stake. Thus, as the meaning of "sustainable organizing" becomes more expansive over time, tensions are bound to occur between organizational actions and organizational discourse, and these tensions act in a productive capacity to further change organizational values and actions (Mitra & Buzzanell, 2015). This means that terms and concepts like "water stewardship" (Aqua) and "the capital of water" (WaterNet) are not static, and neither are the corporatist meanings that critics may see attached to them. Rather, they are bound to evolve, through ongoing deliberation and networking across glocal publics—instances of which are already apparent. That is, even as Aqua's conveners initially emphasized status quo institutionalized meanings for "water areas" or impacted communities, the case study demonstrated how networked publics resisted, insisting both on localized interpretations of these concepts and on global baseline measures for greater accountability. Similarly, although WaterNet's discourse focused on water as a

capital resource, its local and global stakeholders sought to connect this resource to the richness of their lived experiences, systemic policymaking for better access to water, and rejuvenation of local regional structures. The case studies thus indicate a complex interplay of grassroots empowerment and institutional elites, which is hard to dismiss as overwhelmingly favoring one pole or the other.

To conclude this chapter, several directions may be suggested for future research on global communication in the case of environmental NPOs engaging with networked publics. First, researchers should consider the intersection of mainstream media and activist channels, as such nonprofits adopt both local/ global and grassroots/elite strategies to push their agenda (Mitra, 2013). Second, as communication scholars, we ought to interrogate the underlying power relationships and tensions that often go unexplored in the agenda of environmental NPOs, without giving them a free pass on their credentials. Interrogation of these tensions is much more nuanced than simply asserting a corporatist bias in the contemporary operations of NPOs. Rather, we must draw on multiple methods and theoretical frameworks to explore the intersectionality of power/resistance, grassroots/elites, and change/stability as environmental NPOs engage various government, for-profit, and other NPOs across geographical locations (Ganesh et al., 2005).

Finally, even as global communication scholars have studied the mediated connections between places and spaces, they should pay attention to the organizing processes—both formal and informal—at stake, as NPOs (including, but not limited to, environmental NPOs) are actively engaged in "place-making" and place-branding, to draw attention both to their own activities and to the systemic implications of their partner networks.

REFERENCES

Appadurai, A. (1996). *Modernity at large: Cultural dimensions of globalization.* Minneapolis, MN: University of Minnesota Press.

Atkinson, J. (2009). Networked activists in search of resistance: Exploring an alternative media pilgrimage across the boundaries and borderlands of globalization. *Communication, Culture, & Critique, 2*, 137–159.

Bäckstrand, K. (2003). Civic science for sustainability: Reframing the role of experts, policy-makers and citizens in environmental governance. *Global Environmental Politics, 3*(4), 24–41.

Baym, N., Campbell, S. W., Horst, H., Kalyanaraman, S., Oliver, M. B., Rothenbuhler, E., ... Miller, K. (2012). Communication theory and research in the age of new media: A conversation from the CM Café. *Communication Monographs, 79*, 256–267.

Bennett, W. L. (2003). New media power: The internet and global activism. In N. Couldry & J. Curran (Eds.), *Contesting media power: Alternative media in a networked world* (pp. 17–38). New York, NY: Rowman & Littlefield.

Boyd, D. M. (2011). Social network sites as networked publics: Affordances, dynamics, and implications. In Z. Papacharissi (Ed.), *Networked self: Identity, community, and culture on social network sites* (pp. 39–58). New York, NY: Routledge.

Boyd, D. M., & Ellison, N. B. (2007). Social network sites: Definition, history, and scholarship. *Journal of Computer-Mediated Communication, 13*(1), article 11. Retrieved from http://jcmc.indiana.edu/vol13/issue1/boyd.ellison.html

Castells, M. (2010). *The rise of the network society.* Malden, MA: Blackwell.

Christensen, L., Morsing, M., & Thyssen, O. (2013). CSR as aspirational talk. *Organization, 20,* 372–393.

Contractor, N. S., & Monge, P. R. (2002). Managing knowledge networks. *Management Communication Quarterly, 16,* 249–258.

Cooper, K. R., & Shumate, M. (2012). Interorganizational collaboration explored through the bona fide network perspective. *Management Communication Quarterly, 26,* 623–654.

Diani, M. (1992). Analyzing social movement networks. In M. Diani & R. Eyerman (Eds.), *Studying collective action* (pp. 107–135). London: Sage.

Druschke, C. G. (2013). Watershed as common-place: Communicating for conservation at the watershed scale. *Environmental Communication, 7,* 80–96.

Fraser, N. (1990). Rethinking the public sphere: A contribution to critique of actually existing democracy. *Social Text, 25/26,* 56–80.

Ganesh, S., Zoller, H., & Cheney, G. (2005). Transforming resistance, broadening our boundaries: Critical organizational communication meets globalization from below. *Communication Monographs, 72,* 169–191.

Gilpin, D. (2010). Organizational image construction in a fragmented online media environment. *Journal of Public Relations Research, 22,* 265–287.

Hopke, J. E. (2016). Translocal anti-fracking activism: An exploration of network structure and tie content. *Environmental Communication.* Advance online publication. doi:10.1080/17524032.2016.1147474

Ito, M. (2008). Introduction. In K. Varnelis (Ed.) *Networked publics* (pp. 1–14). Cambridge, MA: MIT Press.

May, S. K. (Eds.). (2012). *Case studies in organizational communication: Ethical perspectives and practices.* Thousand Oaks, CA: Sage.

Mitra, R. (2013). From transformational leadership to leadership "trans-formations": A critical dialogic perspective. *Communication Theory, 23,* 395–416.

Mitra, R. (2017). Sustainability and sustainable development. In C.R. Scott., & L.K. Lewis (Eds.), *International encyclopedia of organizational communication, Vol. 4* (pp. 2337–2346). Malden, MA: Wiley-Blackwell.

Mitra, R., & Buzzanell, P. M. (2015). Introduction: Organizing/Communicating sustainably. *Management Communication Quarterly, 29,* 130–134.

Mitra, R., & Gajjala, R. (2010). Networked agency and building community: Encountering queer "desi" blogging through dialogue. In M. B. Hinner (Ed.), *The interrelationship of business and communication: A forum for general and intercultural business communication* (Vol. 6, pp. 383–407). Frankfurt: Peter Lang.

O'Connor, A., & Shumate, M. (2014). Differences among NGOs in the business-NGO cooperative network. *Business & Society, 53,* 105–133.

Pal, M., & Dutta, M. J. (2008a). Public relations in a global context: The relevance of critical modernism as a theoretical lens. *Journal of Public Relations Research, 20,* 159–179.

Pal, M., & Dutta, M. J. (2008b). Theorizing resistance in a global context: processes, strategies and tactics in communication scholarship. In C. Beck (Ed.), *Communication yearbook 32* (pp. 41–87). New York, NY: Routledge.

Parks, M. R. (2011). Social network sites as virtual communities. In Z. Papacharissi (Ed.), *A networked self: Identity, community, and culture on social network sites* (pp. 105–123). New York, NY: Routledge.

Pickard, V. W. (2006). United yet autonomous: Indymedia and the struggle to sustain a radical democratic network. *Media, Culture, & Society, 28*, 315–336.

Sedereviciute, K., & Valentinia, C. (2011). Towards a more holistic stakeholder analysis approach: Mapping known and undiscovered stakeholders from social media. *International Journal of Strategic Communication, 5*, 221–239.

Self, C. C. (2010). Hegel, Habermas, and Community: The public in the new media era. *International Journal of Strategic Communication, 4*, 78–92.

Shumate, M., & O'Connor, A. (2010). The symbiotic sustainability model: Conceptualizing NGO-corporate alliance communication. *Journal of Communication, 60*, 577–609.

Sprain, L., Carcasson, M., & Merolla, A. J. (2014). Utilizing "on tap" experts in deliberative forums: Implications for design. *Journal of Applied Communication Research, 42*, 150–167.

Stake, R. E. (2000). The case study method in social inquiry. In R. Gomm, M. Hammersley, & P. Foster (Eds.), *Case study method* (pp. 19–27). London: Sage.

Stake, R. E. (2006). *Multiple case study analysis*. New York, NY: Gulford Press.

Stohl, M., & Stohl, C. (2005). Human rights, nation states, and NGOs: Structural holes and the emergence of global regimes. *Communication Monographs, 72*, 442–467.

Sun, Y., DeLuca, K. M., & Seegert, N. (2015). Exploring environmentalism amidst the clamor of networks: A social network analysis of Utah environmental organizations. *Environmental Communication*. Advance online publication. doi:10.1080/17524032.2015.1094101

Treem, J. W., & Leonardi, P. M. (2012). Social media use in organizations: Exploring the affordances of visibility, editability, persistence, and association. In C. T. Salmon (Ed.), *Communication yearbook 36* (pp. 143–189). New York, NY: Routledge.

Vaast, E. (2004). O brother, where art thou? From communities to networks of practice through intranet use. *Management Communication Quarterly, 18*, 5–44.

Varnelis, K., & Friedberg, A. (2008). Place: The networking of public space. In. K. Varnelis (Ed.), *Networked publics* (pp. 15–42). Cambridge, MA: MIT Press.

Veil, S. R., Buehner, T., & Palenchar, M. J. (2011). A work-in-process literature review: Incorporating social media in risk and crisis communication. *Journal of Contingencies & Crisis Management, 19*, 110–122.

Walton, L. R., Cooley S. C., & Nicholson J. H. (2012). A great day for oiled pelicans: BP, Twitter, and the Deep Water Horizon crisis response. *Public Relations Journal, 6*, 1–29.

Warner, M. (2002). *Publics and counterpublics*. Brooklyn, NY: Zone Books.

Waters, R. D., Burnett, E., Lamm, A., & Lucas, J. (2009). Engaging stakeholders through social networking: How nonprofit organizations are using Facebook. *Public Relations Review, 35*, 102–106.

World Commission on Economic Development (WCED). (1987). *Our common future*. Oxford: Oxford University Press.

Xia, L., Yuan, C., & Gay, G. (2009). Exploring negative group dynamics: Adversarial network, personality, and performance in project groups. *Management Communication Quarterly, 23*, 32–62.

Production of the Internal Other in World Risk Society: Nuclear Power, Fukushima, and the Logic of Colonization

ETSUKO KINEFUCHI, UNIVERSITY OF NORTH CAROLINA, GREENSBORO, NC, USA

In his famed work, *Risk Society*, Ulrich Beck (1986/1992) argues that the world has become a risk society. Scientific and industrial development in advanced industrialization brought a set of risks that are no longer limited in time and space. The risks bring consequences that inevitably affect future generations across national borders. The consequences are incalculable as they are beyond scientific and technological imagination. This incalculableness in turn means that the consequences are also noncompensatable. The publication of this book coincided with the Chernobyl nuclear accident—an accident that ended up serving as the most horrific, powerful evidence for Beck's theory. By proposing the theory, Beck hoped for a world that responds with a cosmopolitan sensibility; in world risk society, cosmopolitanism "opens our eyes to the uncontrollable liabilities, to something that happens to us, befalls us, but at the same time stimulates us to make border-transcending new beginnings" (Beck, 2006, p. 341). That is, global risk compels communication between those who otherwise have no interest in each other. Risks "cut through the self-absorption of cultures, languages, religions and systems as well as the national and international agenda of politics, they overturn their priorities and

create contexts for action between camps, parties, and quarrelling nations, which ignore and oppose one another" (Beck, 2006, p. 339).

Unfortunately for the world, risk society with its unwavering faith in technology and insatiable craving for economic progress, has continued to accumulate risks financially, politically, and ecologically rather than reflexively coming together to reduce them. The nuclear meltdown at the Fukushima Daiichi Nuclear Power Station is a result of this failure. On March 11, 2011, a magnitude 9 earthquake triggered a massive tsunami, which subsequently disabled the cooling system of the nuclear reactors and caused hydrogen explosions at the Fukushima Daiichi Nuclear Power Station owned by the Tokyo Electric Power Company (TEPCO). While the Japanese government initially downplayed the disaster, they later determined that the severity of the disaster reached level 7, the highest on the International Nuclear and Radiological Event Scale. The only other accident that received this rating was the Chernobyl accident of 1986.

Five years later, nearly 100,000 of the original 160,000 evacuees remain internal refugees (*The Japan Times*, 2016, January 16). Many of them permanently lost their homes where their families lived for generations. In the meantime, the cleanup of the melted reactors has made little progress. TEPCO admitted that nearly all of the fuel from the No. 1 reactor has melted and fallen into the containment vessel. They believe that the same is true for other two melted reactors. In his interview with *NHK World News* (2015, March 31), Naohiro Masuda, president of TEPCO's Fukushima Daiichi Decommissioning Company, candidly stated, "We have no idea about the debris. We don't know its shape or strength. We have to remove it remotely from 30 meters above, but we don't have that kind of technology, it simply doesn't exist." In his media interview in December 2015, his answer remained the same (Kageyama, 2015, December 17). The radiation level in the reactors, he also stated, is so high that the workers can spend only a few minutes at a time. Initially TEPCO pledged that they would completely decommission the plant by 2051, but this is now an impossible goal. Akira Ono, the chief of the Fukushima Daiichi Nuclear Station, estimates that the whole decommissioning could take 200 years (*Energy News*).

As Japan struggles to deal with the aftermath of the disaster, many countries are turning to nuclear as their energy solution in the face of increasing pressure to neutralize carbon emission, while attempting to satisfy voracious craving for continuous "development"—development closely tied to maximum extraction, industrialization, and consumption. In the backdrop of the competing imperatives, nuclear power remains a highly attractive solution, especially for developing countries. Currently 62 nuclear power reactors are under construction worldwide, the highest number since 1990 (World Nuclear Industry Status Report, 2015). According to the latest update by the World Nuclear Association (2016, February), 45 countries without nuclear power are actively seeking to launch nuclear power programs. And veteran nuclear

power nations are eager to export their technologies to these emerging nations. Japan, too, chose to continue its nuclear power program. Ignoring widespread public protests, the Japanese government restarted its first reactor since the Fukushima disaster in August 2015 and restarted three more as of March 2016. The government hopes to expand the nuclear share to 20% and, like Russia and European nations, is aggressively seeking opportunities to export nuclear power technologies based on the alleged lessons learned from the Fukushima nuclear meltdown.

What does it mean to study culture and communication in this world risk society that refuses to reflexively act upon Beck's thesis? What cultural analysis can we offer as a field? This is the question that inspired my chapter. Advanced industrialization is not only a risk society; it shares the anthropocentric rationalist culture where communication functions to create radical and hierarchized separation and domination between humans and nature and within human groups. To understand the inability of the world risk society to take corrective measures toward what Beck (2008) calls "cosmopolitan material politics," it is imperative that this rationalist culture is examined. This chapter is a small piece of this deconstructive project. I turn to the insights from ecofeminism, particularly the notions of dualism as logic of colonization from late ecofeminist Val Plumwood, to examine how rationalist dualism works through nuclear power industry's penetration of local communities in Japan and through a dispassionate scientific discourse. Nuclear power serves as a particularly relevant site for an analysis of hierarchized polarization of culture and nature in the competing features of the modern industrialized world. On the one hand, it has securely positioned itself as a "clean energy" in the backdrop of accelerating carbon emission that the global community must urgently address while also pursuing endless myopically and anthropocentrically defined "development." On the other hand, nuclear power represents a risk society (Beck, 1986/1992)—modernity that is haunted by risks that accompany its own technological inventions.

RATIONALIST DUALISM: LOGIC OF COLONIZATION

In her life work, late ecofeminist Val Plumwood sought to dismantle hegemonic rationality. Instead of abandoning reason all together, she called for one that is ecologically aware, life sustaining, and liberating. Central to her work is a break from rationalist dualisms, which she saw as the hegemonic organizing principle of modern life. Building on ecological feminism and feminist philosophy, she unfolded the concept of dualism as the central lineament of colonization (Plumwood, 1993, 2002). For her,

> The concepts of rationality have been corrupted by systems of power into hegemonic forms that establish, naturalize and reinforce privilege. Rationalist dualisms especially justify elite

forms of power, not only by mapping the drama of the master subject and his Others onto a dualism of reason and nature, but by mapping many other aspects of life onto many other variants of these basic forms. (Plumwood, 2002, p. 17)

Modern industrialized civilization is based on ontologized rationalist dualism. Wars are fought between *us* and our *enemy*. Nations fight to protect *their* interests at the expense of *others*. *Men* are constructed in opposition to *women*. *White* identity is constructed in contrast to *Black* identity. *Culture* is defined in contrast to *nature*. A dualism is more than dichotomy; it is a construction where "the qualities (actual or supposed), the culture, the values and the areas of life associated with the dualised other are systematically and pervasively constructed and depicted as inferior" (Plumwood, 1993, p. 47). But this is more than a matter of hierarchies because hierarchies can be contingent and alterable whereas a dualism is a result of domination naturalized in cultural expressions. A dualism is

a relation of separation and domination inscribed and naturalised in culture and characterised by radical exclusion, distancing and opposition between orders constructed as systematically higher and lower, as inferior and superior, as ruler and ruled, which treats the division as part of the nature of beings construed not merely as different but as belonging to radically different orders or kinds, and hence as not open to change. (Plumwood, 1993, p. 48)

A dualism, thus, is not a set of free-floating ideas or associations but is a systematic, institutionalized, and naturalized organizing principle of the social world and of the relationship between the social world and the Earth system.

For Plumwood, culture/nature dualism is where the analysis must begin. Reason, this dualism asserts, is the domain of culture whereas nature lacks the ability to reason. Those who are deemed most rational represent "culture," whereas those who do not (or cannot) follow the same reasoning are rendered irrational and thus close to nature. Rationalist dualism justifies domination and colonization of those who are believed to be close to nature. Although some specific expressions of dualism may be challenged in given historical moments, rationalist dualism survives as long as culture/nature dualism is upheld. Breaking from it requires analysis of discursive and non-discursive practices that uphold the dualism. Plumwood (1993, 2002) explains distinct features of dualism, including backgrounding (denial), radical exclusion (hyperseparation), incorporation (relational definition), instrumentalism (objectification), and homogenization/stereotyping. These features are communicative practices that maintain the dualized relationships of center/margin, dominator/dominated, and colonizer/colonized.

Backgrounding refers to the denial of the center's dependency on the other. The dominant center needs and uses the other's services but denies this dependency by positioning itself as the foreground—the universal and the essential—while deeming the subordinated inessential, the background. This is, of course, an illusion, because the dominant needs the other to survive; it is the margin that

defines the center. It is the subordinated that satisfies the needs of the dominant. *Hyperseparation* maintains dualism by denying continuity and capitalizing on and expanding differences while removing or minimizing commonalities. The result is the maximization of distance between the differentiated spheres even to the extent that the spheres are asserted as two worlds with no overlap—the identity of the subordinated is defined in opposition to the dominant identity. This hyper-separation justifies domination and conquest of the subordinated.

Incorporation is the process by which the subordinated is defined in relation to the dominant as a state of lacking the quality of the dominant. Through dualism, "the colonized are appropriated, incorporated, into the selfhood and culture of the master, which forms their identity" (Plumwood, 1993, p. 41). The difference of the subordinated is represented as deficiency, not diversity. The deficiency of the subordinated becomes the reason for control, containment, and dominance. Thus, the other enters into the conception of the center's self only to the extent that it is assimilated into the systems of desires and needs. Plumwood views *instrumentalism* as a special case of incorporation. *Instrumentalism* refers to the use of the dominated for the dominator's sake. The center is the end in itself, but the margins are denied of independent agency and value and are instead defined by their usefulness to the center. Thus, the center does not recognize the margins as moral kin or beings with their own desires and needs. It follows that it is only appropriate that the dominator imposes their own value, agency, and meaning. Finally, *homogenisation* erases the multiplicity and diversity within the margins, thus defining the margins as a class. Homogenization supports other features by producing binarism. Defining the individuals that make up the other as an undifferentiated class makes it easier to dichotomize, which in turn allows radical exclusion, the psychology of instrumentalism, incorporation, and backgrounding of the homogenized other.

Rationalist dualism and its features Plumwood outlined are found everywhere in today's world organized by the principles of global "free market" capitalism, industrialization, and western modernity. We find some of the worst expressions of these principles in, for example, dumping of toxic waste or pollutants in the communities of poor people of color, exploitation of workers in the developing world, contamination of the environment, and endless extractions of natural resources to satisfy rapacious thirst for consumption. All of these principles contribute to the social formation of risk society, but the logic of colonization prevents culture from taking corrective measures and moving toward rationality that is ecologically aware, life sustaining, and liberating.

Nuclear power, too, is a site of rationalist dualism. Under the cloak of "green" and "cheap" energy, the dominant discourse of nuclear power—the discourse by which nuclear power gained acceptance—is built on rationality that regulates fundamentally hierarchically dualized relationships between human communities

and between humans and the environment. I use examples from Japan to develop this argument. I examine government policies, nuclear power industry documents, assertions by pronuclear experts, environmental and community research reports as well as my personal interviews with antinuclear power activists from 2012–2013. The textual data came from governmental and corporate websites, online news media, and university researchers' websites and online reports. The interviews came from my larger ethnographic study of Japan's antinuclear power movement in which I interviewed 34 participants (17 individual interviews and three group interviews, each lasting approximately 60–150 minutes) from nine different localities across Japan. Together, the analysis of these discursive texts provides a glimpse of the dominant discourse and its dissent. These texts provide a glimpse of the dominant discourse and its dissent.

NUCLEAR POWER AS A PROJECT OF RATIONALIST DUALISM

Siting Conditions and Expendability of the Internal Other

Before the Fukushima nuclear meltdown, Japan was the third largest nuclear power nation in the world with 54 reactors. After the World War II, the Japanese government aggressively fostered the development of nuclear power as a way to overcome the scarcity of natural energy sources necessary for rebuilding the nation and growing its economy. The government passed the Atomic Energy Basic Law in 1955 to promote a peaceful use of nuclear technology and established in the following year the Atomic Energy Commission (AEC) to begin the development of nuclear power. But the vision of a dream energy and ensuing good life and prosperity did not include everyone. The very idea of nuclear power could not exist without accepting the expendability of certain lives and certain ways of being—of both humans and the environment.

This expendability was embedded in the very selection of nuclear power sites. In 1964, the AEC published *The Regulatory Guide for Reviewing Nuclear Reactor Site Evaluation and Application Criteria* to begin choosing sites for building nuclear reactors.[1] Today's existing nuclear power station sites were chosen based on this guide. The guide included the following basic siting conditions:

> Regardless of the establishment location, nuclear reactors are required to be designed, constructed, operated and maintained to prevent rare accidents. The following siting conditions are, however, required in principle to ensure public safety in case of rare accident:

> 1. There have as yet been no event liable to induce a large accident and no such event is expected to occur in the future. There have also been very few events deemed liable to expand disaster;

2. In relation to their safety guarding facilities, nuclear reactors shall be located at a sufficient distance from the public; and

3. The environment of the nuclear reactor site including its immediate proximity shall be such that appropriate measures for the public can be implemented as required. (The Nuclear Safety Commission, 1964/1989)

The guide elaborates on "a sufficient distance from the public" by providing an additional explanation. The sufficient distance includes two layers. First is "the non-residential area" where a person may be exposed to radiation damage under a "Major Accident" (the worst case scenario from a technological point of view). Then comes "the low population zone"—the area outside the "non-residential area" but within the distance where the public may be exposed to a "significant radiation hazard" in the case of a Hypothetical Accident (an accident beyond a Major Accident or beyond the available technology wherein safety guard facilities fail and radioactive materials are released) (The Nuclear Safety Commission, 1964/1989).

On its face, the guide appears to have the safety of the local community as the foremost priority. It was created after all to address the safety of citizens. But, when read in the context of local community, the siting conditions reflect rationality based on disposability of the community and the environment around a nuclear power facility. Disposability came up as a theme among local antinuclear activists from different nuclear power towns I visited. Among them is a group of women who have for years protested against the Kashiwazaki-Kariwa Nuclear Power Station, the largest nuclear power facility in the world in terms of the output capacity. The reactors at the station, designed to withstand up to magnitude-6.5 earthquakes (Nakamura, 2012), have had a number of problems after a magnitude-6.8 earthquake hit the area in 2007 but went back online in 2009 until they were forced to shut down due to the 2011 Tohoku Earthquake. One of the women, Mrs. Iso, felt that her country already decided long ago that her community is disposable; "The government is probably thinking that it is just an unfortunate casualty if we die from or are severely affected by a nuclear accident, because we are only a village of 4,000. We are not Tokyo." Mrs. Hayashi echoed Mrs. Iso's thought:

> What gets me is that, even after Fukushima, the government is trying to sell nuclear power technology to other countries, saying that Fukushima is under control. When I heard this on the news, I thought of the people in Fukushima. They are still very much suffering, and yet the government ignores it. People in Fukushima are not considered human [by the government]. It is the same here. We are not included in humanity.[2]

Expendability embedded in the siting regulatory guide was long felt by local residents like these Kariwa women but was backgrounded in the dominant iteration that propagated the safety of nuclear power. Fukushima brought expendability of

the siting rationality to the surface. Fukushima taught that sites that meet these criteria don't exist in Japan. No one predicted that a disaster as monstrous as Fukushima would occur. It was what the AEC calls a "Hypothetical Accident"— an accident that cannot be contained by the existing technology. An accident that was not supposed to happen. The ambiguity of the language such as "non-residential area" and "the low population zone" allowed much room for a range of interpretations for what the distance should be and what population may be considered "low." As a result, plenty of nuclear reactors were built within 10-20 km from cities with 200,000 or more populations. Still more are being built in close proximity. In Oma, Aomori Prefecture, J-Power has largely completed a reactor adjacent to a private property with a residence. In Kaminoseki, Yamaguchi Prefecture, Chugoku Electric Power Company has been trying to build a nuclear power station only 3.5 km from Iwaishima, an island community.

Even if numerical distance were assigned to determine safe zones, radiation from nuclear power accident is unlikely to circulate in accordance with the defined radius. Contamination areas cannot be fully predicted because they are always subject to the amount of radiation released in the air, wind direction, temperature, and rain—the factors beyond human control. Again, Fukushima demonstrated this unpredictability; in the weeks following Fukushima, a high level of radiation was detected 50–60 km northwest of the crippled plant, whereas the radiation level at just 5 km north of the plant was among the lowest.[3] When analyzed in the context of a real, serious accident, sites suitable for nuclear power do not exist. The very siting criteria are a myth that hides the inevitability of sacrificing certain lives as expendable.

As nuclear power is systematically hailed as clean energy, its colossal risks and damages to the environment rarely enter the dominant discourse of nuclear power. The natural environment becomes no more than a set of inanimate resources to be exploited and trumped on the road to human prosperity. The regulatory guide for siting conditions includes no consideration for the environmental harms that accompany nuclear power even without major accidents. Nuclear power uses massive amounts of water for cooling and discharges spent hot water back into the ocean raising the water temperature by 7°C, affecting marine life. Masanori Sato, professor of marine biology, calls nuclear power a "marine baby killing machine" (*Alterna*, 2012, April 16). He explains that, when massive water is retrieved from the ocean, planktons as well as eggs and babies of sea life are also sucked in and are killed by heat and sodium hypochlorite used to prevent organisms from sticking to the pipes. In addition, radioactive water used for cleaning buildings and clothing is dumped back into the ocean along with the hot water. According to Sato, although the radiation level is low, massive radioactive water saturates marine life in radiation, inevitably affecting the ecology of the ocean.

Since Japan became nuclear-free in 2011 after the Fukushima nuclear disaster, the improvement to the marine environment has been reported from a number of nuclear power towns. For example, dead large ocean animals were found daily at the beaches near the Sendai Nuclear Power Station (whose Number 1 reactor was switched back on in August 2015 for the first time since Fukushima), including sharks, stingrays, whales, dolphins, and sea turtles. These occurrences stopped entirely since the reactors went offline in 2011 (*Harbor Business Online*, 2015, September 6). It is because of damage to ocean life that fishery associations receive large sums of compensation in exchange for renouncing their fishing rights for the areas near nuclear power stations. Whether or not the compensation is worthwhile is debated. Regardless, it is not the marine life that is being compensated or even considered in this economic equation.

Nuclear power site safety as defined in the regulatory guide, in short, is built on an unarticulated but clearly underlying moral stance that the regions surrounding nuclear power plants and the people in them are expendable in the event of a Major Accident or worse, a Hypothetical Accident. To use the language of rationalist dualism, the regions, both the people and the natural environment, are instrumentally defined but their simultaneous indispensability and expendability is systematically backgrounded. In her discussion of ecology and democracy in the context of the logic of free market, Plumwood (1996) argues that this logic treats the marginalized and nature similarly as expendable, defining that their health, their land, and thus their lives are of low value. The siting regulatory guide (and other regulations that were developed to support the nuclear power industry) builds on this colonial logic that produces expendable others *within* a nation—a political, cultural community that is normatively constructed as an imagined communion of a horizontal comradeship despite existence of inequalities (Anderson, 1983/1991). As I discuss in the next section, the colonial logic also underpins the ways nuclear power penetrated and created gross dependency of local communities on nuclear power.

Nuclear Power Dependency and Logic of Colonization

While the policymakers in post-WWII Japan swiftly fashioned legal and political infrastructure to support the construction of nuclear power stations, there was considerable public opposition to nuclear technology. After all, it was nuclear bombs that killed over 200,000 people in Hiroshima and Nagasaki. There was also the U.S. thermonuclear testing on Bikini Atoll in March 1954 that exposed the crew of a Japanese fishing boat, Daigo Fukuryu Maru, to nuclear fallout from an explosion 1,000 times more powerful than the one that destroyed Hiroshima. It turned out that Daigo Fukuryu Maru wasn't the only victim; the Ministry of Health and Welfare later reported that the fallout exposed 856 Japanese fishing

boats and 20,000 crew members to radiation, and led to dumping of 75 tons of tuna caught between that March and December (Schreiber, 2012, March 18).

In the backdrop of the pervasive public distrust of nuclear technology, the government-utilities complex had to win over the public on two fronts. First, the general public across the nation needed to be "educated" that nuclear power and nuclear bombs are entirely different and that nuclear power is absolutely safe. As I wrote elsewhere (Kinefuchi, 2015), this was done through aggressive media campaigns that promoted public acceptance of nuclear power as a peaceful and extraordinary technology that allows Japan to become energy independent. This narrative was reinforced through other mediums such as pronuclear science and social studies in public schools and family-friendly educational and entertainment facilities financed by utilities. Such persuasive public relations strategies constituted what Aldrich (2008) calls soft power control—non-coercive but effective ways to capture the hearts and minds of citizens.

The other front was the persuasion of local towns to accept nuclear power. This was the key, for no reactor would be built without the towns' consent. In every community that was chosen as an intended site for nuclear power reactors, there were intense clashes between those who more or less welcomed nuclear power and those who opposed it.[4] The struggle lasted many years and sometimes decades. Some of the communities ended up eventually agreeing to the construction of a nuclear power plant, others succeeded in nullifying the plan all together, and yet others are still fighting. Currently, seventeen towns across Japan are homes to 43 operable reactors (World Nuclear Association, 2015, August 27).[5] Although there are many differences across these communities chosen as the sites of nuclear power stations, they also share notable similarities. Some of the commonalties are geological and geographical suitability for nuclear power facilities; the targeted towns are all coastal because nuclear reactors need massive quantities of water for operation, and the ground must be hard and strong (i.e. no known fault line) to withstand earthquakes. But the communities have other traits in common; all of them are remote towns that traditionally relied on agriculture and fisheries for livelihood but were experiencing shrinking population and were not comfortable if not struggling economically. For the government-utilities complex, these conditions were an opportunity to sell nuclear power. The government enacted in 1974 the Three Laws for Electric Power Resource Sites to provide subsidies to local governments that accepted an electric power plant, especially nuclear power. In the last 40 years (1974 to 2013), the government spent about three trillion yen (25 billion US dollars) on the subsidies (*Mainichi Shimbun*, 2015, August 14). The towns also received sizable property tax revenues from the plants.

These financial incentives were a powerful tool of incorporation. Nuclear power won't exist if no local community accepts it. This obvious dependent relationship is obfuscated and inverted by incorporation—defining of the subordinated in terms of

what it lacks (Plumwood, 1993, 2002). A discursive work of incorporation is seen, for example, in the subsidies system explained by the Federation of Electric Power Companies of Japan:

> This [the Three Laws] is designed to ensure that the profit from the electric power station is sufficiently shared with the local community. This system has effectively promoted local development. In order for a nuclear power facility and local community to co-exist and co-prosper, it is vital that the central government, the local government, and the electric power company come together as one and cooperate and collaborate for the development of the local community. The subsidies play an important role in the maintenance of the industrial and social bases of the local community. They help the development of the local community by financing public facilities such as road, park, plumbing, school, and hospital and assist local industries by providing funding for facilities and human resources development. These bases will be built in consultation with the local residents. In addition, once the reactor goes online, the community will receive property tax and other tax revenues for many years to come.[6]

This is the narrative sold to local communities. Although it is the government-utilities complex that needs the local community, the narrative hides this detail and inserts the subsidies (and thus the government-utilities complex) as the savior of the community. It constructs local communities as lacking strong industrial and social bases for its flourishing. It entices to accept nuclear power with promises of solutions to their problems: nuclear power brings them hefty property tax and employment, and, through substantial subsidies, they can have a state-of-the art community center, hospital, school, and wider and better roads. Financial incentives acted as a potent persuasive instrument especially in towns with diminishing civic activity due to declining population or weakening fishing and farming cooperatives (Aldrich, 2008).

A question to be asked here may be whether nuclear power indeed helped to create prosperous towns. A study by Tokyo Autonomy, a public interest incorporated foundation specializing in the research of local governments, offers relevant insights. They found that half of the towns that accepted nuclear power have seen deterioration of their finances and heavy dependence on the nuclear power industry (*Japan Agricultural Communications*, 2011, August 1). The study report explains a typical scenario. Initially, towns built many public facilities using the property tax and subsidies from nuclear power. A town with a 1,350 MWh nuclear power station, for example, received about 63 million yen (5.7 million US dollars) in property tax the first year of operation, but, since this is depreciable assets tax, the tax revenue decreased as years passed; in five years, the town would collect a half of what they received in the first year and only about 1 million yen in 20 years. What is left are all the facilities they built that they are unable to maintain. Towns became dependent on the subsidies to pay for not only construction of public facilities such as schools and nursing homes, but for upkeep of these facilities

from salaries to operational budgets. In addition, a large portion—70 to 80%—of local businesses relies on the nuclear power industry. In short, towns that used to manage without nuclear power have become thoroughly dependent on it.

Other reports tell the same story. In the towns where Fukushima Daiichi (where the disaster occurred) and Fukushima Daini nuclear stations are located, the public finances deteriorated despite the large subsidies, leaving some of the towns no alternative but to ask for the construction of additional reactors so they could receive further subsidies and property tax (Onitsuka, 2011). By 2007, the town of Futaba, where the crippled Fukushima Daiichi Nuclear Power Station exists, nearly went bankrupt and asked TEPCO to build two more reactors (Fackler & Onishi, 2011, May 30). Subsidies immediately rolled into Futaba. A Kobe University research team (Fukui Wakasa Fieldwork Report, 1999) reported a very similar pattern of economic deterioration and nuclear power dependency in Mihama Town, one of the first towns that accepted nuclear power in Japan. Nuclear power brought serious damage to Mihama's traditional economy base— agriculture, forestry, fisheries, and other local industries—as would-be successors sought employment with nuclear power or related businesses, obliterating the traditional economic practices.

These stories reveal that nuclear power brought immediate and temporary material and financial wealth at the cost of the long-term well being of the communities. As a local economy becomes dependent on the existence of nuclear power, other means of sustaining the community that emerged over time in accordance with the surrounding biodiversity—farming, fisheries, and other local land-based industries—were relegated to the margins without heirs and support and eventually die out. Hisao Ito, who prepared the Tokyo Autonomy report, observed that, in post-WWII Japan, the national policy regarding farming towns did not have the best interest of the towns in mind—one that seeks to create strong communities with local agriculture as its foundation. Rather, it was one that prioritized the prosperity of urban metropolis at the expense of rural communities.

The residents in cities are no doubt complicit in the rise of nuclear power by virtue of consumption but they were also insulated from the plight of the nuclear power towns by remoteness. In her discussion of our (humans') inability or reluctance to see the ecological consequences of our anthropocentric decision, Plumwood (2002) suggests that remoteness, which is accomplished in a number of ways, allows this dissociation. The metropolis is removed not only spatially by distance from the nuclear power communities but also communicatively and epistemically, through ubiquitous pronuclear power propaganda that presented the moral superiority of nuclear power as clean, safe, and indispensable (Kinefuchi, 2015) while silencing the question of enormous risks and costs to the local communities and the natural environment.

Remoteness also takes the shape of economic rationality. The rationality that nuclear power communities are handsomely compensated became a tool to distance not only the government-utilities complex but also the city consumers from the plight of the local communities. Not surprisingly, the news of financial troubles that these communities experience as a result of accepting nuclear power did not emerge until after the Fukushima disaster. Following the logic of colonialism (Plumwood, 1993, 2002), the rural towns in essence became the instrument of prosperity for the government-utilities complex and the urban cities. Under this logic, the towns' absolute necessity for the existence of nuclear power is veiled and upturned by the discourse of the *essential* role that nuclear power plays in attaining economic wealth that these towns were deemed lacking. What is further significant in the dualism at work here is that not only did nuclear power symbolically disguise and invert the dependency relationship, but also, through injecting itself into the heart of the towns, it in fact manufactured material perpetual dependency of the towns on nuclear power.

Since August 2015, Japan restarted four reactors that passed the safety tests under the new more stringent safety regulation. A Reuters' analysis based on questionnaires and interviews with over a dozen experts and ten nuclear reactor operators concluded that only one-third, or at best two-third of the reactors will pass the new safety tests (Saito, Sheldrick, & Hamada, 2014, April 2). For the communities whose lives depended on nuclear power, failing the tests may mean a death sentence. In fact, last four nuclear-free years brought serious financial hardships to nuclear power towns. For example, between two towns—Mihama and Tsuruga—the economic loss is estimated to be about 20 million US dollars, and many local businesses that served nuclear power have been suffering (*Sankei Shimbun*, 2015, June 4). This desperation also explains the seemingly appalling move by town leaders soon after the Fukushima catastrophe. Just three weeks after the explosions at the Fukushima Daiichi Nuclear Station, several mayors of nuclear power towns, including the mayor of Futaba (the home of the crippled nuclear reactors) visited the Prime Minister's residence to make a plea not to change the national policy to expand nuclear power (*Fukui Shimbun*, 2011, April 5). Life without nuclear power is now inconceivable in the culture of manufactured dependency even if it means living with the possibility of another Fukushima.

Logic of Colonialism in Dispassionate Science: Nuclear as a "Clean and Safe Energy" for Prosperity

The tenacity of the nuclear-as-clean-and-safe articulation is maintained not only by corporations and governments that have vested interest in continuing nuclear power programs. Experts with global media platforms also shape its discourse. Immediately after the explosions at the Fukushima Daiichi nuclear reactors, renowned climate

scientist James Lovelock stated in *The Guardian* that the danger of nuclear power is "a monstrous myth" (Vidal & Harvey, 2011, March 15). Among the tens of thousands of people who were killed, none of their deaths were due to nuclear power, he claimed. As for Chernobyl, it was "an idiotic mess-up that could only have occurred in the Soviet Union." He noted that only 56 people were killed in Chernobyl, a number far smaller than the casualties from oil refineries and coalmines.[7] In another interview with *The Guardian* (Moss, 2014, March 14), he remarked that rejection of nuclear energy is absurdity that comes from "the religious side":

> They feel guilty about dropping atom bombs on people. Here was this extraordinary gift given to humans—a safe, cheap source of power—and it gets horribly abused right at the start. We're still playing out the guilt feelings about it. But it's sad because we in Britain could now be having cheap energy if we'd gone on building [nuclear power stations].

A similar argument is made by James Conca, an environmental scientist who regularly contributes to *Forbes Magazine*:

> Contrary to all the hype and fear, Fukushima is basically a large Superfund site. No one will die from Fukushima radiation, there will be no increased cancer rates, the food supply is not contaminated, the ocean nearby is not contaminated, most of the people can move back into their homes, and most of the other nuclear plants in Japan can start up just fine. (Conca, 2015, March 16)

And in another post, Conca concludes that

> Nuclear energy has proven to be the safest and most efficient of all energy sources, from both the human health and environmental perspectives. In total, to produce a trillion kWh of electricity, nuclear takes less land, uses less steel and concrete, has less emissions, kills fewer people, and has lower life-cycle costs than any other energy source. (Conca, 2015, July 7)

As with the regulatory guide and the economic incentive used to gain the consent of local communities in Japan, expert commentaries like these summon dualist rationality. This time, dualism with scientific, supposedly objective empiricism on one side and emotional, bodily, the personal, and political on the other (Plumwood, 2002). The commentaries construct those who object to nuclear power as too irrational, emotional, and frenzied to see the gift of nuclear power. From this dispassionate, "objective" standpoint, the opposition is irrational and even unethical for rejecting this "cheap, safe, green" energy; in the midst of a global imperative to reduce carbon emissions while also facing the need for continuing economic development, it is in fact wrong to reject nuclear power. Armed with rationalist interpretations of knowledge—where knowledge is the property of a rational knower, the claims of these experts become a colonial instrument of private economic power.

This rationality, however, falls apart when examined against the real costs—financial, social, and environmental—of nuclear disaster. Chernobyl has so far amounted to US$235 billion. Fukushima is estimated to cost over eleven trillion yen (US$96 billion) between compensations, cleanup and decommissioning of the crippled reactors (*NHK News*, 2014, March 11). Putting aside the contested claims of cheap, safe, and green, the problematic of expert commentaries crystallizes when the attention is paid to the consequences that Fukushima evacuees deal with every day—the "other" side on which the consequences systematically fall. Inside Fukushima, life is ominously different from Conca's cheerful assessment of nuclear as "the safest and most efficient of all energy sources, from both the human health and environmental perspectives." Although the link between the sudden increase in thyroid cancer among children and exposure to radiation from the disaster is highly debated (NPR, 2015, October 8), one worker's leukemia was officially tied to Fukushima (Reuter, 2015, October 20). More than 2,000 people died from the evacuations necessary to avoid exposure to high level of radiation. The deaths are due to psychological and physical exhaustion and disorientation from forced uprooting and loss of family and social support networks (Fairlie, 2015, August 20). The number includes 56 suicides.

If nuclear power were safe as pronuclear power experts claim, it follows that there was no need to evacuate. Without evacuation, 2,000 lives would have been lost. Journalist William Vollmann (2015, March), who followed the Fukushima disaster since 2011, wrote in *Harper's Magazine* what he learned from being among Fukushima refugees. In an anti-nuclear power protest he witnessed, one farmer lamented that he is unable to feed his cows his own grass because it is forbidden; grass, compost, hay are all contaminated with cesium. A woman shouted, "Those who make the decisions are not affected by radiation because they live in Tokyo." One day, Vollmann accompanied a 62-year-old man, Endo, who returned to his home in a high radiation area to clean and take some necessary items. The former residents like Endo are allowed to go back fully clothed in anti-radiation suits only up to six hours during the daytime. Endo still pays a mortgage for his damaged, radioactive house; if the residents' homes were not damaged more than 50%, they are still obligated to pay mortgages even though their homes are uninhabitable (Vollmann, 2015, March).

Beyond the human communities, the consequences on the environment are also immense. The Chernobyl nuclear accident instantly killed more than 400 hectare of pine tree forest when the radioactive particles fell on the trees. Now known as the Red Forest, it is one of the most contaminated places on Earth. Birds have smaller brains, fewer insects inhabit, and dead trees are not decomposing even after 30 years because the organisms that decompose trees also suffered from acute radiation exposure. Fukushima's ecosystems, too, are suffering. The forests around the Fukushima Daiichi Nuclear Power Station were showered with nuclear

fallout and became highly radioactive. The survey of the native Japanese fir tree forests near the crippled plant showed abnormal changes to the trees, particularly in areas with higher air rates of radiation (*The Asahi Shimbun*, 2015, August 29). The massive amount of groundwater around the plant is still so radioactive that it has to be contained in the highly contaminated buildings, which could further contaminate the water (Kumagai, 2015, December 26). Many animals that residents could not or did not take with them were not only exposed to radiation but were left to survive on their own, starved to death, or were killed (Lah, 2012, January 27).

When expert scientists define nuclear power as the safest, cleanest, most efficient gift to humans, it does not only background the "other" but erases all these sufferings—for humans and beyond humans—as no more than irrational hype and myth. While the experts may genuinely believe in this definition and may even think of their position as reflective of the larger social and environmental good (e.g., "less emissions"; "kills fewer people"), the rationality is fundamentally an unjust one, for it relies on dissociation of humans and the biosphere that sustain human civilization as expendable and masks enormous risks and costs it creates. Such dissociation is made possible by remoteness; one can dismiss the consequences of decisions if the consequences do not systematically fall on them (Plumwood, 2002). One can shrug off the suffering caused by a nuclear disaster as no more than, as Conca calls it, a Superfund site—a polluted land that just needs to be cleaned up.

Implications for Culture and Communication in World Risk Society: Moving beyond Logic of Colonization and Anthropocentrism

Now I return to the question I posed in the introduction. What does it mean to study culture and communication in this world risk society that refuses to reflexively act upon Beck's thesis? The late Ulrich Beck (1986/1992, 2006, 2008) believed in cosmopolitan material politics where global risks—which know no time or spatial boundaries—and anticipated catastrophe serve as the currency for tearing down organized irresponsibility, compelling communication across differences, and eventually transforming global politics. This sense of cosmopolitan politics has occurred to a degree. Returning to the example of nuclear power, as a result of Fukushima, large-scale antinuclear protests occurred in many parts of the world. Some nations decided that nuclear power, with its prohibitive risks, is no longer a viable energy solution. Immediately after the Fukushima disaster, German Chancellor Angela Merkel declared the closing of aging nuclear power plants after seeing that Japan, a veteran nuclear power nation with highly advanced technology, was unable to prevent a nuclear catastrophe. This was a drastic shift from a few months before the disaster, when she announced prolonging the lives

of reactors by 12 more years. Germany plans to go nuclear free by 2022 while also seeking to be carbon-free (Appunn, 2015, July 24). Other nations—Italy, Spain, and Switzerland—declared their plan to become nuclear-free. In Taiwan, extensive public protests led the government to seal the No. 1 reactor and suspend the No. 2 reactor at Lungmen Nuclear Power Plant.

Yet, these are in a clear minority. Despite Three Mile Island, Chernobyl, and Fukushima, the narrative of nuclear power as a clean, safe energy technology continues to live on. A few weeks after the disaster, the head of Russia's nuclear authority, Sergei Kiriyenko, criticized Japan for exaggerating the magnitude of the disaster by elevating it to level 7. Unaffected by its own nuclear catastrophe and Fukushima, Russia continues to build and export nuclear power technology, as does the United States. And so do many other nations. Just a couple of months after the disaster, South Africa's energy minister affirmed the central role nuclear energy would continue to play in the nation's energy policy (World Nuclear Association, 2015, June). Belgium, withdrawing its earlier post-Fukushima declaration to phase out nuclear power, restarted in January 2016 two 40-year-old reactors with a history of serious safety flaws, despite the protests from the surrounding and international communities. As of 2016, 31 countries own commercial nuclear power reactors, 62 reactors (the highest number since 1990) are under construction worldwide, and 45 countries are actively seeking to launch nuclear power programs. (World Nuclear Association, 2016, January). Within Japan, contrary to the nuclear-free wish of the majority of its citizens, the authorities have allowed the restart of four reactors and are planning to bring back many more to raise the nuclear energy share to at least 20%.

All these moves to embrace nuclear power demonstrate that the presence of and awareness about global risks are not a sufficient condition for fostering the kind of cosmopolitan sensibility and politics that Beck envisioned. In the age of global and around-the-clock media, there is considerable awareness about tragedies, injustices, and sufferings resulted from nuclear power and other global risks. Yet, the state-corporation complex everywhere continues to produce a culture that ever accumulates risks in the name of progress, and we as citizens of the industrialized world fully participate in keeping this culture alive. As we do so, we silence, as environmental philosopher Derrick Jensen (2004) argues, the voices of those we don't want to hear, for this silencing is central to the working of the culture we live in.

Cosmopolitan politics will not emerge until we begin to dismantle the logic of colonialism and remoteness so ingrained in our modern industrialized world. For me, this suggests at least two lines of work in the study of culture and communication. First, we ought to pay attention to how our dominant communicative practices and their underpinning assumptions, beliefs, and values work to produce and preserve rationalist dualisms and their accomplices—isolation, separation,

hierarchy, and sacrifices—in the name of progress not only within human communities but also between humans and the larger life giving biosphere. By making visible the links between discourse and rationalist dualisms, we can begin to alter the discourse or offer a different discourse that sutures progress to a culture where, following Plumwood (2002), reason is ecologically aware, life sustaining, and liberating. This chapter is a small piece toward this articulation.

But this alternative discourse must come from somewhere. The other work then is a more fundamental reimagining of self, culture, and communication. For Thomas Berry (1990), David Abram (1997), Vandana Shiva (1993), and many other Earth scholars like them, it begins with reintegrating humans with the rest of the Earth and realizing that humans are a dimension of it. As Shiva (1993) puts it, "we do not carry the earth; the earth carries us" (p. 276). This inversion necessitates reorientation of the way we see and relate to the more-than-human world. The natural world is not only alive and sensuous but is the guide for building a life-sustaining culture. It communicates to us if we listen. And this listening, as Donal Carbaugh (2007) argues, is imperative to our own communication and sense of who we are in the world:

> We must not forget that our verbal imbrications are in some sense secondary translations of other natural systems of expression, from rocks and rapids to ravens. And we must become better attuned to those other expressive systems, to what each is saying to us, in its own way, and then we might learn to speak better, in our own words, on its behalf, as a result of this process. Without constant reminding of this as part of the larger process, we stand leaning heavily on our own words, and are somewhat less steady in the world we seek to understand, or the world we "stand up for" and care for, as Edward Abbey put it. (p. 68)

If we are to take the Earth scholars' plea and Carbaugh's observation seriously, our theory and praxis of self, culture, and communication will have to change considerably but toward profoundly contextualized ones.

We can also take guidance from human communities. Indigenous cultures around the world understand the primacy of acknowledging the nature as a communicator and a guide to humans and have maintained integral relationships with nature. In the indigenous tribes in Nepal, Indonesia, and the Americas, for example, the tribal shamans act as the intermediaries between the human community and the larger ecological world, making sure that the relationship is balanced and reciprocal (Abram, 1997). Such intimate human-nature relationships are also found in the traditions and classic writings in various cultures: Omaha Indians introducing their newborns to the entire universe; the Iroquois giving thanks to the earth; old Chinese writings that define a truly developed person as someone who becomes one with heaven, earth, and all lives; and Indian tales full of human intimacy with other animals and forest life (Berry, 1988). There is much to learn from these cultural practices.

But human-nature relationships based on mutuality, balance, and respect are not just in old traditions, classic tales, and indigenous cultures; however marginalized they are, they exist in today's world as well. The film *This Changes Everything* (Lewis, Barnes, & Lewis, 2015) (based on Naomi Klein's book of the same tile) gives us a glimpse of those relationships as it takes the audience to various parts of the world—Canada, the United States, China, India, Germany, and Greece. People in these different localities similarly fighting to preserve the integrity of lands, air, water, and forests, understanding that protecting them ensures the health of human communities as well. The Beaver Lake Cree Nation in Canada fights to protect the land from the Alberta tar sands project not only because they have a native title claim to the land but more importantly because humans are only borrowing the land from the Earth. In Greece, people rose up to protect revered mountains and seas when they were targeted for mining in the name of saving the country from a severe economic crisis. Back in Japan, I met remarkable groups of people who have been fighting to resist the construction of nuclear power reactors for decades, declaring that clean air, clean soils, and clean oceans are the basis of all life.

All this tells me that sustainable wisdom is everywhere if we pay attention. While different cultures may have established somewhat different relationships with the larger ecological sphere, they also share wisdom that situates human communities as an integral part of the Earth. The wisdom transcends cultures because it, as Jensen (2004) puts it, comes from "a language older than words. It is the language of bodies, of body on body, wind on snow, rain on trees, wave on stone. It is the language of dream, gesture, symbol, memory" (p. 2). Jensen mourns that we have not only forgotten this language but we don't even remember its existence. For many of us, this is true, but the evidence of people rising up on behalf of the natural world everywhere tells me that the language still exists however endangered it is. We need to seriously relearn this language, and the scholarship of culture and communication can be a vital catalyst for remembering and reviving it.

NOTES

1. There are 17 regulatory guides regarding the prevention of accidents. The guides concern siting, design, safety evaluation, and radiation dose. Only one guide addresses siting. See http://www.cas.go.jp/jp/seisaku/icanps/eng/120224Honbun06Eng.pdf from the Japanese Cabinet Secretariat.
2. The women's comments were taken from my interview with them in 2013.
3. See "Radiation contour map of the Fukushima Daiichi accident" available at http://www.haya kawayukio.jp/pub/2011/09decJG.jpg
4. The struggle should not be understood as simply a fight between two dichotomized sides—pro- nuclear and antinuclear. The initial stages of a nuclear power construction project engage only

the leaderships, and the residents are often left out of the conversation. There are also tremendous psychological and cultural pressures placed on residents to accept nuclear power. These are crucial relational and political dynamics but are beyond the scope of this chapter.
5. There were many more towns—as many as 30 according to a journalist, Shin Yamaaki (2012)—that refused to live with nuclear reactors in their backyards.
6. The benefit was explained in their Japanese language website. This is my translation.
7. According to the World Health Organization's report in 2005, 50 emergency workers died of acute radiation syndrome and nine children died of thyroid cancer. Contrary to Lovelock, the WHO estimates that about 4,000 people, including the 59, out of about 600,000 emergency workers and residents, may die from exposure to radiation during the accident.

REFERENCES

Abram, D. (1997). *The spell of the sensuous*. New York, NY: Vintage Books.
Aldrich, D. (2008). *Sight fights: Divisive facilities and civic society in Japan and the West*. Ithaca, NY: Cornell University Press.
Alterna. (2012, April 16). Retrieved from http://www.alterna.co.jp/8804
Anderson, B. (1983/1991). *Imagined communities*. London: Verso.
Appunn, K. (2015, July 24). The history behind Germany's nuclear phase-out. *Clean Energy Wire*. Retrieved from https://www.cleanenergywire.org/factsheets/history-behind-germanys-nucle ar-phase-out
Beck, U. (1986/1992). *Risk society: Toward a new modernity*. London: Sage.
Beck, U. (2006). Living in the world risk society. *Economy and Society, 35*(3), 329–345. doi:10.1080/03085140600844902
Beck, U. (2008). *World at risk*. Cambridge: Wiley.
Berry, T. (1988). *The dreams of the earth*. San Francisco, CA: Sierra Club Books.
Berry, T. (1990). *The dream of the earth*. San Francisco, CA: Sierra Club Books.
Carbaugh, D. (2007). Response to Cox: Quoting "the environment": Touchstones on Earth. *Environmental Communication, 1*(1), 64–73.
Conca, J. (2015, March 16). The Fukushima disaster wasn't disastrous because of the radiation. *Forbs*. Retrieved from http://www.forbes.com/sites/jamesconca/2015/03/16/the-fukushima-disas ter-wasnt-very-disastrous/
Conca, J. (2015, July 7). What about nuclear power isn't good? *Forbes*. Retrieved from http://www. forbes.com/sites/jamesconca/2015/07/07/what-about-nuclear-power-isnt-good/?ss=energy
Energy News. (2015, March 31). Retrieved form http://enenews.com/times-worst-possible-result-re vealed-fukushima-plant-chief-centuries-pass-before-humans-invent-deal-molten-fuel-videos
Fackler, M., & Onishi, N. (2011, May 30). *In Japan, a culture that promotes nuclear dependency*. Retrieved from http://www.nytimes.com/2011/05/31/world/asia/31japan.html?_r=0
Fairlie, I. (2015, August 20). *Fukushima update*. Retrieved from http://fukushimaupdate.com/fukushi ma-thousands-have-already-died-thousands-more-will-die/
Fukui Shimbun. (2011, April 5). Retrieved from http://www.fukuishimbun.co.jp/localnews/earth quake/27359.html
Fukui Wakasa Fieldwork Report. (1999). *Genpatsu to chiikishinkou: Mihama Cho no jirei*. Retrieved from http://soc1.h.kobe-u.ac.jp/gakusei/hattori/mihama.html
Harbor Business Online. (2015, September 6). Retrieved from http://hbol.jp/58720

Japan Agricultural Communications. (2011, August 1). Retrieved from http://www.jacom.or.jp/archive03/tokusyu/2011/tokusyu110801-14409.html

Jensen, D. (2004). *A language older than words.* White River Junction, VT: Chelsea Green Publishing Company.

Kageyama, Y. (2015, December 17). No promises in Fukushima cleanup, director says. *The Japan Times.* Retrieved from http://www.japantimes.co.jp/news/2015/12/17/national/no-promises-fukushima-cleanup-director-says/#.VtCwj8c4kkg

Kinefuchi, E. (2015). Nuclear power for good: Articulations in Japan's nuclear power hegemony. *Communication, Culture, & Critique, 8*(3), 448–465. doi:10.1111/cccr.12092

Kumagai, H. (2015, December 26). TEPCO confronts new problem of radioactive water at Fukushima plant. *The Asahi Shimbun.* Retrieved from http://ajw.asahi.com/article/0311disaster/fukushima/AJ201512260045

Lah, K. (2012, January 27). Resident defiant in Japan's exclusion zone. *CNN.* Retrieved from http://www.cnn.com/2012/01/27/world/asia/japan-zone-resident/

Lewis, A., Barnes, J. (Producers), & Lewis, A. (Director). (2015). *This changes everything* (Motion picture). New York, NY: FilmBuff.

Mainichi Shimbun. (2015, August 14). Retrieved from http://mainichi.jp/select/news/20150814k0000m040125000c.html

Moss, S. (2014, March 14). James Lovelock: 'Instead of robots taking over the world, what if we join with them?' *The Guardians.* Retrieved from http://www.theguardian.com/environment/2014/mar/30/james-lovelock-robots-taking-over-world

Nakamura, M. (2012). *Gijutsusha Rinri to risuku manejiment.* Tokyo: Ohmsha.

NHK News. (2014, March 11). Retrieved from http://www3.nhk.or.jp/news/genpatsu-fukushima/20140311/1516_songaigaku.html

NHK World News. (2015, March 31). *Decommissioning chief speaks out.* Retrieved from http://www3.nhk.or.jp/nhkworld/english/news/features/201503312108.html

NPR. (2015, October 8). *Fukushima study links children's cancer to nuclear accident.* Retrieved from http://www.npr.org/sections/thetwo-way/2015/10/08/446873871/fukushima-study-links-childrens-cancer-to-nuclear-accident

Onitsuka, H. (2011). Hooked on nuclear power: Japanese-local relations and the vicious cycle of nuclear dependence. *Asia-Pacific Journal, 10*(2). Retrieved from http://www.japanfocus.org/-Hiroshi-Onitsuka/3676/article.html

Plumwood, V. (1993). *Feminism and the mastery of nature.* London: Routledge.

Plumwood, V. (1996). Has democracy failed ecology? An ecofeminist perspective. In F. Mathews (Ed.), *Ecology and democracy* (pp. 134–168). London: Frank Cass.

Plumwood, V. (2002). *Environmental culture: The ecological crisis of reason.* London: Routledge.

Reuter. (2015, October 20). *Japan acknowledges possible radiation casualty at Fukushima nuclear plant.* Retrieved from http://www.reuters.com/article/us-japan-nuclear-fukushima-idUSKCN0SE0VD20151020

Saito, M., Sheldrick, A., & Hamada, K. (2014, April 2). Only a third of nuclear reactors may be restarted. *Japan Times.* Retrieved from http://www.japantimes.co.jp/news/2014/04/02/national/only-one-third-of-nations-nuclear-reactors-may-be-restarted-analysis/#.Ve3wcs4-IYU

Sankei Shimbun. (2015, June, 4). Retrieved from http://www.sankei.com/west/news/150604/wst1506040006-n2.html

Schreiber, M. (2012, March 18). Lucky Dragon's lethal catch. *The Japan Times.* Retrieved from http://www.japantimes.co.jp/life/2012/03/18/general/lucky-dragons-lethal-catch/#.VeT_Wc4-IYU

Shiva, V. (1993). Decolonizing the north. In M. Mies & V. Shiva (Eds.), *Ecofeminism* (pp. 264–276). London: Zed Books.

The Asahi Shimbun. (2015, August 29). *Morphological defects found in Japanese fir trees around Fukushima nuclear plant.* Retrieved from http://ajw.asahi.com/article/0311disaster/fukushima/ AJ201508290045

The Federation of Electric Power Companies of Japan. (n.d.) Retrieved from http://www.fepc.or.jp/ nuclear/chiiki/nuclear/seido/

The Japan Times. (2016, January 16). *Fukushima nuclear evacuees fall below 100,000.* Retrieved from http:// www.japantimes.co.jp/news/2016/01/09/national/fukushima-nuclear-evacuees-fall-100000/#. VtCov8c4kkg

The Nuclear Safety Commission. (1964/1989). *Regulatory guide for reviewing nuclear reactor site evaluation and application criteria.* Retrieved from http://www.nsr.go.jp/archive/nsc/NSCenglish/ guides/nsc_rg_lwr.htm

Vidal, J., & Harvey, F. (2011, March 15). *Japan nuclear crisis prompts investor confidence in renewables.* Retrieved from http://www.theguardian.com/environment/2011/mar/15/japan-nuclear-explo sion-energy-renewables

Vollmann, W. T. (2015, March). *Invisible and insidious: Living at the edge of Fukushima's nuclear disaster.* Retrieved from http://harpers.org/archive/2015/03/invisible-and-insidious/

World Nuclear Association. (2015, June). *Nuclear power in South Africa.* Retrieved from http://www. world-nuclear.org/info/Country-Profiles/Countries-O-S/South-Africa/

World Nuclear Association. (2015, August, 27). *Nuclear energy in Japan.* Retrieved from http://www. world-nuclear.org/info/Country-Profiles/Countries-G-N/Japan/

World Nuclear Association. (2016, January). *Nuclear power in the world today.* Retrieved from http:// www.world-nuclear.org/information-library/current-and-future-generation/nuclear-power-in- the-world-today.aspx

World Nuclear Association. (2016, February). *Emerging nuclear energy countries.* Retrieved from http:// www.world-nuclear.org/info/Country-Profiles/Others/Emerging-Nuclear-Energy-Countries/

World Nuclear Industry Status Report. (2015). Retrieved from http://www.worldnuclearreport.org/- 2015-.html

Yamaaki, S. (2012). *Genpatsu wo tsukurasenai hitobito.* Tokyo: Iwanami Shinsho.

What's New about Global Social Justice Movements?

SHIV GANESH, MASSEY UNIVERSITY, PALMERSTON NORTH, NEW ZEALAND

The term *Neoteros* was used by Cicero, as he described a form of new, avant-garde late Greek poetry that broke significantly with previous traditions. He used the term *neoteric* to underline fascination with the *idea* of newness itself, rather than the inherent character of what was new per se (Johnson, 2007). Neoterics are now a powerful epistemic force in the academy: the collective captivation of researchers with newness significantly shapes the search for and the construction and production of knowledge, and is evident in any number of institutional academic dynamics, from the significant emphasis in social science research on what is trendy, to the peer review and publication process itself, to even deeper epistemic preoccupations with identifying gaps, establishing findings, and building on or destroying paradigms. The preoccupation with what is new is also part and parcel of a broader capitalist dynamic that forces a constant search for innovation, new value and change.

Many arguments, speculations, assumptions and predictions about contemporary global justice movements are neoteric. Scholars and activists alike have contended that the contemporary wave of global social justice movements are new, unprecedented, and represent a sharp break from those that we have seen in the past. Such neoteric positions are embedded in multiple theoretical perspectives, ranging from critical post-Marxist expositions about commonwealth and multitudes made by such scholars as Hardt and Negri (2010) to more mainstream institutional and

structural perspectives on technological transformations in collective action (e.g., Bennett & Segerberg, 2013).

In this essay I hope to trouble our easy preoccupation with newness by looking carefully at three neoteric arguments that are pervasive in scholarly and public discussions about contemporary global justice activism: first, that global social justice movements have the unprecedented ability to bring diverse and disparate groups into political coalitions; second, that global activists have blurred traditional boundaries between media production and consumption; and third that activists no longer need formal organizations to perform traditional social movement functions. Underlying these three arguments is the simultaneously surprising and pervasive assumption that globalization itself causes and enables resistance to it, or in other words, the very fact that we have global economic and technological systems enables activists to organize globally. It is worth discussing that notion in some detail at the outset.

The globalization-causes-resistance premise is evident in a lot of scholarship on globalization and activism. Take for example, Manuel Castells's (2012) recent book on contemporary global activism, *Networks of Outrage and Hope*. Castells argues here that contemporary activism, guided by what he elsewhere calls "communication power," is produced by a global network society. This in turn is a product of a range of forces that have been brewing since the second world war: first, the crisis and restructuring of industrialism and its two associated modes of production, capitalism and statism, and a new focus on information-based or "informational" capitalism; second, the freedom oriented, cultural social movements of the late 1960s and early 1970s that emphasized personal autonomy above community; and third, the signal change in information and communication technologies that began after the second world war.

Two aspects of the globalization-causes-resistance premise merit further scrutiny: the first has to do with enablement, and the second with dialectic. The idea that globalization *enables* resistance to it is evident not only in historically grounded analyses like Castells, but also in the work of such scholars as Saskia Sassen (2007), who has argued that extended technological connectivity and reflexivity enables activists to enter arenas that were once exclusive to nation states. Others, like Lance Bennett (2003) or Sidney Tarrow (2005) have outlined how global activism manifests in terms of a scale shift, which entails activists being able to move across borders, create transnational coalitions, and work internationally. A second aspect of this argument is what one might call dialectical, and is encapsulated in the very basic Marxist idea that capitalism contains the seeds of its own destruction. In other words, the very existence of capitalism and the sheer scale of injustices perpetrated by neoliberal regimes themselves automatically imply or generate resistance to the regime (Barker, Cox, Krinsky, & Nilsen, 2013).

While the dialectical character of globalization and resistance to it is compelling, this essay works towards allaying two concerns that might arise from casual adoptions of the notion that global capitalism *causes* resistance. First, such easy assumptions might detract attention away from understanding some of the more specific mechanisms and processes that fuel the growth of social movements. Social movement scholars have, after all, maintained for a long time that while injustice creates movements, the growth of any given movement, global or otherwise, is not caused simply by the scale of injustice, especially given widespread consent to domination or large-scale quiescence in the face of injustice. In many ways, quiescence in the face of injustice (Gaventa, 1980) is precisely the problem that has driven the development of more specific explanatory mechanisms or interpretive schema to understand how movements spread and grow: these include such well-known research areas as resource mobilization, political opportunity structures, communicative framing, frame alignment and frame bridging, the diffusion of protest repertoires, and so forth.

A second and related concern with easy assumptions that globalization causes resistance is that it gets us to treat resistance as inevitable, possibly detracting from coming to grips with the struggle, contingence, risk and effort associated with organizing for global justice. In other words, there is nothing inevitable about either justice or progressive change, and the more we are able to study just how both can be procured, the more useful our scholarship is likely to be, both in terms of its theoretical resonance and its pragmatic value.

For all these reasons, we require careful approaches toward understanding what is global and new about social justice, especially given there has been transnational activist organizing and movement across national borders for many decades now. This essay works toward developing such understanding by interrogating the three neoteric arguments outlined earlier, using examples from my ongoing fieldwork in Aotearoa New Zealand, a country in which I have lived and worked since 2005. I will draw from four clusters of studies that I have conducted in this period based on several sets of in-depth interviews, surveys (e.g., Ganesh & Stohl, 2010, 2013) and ethnographic observations (Ganesh, 2014). My intent in this essay, however, is not so much to present specific insight from these studies as it is to use them retrospectively, to illustrate broader points. For specific insights, methods, and findings, I refer the reader to the studies cited here.

ARGUMENT ONE: MOVEMENT DIVERSITY

One of the signature features of global social justice movements has been the claim that it has the unprecedented ability to bring diverse and disparate groups into political coalitions. The variety of labels for global justice organizing itself— globalization from below, or antiglobalization, points toward the idea that it

is more a "movement of movements" or a network of networks, and as Nick Crossley (2002) has said, global social justice is more a field of movements than a traditionally unified movement. Scholars and activists alike contend that such diversity is one of the defining features of what constitutes global justice. That is, one of the reasons that the global justice issues have been so visible over the last fifteen years is the fact that what comprises global justice is a range of actors, involved in a wide variety of causes, using a range of methods, in a number of locations (Tarrow, 2005). Indeed, the very fact that the target of global justice organizing shifted in the late 1990s from a relatively singular focus upon neoliberalism, in the form of protests against the World Trade Organization, to the more complex nexus between neoliberalism and neoconservatism a few years later, in the form of protests against the Iraq war, to even greater complexification in the form of tracing connections between neoliberalism, financialization, ecological devastation and climate chaos, and contemporary conservative politics, is evidence of the flexibility and multidimensionality of activist agendas worldwide (Klein, 2007).

In this sense, diversity and complexity is at the heart of global justice, and such global diversity can be said to have at least three sets of meanings. The first type of diversity relates to the heterogeneity of structure. *Heterogeneity* has been used to describe grassroots networks in global justice (Routledge, 2003) and refers primarily to the range of structurally different groups, from unions to anarchists to church groups, that have forged dynamic alliances as they mobilize against neoliberalism (McAdam, Tarrow, & Tilly, 2001).

A second type of diversity has to do with the variety of political agendas present in global social justice movements. Some groups have a reformist agenda, others strive for autonomy, still others have ecological objections to capitalism, and some reject it in favor of socialism (Hardt & Negri, 2000). All four of Wilson's (1973) political orientations of social movements (alternative, redemptive, reformative and transformative) are thus apparently evident in the global justice movement. Contemporary global justice movements, it is argued, therefore represent a wider coalition and broader base for political action than that evident in previous generations of protest movements.

A third kind of diversity has to do with complexity and diversity of frames that characterize the global social justice movement. Complexity refers to the wide variety of issues that are discursively and materially linked to global frames. Current theoretical and empirical work on complexity in social movements often relies on critiques and modifications of frame-based approaches to social movements developed by Snow et al. (Benford & Snow, 2000; Snow, Rochford, Worden, & Benford, 1986), which emphasize ideas of frame bridging, alignment and transformation. Scholars of framing argue that contemporary social movements are much more likely to be already global in their orientation and frame issues in ways that

are compatible with global discourses on the subject, privileging those over local articulations of issues.

These three characteristics need to be considered with reference to a few issues. First, social movement scholars have known for a while that segmentation in social movements is not new. Gerlach and Hine (1970) talked about the segmentary characteristic of a social movement organization close to 50 years ago, proposing what they called a SPIN model that describe social movements in terms of four characteristics: Segmented, Polycephalous, Integrated, and Networked, using it, among other issues, to talk about the importance of loosely affiliated radical flanks in social movements that prevent assimilation and co-optation. In this sense, internal structural diversity that we see in global social justice, or the fact that it is comprised of large formal organizations, such as Greenpeace, interacting extensively with emergent, informal and even chaotic kinds of activist groups, is not entirely new. Even the various groups that participate in global protests that are iconic definitions of the movement are not all newly constituted. Some studies have indicated that protest participants, even in large global protests, tend to be rooted in traditional sectors of activism. Della Porta and Mosca's (2005)'s study of Genoa G7 protests, for instance, found that the bulk of protest participants hailed from familiar sectors of domestic politics: 40% had a trade union background, and 52% were student activists.

Second, my own work in Aotearoa New Zealand indicates that global social justice activists have historically been comprised of what one might consider the traditionally political left, but specific alliances and coalitions between these groups continue to shift and morph. A split on the left between socialist and anarchist groups on one hand and liberal left groups on the other was clearly evident in October 2007 after the government arrested seventeen activists alleging that they had been engaged in a terrorist plot against the government. Charges were eventually dropped and the political motivations of those who pressed charges were made clear, but the episode revealed some important tensions between liberal groups who were more likely to accept the government position, and radical groups, who were severely critical of it. These fault lines were at least temporarily submerged as a result of Occupy, which in late 2011 had the happy result of bringing together several political parties, peace activists, radical anarchists, socialists, liberarians, trade and labour unions, and even parts of the Labour party. Those new relationships remorphed and tightened amongst some groups a few years later, particularly amongst socialist and anarchist groups, resulting in the establishment of coherent resistance to the Trans-Pacific Partnership (TPP) agreement, starting in 2012.

However, the scale of these alliances do not measure well against movements from a generation or two ago, in particular the 1981 protests against the South Africa Rugby union tour of the country. Popularly known as the Springbok tour, it resulted in a wide variety of groups coming together, including both traditionally

left and right groups, and in a sense, that diversity was bigger, and the groundswell more populist than what we have seen postneoliberalism, and oriented toward global social justice. In fact, the largest set of mobilizations in the country across the political spectrum continues to be the mobilization to Save Lake Manapouri, which occurred in 1967, and which resulted in what is still the largest petition ever submitted to Parliament, with close to 2 million signatures. Taken together then, there are some grounds for ambivalence about blindly endorsing claims about the range of ideological diversity that characterize contemporary global social protests.

Third, a network study I conducted with my colleague Cynthia Stohl in 2007 (Ganesh & Stohl, 2010) found that even amongst the range of groups involved in contemporary global social justice, diversity of representation and membership did not imply equality. A quantitative webcrawler network analysis we conducted showed that of the 68 groups that were linked into global social justice network in the country, some groups were definitely more central than others. In particular, peace activists were the most central to the network, followed by economic justice groups. Animal rights groups and indigenous rights groups were also reasonably well embedded. However, feminist and queer rights groups (in particular Anarcho-feminist groups) were connected only to one or two other groups in the network, and consequently were marginalized even. In fact, they tended to form their own clusters, and we observe that they continue to be somewhat marginal to movements against corporate globalization: even groups such as the Queer Avengers, for instance, who are committed to resistance against the TPPA, are not central to it. The diversity of groups, therefore, does not imply the equality, equal stake or even equity of different groups in the nebulous notion of global social justice.

Finally, our studies and observations have found that not very many activist groups actually maintained rich transnational activist connections, and that there was considerably less interest in mobilizing on issues outside the country (a phenomenon characteristic of global activism, which Sydney Tarrow (2005) calls *externalization*) than there was on mobilizing on justice issues as they impacted the country. Certainly, there was substantial evidence of what Tarrow calls *internalization*, where issues that arise in one part of the world become local issues, and *global framing*, where local issues are articulated in global terms. The latter has been particularly evident in environmental justice issues, where antimining activists have been more and more likely to discuss the impact of mining in translocal terms, invoking discourses of global climate change.

However, we found that global framing itself was a complex issue, and that activists sometimes mobilized *against* global frames. Take the highly loaded word "terror" for instance. In May 2008, three activists affiliated with *Swords into Ploughshares*, itself an international organization that focuses on peace and uses direct action methods, destroyed a satellite dome at the Waihopai spy base, run by

the US military, framing it as a protest against Aotearoa's support of the US-led "global war on terror." They were subsequently acquitted.

Moreover, even as activists used the idea of a "global war on terror" to internalize and frame the issue in discussions with each other and the media, they simultaneously resisted internalization and global framing. A case in point is the October 2007 raids discussed earlier, where seventeen environmental, peace, Māori sovereignty and feminist activists were arrested in an expensive nation-wide operation by the police under the country's antiterror laws for allegedly planning terrorist attacks against New Zealand. In the process, the police broke into the homes of an entire Māori community, as well as the homes of several dozen activists throughout the country. Protests throughout the country focused extensively on resisting the dominant global frame, and mobilized by highlighting why the issue was not terror. Activist tactics subsequently focused considerably on localizing and domesticating the conflict within national boundaries, and questioning state definitions of terror. Thus, even when activists work with global frames and discourses, they are likely to use them and resist them strategically, and it is difficult to cast their work as being unequivocally more global than local, as a neoteric discourse might suggest.

ARGUMENT TWO: MEDIA PRODUCTION AND CONSUMPTION

A second neoteric argument that we often find regarding global social justice activism, especially in the context of media activism is that activists have blurred traditional boundaries between media production and media consumption. Whereas we know from scholars like John Downing (2001) that radical media have had a complex history in the U.S. and elsewhere, scholars such as Bennett (2003) or Pickard (2006) have said that with the advent of digital technologies, for the first time, activists have been able to take on mainstream media by blurring distinctions between media production and consumption. By virtue of being able to upload information, stories, images and coverage of protests on sites such as Indymedia, activists, starting around the turn of the millennium began to bypass the spin of mainstream media and get their message out to each other and to a wider audience. For instance, Hackett and Carroll (2006) argued that the ability of activists to engage in media activism through disrupting symbolic production doesn't just "disrupt codes" in civil society, it also contains material challenges. The proliferation of small-scale, interventionist, ironic and fragmented sites of media production is now seen as an endemic feature of new activism, whether queer, environmental, feminist or peace. Indymedia in particular was an early posterchild for such arguments, and its slogan still is: Don't Hate the Media, Become the Media.

As in the previous section, I would like to make these ideas about the blurred institutional boundaries between media production and consumption more complicated and contextual, once again with examples from Aotearoa New Zealand. Instead of the romantic picture of activists as Internet warriors and heroes that one can see in many popular or sometimes academic interpretations of the role that activists play in everything from mobilizing protests to culture-jamming, our interviews found that global justice activists in the country sometimes endorsed digital technologies, but on other occasions, were equivocal about its value, and still other times were downright skeptical about it. sometimes were equivocal, and at other times were quite skeptical about it. Specific details of the study can be found in Ganesh and Stohl (2010), but here I will recap three particular issues that activists have described to us over the years as they grappled with digital technologies: issues of relevance and relatedly access, the potential for digital surveillance, and the effort required to produce media content. We found their perspectives on each of these changing and becoming more complex over the years.

In 2007, I found several activists querying the centrality of digital technologies to their work. Some talked about how it was important to them, but they also invoked classic digital divide discourses (see Ganesh & Barber, 2009) in terms of echoing concerns about the ability of *other* people to access these technologies and media, and they worried about not reaching people in rural communities who were truly vulnerable and who were most in need of mobilization. By the time we studied the Occupy movement in 2011 and 2012 however, I found that things had changed, even though several people we interviewed were the same activists I had engaged with a few years earlier. One in particular, who had been particularly active in setting up the Indymedia website for the country, talked about how much access to technologies had changed; in his view, the main issue now was not so much whether people had access to the Internet or not, it had to do with their ability to access noncorporatized platforms. "I worry that using Facebook to organize means that we are really endorsing a more insidious, covert, like, form of globalization," he said. "Everything that we do is data for them. Nothing that we can do on Facebook against Facebook can actually damage Facebook. We have to find other platforms." The issue of access, it seemed, had become more complex, where activists were now worried about the ability of communities to access and use democratic media.

Related to this was a second enduring concern that global social justice activists have expressed to me over the years: the potential for surveillance. This was definitely the case in 2007, where activists were concerned about the dominant place that Indymedia occupied as a source of information. Some activists were particularly concerned about their personal safety in the light of the fact that Indymedia was not only used by activists; the fact that it was public meant that announcements about rallies and events were monitored and used by other groups,

notably the police, but also White Supremacy groups. Activists had been particularly concerned that Neo-Nazi groups in and around the Wellington area between 2004 and 2006 had begun to stage counter protests at short notice because they had quick and immediate access to when rallies for social justice or indigenous rights were occurring.

In 2012 and 2013, these concerns were if anything, more visible, and activists had recognized the need to mobilize around surveillance as a global justice issue in its own right. Activist groups were particularly concerned about surveillance in the context of Edward Snowden's revelations regarding surveillance by the National Security Agency in the U.S., and Aotearoa New Zealand's participation in the Five Eyes network. There were protests around the Government Communication Security Bureau (the GCSB) when its role in spying on the German entrepreneur Kim Dotcom came to light in 2012, and also subsequently, when the government pushed through legislation that expanded the scope of cybersecurity legislation to collect information from foreign citizens and also assist private corporations. The law was passed just a month after Snowden's revelations came to light, in July 2013, and once again there were protests across the country against the passage of the bill.

A final issue that activists discussed with me in 2007 had to do with the amount of effort, time and energy that they expended in producing digital content, which pushes against commonplace neoteric assumptions held both in academic research and popular discourse about digital natives and Millennials, that that digital natives easily and effortlessly use technology to organize and multitask, drastically unlike previous generations (see Hitchcock, 2016 for a critique). In 2007, activists I engaged with, regardless of age, talked about their inability to manage time sufficiently enough to be effective at using technology, and they talked about feeling that they were working alone on technology without much help. They exerted considerable effort to make and produce videos, track issues online and keep information up to date.

Again, this had exacerbated in 2012 and 2013, with activists discussing how difficult it was to follow threads and issues, and coordinate their messages across a range of platforms, especially given the increasing fragmentation associated with digital media use. One activist told me in 2014 that paradoxically, he felt he had begun to rely on mainstream media again, because any buzz he was generating on Facebook or Instagram was simply not enough to get him traction on issues, and that politicians in the country still seemed to be more responsive to an Op-Ed he had written in the New Zealand Herald than they were to the number of "likes" that one of his posts on Facebook received.

Taken together then, issues of access, corporatization, surveillance, effort and the continued influence of "mainstream" media significantly complicate the somewhat romantic neoteric argument that activists are as much media producers as

consumers. While they clearly exert more agency in the media environment, doing so takes considerable energy, its impact can sometimes seem increasingly marginal, and it appears that their own creative energy is only one small step ahead of an increasingly corporatized digital media environment.

ARGUMENT THREE: THE END OF ORGANIZATION

A third and final neoteric argument this essay grapples with follows from the first two. That is, given the broad reach and agility of contemporary movements, and the ability of activists to act on their own, formal social movement organizations are in major decline as they are no longer required to perform traditional social movement functions. Bimber, Flanagin, and Stohl (2005), contra to Cooren and Taylor (1997), observed that traditional theories of collective action posited that formal membership-based organizations such as the National Organization of Women or The National Rifle Association played a historically central role in collective action because of the high costs of communicating and coordinating and the need to pool resources. Now, however, the argument goes, the digital environment has radically altered the organizational landscape, historically high costs of coordination and communication are now insignificant, and individuals have considerable communicative agency as a result, and can accumulate ideas, perspectives and support in a way that only organizational leaders could in a previous era (Fisher, Stanley, Berman, & Neff, 2005). In other words, individuals are more able to act as brokers of issues and agendas, and that significantly changes how social movements organize.

This argument has held considerable sway in several accounts of contemporary collective action, particularly in Bennett and Segerberg's (2013) account of what they called the logic of connective action, where activist work is fueled by the work of self-organizing groups, and formal organizational leadership, intervention, framing or agenda-setting is either weak or absent. Consequently, contemporary movements, fuelled as they are by digitally enabled networking, do not rely on formal organizations and summon an entirely new and more volatile set of communicative dynamics. Instead of command and control hierarchies and social movements that look like campaigns, we have decentralized decision-making and protests that look like disorganized mobs. Instead of enduring relationships between central organizers, we have weak or thin ties amongst a large group of activists. And instead of a core group of activists who are passionately concerned about justice, we have digital microparticipation by a large group of people—what some commentators have disparagingly referred to as clicktivism or slacktivism.

At the same time, there is an emerging body of work (e.g., Bakardjieva, 2015; Bimber, Flanagin, & Stohl, 2012; Ganesh & Stohl, 2010, 2013) that argues that current organizing in social movements does not represent the sharp break from

the past posited by popular models of digital activist organizing. Our 2013 study, for example, found that technologies did in fact provide activists with considerable communicative agency, and they functioned to connect audiences and issues, and coordinate with others easily across time and space. However, despite this agency, their work was enabled by a set of networks and relationships with other activists that had often spanned decades. Even new groups and coalitions that activists have created were based on extant networks and groups.

For instance, the need amongst activists in the country in 2012 to mobilize around the Trans-Pacific Partnership Agreement discussed earlier, meant that several activists were able to draw on relationships built a full generation ago when groups such as ARENA and CAFCA had rallied against several free trade deals and various rounds of WTO negotiations in the late 1990s and early 2000s. Even though these groups were no longer active, they had been successful in laying down a network of relationships and, trust amongst activists across the country, who themselves were now seen as icons, including Jane Kelsey, Moana Jackson, and John Minto. This in turn made it easier to organize protests against TPPA across the country, not only in large cities, but also in regional hubs, in 2012 and 2013.

As a result, even as protests in late 2012 and throughout 2013 occurred across the country, it seemed that some of them were more informed by dynamics associated with digitally networked action than others. In Auckland, for example, a late 2012 protest was especially chaotic (Ganesh, 2014), was organized on social media and no "organization" as such was leading the protest, my participant observation in the relatively small town of Whanganui at a related protest in March 2014 indicated that local trade unions had been contacted by their counterparts in other cities, and that a decades-old set of relationships had been activated by the broader movement. Therefore, even as a younger generation of activists, increasingly politicized by the government's austerity policies after 2008, joined anti-TPPA protests, their work was built on top of another layer of historic organizing that relied on an often tacit exercise of a collective "we."

My experience with activist organizing in New Zealand suggests therefore, that activist organizational formation is dependent not only upon the need to communicate and coordinate around movement issues, but also to construct and nourish a collective identity, the dynamics of which are not well captured in contemporary accounts of connective action. Of late, scholars have recognized the importance of collective and coalitional identity to contemporary movements. As Bakardjieva (2015) argued: "while recognizing the formative materiality of communication technologies, however, analysts should resist the urge to derive the logics of political action from the structure of the medium. There is no escape from the laborious examination of the pesky minutia of historical, social and cultural contexts, concrete political situations, configurations of social actors and the content of concrete demands and struggles." Organizing processes therefore, are as

rooted in collective histories and material injustices as they are in the heightened agency of activists in an era of communication abundance.

DISCUSSION

I have used the three neoteric arguments outlined in this essay as a foil to establish that contemporary global justice movements are not striking because they are new, unprecedented, or have a sharp break with the past. Rather, they bring together old and new forms of organizing; sometimes yoking them together, and sometimes holding them in tension. Sometimes "old" and "new" are complementary, as when contemporary organizing efforts for global justice draw upon the experience of activists who have been involved in protests for years. And sometimes, the old and new are clearly in tension, as when even as internet and media activism explode, activists who use that media struggle on a number of fronts, in turn affecting how they organize.

Additionally, hybridity is evident in global justice organizing, even as regards framing, and internalizing contention, which theorists have said is most common in contemporary global movements. Take the fact that even as global peace movements tried to disturb the global war on terror, activists worked within traditional nation-state boundaries, and activism around terrorism shifts scales by scaling up (using public outrage about the war on terror to critique local militarization) and scaling down (resisting definitions of activists as terrorists). Further, protests emerge as acting both in the realm of civil society as well as acting to challenge production—the G20 protests in 2009–10 were a case in point. It is also clear that even as activists construct global targets, they act with reference to nation-state politics, as evident in the 2010 protests at the Association of South East Asian Nations in Pattaya, Thailand. Again, new social movements have always arguably been hybrid, functioning to challenge both civil society and production, both in northern and southern societies.

One additional note worth mentioning, and a powerful case for understanding contemporary social movements as hybrid rather than new forms has to do with Habermas's critique of new social movements in the 1960s, which focused upon their emphasis upon identity and lifestyle, and their focus on civil society rather than public policy and economic change. Criticism of the Habermasian view has been extensive (McCarthy, 1981) but it is worth also mentioning is that considering hybridity gets us away from understanding even those movements as being purely "civil," as they drew significantly upon traditions of expressing labour unrest even as they invented new forms of protest. The Mattachine Society, one of the most influential and prominent Pre-Stonewall groups, for example, was founded by people who were significantly involved with the communist party,

including Harry Hay: the initially confrontational tactics of the society, at least until Hay's departure until 1953, was arguably because of the close connections with other forms of radicalism, which in turn affected how the movement developed its frames of oppression and alienation, as well as its forms of contention.

It follows then, that newness and diversity are clearly identity statements in the global social justice movements, and I would suggest that we study how they function as claims, rather than ontologize them per se. This does not imply that they are unimportant: on the contrary, they clearly are: but we need to look further at how they might function to structure movements in potentially paradoxical ways—for instance, by simultaneously incorporating groups such as anarcho-feminists, and then rendering them relatively marginal. In this sense I am also asking for more care in understanding how the "global" actually operates in social movements, both in the "north" as well as the "south" so that we can both describe as well as act in them better, and more fully.

Thus, in terms of revisiting the issue of the dialectics of power and resistance, we need to be even more complicated about our considerations of dialectic. In understanding paradox, we have too often treated competing forces as equivalent—in fact, in some ways the very word "contradiction" implies that—yet, we know from Foucault that both power and resistance function in very different ways. Consequently, we need to move away from structurally equivalent understandings of dialectice and treat dialectical dynamics with more complexity.

By way of concluding, I would offer that the idea of organized dissonance is an especially useful way to look at contemporary global justice movements because it helps us think through how the "old" might rub against the "new" in contemporary forms of collective action. Relatedly, we need to explicitly historicize contemporary movements, not dichotomizing between global social justice movements and those that preceded them, and appreciating how contemporary movements are embedded with and against not only global, but also colonial logics, histories and geographies.

REFERENCES

Bakardjieva, M. (2015). Do clouds have politics? Collective actors in social media land. *Information, Communication & Society, 18*(8), 983–990.

Barker, C., Cox, L., Krinsky, J., & Nilsen, A. G. (2013). Marxism and social movements: An introduction. In C. Barker, L. Cox, J. Krinsky, & A. G. Nilsen (Eds.), *Marxism and social movements*. Boston, MA: Brill.

Benford, R., & Snow, D. E. (2000). Framing processes and social movements: An overview and assessment. *Annual Review of Sociology, 26*, 611–639.

Bennett, W. L. (2003). Communicating global activism: Strengths and vulnerabilities of networked politics. *Information, Communication and Society, 6*(2), 143–168.

Bennett, L., & Segerberg, A. (2013). *The logic of connective action: Digital media and the personalization of contentious politics*. Cambridge: Cambridge University Press.

Bimber, B., Flanagin, A., & Stohl, C. (2005). Reconceptualizing collective action in the contemporary media environment. *Communication Theory, 15*(4), 365–388.

Bimber, B., Flanagin, A., & Stohl, C. (2012). *Collective action in organizations: Interaction and engagement in an era of technological change*. Cambridge: Cambridge University Press.

Castells, M. (2012). *Networks of outrage and hope: Social movements in the Internet age*. Cambridge, UK: Polity Press.

Cooren, F., & Taylor, J. R. (1997). Organization as an effect of mediation: Redefining the link between organization and communication. *Communication Theory, 7*(3), 219–260.

Crossley, N. (2002). Global anti-corporate struggle: A preliminary analysis. *British Journal of Sociology, 53*(2), 667–691.

della Porta, D., & Mosca, L. (2005). Global-net for global movements? A network of networks for a movement of movements. *Journal of Public Policy, 25*(1), 165–190.

Downing, J. (2001). *Radical media: Rebellious communication and social movements*. Newbury Park, CA: Sage.

Fisher, D. R., Stanley, K., Berman, D., & Neff, G. (2005). How do organizations matter? Mobilization and support for participants at five globalization protests. *Social Problems, 52*(1), 102–121.

Ganesh, S. (2014). Unraveling the confessional tale: Passion and dispassion in fieldwork. *Management Communication Quarterly, 28*(3), 448–457.

Ganesh, S., & Barber, K. F. (2009). The silent community: Organizing zones in the digital divide. *Human Relations, 62*(6), 851–874.

Ganesh, S., & Stohl, C. (2010). Qualifying engagement: A study of information and communication technology and the global social justice movement in Aotearoa/New Zealand. *Communication Monographs, 77*(1), 51–74.

Ganesh, S., & Stohl, C. (2013). From Wall Street to Wellington: Protests in an era of digital ubiquity. *Communication Monographs, 80*(4), 425–451. doi:10.1080/03637751.2013.828156

Gaventa, J. (1980). *Power and powerlessness: Quiescence and rebellion in an Appalachian valley*. Urbana, IL: University of Illinois Press.

Gerlach, L., & Hine, V. (1970). *People, power, change: Movements of social transformation*. Indianapolis, IN: Bobbs-Merrill.

Hackett, R., & Carroll, W. (2006). *Remaking media: The struggle to democratize public communication*. New York, NY: Routledge.

Hardt, M., & Negri, A. (2000). *Empire*. Cambridge, MA: Harvard University Press.

Hardt, M., & Negri, A. (2010). *Commonwealth*. Boston, MA: Harvard University Press.

Hitchcock, S. D. (2016). *Generations at work: A phronetic approach to aged and generational scholarship* (PhD thesis). Arizona State University, Tempe, AZ.

Johnson, W. R. (2007). Neoteric poetics. In M. B. Skinner (Ed.), *A companion to Catullus* (pp. 212–232). Malden, MA: Blackwell Publishing.

Klein, N. (2007). *The shock doctrine: The rise of disaster capitalism*. New York, NY: Metropolitan Books.

McAdam, D., Tarrow, S., & Tilly, C. (2001). *Dynamics of contention*. Cambridge, UK: Cambridge University Press.

McCarthy, T. (1981). *The critical theory of Jurgen Habermas* (2nd ed.). Cambridge, MA: MIT Press.

Pickard, V. (2006). Assessing the radical democracy of Indymedia: Discursive, technical and institutional constructions. *Critical Studies in Media Communication, 28*(1), 19–38.

Routledge, P. (2003). Convergence space: Process geographies of grassroots globalization networks. *Transactions of the Institute of British Geographers, 28*(3), 333–349.

Sassen, S. (2007). *A sociology of globalization.* New York, NY: W.W. Norton.

Snow, D., Rochford, B., Worden, S., & Benford, R. (1986). Frame alignment processes, micromobilization and movement participation. *American Sociological Review, 51,* 464–481.

Tarrow, S. (2005). *The new transnational activism.* Cambridge, UK: Cambridge University Press.

Wilson, J. (1973). *Introduction to social movements.* New York, NY: Basic Books.

Critical
Intercultural
Communication
Studies

General Editor, Thomas K. Nakayama

Critical approaches to the study of intercultural communication have arisen at the end of the twentieth century and are poised to flourish in the new millennium. As cultures come into contact—driven by migration, refugees, the internet, wars, media, transnational capitalism, cultural imperialism, and more—critical interrogations of the ways that cultures interact communicatively are needed to understand culture and communication. This series will interrogate—from a critical perspective—the role of communication in intercultural contact, in both domestic and international contexts. This series is open to studies in key areas such as postcolonialism, transnationalism, critical race theory, queer diaspora studies, and critical feminist approaches as they relate to intercultural communication, tuning into the complexities of power relations in intercultural communication. Proposals might focus on various contexts of intercultural communication such as international advertising, popular culture, language policies, hate crimes, ethnic cleansing and ethnic group conflicts, as well as engaging theoretical issues such as hybridity, displacement, multiplicity, identity, orientalism, and materialism. By creating a space for these critical approaches, this series will be at the forefront of this new wave in intercultural communication scholarship. Manuscripts and proposals are welcome that advance this new approach.

For additional information about this series or for the submission of manuscripts, please contact:

Dr. Thomas K. Nakayama
Northeastern University
Department of Communication
360 Huntington Ave
Boston, Massachusetts 02115

To order other books in this series, please contact our Customer Service Department:
(800) 770-LANG (within the U.S.)
(212) 647-7706 (outside the U.S.)
(212) 647-7707 FAX

Or browse online by series:
www.peterlang.com